GERHARD
RICHTER
DOUBT AND
BELIEF IN
PAINTING

Gerhard Richter, 1998

GERHARD RICHTER
DOUBT AND BELIEF IN PAINTING

Robert Storr

The Museum of Modern Art, New York

This volume is produced by the
Department of Publications
The Museum of Modern Art, New York
Edited by Harriet Schoenholz Bee
Design and composition by Gina Rossi
Production by Christopher Zichello
Printed and bound by Dr. Cantz'sche Druckerei,
Ostfildern, Germany
Printed on 150gsm Eurobulk

Texts for parts one and two are reprinted from
Gerhard Richter: Forty Years of Painting by Robert Storr,
published by The Museum of Modern Art in 2002.

Texts for part three are reprinted from *Gerhard Richter:
October 18, 1977* by Robert Storr, published by
The Museum of Modern Art in 2000.

Library of Congress Control Number: 2003103401
ISBN: 0-87070-355-2

Published by The Museum of Modern Art
11 West 53 Street, New York, New York 10019
www.moma.org

Distributed in the United States and Canada by
D.A.P. / Distributed Art Publishers, Inc., New York

Distributed outside the United States and Canada by
Thames & Hudson, Ltd., London

Cover: Gerhard Richter. Detail of *Stag [Hirsch]*. 1963.
Oil on canvas, 59" × 6' 6¾" (150 × 200 cm). GR 7.
Private collection

Printed in Germany

CONTENTS

PREFACE

The meaning of modern art will never be a settled question; that is the souce of its vitality. Art histories are written with the foreknowledge that they will, sooner or later, be rewritten. Meanwhile, successive groups of observers bring new eyes and new contextual awareness to bear on the imagery, forms, and mediums artists adhere to and reconfigure. No artist has made the pluralist, often contradictory nature of modern and contemporary art more apparent than the German painter, photographer, printmaker, film-maker, and installation artist Gerhard Richter. The range of his activity and the variety of aesthetic means and manners he has explored—from photo-based realism to traditional portraiture and landscape, from monochrome and minimal abstraction to gestural abstraction and mirror paintings—is extraordinary. Some observers who view Richter as a quintessen-tial postmodernist, deplore him as a chameleonlike virtuoso with no essential commitment to any of the ideas or techniques he employs. Others celebrate his ability to make art-in-the-image-of-art as a tool for demystifying modernist practices generally, and painting in particular.

The three texts reprinted in this volume recognize the possible arguments in favor of these and other so-called postmodernist assessments of Richter, but collectively they take a quite different tack, placing him squarely in, and not at the end of, the ongoing history of modern art. Rather than assign him the role of capricious despoiler of high art's accu-mulated traditions (the conservative position) or that of a radical negator of received ideas and illusions (the ideologically opposing position), I have found it more useful to examine his predicament as an artist driven by doubt about the validity of his artistic vocation, but equally unconvinced by the categorical rejection of art typical of some of the avant-gardes of his time. The texts were written independently of one another, and constituted two earlier Museum of Modern Art publications, *Gerhard Richter: October 18, 1977* (2000) and *Gerhard Richter: Forty Years of Painting* (2002), the latter of which accompanied the Museum's retro-spective exhibition of the same name. The monographic essay on Richter's magisterial series of paintings, *October 18, 1977*, was completed first, and the full retrospective treat-ment of his art and life followed. Nonetheless, the two main parts of this reader were framed with each other in mind. I chose to devote a single book to the complex historical and polit-ical issues addressed by the October cycle, as well as the equally controversial social and artistic issues its creation and subsequent reception raised, rather than distort the overall flow of the longer text by an extended analysis of these pictures.

The longer, more comprehensive essay, Part One in this volume, looks at Richter's career with historical, political, and philosophical concerns firmly in mind. In a variety of modes, Richter paints things about whose meaning he is unsure and about whose claims to mimetic accuracy or aesthetic authenticity he is also unsure. His great gifts as a painter are precisely what permit him to articulate those doubts as well as anyone proposing to use them in a straightforward affirmative fashion. Thus Richter's photo-based pictures undo the *trompe l'oeil* effects and factual claims of conventional realism, in particular Photo-Realism, whose heightened optical resolution Richter's famous "blur" dissolves. By the same token, Richter's forays into various modes of abstraction satisfy all the formal requirements of paintings of

that type while making manifest the degree to which these supposedly natural or logically necessary styles depend on conventions predicated on belief in inherent truth.

Here, a fundamental skepticism toward ideology—be it political or aesthetic or the two combined—prompts Richter's simultaneous demonstration of how evocative or probing art can be and how much at risk we are of misunderstanding it and the world it purports to represent or reflect if we take appearances at face value. Moreover, rather than approach this skepticism primarily as a function of psychological or philosophical predisposition, this essay attempts to ground it in Richter's experience of some of the most terrible moments in the twentieth century in one of the most conflicted places in the world: prewar and postwar Germany. Thus, given the need to coordinate such different perspectives, my synoptic account of Richter's growth and maturity employs a narrative mode. Despite its current unpopularity among scholars, this mode has certain intellectual advantages. In my view, narration paralleled by critical commentary remains among the most flexible and textured ways of linking what happens to people with what happens in works of art.

Part Two, originally published with the comprehensive essay, comprises an edited version of a three-day interview with the artist, and suggests other avenues of inquiry into Richter's manifold production. It also raises questions about the role and importance of an artist's statements—and silences—in judging his or her life and work.

Part Three reprints the full text on the fifteen paintings collectively titled *October 18, 1977*. Here, a primary aim was to set the stage for the events surrounding the emergence, actions, arrests, trials, and deaths of the principal leaders of the Baader-Meinhof group in ways that would help readers unfamiliar with the period understand the sources of postwar German radicalism, the effects it had on Germany as a whole, and some of the impact it had on the artistic world in which Richter operated. Against that background, it seemed that my discussion of his purpose in dedicating himself to painting scenes of that story would be more objective if informed by knowledge of what this band of urban guerillas actually did and didn't do, and, to the extent it can be grasped, why they chose such an extremist course. It was also my hope that a careful weaving into my analysis what Richter himself has said about his own political and aesthetic attitudes and about his motives for creating these pictures would put to rest two simplistic charges against him. The first is that he sought to eulogize terrorists and preach their cause. The second, coming from the other end of the political spectrum, is that as an established artist out of sympathy with the Left he had no right to depict the martyrdom of revolutionaries. Although widespread, these antithetical interpretations cannot both be true. My view is that neither is true, and that the underlying impulse behind Richter's decision to tackle this subject was a deep sensitivity to the tragic dimension of the twentieth century, a tragedy deeply rooted in a tendency to see things ideologically in black and white, for which Richter's signature gray—and in these pictures the most somber and chilling of grays—is the emblem of an anguished uncertainty about historical truth as well as of a principled refusal to take sides in a contest of destructive absolutes.

Therefore, this latest book, intended as an affordable volume primarily for students, approaches the artist from multiple but overlapping angles, in the conviction that none of them, including the ones upon which I have most relied, will exhaust the richness and difficulty his work encompasses. The oeuvre of this artist stands as a signal challenge to the many aesthetic methodologies and discourses currently in use. In that spirit, this volume is designed to further complicate matters rather than resolve them and to clarify questions only with the intent of raising the level of discussion, rather than impose a monolithic reading of Richter's multifaceted work. —*Robert Storr, 2003*

Gerhard Richter, mid-1970s

PART ONE

GERHARD RICHTER: FORTY YEARS OF PAINTING

by Robert Storr

INTRODUCTION: THE 2002 RETROSPECTIVE

The present retrospective of paintings by Gerhard Richter is long overdue. As the first comprehensive exhibition of the work of the seventy-year-old German artist to appear in New York, it follows two previous surveys held over a decade ago in other parts of the country. The first was a synoptic overview consisting of only twenty-two paintings, organized in 1987 by John T. Paoletti for the Wadsworth Atheneum in Hartford, Connecticut, as part of its Matrix series, a program usually focused on emerging artists. That Richter was fifty-five when the show opened indicates the lag in recognition his paintings have met in the United States, although on that occasion the art critic Roberta Smith, in *The New York Times*, hailed the artist as "one of the most important West German painters of the postwar period."[2]

Close on the heels of the Hartford show, the Art Gallery of Ontario in Toronto widened the public's view of Richter in 1988 with an eighty-painting survey of his career that traveled to the Museum of Contemporary Art in Chicago, the Hirshhorn Museum and Sculpture Garden in Washington, D.C., and the San Francisco Museum of Modern Art, organized by Roald Nasgaard and I. Michael Danoff. In the fifteen years since that exhibition, Richter has become an increasingly visible figure in American galleries, group or thematic shows at museums, and exhibitions devoted to one or another aspect of his work, such as the presentation of Richter's cycle of canvases *October 18, 1977*, at The Museum of Modern Art in 2000, and *Gerhard Richter in Dallas Collections*, which opened the same year, and which, along with a selection of paintings, also included a complete set of the artist's multiples recently acquired by the Dallas Museum of Art.

The fact remains, however, that compared to American contemporaries of comparable achievement—Jasper Johns and Robert Ryman, to name two—Richter is relatively unfamiliar to the general American public, and still insufficiently known or understood by the dedicated audience for modern art. Only two years older than Richter, Johns (who was born in 1930), has had three full-scale retrospectives in New York, not counting exhibitions of his drawings and his prints; still other exhibitions elsewhere in the country have concentrated on particular series of pictures. Ryman (also born in 1930) has had two large New York retrospectives and one moderately sized one. If one were to add to this list somewhat older artists, such as Roy Lichtenstein—whose early Pop images helped spur Richter to make paintings of equal radicality within months of seeing them—or Robert Rauschenberg, who, along with Lichtenstein, had a powerful impact on Richter's friend Sigmar Polke—the discrepancy between the attention given American artists of the post-Abstract Expressionist generation and that paid to leading painters on the opposite side of the Atlantic (not to mention other parts of the world) becomes more glaring.

Things have not been much better—and sometimes have been worse—for European artists who came of age before Richter. Joseph Beuys, Richter's mercurial colleague on the faculty of the Art Academy (Kunstakademie) in Düsseldorf, and among the most influen-

ROBERT STORR

tial experimental artists of his period, has had only one American retrospective (at the Solomon R. Guggenheim Museum in New York in 1979) and one large survey of his drawings (at the Philadelphia Museum of Art and The Museum of Modern Art in 1993–94). Lucio Fontana, a vital link between prewar and postwar Italian avant-gardes, who helped open Richter's eyes to modernism, has had only one retrospective in New York (at the Guggenheim in 1977); and Marcel Broodthaers, a cryptic but essential counterforce to Pop art and a seminal figure in Conceptual art, with whom Richter collaborated in the early 1970s, was given a retrospective by the Walker Art Center in Minneapolis in 1989, which never made it to New York. Finally, two artists in whom Richter has expressed scant interest but who helped set the stage for him and his contemporaries, Yves Klein and Piero Manzoni, have found even less favor. A Klein retrospective was held at The Jewish Museum in New York in 1967, after which none has been mounted in the United States; and Manzoni has had only two gallery exhibitions and no American retrospective.

The motive for compiling this fragmentary and admittedly argumentative list is merely to point out the most obvious evidence of America's, and in particular New York's, cultural nearsightedness. This myopia is not the fault of the American artists who have benefited from it but, rather, the consequence of dramatic shifts in power. After 1945 the United States experienced an unanticipated, largely unchallenged, expansion of its economic, political, and military might—along with an extraordinary, often glorious, fulfillment of its untapped artistic potential. This was not a Renaissance, since it came without precedent, but rather a convergence of creative energies and social circumstances whose explosive effect sent shock waves across the nation and abroad. From roughly 1945 to 1975 there were as many good reasons to think that New York City was where advanced culture "happened," as there were ambitious artists working in downtown apartments and lofts—and there were a lot of them. Widespread opinion had it that Paris had ceded its status as the capital of modernism to New York, but this consensus was predicated on the assumption that modernism had always had such a capital, and that, failing one, it was bound to have another. Although contested, the transfer seemed clear enough: from the mid-nineteenth up to the mid-twentieth centuries it had been France's turn, this time it was America's. Fueled by quantities of art (much of it truly innovative) and by intense debate (much of it ideologically narrow but all the more compelling), Americans, with New Yorkers in the lead, soon got used to the idea that anything and everything of real consequence in contemporary art either originated there or would find its way there soon enough.

The alternative model of a polycentric art world in which far-flung, relatively small but genuinely cosmopolitan regions or cities were connected to one another by loose networks of artists, dealers, critics, and curators nurturing divergent but vigorous strains of avant-garde art had dawned on relatively few people caught up in the feverish, demonstrably fertile activity of the Tenth Street or SoHo art scenes. However, this was exactly the model that was developing all over Europe: in Austria, Denmark, Belgium, the British Isles, France, Italy, and, most dramatically, in Germany. There, in Düsseldorf, Cologne, Berlin, and other pockets of ferment the first modernist German art to appear since Adolf Hitler came to power in 1933 was being made. Although some individuals and tendencies were able to attract attention for more-or-less brief periods of time, it was not until the early 1980s that the overall dynamism of the German art scene was generally acknowledged in the United States. The work that captured the spotlight first—and held it—was work that fit the conventional American idea of what authentic German modernism had always looked like, which is to say Expressionist, with all that the term connotes: full-bore

emotionalism and gestural and chromatic violence. Typical of this perspective, in many ways, was a 1983 exhibition at the Saint Louis Art Museum, *Expressions: New Art from Germany*, which featured the work of Georg Baselitz, Jörg Immendorff, Anselm Kiefer, Markus Lüpertz, and A. R. Penck, among others. This revival of painting dovetailed with the resurgence of painterly figuration in New York, which despite the disparate work of its star performers, Jean-Michel Basquiat, Eric Fischl, David Salle, and Julian Schnabel, was labeled, neo-Expressionism, along with that of Baselitz and his cohorts. It came after almost a decade of art making and art discourse preoccupied by forays into new media and out-of-the-studio territory—installation, site-specific sculpture, land art, video, text art, photo-documentation, performance art—carried on under the aegis of new aesthetic paradigms heavily influenced by Marxism, feminism, linguistics, and the social sciences; and it stirred a powerful backlash among the advocates of the suddenly overwhelmed and no longer youthful post-Minimal avant-gardes of the 1970s.

The resulting side-taking and polemical shortcuts employed by critical adversaries made it almost impossible for anyone to concentrate on the obvious differences among the diverse representatives of this reborn—or retread—German variant of Expressionism. This caused some people to overlook or hastily acknowledge in passing the conceptual component of Kiefer's early photo-based work, in order to linger over his grand-manner tableaux and neo-Gothic woodcuts, and led others to ignore the political thrust of Immendorff's otherwise broad-brush Café Deutschland paintings, not to mention the agit-prop and neo-Dada work that preceded them.[3] Above all, this lumping together of everything German into the "Expressionist" basket made it hard to see and virtually impossible to reckon with paintings that simply would not fit this description. Both Richter and Polke fell into this category, which goes a long way toward explaining why neither one of them fully emerged in his own right until the 1980s were almost over.[4]

Granted, Richter had by that time been making brightly colored gestural abstractions for a decade, examples of which had been included in a number of exhibitions that framed the public's understanding of the "new spirit in painting," to borrow the title of one such show. But the strange deliberateness of these canvases did not conform to the heated spontaneity that was the basis of the Expressionist myth: in particular, the earliest works of this kind in which what appears at a distance to be a bold slash of heavy pigment or a shimmering wash of color reveals itself up-close to be a flat illusionistic rendering of expressionist painterliness. Moreover, those intrigued enough by what Richter called his Abstract Pictures to look further into his work might have found landscapes, still lifes with skulls, wine bottles, burning candles, and the occasional portrait—all of which bore dates similar to those of the abstractions. Additional investigation would have revealed that Richter's work could be traced back to 1962 and that, almost from the outset, it was characterized by the same kinds of simultaneous stylistic contrasts that were found in his most recent paintings.

In the 1980s confusion about what was recent and what belonged to the past was prevalent in a context where the "newness" of the new German art often meant that people took little or no account of the facts that the artists they were encountering for the first time were actually in mid-career, and the work they were discovering had quite possibly been made ten or even twenty years before. In short, this was art without an art history. As familiarity with it grew, the need for a substantial rewriting of existing histories of European art in the second half of the twentieth century—histories previously dominated by famous survivors of the prewar avant-gardes and postwar eminences such as Jean Dubuffet and Francis Bacon, with a nod to British Pop art and varieties of hard-edge abstraction

in France, Switzerland, and Germany—had become even more imperative, as had a fundamental rethinking of American art history in the same period.

The multifaceted nature of Richter's output posed an especially daunting challenge to the received aesthetic wisdom of an American public educated to the idea that modernism consisted of the linear progression of movements propelled by individual talents struggling to make their distinctive contribution to "mainstream" painting and sculpture. Criticism of this kind presupposed a logical and, in hindsight, necessary evolution of styles—from figuration to abstraction, or at least from realism to more interpretive forms of depiction—advanced by artists whose reputations for creative rectitude were consolidated around readily identifiable bodies of work. After World War II the cult of authenticity rested upon artists' sincere efforts to match their work with their experience; and the cult of formal integrity rested upon the consistency of their intentions with regard to the larger scheme of their medium's predicted development. Inauthentic, insincere, or inconsistent art—signaled by stylistic zigzags and about-faces as opposed to uninterrupted forward motion—were a matter of existential bad faith or aesthetic fickleness.

The positive role models for this ethos are legendary: Vincent van Gogh's agonizing self-transformation from provincial amateur working in a stilted, already old-fashioned naturalist manner to a pioneering Post-Impressionist; Piet Mondrian's solitary pilgrimage from a similarly conservative naturalism through Symbolism to the earthly paradise of pure nonobjective art; and Jackson Pollock's desperate battle against his demons and technical awkwardness leading to the invention of a psychologically charged but pictorially unfettered allover abstraction. Conveniently bypassed in the construction of this archetype was the always pluralistic Pablo Picasso, who reveled in changing artistic directions as well as in raiding art history and the work of his contemporaries for anything he could use; and Francis Picabia, who was as stylistically promiscuous as Picasso (though not as seductive), and even more brazen in his indifference toward aesthetic idealism of the sort that produced the intertwined narratives of the modern artist as a uniquely purposeful being and modernism as an ever more concentrated force unswervingly targeted on wholeness or on irreducible essences. Although Picasso defined high modernism in the public imagination, consensus taste often treated him as if he were heroically beyond it, while that same consensus dismissed Picabia—especially the peek-a-boo, decorative neoclassical pictures and pastiches of pulp pinups he painted after abandoning Cubism and Dada—as if he were ignominiously beneath it.

By the 1960s few artists in Europe or America thought, as Pollock and Willem de Kooning had twenty years earlier, that Picasso was "the man to beat," but in Europe, as distinct from America, the idea that Picabia's multifariousness might open paths through the unified-field theory of modernism had taken hold.[5] When asked in 1979 about the superficial slickness and apparent detachment of his photo-based painting, Richter replied: "I would say that my behavior is a little comparable to Picabia, wouldn't you?"[6] The interviewer reporting Richter's remark added that it was delivered coyly, but that is unlikely. Rather, the positive invocation of Picabia's name marked the line separating observers who were wedded to the notion that important artists set themselves apart by the creation of a signature style (and who, therefore, could not believe that anyone serious would opt for eclecticism) and practitioners who were increasingly impatient with the demand that they invent and then stick to such a style as proof of their absolute "originality," since it was indicative of the kind of imposed value that their free appropriation of images and mimicry of established styles had called into question. The unexamined expectation that artists do one thing—their thing—

gave traction to painters like Richter who were gifted with the ability to do many things but doubtful of the inherent validity or necessity of any single way of working.

Richter's technical facility coated the pill he offered those with doctrinaire modernist taste, but it also heightened suspicion. The virtuosity he demonstrated—a virtuosity he has been at pains to play down for this very reason—reinforced the belief of some detractors that he was a trickster or, worse, an opportunist ready with good-looking pictures to suit every sensibility and every turn of the fashion wheel.[7] But if that were really the case, why did Richter show his work in mixed batches when it would have been more efficient, as well as less easily subject to antagonistic scrutiny, for him to funnel each genre's examples to its receptive public? Instead, Richter has deliberately muddied the waters and opened himself up to attack by insisting that appreciation of any given aspect of his production is contingent on an awareness of its overall multiplicity of aspects.

Speaking at a round table convened in 1994 to consider the problem of Richter's many guises, the writer Diedrich Diederichson argued: "The paintings don't only stand for themselves. They are, so to speak, stage directions for viewing other paintings."[8] A more sympathetic view was taken at the time of Richter's first New York exhibition in 1973[9] by Peter Frank: "As Richter's art is dependent on his own history . . . the Onnasch Gallery correctly showed Richter in retrospect."[10] Frank was the first American critic to recognize the impact on Richter of Fluxus—a neo-Dada tendency to which Frank was also close—and based on that association pronounced him "a conceptual painter" whose "paintings are statements about ideas for paintings—almost tautologies but more evasive and unsettled."[11] Early on, then, Frank's commentary set the tone for the supportive response to Richter's deft, cool, and hermetically multifarious picture making.

That presumption that the artist was a Conceptualist in studio garb was the jumping-off point for Nasgaard's essay in the catalogue of the 1988 Richter retrospective. Noting that he was the only painter in The Art Institute of Chicago's *Europe in the Seventies: Aspects of Recent Art*, a 1977 exhibition he described as the "most dramatic rejection of conventional media ever observed in an art exhibition that purports to survey both a decade and a continent," Nasgaard said: "Here Richter's paintings kept company with Arte Povera artists and other European counterpoints of Minimal and Conceptual Art. And, indeed, this has been the more critical context for his work: where what is addressed is the conceptual basis of his painting, or its deconstructivist program. The discussion therefore has often led away from painting—an orientation also supported by Richter's own ventures into other kinds of work—performance, collaboration, inventories, photographs, objects, books."[12]

When Nasgaard wrote this, the war between neo-Expressionism's defenders and its adversaries had reached its climax, and was settling into a stalemate. Chief among the latter were critics who, having cut their teeth on Minimal, Process, and Conceptual art in the 1960s and 1970s, set about to construct artistic teleologies that drew direct connections between those tendencies and more recent varieties of postmodern art, even as they used that ostensibly radical new art and the psychoanalytic, linguistic, and political underpinnings in which it was entangled to deconstruct the existing teleologies of modernism. With few exceptions, this self-consciously anti-aesthetic school of thought took it as a given that painting had been rendered historically obsolete by new media—in particular by photomechanical means that permitted the mass reproduction of words and images. If painting were to serve any credible function, they maintained, it would be as an instrument to hasten the demolition of the formal and ideological foundations that had previously held painting up and guaranteed its preeminence among other art forms.[13] From this vantage point, for example, David

ROBERT STORR

Salle's overlaying of pirated fragments from Picasso, Max Beckmann, Reginald Marsh, advertising, and the comics (a procedure derived from the work of Polke) was seen as canceling one order of image with another, until all—"high" as well as "low"—were marked null and void.

While pioneers of reductive abstract painting such as Ryman and Frank Stella were regarded as saving remnants of the modernist avant-garde and granted special dispensation from the sweeping declaration that painting was dead by those dedicated to the proposition that painting was a social and aesthetic anachronism, Richter the postmodern polymath was accorded a special—and especially—problematic role as the unrivaled anti-master of his craft who could demonstrate once and for all that painting had exhausted its formerly protean possibilities—possibilities which could never be revived no matter how skillfully they were evoked.

And so when the German-born, American-based art historian, and Richter's longtime friend, Benjamin Buchloh, told the artist that critical commentators had "started to see you as a painter who knows all the tricks and techniques, and who simultaneously discredits and deploys all the iconographical conventions. . . . At the moment, this makes you particularly attractive to many viewers because your work looks like a survey of the whole universe of twentieth-century painting, presented in one vast, cynical retrospective," he was inverting the hostile view that Richter was a gifted jack-of-all-trades and offering the repolarized condemnation as a compliment.[14] In sum, doctrinaire exponents of Marcel Duchamp's conceit that "retinal," or perceptual, forms of art had been permanently eclipsed by conceptual ones cast Richter as the man who could thoroughly undo painting precisely because he could do it so well.

Richter's own complex, intermittently gloomy feelings about painting's prospects are by no measure so categorical or so extreme. Acutely conscious of his own limitations and those of his medium, Richter responded to Buchloh by saying that he saw "no cynicism or trickery or guile" in his practice. Pressed by the critic to admit that the tension in his work between depiction and self-reflection—in other words, the making of images and the critical examination of them—was set up in order "to show the inadequacy, the bankruptcy of both," Richter replied, "not the bankruptcy, but always the inadequacy," after which he took care to stipulate that he meant this "in relation to what is expected of painting."[15]

He might just as well have said what *he* expected of painting, by which we may understand "everything" shadowed by the fear of "nothing." The existential misgivings about the medium Richter harbors as a practitioner are fundamentally different from the rhetorical certainties his postmodernist supporters have ascribed to him in their desire to make him a standard-bearer for their overdetermined brand of endgame speculation. If Richter has managed to straddle the divide between conceptual and perceptual art—art as analytic method and art as the material expression of intuitions and emotions—it has not been a matter of hedging his bets, and it has certainly not been the easy way out. Instead, Richter has persisted in bridging the gap—a dichotomy which, in the hands of those who most rigidly stress it, raises the schizophrenic separation in our culture between thinking and doing to the level of a supposedly "progressive" principle—because the alternative of stepping to one side or the other in order to contemplate the opposite cliff in greater comfort and with diminished risk of being misunderstood was untenable. Looking back from the fenced-in promontory of an ideologically secure position at the articulate but nonverbal means by which he had groped toward truths or partial truths, was inconceivable to him. And so, conversely, was a retreat into the safety of artistic tradition with an occasional glance over his shoulder toward the brink of philosophical doubt to which the daily practice of painting had brought him.

Although critics have spoken his name—and the most attentive have spoken well, with the result that there is a rich and rapidly growing body of commentary on his work— no one has set forth the terms of Richter's dilemma more cogently than the artist himself. In interviews, letters, and private ruminations, the leitmotifs of Richter's thought have been clearly stated from the very beginning: faith versus skepticism; hope versus pessimism; engagement versus neutrality; self-determination versus fatalism; imaginative freedom versus ideology. In the work itself these dialectical binaries and the ramifications they have engendered take on a visual, and, beyond that, material reality: impersonal iconography versus delicacy of facture; veiled intimacy versus formality of presentation; chromatic austerity versus rich tactility; optical splendor versus physical remoteness; gestural exuberance versus strict self-censorship; resistance to easy pleasure versus exquisite hedonism; somberness versus playfulness; forthright assertion of image as object versus mistrust of the image as representation.

These attitudes and qualities are manifest throughout his career and across his artistic production, and, as cited above, their scope has included everything from performance, artistic collaboration, and installation to sculpture, drawings, watercolors, photographs, multiples, and books. Nevertheless, with the exception of a graphic variant of his first mature painting, *Table* (1962), and Richter's portrait busts of himself and Blinky Palermo, the present retrospective is exclusively focused on paintings. Several considerations have determined that decision; some are practical, others cut closer to the heart of the debate over Richter's accomplishment and his place among the leading artists of his day. First, Richter has been enormously prolific, and any exhibition attempting to deal in depth with his work in all mediums would surpass the current spatial capacities of The Museum of Modern Art (as well as most other museums). At over 113 works, this exhibition is already among the largest the Museum has ever devoted to a contemporary artist. Second, three recent exhibitions lessen the immediate need (and opportunity) for an extensive coverage of Richter's work on paper: the Dia Center for the Arts' yearlong New York presentation of the complete *Atlas*, organized by Lynne Cooke in 1995–96; *Gerhard Richter: Drawings 1964–1999*, organized by Dieter Schwarz for the Kunstmuseum Winterthur, Switzerland, in 1999, which, though it did not travel to the United States, has been documented in a scholarly catalogue in wide circulation; and the previously mentioned Dallas Museum of Art exhibition, comprising all of Richter's multiples, organized by Charles Wylie in 2000.

The third, and overriding, criterion in deciding to concentrate on Richter's work on canvas is simply to acknowledge that painting has always been his primary concern and for appreciable periods his *only* concern. Although Richter began, as many young artists do, by drawing and painting in watercolors, the body of drawings produced in the early 1960s and mid-1970s is relatively small, and it is only in 1982 that drawing became a major, though still fitful, part of his studio regimen. Moreover, between 1952—when he entered the Art Academy (Kunstakademie) in Dresden, where the curriculum centered on oil painting—and 1977, Richter did not take up watercolors again, and then, after a brief flurry of activity lasting through 1978, he once more abandoned the medium before returning to it in earnest in 1984. Meanwhile, better than half of Richter's multiples were produced between 1965 and 1974, and, with the exception of the 1978 artist's book *128 Details from a Painting*, it was not until 1991–92 that he began to make graphic and photographic work that significantly altered the parameters of his larger aesthetic project.

The interpretative maze that has grown up around Richter's oeuvre has at times distracted viewers from the fact that the pictorial maze he has built within that critical outer

ROBERT STORR

structure is made not merely of pictures—images subject to the kind of semiotic analysis that would treat them all as essentially the same regardless of their material presence—but of paintings whose meaning can only be grasped, if fleetingly and with difficulty, by the fully alert senses in tandem with an agile, rather than dogma-bound, mind. Furthermore, one would have hoped, a dozen years after the 1980s, that even the most hard-line opponents of painting's resurgence would concede that there is little left to gain and perhaps something of significance to be lost by continuing to use painting as a rhetorical whipping boy. Painting is no longer the dominant medium it once was. There is no urgent need to topple it from its pedestal when other practices have begun to crowd painting on an equal, or nearly equal, footing. Moreover, the new art forms championed at its expense have begun to show their age and accumulate the burdens that come with tradition in any medium. And, insofar as special political and social status was accorded those art forms because they were ignored by the market or otherwise escaped the corrupting effects of commodity capitalism, which had supposedly compromised painting beyond redemption, recent expansion and diversification of the market have deprived them of that virtue.

The moment is ripe, then, to reexamine Richter at one remove from these increasingly dated and preemptive ways of looking, and to see his work more clearly from all the many angles from which it begs to be seen. Whatever has been or may be said about his contribution to the medium—be it as lethal parodist, dour undertaker, dry-eyed mourner, systematic debunker of clichés, demystifying conjurer of illusions, or as tenacious seeker of ways to make visible the longing and queasy uncertainty inherent in our hunger for pictures—Richter has, paradoxically or stealthily, demonstrated painting's resiliency. Fifty years after Richter found his vocation and forty years after making his first distinctive mark, the accumulated evidence selectively presented in this exhibition vindicates his faith in an art form fewer and fewer of his closest supporters have believed in, and much of the general public has taken for granted at high cost to painting's ability to convey fresh meaning. In any event, it is a medium that has come to depend on Richter's severe scrutiny—and it has survived and thrived in large measure because of it.

Table [Tisch]. 1962. Oil on canvas, 35½ × 44½" (90.2 × 113 cm). GR 1. San Francisco Museum of Modern Art. Extended loan from a private collection

Maquette for Table [Entwurf für Tisch]. 1962. Magazine clippings with annotations by the artist, approx. 18 × 12" (48 × 30 cm). Private collection, Frankfurt.

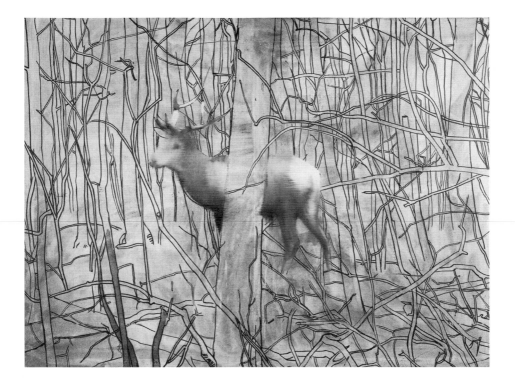

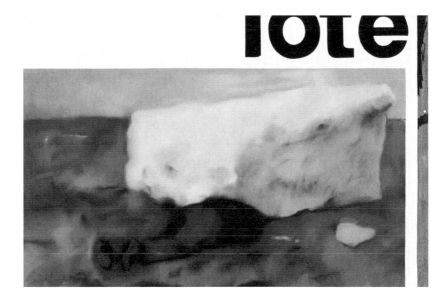

Stag [Hirsch]. 1963. Oil on canvas, 59" × 6'6¾" (150 × 200 cm). GR 7. Private collection

Dead [Tote]. 1963. Oil on canvas, 39¾ × 59¹⁄₁₆" (100 × 150 cm). GR 9. Private collection, Frankfurt

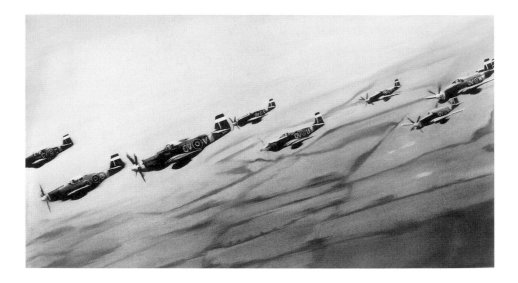

Mustang Squadron [Mustang-Staffel]. 1964. Oil on canvas, 34½ × 59⅛" (87.6 × 150.2 cm). GR 19. Collection Robert Lehrman, Washington, D.C.

Uncle Rudi [Onkel Rudi]. 1965. Oil on canvas, 34¼ × 19¹¹⁄₁₆" (87 × 50 cm). GR 85. The Czech Museum of Fine Arts, Prague. Lidice Collection

ROBERT STORR

Horst and His Dog [Horst mit Hund]. 1965. Oil on canvas, 31½ × 23⅜" (80 × 60 cm). GR 94. Private collection, New York

Phantom Interceptors [Phantom Abfangjäger]. 1964. Oil on canvas, 55⅛" × 6′2¾" (140 × 190 cm). GR 50. Froehlich Collection, Stuttgart

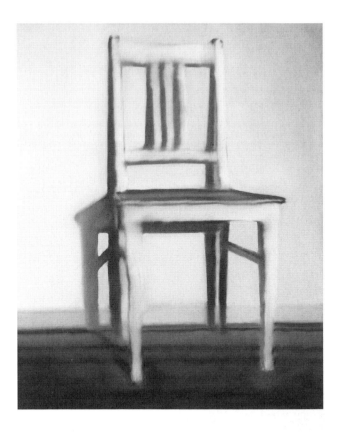

Flemish Crown [Flämische Krone]. 1965. Oil on canvas, 35 $\frac{7}{16}$ × 43 $\frac{5}{16}$" (90 × 110 cm). GR 77. Private collection

Kitchen Chair [Küchenstuhl]. 1965. Oil on canvas, 39 $\frac{3}{8}$ × 31 $\frac{1}{2}$" (100 × 80 cm). GR 97. Kunsthalle, Recklinghausen, Germany

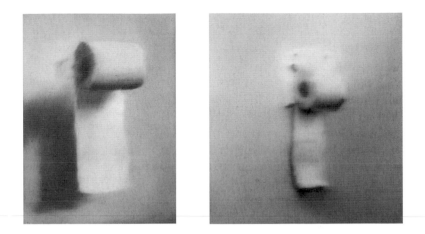

Toilet Paper [Klorolle]. 1965.
Oil on canvas, 21 $^{11}/_{16}$ × 15 $^{3}/_{4}$"
(55 × 40 cm). GR 75-1. Collection
Joshua Mack and Ron Warren

Toilet Paper [Klorolle]. 1965.
Oil on canvas, 27 $^{9}/_{16}$ × 25 $^{5}/_{8}$"
(70 × 65 cm). GR 75-3. Courtesy
Massimo Martino Fine Arts and
Projects, Mendrisio, Switzerland

**Administrative Building
[Verwaltungsgebäude].** 1964.
Oil on canvas, 38 $^{1}/_{4}$ × 59" (97.2 ×
149.9 cm). GR 39. Private
collection, San Francisco

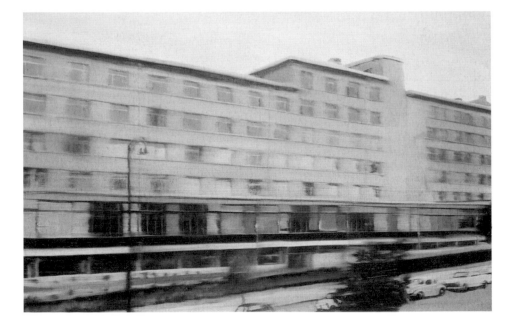

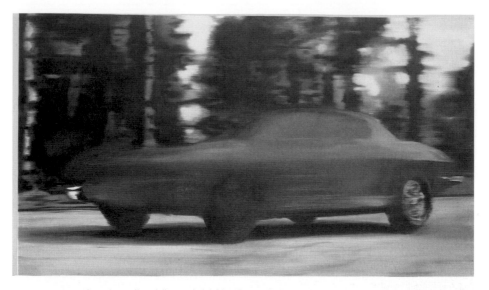

Ferrari. 1964. Oil on canvas, 57" × 6' 6½" (144.8 × 199.4 cm). GR 22. Modern Art Museum, Fort Worth. Purchase, Sid W. Richardson Foundation Endowment Fund

High Diver I [Turmspringerin I]. 1965. Oil on canvas, 6' 2 $^{13}/_{16}$" × 43 $^{5}/_{16}$" (190 × 110 cm). GR 43. Courtesy Massimo Martino Fine Arts and Projects, Mendrisio, Switzerland

opposite, top: **Cow [Kuh].** 1964. Oil on canvas, 51 $^{3}/_{16}$ × 59 $^{1}/_{16}$" (130 × 150 cm). GR 15. Kunstmuseum, Bonn. Hans Grothe Permanent Collection

opposite, bottom: **Motor Boat (first version) [Motorboot (erste Fassung)].** 1965. Oil on canvas, 66 $^{15}/_{16}$ × 66 $^{15}/_{16}$" (170 × 170 cm). GR 79-a. Private collection

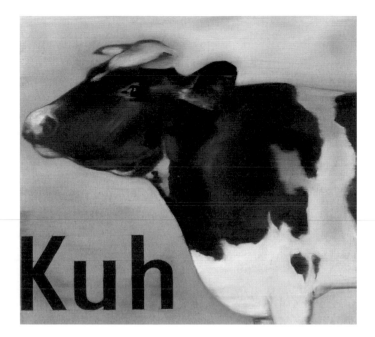

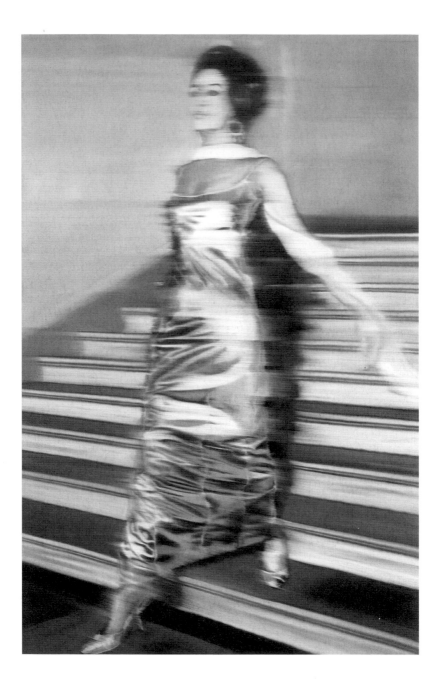

Woman Descending the Staircase [Frau, die Treppe herabgehend]. 1965. Oil on canvas, 6'7" × 51" (200.7 × 129.5 cm). GR 92. The Art Institute of Chicago. Roy J. and Frances R. Friedman Endowment and gift of Lannan Foundation, 1997

ROBERT STORR

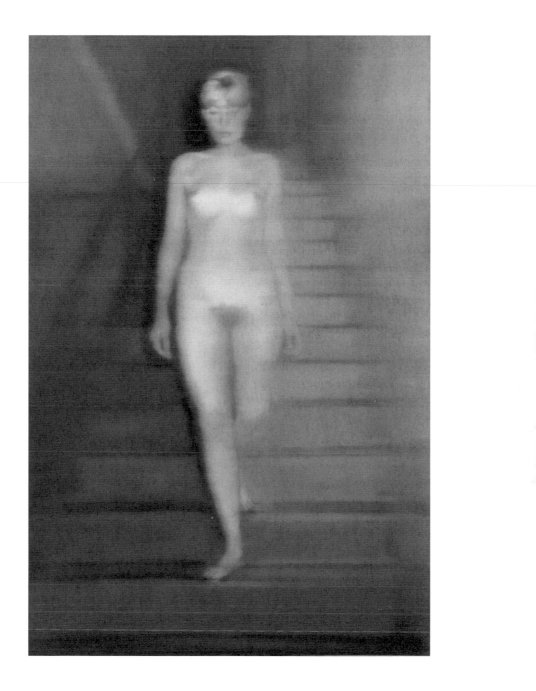

Ema (Nude on a Staircase) [Ema (Akt auf einer Treppe)]. 1966. Oil on canvas, 6'6¾" × 51³⁄₁₀" (200 × 130 cm). GR 134. Museum Ludwig, Cologne

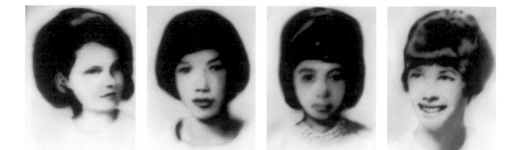

Eight Student Nurses [Acht Lernschwestern]. 1966. Oil on canvas; 8 paintings, each, 36⅜ × 27⁹⁄₁₆" (95 × 70 cm). GR 130. Kunstmuseum, Winterthur. Permanent loan

Helga Matura with Her Fiancé [Helga Matura mit Verlobtem]. 1966. Oil on canvas, 6'6⁹⁄₁₆" × 39" (199.5 × 99 cm). GR 125. museum kunst palast, Düsseldorf

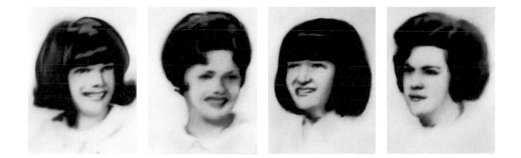

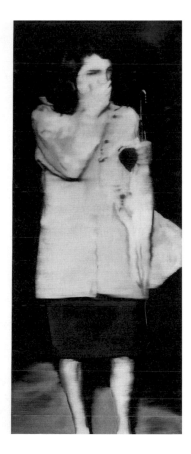

**Woman with Umbrella [Frau mit
Schirm].** 1964. Oil on canvas,
63 × 37⅜" (160 × 95 cm). GR 29.
Daros Collection, Switzerland

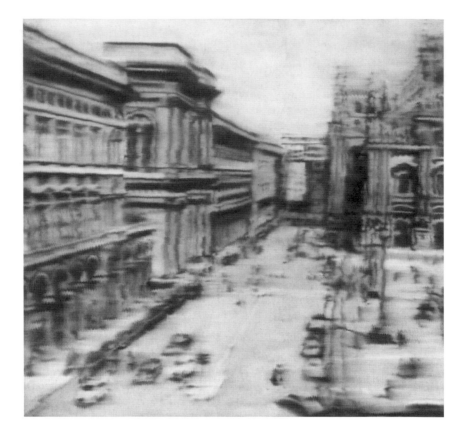

**Cathedral Square, Milan
[Domplatz, Mailand].** 1968. Oil
on canvas, 9' 1¼" × 9' 6 3/16" (275 ×
290 cm). GR 169. Park Hyatt
Collection, Chicago

Townscape PL [Stadtbild PL].
1970. Oil on canvas, 6' 6½" ×
6' 6½" (199.6 × 199.6 cm).
GR 249. The Museum of
Modern Art, New York.
Fractional and promised gift of
Jo Carole and Ronald S. Lauder

ROBERT STORR

Townscape Madrid [Stadtbild Madrid]. 1968. Oil on canvas, 9' 1 1/16" × 9' 6 13/16" (277 × 292 cm). GR 171. Kunstmuseum, Bonn. Hans Grothe Permanent Collection

Townscape SL [Stadtbild SL]. 1969. Oil on canvas, 48 7/16 × 48 13/16" (123 × 124 cm). GR 218-1. Courtesy Massimo Martino Fine Arts and Projects, Mendrisio, Switzerland

I: BEGINNINGS

"THE ARTIST IS RESPONSIBLE
FOR HIS HISTORY AND HIS
NATURE. HIS HISTORY IS
PART OF HIS NATURE."
—Ad Reinhardt[1]

Gerhard Richter was born in Dresden in 1932. Three years later his family moved to the small town of Reichenau in Saxony, where his father was employed as a school teacher. It was the first of two relocations that would keep the young Richter, for the most part, out of harm's way during the upheavals of the twelve-year Third Reich and the early years of the Soviet occupation that followed. The second move was to the still smaller village of Waltersdorf in 1942. His father Horst Richter was an affable but, in many respects, ineffectual man; he was also a staunch Protestant and, like most functionaries, a member of the National Socialist Party. Mobilized after the outbreak of war, as were Richter's maternal uncles Rudi and Alfred, he first served on the eastern front in Russia, though not on the front lines, and later on the western front, where he was taken prisoner by the Americans. Released in 1946, he made his way back to Waltersdorf but was never able to find his footing again; as an ex-Nazi he was not allowed to return to his teaching post, nor did he ever fully reintegrate himself into the family. "He shared most fathers' fate at the time. . . . Nobody wanted them."[2]

Before her marriage, Richter's mother, the former Hildegard Schönfelder, had been a bookseller in Dresden, and when she reluctantly moved away from that cultural center she brought with her a passion for music and for the classics of German literature. The daughter of a gifted concert pianist who had given up his career to manage the family brewery business (only to superintend its collapse), she had a sense of her own special status within the community and passed this on to her son.

Although Richter's parents were a mismatched couple, family life before the war was typical of the provincial petite bourgeoisie or, as Richter summed it up, "simple, orderly, structured—mother playing the piano and the father earning money."[3] With the father absent during war, family life was more eventful than before. Like all boys, Richter was drummed into the Hitler Youth. "I was very impressed by the idea of soldiers, of militarism, maybe Hitler, that was impressive," he recalled, but the Hitler Youth, "was too tough for me. I don't like fighting games, I wasn't very sporty."[4] Besides that: "They were all a bunch of pompous asses. When you are twelve you're too little to understand all that ideological hocus-pocus, but even though this might sound funny now, I always knew I was something better than they were. Hitler and soldiers, and all of that was for plebeians, whereas my mother always kept me close to 'culture,' to Nietzsche, Goethe and Wagner."[5] Nevertheless, the disruptions of war broke the pall of small-town life, and Richter seems to have welcomed them with curiosity and a certain relish. He and his friends would scout the woods with an army rifle and take pot shots at the trees, while military trenches were dug behind his house, squadrons of American planes dropped propaganda leaflets from on high, and Russian MiGs flew low overhead hunting for German army trucks. Richter recalled: "There were weapons and cannons and guns and cigarettes; it was fantastic."[6]

There was also fear and terrible, though distant, destruction. In February 1945, Allied bombers unleashed a firestorm over Dresden that ranks as the most devastating aerial

ROBERT STORR

assault in history prior to the first use of atomic weapons in Hiroshima and Nagasaki later that year. Although details have been lost to memory, Richter's recollections of being alerted to the Dresden attack in nearby Waltersdorf are vivid enough: "In the night, everyone came out into the street in this village 100 kilometers away. Dresden was being bombed, 'Now, at this moment!' We knew because of the radio, and you could hear it, [though] I can't remember whether I really heard it, whether that was possible . . . but maybe over the radio."[7] His grandmother and aunt had been in Dresden at the time and survived the raid. While he remembers exploring a "totally damaged" city when he went there five years later and knew that it had "been very awful there," he also recalls having listened excitedly to descriptions of people walking through the burning wreckage of buildings.[8] It was as if his grandmother and aunt were telling a picaresque story. More likely, however, it was the boy's adolescent spirit, reveling in the turmoil nearer to home, which caused him to hear their account in that way; and perhaps it was his instinct for deflecting trauma that turned catastrophe into adventure.

Although Richter had prepared to flee the Russian advance by making a small cart, in the end he remained in Waltersdorf. The first phase of the Soviet occupation was chaotic and at times brutal (looting was widespread and rapes were common), but before long relative order was reestablished and with it came some mixed blessings. According to Richter: "It was very nasty, [but] when the Russians came to our village and expropriated the houses of the rich who had already left or were driven out, they made libraries for the people out of those houses. And that was fantastic. We could get all the books: [Hermann] Hesse, [Ernst] Wiechert, [Lion] Feuchtwanger. All that stuff was suddenly there. Later it was forbidden. You could almost not buy a Thomas Mann. But at the beginning everything was there."[9]

In 1945, having failed math, Richter left grammar school and enrolled in a trade school where he studied accounting, stenography, and Russian (required by Soviet authorities). Among his friends in those days were a slightly older local painter, of little talent but a mentor of sorts, and a photographer whose father had a darkroom where Richter briefly worked as an assistant. It was under his tutelage that Richter took the snapshots that fill his photo albums of this period. In 1948 Richter left home, and settled in the nearby town of Zittau, where he took up residence in a hostel for apprentices. During this period he read avidly his mother's beloved philosopher Friedrich Nietzsche, but also Karl Marx; boldly breaking with his parents' stern faith and firm in his new materialist convictions, he renounced religion. "By the age of sixteen or seventeen I was absolutely clear that there is no God—an alarming discovery to me, after my Christian upbringing. By that time, my fundamental aversion to all beliefs and ideologies was fully developed."[10]

By the time he was fifteen Richter had also begun to draw on his own with some dedication, his first success in this medium being a nude that his parents discovered with a combination of embarrassment and pride. At sixteen he attended a summer camp, where he continued to draw and fell in love for the first time. Asked when he decided to be an artist he has said: "I didn't know when I was fourteen or fifteen, but from age sixteen on I knew it."[11] At seventeen he started experimenting with watercolors, but his professional prospects did not yet include a career as a painter. Instead, he thought about being a forester (but he was small and not physically rugged enough for the job), a dental technician (a visit to the local dentist's office scared him off), and a lithographer (a visit to a printing plant likewise put an end to that idea).

Richter's first art-related job was as a member of a team that made Communist banners for the government of the German Democratic Republic. However, during his five-month

stint he never actually painted any slogans, having been assigned the task of washing them off old banners to make them ready for newly mandated exhortations. This unpromising start, plus friendships formed at night school, led to his positions as a sign painter and theater set painter. The latter of the two, in addition to the classes he attended, helped fill in gaps in his education, inasmuch as the company produced plays by Johann Wolfgang von Goethe, Friedrich von Schiller, and other classic authors, along with operas and operettas. Richter plunged into this bohemian milieu enthusiastically, but his refusal to do more menial painting jobs for the theater resulted in his being fired. With that experience behind him and hoping to set out in earnest on his chosen path he applied to the Dresden Art Academy but was turned down in part for lack of preparation and in part because he was viewed as being "too bourgeois."[12] Advised to try to solve that problem by associating himself with a state-run Socialist organization, Richter took another job producing propaganda, for which he painted posters of Stalin among other approved subjects. Using this position as a way back into the system, he reapplied to the Dresden academy in 1950 with a portfolio of drawings and watercolors—including a semiabstraction that puzzled his examiners, who gave it the title "Volcano" to allay their discomfort—and was accepted.

Prior to the bombings, which destroyed the heart of the city and many great masterpieces in the world-renowned Zwinger Museum, Dresden had been one of the cultural centers of Germany. While it had formerly been the home of the Expressionist painter Ernst Ludwig Kirchner and the base for the *Brücke* (Bridge), the artists' group he founded in 1905, its academy, like that of Munich, was a longstanding bastion of conservatism. When Richter entered the academy as a student, it still retained some of that distinction, but its curriculum had been radically changed to accommodate the Communist Party's policies of Socialist Realism. While still on his own, Richter had steeped himself in the old and modern masters—Albrecht Dürer, Diego Velázquez, Rembrandt van Rijn, the Impressionists, and Lovis Corinth—whose work he could find reproduced in books and albums that represented consensus taste in the 1930s and 1940s. However, the hardening of the party line as the cold war set in meant that Impressionism—considered a "bourgeois" movement—was soon out of official favor. German Expressionism and other modernist tendencies that had been banned by Hitler after the famous *Degenerate "Art"* (*Entartete "Kunst"*) exhibition of 1938 were largely unknown because of censorship and in any case completely off-limits. Richter's personal pantheon at that time included Velázquez, Édouard Manet, Caspar David Friedrich, and Max Beckmann. "[Adolf] Menzel I knew," Richter said of the nineteenth-century German realist and history painter, "but I was not so impressed." Also included in his field of awareness were Pablo Picasso and the Italian artist Renato Guttuso, both of whom were prominent Communists whose formal and expressive deviation from realism was therefore tolerated by the Soviet leadership.[13] Although information about modern art filtered in through magazines and newspapers, Richter and his fellow students were largely cut off from developments in the West, and Richter's only direct contact with a representative of the prewar avant-garde left him suspicious. Early in Richter's years at the academy Otto Dix, the Expressionist painter of the first decades of the twentieth century and a leading exponent of the socially critical *Neue Sachlichkeit* (New Objectivity) movement of the 1920s, visited the school. But by then his painterly manner had become decorative and his subject matter blandly humanist. Moreover, with his large floppy hat, he dressed like an old-fashioned artistic dandy. Richter's encounter with him triggered a response that would be characteristic thereafter, namely his "mistrust of people who are very flamboyant . . . this seductive side that people are taken in by. I don't even know if

ROBERT STORR

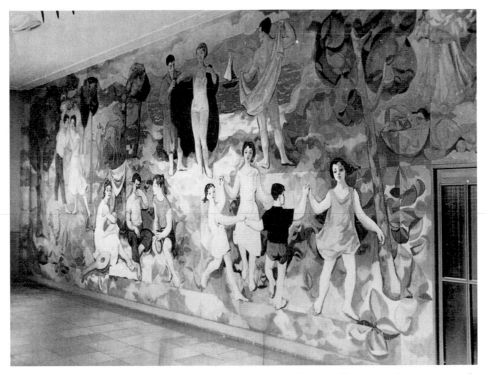

Gerhard Richter. **Mural.** 1956. Deutsches Hygienemuseum, Dresden. Installation view, late 1950s; mural now covered.

Dix had that, but he appeared to because he came from the West, as if he were coming from a different planet."[14]

The five-year curriculum at the academy was strictly traditional—drawing followed by painting in oils—with portraits, nudes, still lifes, and set-piece figurative compositions providing the basic pictorial program. Curiously enough, though, the mural department in which Richter chose to study, was well known as a sanctuary from the most rigid application of the Socialist Realist model because it was assumed that the demands of wall decoration would permit a measure of otherwise unacceptable "formalism." Given the choice between the grim class-struggle narratives of André Fougeron (a French painter then in vogue at the academy) and the sophistication and pictorial verve of the muralist Diego Rivera (like Guttuso and Picasso, an internationally renowned ornament of the Stalinist Left), Richter chose the model represented by Rivera, even though his own style and methods owed nothing to the Mexican's. Heinz Lohmar, the professor in charge of the mural department, had been a minor Surrealist in Paris before the war, and, although a loyal Communist Party member, remained a comparatively well-informed and cosmopolitan figure, in Richter's words, "a very interesting type, a little gangster." [15] In this context, Richter completed the four years of mandatory painting exercises and for his fifth and final year, was given a studio of his own and a major commission for a mural in the German Hygiene Museum [Deutsches Hygienemuseum] in Dresden.

As a composition, Richter's painting there is true to its type and period: solidly modeled figures of healthy men, women, and children engaged in life-enhancing activities. None of the figures has any individuality, but despite this and its other formulaic qualities

the painting as a whole has a certain graphic energy resulting from a simple design, lack of rhetorical overkill, and general ease of execution. In short, it offers the pleasures of a well-made thing that accepts its own conventions and operates unpretentiously within them. Although Richter says he "always tried" to believe in the content of his commissioned work he and his comrades could not muster any real fervor for the cause they ostensibly served.[16] Nevertheless, a hint of conviction couched in the political code words of the time or, at least, the suggestion of genuinely mixed feelings, enters into his published statements on the subject of muralism. Thus, in a 1958 article, Richter cautiously but firmly pushes for rationalizing the bureaucratic process that governed commissions, refers to pressures he "never took seriously" to adhere strictly to Socialist Realism, and mentions the dangers of "stupid dogmatism."[17] In an earlier article of 1956, he wrote at length about the promise and problems of painting's "reorientation toward architecture"; argued for the merits of seeking stylistic "originality and freshness"; described his own technique of building up the image by blocking it in equal perpendicular strokes; but emphasized his awareness that "this last is not to be confused with 'painterly' carelessness," when instead, "cleanliness and clarity of the total painting and every individual form is the tendency of our efforts in mural painting."[18]

Furthermore, he called "for an art that steps outside of the private sphere and represents the absolute general good," and spoke of his ambition to make a painting that is "festive-bright, cheerful, at the same time calming, clear and rational."[19] At face value, Richter's comments might read as an adroit accommodation to an imposed aesthetic doctrine, but signs of his own independence and of his desire to open up creative room within that doctrine are plainly evident. More striking, on reflection, are the implicit contrasts and correspondences these texts set up. On the one hand, the work for which Richter later became known was the antithesis of "cleanliness and clarity of the total painting and every individual form."[20] On the other hand, his abiding distrust of self-dramatizing or overtly introspective painting as well as his belief in art as a moral undertaking echo his advocacy of "an art that steps outside the private sphere and represents the absolute general good," even as his interest in painting's "reorientation toward architecture" is reflected in the various public commissions he accepted after coming to the West and in the unrealized projects for rooms constructed around mirrors or large-format canvases.[21] These unexecuted works are documented in *Atlas,* Richter's ongoing archive of sources for his work begun in 1969.

Although Richter remembers completing only a couple of murals, there is evidence of others, some of them in a heroic socialist mode. One of his outdoor political pictures shows a bare-chested man distributing official newspapers; another large indoor painting features muscular men and women wielding sledge-hammers and paving stones, and waving banners as they confront mounted troops swinging truncheons. Richter's later condemnations of ideological art are something more than the opinions of a man who simply lived under authoritarian regimes; they are those of someone who had participated in the creation of a state culture. That said, Richter's apprenticeship and journeyman years in the East constitute a substantial preamble to his career in the West, and not just a uniformly and transparently negative experience against which to react. Indeed, they represent a struggle to answer serious aesthetic challenges, but one pursued on terms that made any artistically satisfying answers impossible. Like all real struggles they left scars, but they also clarified and strengthened his basic inclinations.

Although Richter had already shown a rebellious streak, one can hardly fault him for trying to find his niche, or for being naive in gauging the long-term hopes for greater artis-

tic freedom. In 1953 Stalin died, and the Korean War—one of the cold war's many hot wars—came to an end. The East–West stand-off seemed to relax for a moment, although by 1956, following uprisings in Czechoslovakia, Hungary, and Poland, it locked-in even more rigidly than before. For a young painter who had barely made it out of his small-town setting and into the academy, the relatively comfortable life he led had much to recommend it. The circle of friends with whom he associated included Marianne [Ema] Eufinger, a textile design student he met around 1951 and married in 1957.[22]

Moreover, the success that greeted Richter's initial public projects must have been gratifying no matter how restless he felt about having their parameters dictated to him. Those successes increased the demand for his work and brought certain "perks": a steady income, a motorcycle, then a small car, and travel abroad. Richter's first such trip was in 1955 when he toured West Germany to study mural painting there and took a week-long excursion to Paris. Of the visit to Paris Richter remembered: "I went to galleries and museums, but I don't remember any of that. [And] I tried to find the existentialist hangouts with music and literature, but I never found them. You had to know the addresses and I couldn't speak French."[23] The second trip was also to West Germany, where Richter saw Documenta 2, one of a series of omnibus exhibitions brought into being by Professor Arnold Bode, whose aim was to reintroduce Germany to international modernism and to its own avant-gardes after the long darkness of the Nazi era. Strategically located in Kassel, a city close to the border between the German Democratic Republic and the German Federal Republic, the show was also a deliberate enticement to East Germans whose cultural horizons were still blocked. Having missed the first exhibition in the series in 1955, Richter took full advantage of the second one four years later, photographing virtually all the work he saw for reference when he returned home. It was the turning point of his artistic life, and two painters in particular were responsible: "I . . . was enormously impressed by [Jackson] Pollock and [Lucio] Fontana. . . . The sheer brazenness of it! That really fascinated me and impressed me. I might almost say that those paintings were the real reason I left the GDR. I realized that something was wrong with my whole way of thinking. . . . But that is what I mean, I lived my life with a group of people who laid claim to a moral aspiration, who wanted to bridge a gap, who were looking for a middle way between capitalism and Socialism, a so-called Third Path. And so the way we thought, and what we wanted for our own art, was all about compromise."[24]

The nerve that Pollock and Fontana hit had already been sensitized by Richter's unavailing attempts to adapt a variety of existing styles to his own needs. Other than the (now overpainted) mural at the Hygiene Museum, the only surviving record of Richter's work prior to 1962 are the albums of photographs he took of murals, paintings, and drawing before the work itself disappeared or was destroyed. These efforts include moody watercolors of the countryside of his native Saxony, made when he was in his teens, commissions, work done at the academy, and work done independently. Among the independent works are life studies, many with the generalized features and full volumes of his murals (two paintings of women reading are reminiscent of David Alfaro Siqueiros's heavy modeling); and face and figure compositions with the abstraction and graphic filigree of works by Picasso of the late 1940s and early 1950s (a drawing of a tractor in a field, pastiches of Picasso's drawing *Knight and Page Boy* and the murals, *War* and *Peace*, he created for a Cistercian chapel in Vallauris, France, in 1951–52), heads that mimic Picasso's peace-movement posters and his prints and sketches of Françoise Gilot, and several sheets devoted to skulls. While the skulls clearly seem inspired by Picasso's treatment of the same subject (for example, *Still Life with Skull, Leek, and Pottery* 1945), they also presage Richter's return

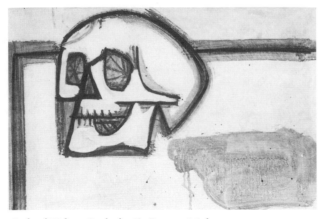

Gerhard Richter. Study for **Skull**. c. 1956. Ink on paper, approx.
11¹³⁄₁₆ × 15¾" (30 × 40 cm). Preparatory sketch for a mural in the
Deutsches Hygienemuseum, Dresden. Whereabouts unknown

to the subject in paintings of 1983 and in drawings of 1986. It is worth pointing out that when Richter began painting skulls and candles in the 1980s, some observers assumed that he was ironically invoking the memento mori of neo-baroque or neo-classical painting, then in fashion. Rather, it appears that he was going back to a motif from the earliest chapters of his own development and, indirectly, resuming his "conversation" with Picasso by offering his uncanny but impersonal rendition of the image as a lasting riposte to Picasso's ceaselessly inventive but too often facile stylizations. Richter had once imitated such stylizations in the hope that they might solve his problems; but in the final analysis they offered him nothing except a reminder of his own lack of invention.

Mixed into this miscellany (which encompasses self-portraits, portraits of Ema, copies from Dürer, quasi-abstract scenes in a delicate Lyonel Feininger-like mode, and schematic landscapes and still lifes with muted expressionist color) are a handful of undated paintings and drawings influenced by Art Informel painting, or Abstract Expressionism. Their energy is confined by their small format, but is still palpable. For the rest, Richter's documented work of the mid- to late 1950s is competent or more than competent, seldom distinctive, often sentimental, and occasionally pretty. Richter's predicament was compounded in his own mind by what he saw as a temptation to regard any opposition to the meretriciousness of official art as an inverse guarantee of aesthetic quality: "For an artist the situation in Dresden was unreal. They [the cultural bureaucracy] by calling you a formalist could deny you the opportunity to exhibit. This gave you a false sense of your own importance. [It] made you think that you were a great artist, when really you were nothing."[25] Richter was in a double bind, and one can readily appreciate his frustration and well imagine the shock the sight of works by Pollock and Fontana engendered. But there is one further thing to note; unlike some artists who trained in the Eastern bloc (Eric Bulatov and the team of Vitaly Komar and Alexander Melamid, for example), Richter was not a master of academic illusionism when he left Dresden. Quite the contrary; nothing in his work foreshadowed the extraordinary proficiency of his photo-based paintings. Richter the virtuoso was a product of his own re-education as a painter once he arrived in the West rather than the strange reincarnation of an accomplished but conservative technician schooled in the East.

Although the impact of Documenta 2 was immediate, Richter did not pull up stakes for another two years. Coming back from a trip to Moscow and Leningrad in 1961, his train unexpectedly went directly through East Berlin to West Berlin, where he disembarked and put his luggage in safe storage. He then returned to Dresden, hurriedly sold his car, gathered a bare minimum of possessions, and arranged for a friend to drive him and Ema to Berlin (to avoid the closely watched East German trains). From that point, pretending to be day-trippers, they crossed over from the eastern into the western zone on the subway.

ROBERT STORR

Richter and his wife first stopped at the home of her parents, who had emigrated some years before; but with a small allowance granted refugees by the West German government in their pockets, their initial destination was Munich and the highly regarded art academy there. However, a friend from the Dresden academy whom Richter visited in Düsseldorf, encouraged him to look instead at the academy in that Rhineland city, whereupon Richter changed his mind. With a two-year scholarship, he enrolled in the class of the uninspiring painter Ferdinand Macketanz, but before long he switched into that of Karl-Otto Götz, an exponent of Art Informel, or gestural abstract painting, whose work had been included in Documenta 2 and who was an active presence in the local art scene. That scene, in particular, and the German art world in general were in the throes of a dramatic transformation.

The vision of modernism advanced at the first Documenta by Bode and his colleague, the art historian Werner Haftmann, was that of a varied but essentially integrated tradition defined by a succession of "isms." These tended toward abstraction but retained a strong "humanist" aspect through their anthropomorphic or natural imagery or in their emphasis on rationality as an expression of progress. The first Documenta gave precedence to avant-gardes that had come into being just before or after World War I—Fauvism, Expressionism, Orphism, Cubism, metaphysical painting, and de Stijl—and then leapfrogged to contemporary post–World War II work by representatives of Art Informel, by artists pursuing geometric abstraction, and by an assortment of figurative painters and sculptors of a more-or-less existentialist bent. Conspicuously absent from this lineup was any significant representation of Surrealism—only Joan Miró and Max Ernst were accounted for—nor, with the exception of a single work by Kurt Schwitters, was Dada acknowledged. In 1959 Documenta 2 partially made up for these lacunae—Kazimir Malevich stood in for the Russian Suprematists and Constructivists, who had been wholly overlooked in the previous exhibition, while Matta, René Magritte, and Yves Tanguy weighed in for Surrealism. The biggest change was the influx of Americans, a shift in orientation facilitated by the advisory role of Porter A. McCray, Director of the International Program of The Museum of Modern Art. In the same year, under his aegis, the Museum had also mounted the first survey of the New York School to tour Europe—*The New American Painting*. The second Documenta exhibition focused on many of the same Abstract Expressionist and Color Field painters, among them Sam Francis, Helen Frankenthaler, Adolph Gottlieb, Franz Kline, Jackson Pollock, Mark Rothko, Clyfford Still, and Barnett Newman, who subsequently became one of Richter's favorite artists. Almost lost in the shuffle at Kassel was one of the most innovative painters of them all, Robert Rauschenberg.

If Pollock, who had been dead for three years, still symbolized the New American Painting in 1959, then Rauschenberg, only thirty-four, was the harbinger of things to come. It is one of the ironies of history that Rauschenberg's neo-Dada aesthetic should have come to the attention of the German art world before that world had fully reacquainted itself with its own Dada artists, although a 1958 survey of their work had been mounted by the Kunstverein für die Rheinlande und Westfalen in Düsseldorf, and a retrospective of the work of Kurt Schwitters, Rauschenberg's most important precursor, had been held in Hannover in 1956. In 1960 Rauschenberg and Cy Twombly were paired in a show at Galerie 22 in Düsseldorf, run by Jean-Pierre Wilhelm, a dealer who represented Götz, Emil Schumacher, and a number of other artists associated with Art Informel. Theirs was the last exhibition Wilhelm presented, and in a sense it not only marked the end of an era for his gallery but signaled a decisive change in the direction contemporary art would take. Having come from

the East, where he had been shut off from information about Germany's avant-garde past, Richter remembers that he learned about Schwitters and his contemporaries "by way of Rauschenberg."[26] But, he concluded: "I don't think it's that bad. And I don't regard Schwitters as the innovator and Rauschenberg as the exploiter."[27] Furthermore, Rauschenberg offered new technical solutions to the problems of image appropriation and image grafting. At Galerie 22 he exhibited his *Thirty-Four Drawings for Dante's "Inferno,"* all of which had involved transferring newspaper and magazine images to another paper surface by soaking them in solvents; and although Richter had not yet arrived in Düsseldorf when the Rauschenberg–Twombly show went up, the method Rauschenberg used found applications in Richter's work two years later.

It is a further historical irony that Fluxus, the most radical and, for many people in Richter's circle as well as Richter himself, the most influential of resurgent Dada's many forms should have owed its existence to the United States Army, acting as its unofficial patron. Already, with the G.I. Bill paying for the education of veterans, the armed forces were responsible for shipping a number of cutting-edge artists overseas. And so Al Held, Ellsworth Kelly, and countless others flocked to Europe after 1945 with government stipends, which made the G.I. Bill the second most important example of federal sponsorship of the arts after the Depression-era Works Progress Administration. Following a parallel path, George Maciunas, the New York–based founder of the anarchic Fluxus movement, traveled to West Germany in 1961 on the promise of a job working as a graphic designer for the United States Air Force. Upon his arrival, he made contact with future collaborators Ben Patterson, who sold encyclopedias to the families of American servicemen stationed there, and Emmet Williams, who wrote for the Army newspaper, *Stars and Stripes*, where the Fluxus phenomenon was written up for the first time, by Williams. Together with Patterson, Williams, and Nam June Paik, a Korean composer who had studied in Freiburg and made connections with the avant-garde music scene in Darmstadt and Cologne, Maciunas proceeded to establish a beachhead for a multipronged assault on the existing artistic order. "To establish [the artist's] nonprofessional, nonparasitic, non-elite status in society," Maciunas argued, "he must demonstrate his own dispensability, he must demonstrate [the] self-sufficiency of the audience, he must demonstrate that anything can substitute [for] art and anyone can do it."[28] Not so much anti-art as anti-institutional, Maciunas further characterized Fluxus as "a fusion of Spike Jones, Vaudeville, gag, children's games and Duchamp," all with a dash of revolutionary Marxism.[29]

The postwar ascendancy of Marcel Duchamp, an artist famously inactive since the 1920s—or so he wanted people to believe—was signaled in America by the interest in the composer and Fluxus inspiration John Cage and the artists who gathered round him, principally Rauschenberg and Jasper Johns. In Europe, Duchamp, who traveled frequently to France and Spain, also captured the imagination of the younger generation, in particular Jean Tinguely, Daniel Spoerri, and others associated with the proto-Pop Nouveaux Réalistes in Paris. Having twice been left out of Documenta, Duchamp was first seen in depth in Germany in a 1965 exhibition in Krefeld, by which time he had already made a deep impression on artists in the Rhineland, not least of them Joseph Beuys. However, as much of a touchstone as Duchamp's work became for a rising group of European painters, sculptors, conceptual, and performance artists, some of them and their critical supporters were at the same time anxious to dissociate themselves from the anti-art, or as they perceived it, primarily nihilistic thrust of early Dada. The French critic Pierre Restany thus sought to transform the negative reading of Dada generally and of Duchamp's work in particular—an

ROBERT STORR

interpretation he blamed on the Surrealists—into a positive one. Speaking for the Nouveaux Réalistes in 1961, he wrote: "Dada is a farce, a legend, a state of mind, a myth. A badly behaved myth whose subterranean survival and capricious manifestation upset everyone. . . . The esthetic of absolute negativity has been changed into methodical doubt, thanks to which it will finally be able to incarnate new signs. The new realists consider the World as a tableau, the Great Work from which they appropriate fragments invested with universal significance. They present us the real in all the diverse aspects of its total expressivity. . . . In the present context the ready-made of Marcel Duchamp takes on a new sense. After the No and the ZERO, there is a third position for the myth; the anti-art gesture of Marcel Duchamp has been charged with positive energy. The Dada spirit identifies itself with a method of appropriation of exterior reality of the modern world. The ready-made is no longer the height of negativity or of polemic, but the basic element of a new expressive repertoire. Such is the new realism: a direct means for getting one's feet back on the ground but at 40 degrees above Dada zero, at that precise level where man, if he succeeds in reintegrating himself with the real, identifies his own transcendence, which is emotion, feeling, and finally poetry."[30]

For his part, Beuys, after having appropriated the Readymade, as well as strategies for cultivating his artistic persona from Duchamp, would eventually disown him, ascribing responsibility for Dada's supposed failure to Duchamp's elegant abdication. Rather than affirm Dada's anti-art stance by refusing to make any more art, as Duchamp had apparently done, Beuys sought to explode traditional aesthetic categories with an expanded definition of art whereby everyone was an artist insofar as they approached their lives creatively. Against that messianic dream Beuys declared: "The silence of Marcel Duchamp is overrated."[31]

Prior to Beuys's attempts to overthrow the father of Dada, Maciunas's interest in Duchamp and in Paik's links to Cage consolidated the Dada legacy in Germany and, quite literally, put it into action. In this regard, Maciunas took his cue from the Zero Group. Founded in Düsseldorf in 1957 by Heinz Mack, Otto Piene, and Günther Uecker, Zero had mixed monochrome painting, technological forms such as kinetic and light art, and utopian musing about beginning modernism over again from "zero," and drew attention to itself by organizing a number of public spectacles. In much the same spirit, Maciunas put together a series of Fluxus Festivals to promulgate his ideas. These became the first Happenings or, as the Fluxus artists preferred, "events" to hit Germany, and they made a huge impression. That Richter should have been attracted to Fluxus at all, much less been as liberated by it as he had been by Pollock and Fontana, is surprising given Fluxus's hostility toward traditional studio practice. To understand why, it is necessary to consider the new context in which Richter found himself.

With their burgeoning museum and gallery scenes, Cologne and Düsseldorf jointly became the center for experimental art in Germany. In addition to the artists and tendencies mentioned above, these cities also felt the impact of Wolf Vostell, Yves Klein, Piero Manzoni, and Lucio Fontana. A German neo-Dadaist, Vostell was a painter, sculptor, and experimenter with mixed mediums whose theories of de-collage—or the deconstruction of images by tearing and recombining—followed the example of the French artists François Dufrêne, Raymond Hains, Jacques de la Villeglé, and the Italian Mimmo Rotella, whereas Vostell's early video work paralleled that of Paik. The brother-in-law of the Zero artist Uecker, Klein was the dandified forerunner of Beuys's special blend of conceptualism and mysticism. In 1958–59 Klein had worked on and off in Gelsenkirchen, in the Ruhr valley,

Gerhard Richter. **Untitled (One of Many Efforts to Paint Abstractly).** 1960. Mixed mediums on cardboard, approx. 7⅞ × 7⅞" (20 x 20 cm). Whereabouts unknown

creating a large sponge mural for a theater there; and in 1961, a year before his death, he was given a major exhibition at the Museum Haus Lange in Krefeld. A monochrome painter with ties to Zero, Manzoni was a whimsical demythologizer of aesthetic pieties whose conceptual and performance work overlapped with those of Klein, and whose early death in 1963 followed that of his French counterpart. Fontana, Manzoni's mentor, was also a ubiquitous presence in Germany around this time. Starting in 1960, he exhibited frequently in Cologne, and in 1962 the Städtisches Museum, Leverkusen, organized an important retrospective of his work.

For Richter, who knew nothing of Duchamp and Dada when he had arrived, it was a heady environment, and in order to assimilate the contradictory mass of information he had to start over again from scratch. Still bound by the ideal he had brought from Dresden of finding a "third way," a path between capitalism and socialism, between tradition and the avant-garde, Richter identified with Jean Dubuffet, Jean Fautrier, and Alberto Giacometti—role models that he called "transitional figures."[32] More than the impact of these figures, however, the early works he made at the Düsseldorf academy with cardboard, stiffened fabric, and heavily laid-on paint show the influence of Fontana's slashed canvases and Alberto Burri's pigment-caked torn-burlap assemblages: "I painted through the whole history of art toward abstraction," Richter said of his first year there.[33] "I painted like crazy, [and] I had some success with all that, or gained some respect. But then I felt that it wasn't it, and so I burned the crap in some sort of action in the courtyard. And then I began. It was wonderful to make something and then destroy it. I was doing something and I felt very free."[34]

Although the Art Informel movement was almost spent, it did leave a residue. Putting together the remarks made on different occasions, the nature of its effect on his thinking is clear: "It was no accident that I found my way to Götz at the time. This 'Informel' element runs through every picture I've painted, whether it's a landscape, or a family painted from a photograph, or the Color Charts or a Gray picture. And so now it is a pursuit of the same objectives by other means. . . . As I now see it, all my paintings are 'Informel' . . . except for the landscapes, perhaps. . . . The 'Informel' is the opposite of the constructional quality of classicism—the age of kings, of clearly formed hierarchies."[35]

In other words, through exercises in a style he quickly discovered was psychologically and formally unsympathetic, Richter nonetheless grasped the lessons that Abstract Expressionism had taught his American counterparts regarding the allover quality of gestural abstraction and a process-determined distribution of painterly incident. The resulting equalization of the surface was such that no area within a painting had greater importance than another, regardless of what one's assumptions about the inherent priorities of a given image might have been. Compositional diagramming fleshed out by schematic figuration was the foundation of his Dresden work, and although the early Düsseldorf work was inspired by

ROBERT STORR

allover painting, the more profound implications of this treatment of painterly effects was its potential for subverting gestural showmanship and self-dramatization. Whatever existential angst Richter may have felt, he was determined not to make a spectacle out of it. In order to avoid that, he had to contradict the expressionist readings to which postwar-era painterliness so readily lent itself. Banality gave him the means. Thus, he defaced an apparently sincere Art Informel picture with an image appropriated from a magazine. He explained: "My first Photo Picture? I was doing large pictures in gloss enamel, influenced by [Winfried] Gaul. One day a photograph of Brigitte Bardot fell into my hands, and I painted it into one of these pictures in shades of gray. I had had enough of bloody painting, and painting from a photograph seemed to me the most moronic . . . thing that anyone could do."[36]

More photo-pictures promptly followed. Several show the same contrariant grafting of styles in reverse. For example, the third image in Richter's catalogue raisonné of paintings, *Party* of 1962, is a crudely delineated image of a group of women and a man "on the town," but the canvas has been pierced or sliced with a knife and in places stitched back together, as if, with red paint splattered over the surface, the cuts were open or sutured wounds. The most obvious reading is that the scene portrayed is the prelude to a sex murder—distantly linking it to *Neue Sachlichkeit* images of *Lustmörder*—but the formal joke is directed at Fontana and his elegant perforations of abstract space.

Other paintings from early in Richter's catalogue raisonné have similar though less overtly satirical dissonance in them. Based on a news photograph that appears in *Atlas: Panel 9*, just opposite the squared-off clipping used for *Party*, the painting titled *Coffin Bearers* of 1962 combines a fairly straightforward rendering of the original black-and-white image heightened by color in the face of one of the undertakers, with loose scumbling of slate gray paint in the upper middle section and a drizzle of light gray paint to the left, over which two number-filled text balloons have been inscribed in white near the mouth of the man furthest to the left. Even more so than the letters scratched into the mottled wall next to the figure in a work such as Jean Dubuffet's *Wall with Inscriptions* (1945), Richter's painterly washes and graffiti balloon are at once gestural enhancements of the image and an impish aggression against naturalism.

The fact that the sources for the third and sixth paintings in Richter's recorded oeuvre appear in the ninth panel of *Atlas*, after more than two hundred images, would suggest that other works had been painted by this time but were destroyed. Indeed, a number were documented by the artist, and some were even exhibited prior to his discarding them; two examples are *Firing Squad* (1962), a composite of an image of men with their arms raised, embellished with a broad-brush vertical skein of paint to the left, and five identical upside-down head shots of a smiling blond beneath; and *Pope* (1962), a white silhouette of Pope John XXIII. Interestingly, neither of these paintings has a source in *Atlas*, although many images that do appear were never painted and others may have been. Meanwhile, sources for works painted after *Party* and *Coffin Bearers* have been inserted into the sequence *before* their source photos, for example, Richter's portrait *Horst and His Dog* of 1965 (page 21) and *Eight Student Nurses* of 1966 (pages 28–29). Furthermore, we have it from the artist that the thirteenth canvas in his catalogue raisonné, *Mouth* of 1963—a disconcertingly large and morbidly hued picture of Brigitte Bardot's lips—was actually made before *Table* of 1962 (page 18), the first work in the catalogue.

Plainly, neither the numbering system for paintings, which Richter established in 1963 and upon which his catalogue raisonné is based, nor the order of images in *Atlas*, which the artist began to assemble in 1969, is entirely chronological. In some cases, the image

groupings in *Atlas* are thematic or taxonomic; panels 1, 2, 3, and 6 are snapshots of family and friends, while panel 4 consists of landscape photographs. In others, the associations are jarring; panel 11 features several pictures of wild and domestic animals, juxtaposed with the pictures used for *Kitchen Chair* of 1965 (page 22) and another of vultures watching over emaciated corpses on a street somewhere in the "third world." Further on in *Atlas* whole panels devoted to concentration-camp pictures are set against others devoted to pornography, an incommensurable pairing

Gerhard Richter. **Atlas: Panel 9.** 1962–68. Black-and-white clippings and photograph, 20⅜ × 26¼" (51.7 × 66.7 cm). Städtische Galerie im Lenbachhaus, Munich

Richter once considered as the possible basis for an exhibition of paintings but abandoned when he found the concentration-camp photographs "unpaintable." Still later, in panels 131, 132, and 133, Richter contrasts press photos of Adolf Hitler speaking or visiting with supporters—a series immediately preceded by mountain views that recall the Nazi cult of the Alps—with news photographs of a lion devouring a tourist that were the basis for *Tourist (with 1 Lion)* of 1975 and related paintings. The editorial mind at work in forming these ensembles seems as determined to disrupt patterns as to create them, as eager to draw attention to certain pictorial equivalencies or disjunctions as to nestle the most personal or shocking items or clusters of items in settings that obscure their meaning to the artist and stymie interpretation based on conventional attitudes regarding intrinsic significance. At once a vast index of primary material and a device for reviewing and rethinking the many possible relations of one image to another as icons in their own right, as image-types, or as entries in his intellectual and artistic autobiography, *Atlas* is a mechanism for simultaneously organizing and disorganizing information, a way of showing the artist's hand and of camouflaging his intimate connections to the contents on display.

The rearrangement of pictures in the catalogue raisonné, meanwhile, corresponds to a related habit of gathering and sorting images in an effort to take stock and identify latent qualities or previously unrecognized possibilities in the work that piled up around him in the studio.[37] If *Atlas* represents a critical use of collage technique on a massive and open-ended scale, then, in the initial phases, the catalogue raisonné, following up on the albums of photos he brought with him from Dresden, is less a literal history of his production than an empirical narrative construct internally adjusted to account for the importance paintings had for him after he had studied them in the context of others of their generation.

Table was not the first photo-based painting he painted—nor was it even the first in which the superimposition of Art Informel gesture over realist subject appears. *Firing Squad* and *Coffin Bearers* came before. Nevertheless, *Table* was the first painting in which the opposition or layering of incompatible styles transcended a polemical use of contradiction and became something tense but whole. Simultaneously austere and assertive, *Table* was the paradigm for which Richter had been waiting, the tuning fork that would set the aesthetic tone of his work for years thereafter, work whose scope would embrace an astonishingly wide variety of images but whose painterly mood was to remain consistently

ROBERT STORR

Gerhard Richter. **Party**. 1962.
Oil on canvas, 59¹⁄₁₆ × 71¹¹⁄₁₆"
(150 × 182 cm). GR 2-1.
Collection Frieder Burda

reserved. In this one work, based on a photograph of a modernist table he had found in the design magazine *Domus* (page 18), Richter became himself as an artist by applying the lessons learned from his ongoing experiments in wiping out reproductions of architectural photographs with turpentine or benzene applied directly to the inked page (experiments similar to procedures Rauschenberg employed in his transfer drawings). Paradoxically, this aesthetic self-discovery meant disappearing into the haze of photographs reincarnated as paintings.

Richter's growing antagonism to the stylistic tendencies taken most seriously at the academy—Art Informel, Zero, and various kinds of conservative abstraction—was shared by his closest student friends, Konrad Lueg, Sigmar Polke, and Blinky Palermo, the last two also having come from East Germany. In the beginning, Lueg was the most crucial to Richter's artistic re-departure: "He was very well informed and he had this cool manner, like Humphrey Bogart. He knew what was going on and how things worked. He knew the mechanisms. He was more arrogant than the other students because he knew more and wasn't so sentimental. It was his advantage and disadvantage at the same time. You have to be a bit sentimental to stay alone in your studio. That was too much for [Lueg]. He needed a public."[38]

These qualities were recognized by the art-world types with whom Lueg hung out. One day the art dealer, Alfred Schmela, who later showed Richter's work, introduced the two companions to one of his professional colleagues, saying of Richter, "He'll be a very good painter," and of Lueg (to Lueg's dismay), "He'll be one of the best gallerists."[39] The author of paintings that were bright, patterned, and pleasingly Pop, Lueg eventually abandoned his modestly successful career as an artist, changed his name back to Konrad Fischer, and did become one of the most important gallerists in Germany, representing, among others, Carl Andre, Lothar Baumgarten, Hanne Darboven, Gilbert & George, Sol LeWitt, Bruce Nauman, Robert Ryman, and, intermittently, his former classmates Richter, Palermo, and Polke.

Polke was wilder and more sardonic than Lueg: "He was very different, he was not cool . . . He had irony. He was very funny. The things we did together were a kind of craziness."[40] Both Polke and Richter felt like outsiders to the art scene: "We thought everything was so stupid and we refused to participate. That was the basis of our understanding," but

Lueg was an insider; the art scene was "his family." [41] Notwithstanding Polke's wild streak, Richter was impressed that "he was able to paint those little dots in his raster paintings by hand with such patience while he was living with his two children and his wife in a small subsidized apartment. . . . We both had apartments like that." [42] In addition to sharing what seems to have been a sibling bond, complete with sibling rivalry, a powerful aesthetic current passed between the two from the time of their meeting in the early 1960s until they went separate ways in the mid-1970s. This led to a two-person exhibition at Galerie h, in Hannover in 1966, to collaborative texts (one of them for that exhibition) in which the artists tease the reader from behind literary masks, to collaborative prints, and to photographs of the pair that amount to performance pieces. Moreover, attention to the scraped red and yellow paint to the left of the couple in Polke's *Lovers II* (1965) reveals an aggressive painterliness prefiguring Richter's own scraped and smeared abstractions of the mid-1970s onward.

For a rough, but possibly useful, comparison to the Richter-Polke friendship one might turn to the aesthetic dynamic between the young Rauschenberg and the still younger Jasper Johns at the outset of their careers. In that relationship Rauschenberg was an omnivorous extrovert with astonishing gifts of improvisation combined with a remarkable capacity for assimilating whatever pictorial resources came his way. The more reticent Johns applied his mastery of paint on canvas to mine the iconic power of each image he addressed and to extract the full measure of its inherent uncanniness. Although six years younger than Richter, Polke was extroverted and inventive in ways not that dissimilar from Rauschenberg, while Richter distilled images with a gravity and rigor not unlike that of Johns, albeit in a style that owes nothing to the Cézannesque tradition to which Johns belongs.[43] Historically, the reciprocal influence of Georges Braque on Picasso and Picasso on Braque during the creation of Cubism comes to mind. Of course, Richter and Polke did not join forces to start a movement, nor has Richter been outstripped in the long run by Polke's always wide reach, but the sparks thrown back and forth between the two men, sparks generated by their temperamental differences as well as by their mutual attraction in an art world where both felt themselves to be alien, was, so long as it lasted, one of the closest and most beneficial exchanges between two first-rank artists in modernism's history.

Of Palermo, the third member of this triumvirate, there is more to be said later, since Richter's greatest involvement with him came in the 1970s after he and Polke had parted company. For now, it is enough to mention two things. First, Palermo's idiosyncratic paintings and objects with their subtle color and lyric sense of shape and line had relatively little to do with the Pop sensibility that Richter, Lueg, and Polke shared. Second, Palermo's dependency on his mentor Beuys held him in an orbit that Richter assiduously avoided. When Richter arrived at the Düsseldorf academy, Beuys had just been appointed Professor of Monumental Sculpture, and his juggernaut through the academy, the Cologne–Düsseldorf scene, and the European art world had barely begun. As Richter remembered it: "In 1962 I saw a young man in the Düsseldorf academy wearing jeans, a waistcoat, and a hat. I though he was a student, and discovered that he was the new professor."[44] Eventually, when Richter joined the academy faculty in 1971, he and Beuys became colleagues, and, later, after Beuys was dismissed from his teaching position for allowing unauthorized students into his class as a part of his campaign for educational reform, Richter supported him (along with the novelist Heinrich Böll and others) to the extent of lending his name to the roster of participants in Beuys's alternative "Free International College for Creativity and Interdisciplinary Research." All the same, Richter had reservations about Beuys and his

activist view of art; the degree to which those ideals and Beuys's larger-than-life persona loomed over everyone working in his vicinity posed an ongoing challenge to Richter's own more skeptical, and decidedly anti-utopian, outlook. In the final analysis, however, Richter appreciated "the dangerous quality Beuys had," and in a double-edged and self-deprecating memorial statement summed up his feelings: "This phenomenon . . . took us by surprise 25 years ago, and soon appalled us, unleashing admiration, envy, consternation, fury . . . which, for all our rebelliousness, gave us a framework in which we could 'carry on' in relative security."[45] It was Beuys who brought Fluxus to the academy, where he arranged for and participated in the two-day Festum Fluxorum Fluxus on February 2 and 3, 1963. By then the friendship of Richter, Lueg, and Polke had already formed. "Contact with like-minded painters—a group means a great deal to me: nothing comes in isolation. We have worked out our ideas largely by talking them through. . . . One depends on

Sigmar Polke. **Lovers II [Liebespaar II].** 1965. Oil and enamel on canvas, 6'2¾" × 55" (190 × 140 cm). Courtesy Michael Werner Gallery, New York and Cologne

one's surroundings. And so the exchange with other artists—and especially the collaboration with Lueg and Polke—matters a lot to me," wrote Richter.[46] Witnessing Fluxus galvanized the group, Richter recalled: "Shocking absolutely shocking—they pissed in the tub, sang the German national anthem, covered the audience with paper, poured laundry detergent into the piano, attached microphones to fountain pens."[47] "It was all very cynical and destructive; it was a signal for us and we became cynical and cocky."[48] Within months the three painters were staking out their own territory.

That year, Richter and Lueg had traveled to Paris, where they paid a call on Iris Clert, who represented Klein and other artists, and also visited Ileana Sonnabend, whose Paris gallery was linked to the New York gallery of her husband Leo Castelli (together they represented most of the leading neo-Dada and Pop artists). Clert showed no interest at all in the Cologne delegation, but Sonnabend received them, whereupon they declared themselves to be "German Pop artists." Richter particularly remembers being struck by a Roy Lichtenstein painting he saw in the back of Sonnabend's gallery, confirming an interest in Lichtenstein that had been triggered by a reproduction in the magazine *Art International* earlier that year (shortly after which he staged the destruction of his Art Informel work).

The timeliness of these encounters is significant. Like Richter, Lichtenstein had been painting for a decade before he found his own identity; his very first Pop pictures date from 1961, only a year before Richter came upon them. Although Polke, rather than Richter, engaged most directly with Lichtenstein's work from a stylistic point of view, both were inspired by its cool detachment and by its confident "anti-painterliness." And both responded to the new art and took off in their own directions from it before Pop art was a fully developed tendency. Thus, while the reflex conclusion might be that Richter, Polke, and their generation simply absorbed a codified style, it is closer to the truth to say that the Germans

recognized the potential of a still evolving phenomenon and altered its course by extending it further through their own efforts and in accordance with their own talents and intentions. They were not one step behind the Americans or, if so, not for long; whatever catching up they needed to do was over almost as soon as they became aware of what had already been accomplished—first in London by Richard Hamilton, Eduardo Paolozzi, and others, and then in New York by Lichtenstein, Andy Warhol, Claes Oldenburg, and their cohorts. From then on Richter and Polke were making fresh sentences in a thoroughly international idiom.

Lueg, whose own work was never the equal of that of his friends, contributed an indispensable entrepreneurial gift. Convinced, as Polke and Richter later wrote, that, "We cannot assume that good pictures will be painted one day: we must take matters into our own hands,"[49] Lueg and the others arranged to show their work in an abandoned building controlled by the municipal government of Düsseldorf. This exhibition, which opened on May 11, 1963, was advertised by an announcement that listed the welter of currently fashionable styles in concentric lines of type around the names of the three principal artists plus that of a fourth member of the group, Manfred Kuttner: "This exhibition is not a commercial undertaking but purely a demonstration, and no gallery, museum or public exhibiting body would have been a suitable venue. The major attraction of the exhibition is the subject matter of

Gerhard Richter and Konrad Lueg. **John F. Kennedy.** 1963. Papier-mâché over wire mesh, 70⅞ × 22⅞ × 10⅝" (180 × 58 × 27 cm). Private collection, Germany

the works in it. For the first time in Germany, we are showing paintings for which such terms as Pop Art, Junk Culture, Imperialist or Capitalist Realism, New Objectivity, Naturalism, German Pop and the like are appropriate. . . . Pop Art has rendered conventional painting—with all its sterility, its isolation, its artificiality, its taboos and its rules—entirely obsolete. . . . Pop Art is not an American invention, and we do not regard it as an import. . . . This art is pursuing its own organic and autonomous growth in this country."[50]

This hit-and-run exhibition garnered little attention, but it posted notice that for those involved anything was fair game. Among the isms cited was a previously unheard-of entry, Imperialist Realism, which in the context of Richter's remark about Pop art not being "an import," nevertheless lends a political cast to the Pop aesthetic for the first time. The second exhibition organized by Lueg and Richter (Polke's absence indicates the internal competitiveness of the artists' alliance) sharpened that political edge. Like the first show, it made use of borrowed space—this time the Berges furniture store in Düsseldorf where the artists were given permission to hang works on the walls in the display areas—and it was titled *Life with Pop: A Demonstration for Capitalist Realism.* Partially inspired by Oldenburg's *The Store*—a 1961 exhibition on the Lower East Side of Manhattan where the artist sold sculptural caricatures of food and dry goods from the rented shop in which they were made—Lueg and Richter orchestrated an evening-long event in which the entire Berges store was conceptually annexed,

including fifty-two bedrooms, seventy-eight living rooms, kitchens, and nurseries.[51] Visitors were greeted in an upstairs waiting room by thirty-nine chairs, each with a copy of the daily newspaper, fourteen pairs of antlers (which had, according to the artist's post mortem report, come from roebuck shot between 1938 and 1942), and two life-sized papier-mâché figures in the style of Carnival effigies, one of the gallerist Schmela, the second of John F. Kennedy.[52] Lueg and Richter appeared in the first exhibition room wearing suits and ties as "living sculptures." Lueg sat in a chair mounted on a white plinth, Richter lounged on a couch—also on a white base—reading a detective story. Other elements of the installation included designer magazines, a set of the complete works of Winston Churchill, a television tuned to the news and to a special on the Adenauer era, which had just ended in 1963, assorted coffee cups, glasses and bottles of beer, and in a wardrobe by the door the "official costume of Prof. J. Beuys (hat, yellow shirt, blue trousers, socks, shoes; to which 9 small slips of paper are attached, each marked with a brown cross . . .)" and beneath which, in a box, was a wax and margarine sculpture by Beuys.[53] Although Beuys was not yet the figure he would become, his Fluxus activity had broken the ice for Richter and his contemporaries, and his presence in the exhibition made that connection, particularly to the performance aspect of the show—guided tours by the artists, music, dancing, liquor—which quickly got out of control. In just over an hour and a half the whole event was over.

Despite Richter's efforts to downplay it, much critical attention has been paid to the label *Capitalist Realism*, and a good deal of confusion has arisen as a result. Within a year of the Düsseldorf "Demonstration" the Berlin dealer René Block picked up on the term and used it for his own purposes in connection with exhibitions and editions he sponsored, grouping Richter with artists with whom he had little in common, among them Wolf Vostell, K. P. Brehmer, and K. H. Hödicke. Moreover, the Fluxus-oriented dealer underscored the political sense of the term, and would later attack Richter for wanting nothing more than to paint beautiful pictures.[54] For his part, Richter certainly never intended Capitalist Realism to be understood as a political movement, nor was there ever anything more than a catch phrase for a one-shot show in his mind. That said, Capitalist Realism is rich in provocative meanings. As a play on Socialist Realism, it turns the tables on the eastern-bloc aesthetic dogmas in which Richter had been schooled, but it has an even more satirical effect when applied to the commercial culture of the West as a substitute for the label *Pop*.

In the definition of Richard Hamilton, the English polymath: "Pop Art is: / Popular (designed for a mass audience) / Transient (short-term solution) / Expendable (easily forgotten) / Low cost / Mass produced / Young (aimed at youth) / Witty / Sexy / Gimmicky / Glamorous / Big business."[55] For Warhol, Pop was a question of "liking," with all the emphasis on excess and novelty implied by Warhol's deadpan delivery.[56] However, the context in which English and American Pop art arose was fundamentally different from that in Germany, where the devastation and shortages of the recent war were fresh in memory despite the relative plenty of the "Economic Miracle," where the new consumerism stirred deep misgivings in many people's minds, and where the ideological battle between "big business" democracy and "big brother" egalitarianism was being fought along a militarized frontier partitioning the country. Socialist Realism heroicized its subjects in the reflection of a distant but radiant utopia; Capitalist Realism turned the glare of the mass media and bright, shiny modern packaging back on themselves to highlight the encroachments of a seemingly limitless new materialism. Richter's own attitude was plainly laid out in a note dated 1962: "I did not come here [West Germany] to get away from 'materialism': here its dominance is far more total and more mindless. I came to get away from the criminal

Gerhard Richter. **Neuschwanstein Castle [Schloss Neuschwanstein].** 1963. Oil on canvas, 6'2¹³⁄₁₆" × 59¹⁄₁₆" (190 × 150 cm). GR 8. Collection Frieder Burda

'idealism' of the Socialists."[57] Unquestionably, Richter shared much of Hamilton's enthusiasm for things young, witty, and sexy, and his affinity with Warhol is likewise indisputable; but his view of the postwar paradise of the 1960s was clouded by his experience of its antithesis, which gave his work, like Polke's and unlike Lueg's, a dark quality from the very start. On one level, then, the equation established between the two economically determined realisms is a throwaway line by a group of cheeky young painters; on another, the symmetry underscores the ideological similarities between two world views vying for dominance in an all-or-nothing game of power politics that made no allowance for the ambivalence felt by those same artists. For Richter, making this point once was enough; however, the semantic judo involved is impossible to forget and its full ramifications hard to escape.

Richter exhibited four works in the Berges furniture store "Demonstration." Only one of them, *Mouth*, would have struck most people as typically Pop. The others, *Neuschwanstein Castle* and *Pope* (1962) and *Stag* of 1963 (page 19), were images that fell outside the normal run of advertising, cartoon, and movie graphics that were Pop's tap roots; and two of them, *Neuschwanstein Castle* and *Stag*, were essentially Photo-Realist, albeit less so than several contemporaneous pictures. At the time he painted these canvases there was as yet no such category. Indeed, there was virtually no one testing the waters Richter had already entered. Malcolm Morley's rough grisaille battleships, generally acknowledged as the first Photo-Realist paintings, were painted in 1964, although Richter very much admired the perfection of Morley's full-color ocean-liner paintings of a year later. Only Richard Artschwager's acrylic on Celotex photo-based portraits and cityscapes date from the same year as Richter's first essays in the genre; Artschwager's work of that kind was not exhibited until 1964 when Leo Castelli gave the artist a show at his New York gallery.[58] When Photo-Realism became a full-fledged movement in the 1970s, Richter was at pains to distance himself from it, even though he was thrown together with representatives of the tendency in Documenta 5 in 1972, including the American Chuck Close and the French painter Jean-Olivier Hucleux. While many Photo-Realists used photography primarily as a means of achieving feats of trompe l'oeil magic (although a technical wizard, Close was the leading exception to this rule), Richter was more concerned with the problematic reality of photographs than in the reality photographs ostensibly recorded.

For Richter, photography's greatest virtue was what it was not. It was not fine art. At any rate not the kinds of photography that had stuck in his mind and to which he was now attracted. "As a boy I did a lot of photography and was friendly with a photographer, who showed me the tricks of the trade," he explained. "For a time I worked as a photographic laboratory assistant: the masses of photographs that passed through the bath of developer every day may well have caused a lasting trauma."[59] Those pictures were ordinary snapshots without aesthetic pretensions. Yet, whatever they lacked in compositional sophisti-

Malcolm Morley. **Boat.** 1964. Liquitex and ink on canvas, 36" × 6' (91.4 × 182.9 cm). The Museum of Contemporary Art, Los Angeles. Partial gift from the Collection of Laura-Lee and Robert Woods. Courtesy Sperone Westwater, New York

cation, they made up for in raw information; and whatever they lacked in expressiveness, they made up for in matter-of-factness. Up to this point, painting had meant subordinating vision to aesthetic principles, things seen to predetermined formats, and the uncertain truth of appearances to the authority of the artist's will-to-style. Removing the filter of creative identity allowed the painter to recognize the disembodied objectivity of the camera image: "The photograph reproduces objects in a different way from the painted picture, because the camera does not apprehend objects: it sees them. In 'freehand drawing,' the object is apprehended in all its parts. . . . By tracing the outlines with the aid of a projector, you can bypass this elaborate process of apprehension. You no longer apprehend but see and make (without design) what you have not apprehended. And when you don't know what you are making, you don't know, either, what to alter or distort."[60]

Richter's epiphany that "the photograph is the most perfect picture," allowed him in a single stroke to have done with the problems of reconciling his artistic taste, talents, and ideas with the demands of an art world obsessed with originality and overdetermined meaning. "It does not change," he said. "It is absolute, and therefore autonomous, unconditional, devoid of style."[61] A certain Fluxus-inspired defiance attended this realization. "I consider many amateur photographs better than the best Cézanne," Richter wrote in 1966.[62] But this declaration also contained an element of humility or at least an escape from the expectation that he "foreground" the maker of the work, allowing him, instead, to pursue a deliberate self-effacement in which the unresolved particularities of the subject painted took precedence over the subjectivity of the artist. When he does speak about himself—with quiet humor—it is as one of a class of things that has asked to be taken more or less at face value: "I like everything that has no style: dictionaries, photographs, nature, myself and my paintings. (Because style is violence, and I am not violent.)"[63] The violence at issue is not merely the overt distortion of reality to which modern art is prone, but the very notion of imposing the self on things as they are, or as they seem to be in a given instance.

The impersonal image Richter sought to make—or remake—through the use of photography corresponds in some respects to those kinds of art produced in response to Cage's theory of chance operations, and, through the agency of Fluxus, Cage was very much a presence in Germany in the early 1960s. After the socially committed art of the 1920s, 1930s, and 1940s, the influence on Surrealism of Sigmund Freud and his concept of the ego, combined with the impact of Existentialism's celebration of the self-made man of thought and action in the 1940s and 1950s, the desire to leave things alone rather than transform them into something else or place them at the service of a larger goal was pervasive. Cage's embrace of randomness was perhaps the most radical version of this tendency in that it cheerfully shrugged off all social, political, and moral imperatives. His

famous "Lecture on Nothing" took a word that was rich in Sartrean anguish and gave it back to the reader as a term signifying a liberating, but always attentive, equanimity. "I have nothing to say," Cage wrote, "and I am saying it."[64] Richter, who has quoted that phrase, was plainly impressed by Cage; but there is a brooding quality to Richter's work—as well as an obvious, if vague, moral dimension—that departs from Cage's more optimistic disengaged model. Nevertheless, before delving into the much-vexed question of photography's special status as a modern medium, it is important to say that its initial value to Richter seems primarily to have been the opportunity it gave him to turn Cage's formulation around and talk about—or represent—everything without stepping forward to say anything and, by that means, to access many of the same artistic freedoms, beginning with the freedom from self that Cage preached.

The philosopher Roland Barthes offers other essential points of reference. He observed that the temporal reality of the photograph arrests life in the click of the shutter and reconstitutes it as "the that has been," making the viewer aware that "Death is the *eidos* of that Photograph."[65] This may be taken as axiomatic with regard to Richter's work, especially insofar as it frequently alludes to or depicts death and thus puts the mortal subject of the painting and the implicitly morbid condition of photography in tension with the immediate presence and sublimated corporeality of the painted picture. Moreover, Barthes's distinction between what he calls the photograph's *studium* (its dominant image and overall scope) and the photograph's *punctum* (the unique, even incidental detail that stops the eye, pricks the mind, and captures the imagination) is also provocative insofar as Richter's brushy re-presentation of photographs tends to obscure the dominant characteristics of the image (studium) or render

Richard Artschwager. **Portrait I.** 1962. Acrylic on wood and Celotex, 6'1¼" × 26" × 12" (186 × 66 × 30.5 cm). Collection Kasper König, Cologne

it generic—a portrait, a landscape—even as it exaggerates existing anomalies (puncta) within the image. The latter occurs often (as an awkward gesture or a byproduct of painterly accents and erasures) and we may take Richter at his word when he says that he turned to photography "not to use it as a means to painting but use painting as a means to photography"—not, that is, to imitate photographs but to remake them in paint.[66] Richter's discovery that photographs freed him from the "conventional criteria . . . associated with art"—from style, from composition, from judgment—and "from personal experience," leaving" nothing to it: it was pure picture" that he wanted to "have" and "show,"[67] can be more vividly understood by attention to Barthes's elliptical intellectual self-portrait, in which he wrote of his own struggle against the entrapments of expression. Barthes said: "He is troubled by any image of himself, suffers when he is named. He finds the perfection of a human relationship in the vacancy of the image: to abolish—in oneself, between oneself and others—adjectives; a relationship which adjectivizes is on the side of the image, on the side of domination, of death."[68] Although Richter seemingly had sided with the image, and many of his images were death-haunted, his motivation and reasoning essentially parallel those of Barthes, resulting in a pictorial language at "degree zero," one that, eschewing domination and violence, had been stripped of adjectives.

"I had very little interest in any critique of packaged culture or the consumer world," Richter said.[69] This sets him apart from his Pop art counterparts, although it might well be argued that given their ambivalences Richter's favorites, Lichtenstein, Oldenburg, and Warhol, had little interest themselves in what is now—with Frankfurt School Marxism in the background—called cultural critique. Instead, Richter's preoccupation was with the iconography of the everyday. Implicit in this was the pathos he saw both in the photograph as object and the image it contained, a pathos indelibly marked by use. Rather than emphasize the photograph's lowliness or meagerness, Richter sought to dignify it, not by making it more glamorous or more aesthetic, but by respecting it for what it is and showing that. "Perhaps because I'm sorry for the photograph," he explained, "because it has such a miserable existence even though it is such a perfect picture, I would like to make it valid, make it visible." [70] Behind this declaration is a commitment to the visible from one of the most demanding of contemporary artists—and, beyond that, a belief in the shared experience of the visible—which should not be taken lightly in a context where attacks on "visuality," "opticality," and the very possibility of communicating directly through the senses are staples of postmodernist discourse. As to the images in the paintings themselves, it was not the chair in the Berges showroom that mattered to him—one of many on display, as in Warhol's Campbell's soup cans or Coca-Cola bottles—but the one in a hundred that sits in the corner and acquires the patina of all things lived with, while emitting the cold aura of all things devoid of innate vitality. Asked by an interviewer what function the subjects of his realist paintings had, Richter simply said, "sympathy."[71] Caught off guard by the answer, the interviewer inquired about his painting of a common chair, and he replied: "It is our chair, which we use. It is really pitiable and very banal, but it has a mood."[72]

The mood or ambience of *Kitchen Chair* of 1965 (page 22) is stark and cold, but it is also haunting. Had Richter set out to make a ghostly object he might fairly be accused of having cheated on his commitment to remove Expressionism, Symbolism, and other aesthetic overlays from his work. In actuality, however, there are no obvious stylistic interventions to account for this effect. Richter says: "Even when I paint a straightforward copy, something new creeps in, whether I want it to or not: something that even I don't really grasp."[73] On several occasions, Richter has not only copied photographs but made several versions of the same image, or very similar images, and the unanticipated or only partially anticipated differences can be striking. There are, for example, three versions of Richter's laconic, scatological, vanity-defying *vanitas* paintings titled *Toilet Paper* of 1965 (page 23).[74] The first one depicts bold, nearly abstract volumes. The second and third, based on another source, are bathed in a penumbral light that catches more detail than does the harsher chiaroscuro of the first version, even as it makes the toilet-paper roll seem more remote. The first is forceful and objective in a semi-Pop manner; the second and third literally foreshadow the quasi-romantic glow that often suffused Richter's paintings starting in the early 1970s. It is a light that Richter withholds from *Flemish Crown* of 1965 (page 22) precisely, it seems, because the subject conventionally calls for it, and the artist is generally loathe to satisfy such expectations, but also because he regarded the kind of bourgeois interior that such chandeliers supposedly ennoble with palpable horror.

The iconography of the everyday also includes things in the environment that refer to situations outside it or realities that routinely intrude on quotidian existence through the media. From that perspective, paintings such as *Stag* and *Neuschwanstein* are simultaneously manipulated reproductions of other images and citations from the "dictionary" of cultural archetypes. The first evokes the traditional German fascination with the wild

(symbolized by the forest and deer) which comes down from Nordic legend by way of Dürer and Romanticism. The second involves the most decadent manifestation of that archaizing tendency, a travel-poster or postcardlike image of Ludwig II of Bavaria's last great architectural folly. It would be a mistake, however, to regard either of these canvases as examples of pictorial camp. Of *Neuschwanstein* Richter said: "The real-life castle is a hideous monstrosity. But it does also have this other, seductive side to it, that of the beautiful fairytale, the dream of sublimity, bliss, happiness—and that's the dangerous part; that's why it's a very special case of kitsch."[75] And of *Stag* he remarked: "It's not the stag's fault if he's been badly painted—'Stag Roaring' over the sofa. For us Germans, in particular, relating to forests as strongly as we do, the stag does of course have a symbolic quality. I wanted to be a forester when I was young, and I was really excited when I found a real stag in the forest and took a photograph. Later I painted him, and the painting was a bit less romantic than my youthful photograph."[76] Insofar as such paintings invite the critical scrutiny of "kitsch" they first acknowledge its genuine—therefore problematic—appeal, and the tug of fundamental poetic and philosophical possibilities they so poorly embody. When Richter quotes from debased sources, it is never merely for the purposes of mocking them, nor is his regard for them (no matter how they trouble or dismay him) ever contemptuous or cynical.

 Stag is the second work in Richter's oeuvre in which the artifice of painting is laid bare. In the first, *Table*, this is accomplished by superimposing two styles of painting; in *Stag* it is done by separating areas of the composition from one another with different gray tints—something that would not occur in the faithful transcription of a black-and-white photograph—while the smearing of the stag against the crisply delineated but unfilled contours of the trees displays the skeleton of drawing against the abraded flesh of paint. *Dead* of 1963 (page 19) simultaneously emphasizes and destroys the illusionism in which Photo-Realism traffics by reproducing a printed image in a vastly enlarged scale and cropping it so that white margins and oversized type are visible while parts of the picture itself are lost. Such cropping and fragmentation are typical of modernist collage, and from one historical angle, *Dead* might resemble a huge excerpt from a tiny Schwitters. Such a comparison may seem farfetched, but it is plausible considering the extent to which Richter was surrounded by artists actively pursuing neo-Dada collage or decollage practices, in particular, Polke, who learned as much from Rauschenberg's pictorial elisions as from Lichtenstein's dot matrices, while contributing far more to those techniques than he borrowed. Inasmuch as both Richter and Schwitters trim or fracture images and break words or parts of words away from their linguistic contexts, both are engaged in a graphic dismantling of the established semantic and pictorial order. Nevertheless, with the exception of the destroyed *Firing Squad*, and the seamless composite *Spanish Nudes* (1967), Richter has seldom pieced disparate pictures together in the same painted format. And, even when he draws attention to the incompleteness of the image—as in the obviously reframed *Dead* or *Ferrari* of 1964 (page 24) or in *High Diver I* of 1965 (page 24)—the relation of figure and ground within the carefully proportioned rectangle achieves equilibrium and reasserts a sense of pictorial wholeness.

 Whereas the *Coffin Bearers* presents the reverential but awkward ceremonies that attend death, *Dead* depicts it as almost comically incidental. Based on a newspaper clipping, it portrays a hapless man felled by a chunk of ice. Painted with a cartoonish economy, the work shows the prostrate man's body lying next to the huge white block. White margins, and one mottled gray one to the right, surround this image, and above, in crisp black letters is the word *tote*, or *dead*. Image and text are equally blunt: the first shows a disastrous

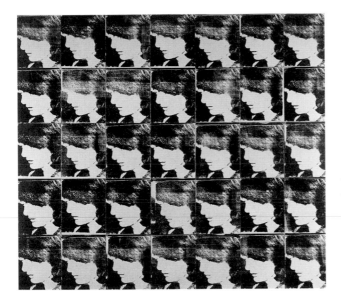

Andy Warhol. **Multiplied Jackies.** 1964. Acrylic and Liquitex silkscreen on canvas; 35 panels, each 20⅛ × 15¹⁵⁄₁₆" (51 × 40.5 cm); overall 8'4⅝" × 9'4¹³⁄₁₆" (255.5 × 286.5 cm). Museum für Moderne Kunst, Frankfurt am Main, previously Ströher collection, Darmstadt

encounter of the inert truncated corpse and a mysterious mass; the second, a pictorially truncated word, confirms its fate. However, in order to read the word, the viewer must supply the missing pieces just as he or she must connect the cold finality of the text to the nearly slapstick image; and this simple but jarring leap of the imagination drives the metaphor home. Throughout Richter's early career—and there are major examples later, as well—consciousness of death is, explicitly or implicitly, the defining characteristic of numerous works. Like Warhol in his Disaster paintings, Richter picked up on the public's horrid fascination with suffering and the media's exploitation of it. On the front page, murder is at once spectacular and banal, raising the ordinarily unfortunate to the level of celebrities, and bringing celebrities down to the level of common people. Seizing upon this macabre permutation of the law of supply and demand, Richter understood, as did Warhol, that the tabloids were modern-day variants of the hierarchy collapsing tradition of the Dance of Death.

At one extreme of this social equation is *Woman with Umbrella* of 1964 (page 29). Based on a news photograph of Jackie Kennedy after the assassination of her husband, President John F. Kennedy, it is notably discreet by comparison to Warhol's many treatments of the same subject—her hand covers half of her face and her name does not appear in the title—and more subtly emotional than Warhol's high contrast, grainy silhouettes of the bravely tearful first lady.[77] Taking advantage of the iconic nature of the source as his foil, Richter turns things around to give us a respectfully distant, gently brushed, almost tender likeness of a grieving woman.

At the other extreme are the two paintings of a murdered prostitute who briefly caught the attention of Germany—*Helga Matura* and *Helga Matura with Her Fiancé*, both of 1966 (page 28)—and individual portraits of the victims of American serial killer Richard Speck: *Eight Student Nurses* of 1966 (pages 28–29).[78] The photographs from which Richter worked show Helga Matura seated in the grass, smiling, and as a smartly dressed woman with her arm around an equally happy and well-turned-out but oddly boyish young man. The first image includes her name in a caption signaling its origins in a newspaper or magazine, the second has none. However, both belong to the genre of before-and-after photographs that the press uses to sentimentalize lurid stories, in which "before" is normality (which upright

citizens can snicker over since they know what's coming, particularly when the victim violated their codes) and "after," with the ghastly twist that brings it about, is annihilation. Richter's painterly transposition of the photographs removes this sentimentality, and in the later painting especially, introduces a genuine poignancy that comes with the awkward mix of formality and informality in the couple's pose, her almost overbearing presence in relation to him, and the focus on their two feet touching, which Richter's treatment of the image turns from a corny gesture to a believably affectionate one.

Eight Student Nurses bears some resemblance to Warhol's Thirteen Most Wanted Men (1964), a group of portraits of criminals based on police mug shots that was commissioned for the 1964 World's Fair in New York. Perhaps mindful of that correlation, Richter explained: "I would rather paint the victims than the killers. When Warhol painted the killers, I painted the victims. The subjects were of ... poor people, banal poor dogs."[79] Indeed, Eight Student Nurses alters and recycles pictorial conventions in delicate and emotionally charged ways, similar to those found in the Helga Matura paintings. Although consisting of eight separate paintings, it is one work. Its standardized format (based on nursing-school class pictures) and an even greater degree of blurring than in the Helga Matura paintings (which reduces each face to an almost, but not quite, schematic of eyes, nose, mouth, and helmet of hair), tend toward homogenization, as does the title which identifies the subjects as a group rather than as individual women.

The collective identity begins with institutional photography and professional regimentation (the nurses are in their uniforms), and is rendered definitive by the arbitrary, media-reinforced circumstances of their deaths. However, the faintly registered peculiarities of one victim's expression, another's permanent wave, or yet another's tilt of the head work against these averaging parameters and open up a shallow space in which these unprepossessing phantoms assume a measure of uniqueness. This, in turn, reminds the viewer that no matter how they have been presented to us before, their deaths, like all deaths, were the ultimate statement of their individuality and solitude. Painting brings these qualities to the surface in ways that photography and photomechanical means cannot—and which each generation of reproduction only exacerbates. "In the age of reproduction," Bernard Blistène has written, "Gerhard Richter, like Warhol or Lichtenstein, is the deviation of the multiple into the original, the successful passage of the plural into the singular."[80] Substituting the handmade mark for the consistent reaction of light on chemical emulsions or the consistent impression of dot screens on paper—the canvas object for the serially printed sheet—Richter's paintings restore a sense of finitude to the human form that had seemingly been superseded by the potential infinity of reproductions. When Richter said that his aim was "not to use [photography] as a means to painting but use painting as a means to photography," he was not looking for a way out of painting but describing a quality— minimum aesthetic intervention—that he wanted for painting. In paintings such as Woman with Umbrella and Eight Student Nurses, Richter was nevertheless able to show what could be done within that minimum to inject feeling into images that had seemingly been emptied of it by overexposure.

In contrast to these public images, although painted in more or less the same manner, are the many private portraits in Richter's work. Conceptually speaking, their prominence and ubiquity in his oeuvre is a paradox. After all, Richter had always shied away from painterly emotionalism and other forms of first-person expression. As early as 1966, he was on record as having said: "I believe the painter mustn't see or know the model at all, that nothing of the 'soul,' the essence, the character of the model should be expressed. Also

ROBERT STORR

a painter shouldn't 'see' a model in a particular, personal way . . . because one certainly cannot paint a specific individual but only a painting, which, however, has nothing to do with the model."[81] Yet insofar as people expected accessible "humanistic" subject matter and overt displays of artistic feeling, it is easy to understand Richter's vehemence and his apparent self-contradiction. Before it came to his own family photographs, Richter was interested in the latent psychological content of family photos as a class. If chairs and other household objects had the status of skulls in classical *vanitas* pictures, then the equally banal snapshot was an icon for the contemplation of, and futile battle against, mortality. Describing photography's historical usurpation of painting's function of representing reality, Richter wrote: "At the same time, photography took on a religious function. Everyone has produced his own 'devotional pictures': these are the likenesses of family and friends, preserved in remembrance of them."[82]

The usually artless, awkward, or deadpan qualities of such icons were a barrier against sentimentality, although sentiment was the reason they were taken. For Richter, this generic aspect was a mask behind which he could conceal himself while inserting numerous images of this type into his lineup of pictures appropriated from the media. For example, in 1965, Richter painted *Woman Descending the Staircase* (page 26), a sleek grisaille image of a fashionable woman striding briskly down a flight of steps that was based on a photograph that he clipped from a magazine and juxtaposed in *Atlas: Panel 13* with a sharply contrasting picture of a decidedly unglamorous secretary walking past the camera, an image he also painted. A year later, Richter painted *Ema (Nude on a Staircase)* (page 27), a subtly tinted color portrait of his wife. The titles, of course, refer to Marcel Duchamp's notoriously iconoclastic *Nude Descending a Staircase* of 1912. But the painting of Ema, with its lovely diffuse naturalism, may be taken as an act of counter-iconoclasm. Indeed, Richter seems never to have been wholly convinced of the radicality of Duchamp's work in the first place. "A very beautiful painting, and utterly traditional," he said, and in the strict technical sense of its being an old-fashioned easel painting executed in the old-fashioned way, he was correct.[83] An inversion of the Readymade, in that it is based on a photograph Richter took for the purpose rather than a found image (it was the first time he had done so), it was the most classical pose the artist had yet painted despite its having been explicitly inspired by an anticlassical Cubist masterpiece. To the degree that it is a witty gesture of defiance directed toward the neo-Dada practices in favor among his peers, the work is an argumentative entry into public discourse, but not the least part of that argument consists of the artist's tender portrayal of his own private reality. It is not just the depiction of any nude descending a staircase, it is Ema.

Nothing like it can be found in American Pop art of the period or, for that matter, in American Photo-Realism.[84] Nor are there equivalents to Richter's paintings of other family members, the most exceptional among them being *Uncle Rudi* of 1965 (page 20). A full-figure small-format likeness of one of his two maternal uncles, the picture portrays the subject posing stiffly in his army uniform and smiling for the camera. On the one hand, *Uncle Rudi* is, for Germans, an immediately recognizable but, after the war, seldom discussed type: "The Nazi in the family."[85] He is not a monster but the average, ordinarily enthusiastic soldier. On the other hand, he was the apple of Richter's mother's eye. "He was handsome, charming, tough, elegant, a playboy, [and] he was so proud of his uniform," recalls Richter, who, as a boy, seems to have been impressed by this paragon of manly virtues, but of whom he adds, "He was young and very stupid, and then he went to war and was killed during the first days."[86] In short, *Uncle Rudi* represents a generation that willingly participated in

its own destruction and the destruction of the millions it tried to dominate. The painting's final destination underscores this point. Included in an exhibition in Berlin organized by Block and dedicated to the memory of the victims of Lidice—an infamous atrocity committed by German troops at Lidice, Czechoslovakia—it was eventually donated to the Czech Museum of Fine Arts by the artist.[87]

A companion painting is Richter's portrait of his aunt Marianne, who appears hovering in the photographic shadows above the artist, a baby at the time the picture was taken. Committed to a mental institution from the age of eighteen Marianne was, in family lore, the antithesis of Rudi and her sister, Richter's mother. Richter said: "Whenever I behaved badly I was told you will become like crazy Marianne."[88] She, too, died during the time of the war—killed by Nazi doctors who organized a large-scale system of "euthanasia" to deal with the chronically ill, the mentally retarded, and the insane.

In the catalogue essay for a 1986 retrospective of Richter's work (by far the best biographical and critical overview of the artist's career until that time), Jürgen Harten asked rhetorically what should be made of these two pictures and others that tell incomplete stories linking Richter's family life to history. A partial answer can be found in another work made the same year as *Aunt Marianne* of 1965. A small, atypically ocher-tinted picture of two men with their backs turned—one wearing a Homburg, the other a policeman's cap— and simply titled *Mr. Heyde*, it is, in essence, a portrait of Marianne's executioner. As a neurologist working under Hitler's mandate, a Doctor Heyde had established a program for the extermination of the medically undesirable. In that capacity, Heyde had pioneered the gassing techniques employed in the "Final Solution." After the war, he continued to practice medicine under an alias, with the knowledge of local officials in Schleswig-Holstein, until he was exposed in 1959. The resulting furor ended with his suicide five days before he was to stand trial. The discovery that Dr. Heyde had succeeded in evading prosecution while living comfortably in Germany broke the spell of postwar amnesia and helped prompt a concerted effort to locate "the murderers among us," to quote the title of a groundbreaking 1946 film about hidden war criminals.[89] Israel's 1961 conviction of the former administrator of the concentration camps, Adolf Eichmann, accelerated the process; and in 1962 the Federal Republic of Germany tried a group of Auschwitz guards, in the first major case of its kind prosecuted under West German jurisdiction.

Painted a few years after these events, *Mr. Heyde* points a finger at the accused with calculated discretion. Rather than strike a dramatic tone or take a position outside the reality to which it refers, Richter treated the matter as an ordinary enigma of the sort that would prompt viewers to wonder, in the same way that they might wonder about any person on the street in the custody of a policeman, Who is Mr. Heyde? What has he done? He looks as if he could be anyone's neighbor, and nothing about the man's demeanor or that of the officer escorting him indicates the enormity of his actions. Together with *Uncle Rudi* and *Aunt Marianne*, *Mr. Heyde* closes the gaps between personal experience and public reality, between a painful guilt-laden past and a present predicated on selective memory— gaps in the fabric of German society and culture kept open by denial and reticence. Richter breaks that silence, quietly but unmistakably. There is nothing in German painting of the time that presents the continued Nazi penetration of daily life so matter-of-factly, so unflinchingly, or from so many sides of the German experience.

Nor is there anything quite like Richter's paintings of military aircraft. The first of these—and only the thirteenth work in his catalogue raisonné—*Bombers* of 1963, shows a flight of American planes methodically dropping explosives from the clouds. *Mustang*

Squadron of 1964 (page 20) depicts low-flying American fighter planes in action. Meanwhile, *Phantom Interceptors* of 1964 (page 21) portrays a group of modern jets. The first two are scenes from World War II, similar to things Richter saw or heard about as a boy; the third depicts a commonplace sight—and media image—in the 1960s when NATO planes were stationed at bases in Germany. In the past, Richter has fended off the suggestion that there was any antiwar message in these paintings: "Pictures like that don't do anything to combat war. They only show one tiny aspect of the subject of the war—maybe only my own childish feelings of fear and fascination with war and with weapons of that kind."[90] Nevertheless, the specific choice of planes and their associations resonates in ways that outstrip these narrow criteria. Although there are two paintings featuring German planes—one of diving Stukas from World War II, one of a modern fighter—it is hard to ignore the fact that the rest are not, and that, in turn, reminds us not only of allied saturation bombing during World War II but of cold-war pressure on Germany after the war to host NATO forces and eventually rearm against the Warsaw Pact. These pressures deeply disturbed many Germans,

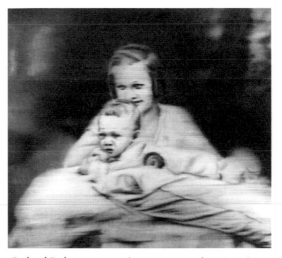

Gerhard Richter. **Aunt Marianne [Tante Marianne].** 1965. Oil on canvas, 47¼ × 51¹⁄₁₆" (120 x 130 cm). GR 87. Private collection

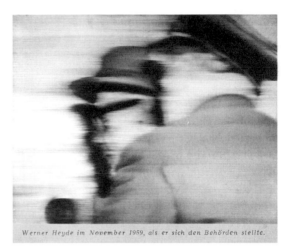

Werner Heyde im November 1959, als er sich den Behörden stellte.

Gerhard Richter. **Mr. Heyde [Herr Heyde].** 1965. Oil on canvas, 21¹¹⁄₁₆ × 25⅝" (55 × 65 cm). GR 100. Private collection

especially as the confrontation with the Soviet Union worsened and American involvement in the "third world" intensified in the 1960s. In a strict sense, these paintings are neutral, in keeping with Richter's intentions, but the political and ideological tensions to which they allude are tangible.

Richter's cityscapes of 1968 are similarly loaded. *Cathedral Square, Milan* (page 30) is the first of his aerial views. The subject is one of the most ornate Gothic churches in Europe and a symbol of feudal civilization in all its grandeur and vulnerability, and, to the left, the portal of a nineteenth-century shopping arcade, a symbol of bourgeois power in all its monumental self-assurance. Brushed in generally thin, gently seismic vertical and horizontal hatchings, the image wobbles optically, and the perspective shifts and torques as if it were emanating from a giant black-and-white television set with bad reception. With

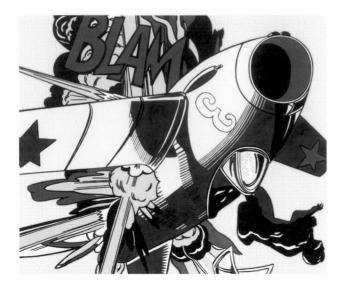

Roy Lichtenstein. **Blam.** 1962. Oil on canvas, 68" × 6'8" (172.7 × 203.2 cm). Yale University Art Gallery, New Haven, Conn. Gift of Richard Brown Baker, B.A. 1935

its deep perspective contradicted by shallow volumes and its abundance of detail—spires, arches, pedestrians, lamps, and cars—barely discernable in the fuzzily interlocking lights and darks, the canvas is, in terms of painterly tradition, the antithesis of Antonio Canaletto's work. In comparison, *Townscape Madrid* (page 31), with its meaty, *alla prima* slabs and dabs of black, white, and gray, is solidly modeled and neatly laid out, as if Manet had been at Richter's elbow. Bracketing these two large pictures at either extreme are two smaller ones of 1969–70: *Townscape PL* (page 30), which resembles the Madrid picture but seen from a higher angle and painted as if the buildings below had been pummeled, and *Townscape SL* (page 31), a lateral view of squared-off housing or office blocks anchoring a rigidly planned setting. On one level, the four paintings are demonstration pieces that show how the allover quality of the composition and paint handling associated with gestural abstraction can be put at the service of representation. On another level, they and others like them—as well as the earlier *Administrative Building* of 1964 (page 23)—are reflections on the new face of Europe and on the other surviving remnants of the old one. The contrast between the woozy splendor of *Cathedral Square, Milan* or the sunny boulevards of *Townscape Madrid*, and the immaculate high-rises of *Townscape SL* or the dreary contemporary facade of *Administrative Building*, is the difference between the prewar and postwar urban context, with the bombed-out *Townscape PL* in the middle.

Viewing his work as a multifaceted, constantly expanding aggregate, it is tempting to accept Richter's early declaration: "I have no favorite pictorial themes."[91] This position is elaborated upon by the statement: "I pursue no objectives, no systems, no tendency; I have no program, no style, no direction. I have no time for specialized concerns, working themes, or variations that lead to mastery. I steer clear of definitions. I don't know what I want. I am inconsistent, non-committal, passive; I like the indefinite, the boundless; I like continual uncertainty."[92] However, other remarks significantly qualify these sweeping dismissals of purpose or preference. Most vivid, is his playful anti-Duchampian assertion: "For me there really exists a hierarchy of pictorial themes. A mangel-wurzel and a Madonna are not of equal value, even as art objects."[93] Another explanation for his recourse to photographs is even more revealing: "Do you know what was great? Finding out that a stupid, ridiculous thing like copying a postcard could lead

ROBERT STORR

to a picture. And then the freedom to paint whatever you felt like. Stags, aircraft, kings, secretaries. Not having to invent anything any more, forgetting everything you meant by painting—color, composition, space—and all the things you previously knew and thought. Suddenly none of this was a prior necessity for art."[94]

If read one way, this list of possibilities has an averaging effect, as though the principal benefit of photomechanical technology were the equivalency it established between stags and aircraft, kings and secretaries. Read another way, the list evokes Richter's excitement at the prospect of these secondhand images giving him the raw data with which to paint the world. To a considerable extent, that is precisely what he did. More so than any Pop artist or Photo-Realist of the time, Richter used the working premise of the inventory to assess contemporary reality from top to bottom, revamping the traditional genres— figure composition, still life, landscape, portraiture—while exploring wide-ranging subject matter: the look and speed of cars in *Ferrari* of 1964 (page 24); the advertised pleasures of the "good life" in *Motor Boat* of 1965 (page 25); pornography in *Student* of 1967; the allure of exotic places as packaged by the travel industry in *Egyptian Landscape* of 1964; the oppressiveness of the urban landscape in *Administrative Building*; and the comfortless furnishings of home in *Kitchen Chair*.

A century before, Charles Baudelaire, writing about a minor painter, Constantin Guys, while in the back of his mind thinking about a major one, Manet, had described what he called "The Painter of Modern Life," whose task it was to catch the "transient, the fleeting, the contingent," that is modernity and give it the immobility of art, to "extract from fashion the poetry that resides in its historical envelope."[95] Transposing the frozen action of the photograph into the enduring but temporally ambiguous realm of painting, Richter fastened on the emblems and ephemera of postwar life and distilled their often bitter essence in tonal pictures whose poetry is a combination of matter-of-fact watchfulness and unrelieved uncertainty.

Given the latitude Richter permitted himself to paint anything, and given his belief that not all subjects have the same degree of importance, there is a cumulative meaning in his choosing to paint family members caught up in the war, menacing airplanes, and cities that recall the bombings of World War II. They do so because they remind us of treasures that were destroyed in whole or in part—in that sense Richter's views of Milan and Madrid are metaphorical counter-images of Cologne or Dresden in rubble after the war—because they look like they actually had been hit or, finally, because they are examples, in Richter's words, of the "horrible, newly built housing developments, so inhuman, so revolting," that were being erected on the ruins of damaged towns or constructed on vacant land in the postwar expansion of the "Economic Miracle."[96] Almost from the moment that Richter began to elaborate his labyrinth of disparate images and styleless styles, he left a trail of crumbs connect paintings imbued with added dimensions of sadness, foreboding, violence, and stifled anger that derive from or refer (often obliquely but sometimes with startling directness) to the dangers and upheavals of his age. As Manet had shown when he ventured into the streets to draw the bloody aftermath of the Commune of Paris, or when he restaged the execution of Maximillian I of Mexico, the Painter of Modern Life may retain his composure and, for the sake of his art, the appearance of neutrality; but he does not avert his eyes at the sight of modernity's horrors. Instead, he is determined to depict the cruelty and absurdity that engender them and the suffering they cause as objectively and as unforgettably as possible. When, in 1988, Richter turned to the subject of the lives and deaths of young German Leftists known as the Baader-Meinhof group, commentators were surprised that he

would try his hand at "history painting," the most problematic and least practiced of tradi-
tional academic genres. But while *October 18, 1977* (pages 188–197), the cycle of fifteen can-
vases that resulted from that effort, radically alter the meaning of that term, precedents for
the decision to make them had existed in his work almost from the beginning. Whether paint-
ing Jacqueline Kennedy or Uncle Rudi, bombers or urban reconstruction, all along Richter
had been painting pictures saturated with history.

Engaged in a balancing act, Richter established a system for maintaining his and the
viewer's distance from the subject, no matter how provocative it might be; it rested on one of
two painterly decisions, and frequently on both. The first was to obscure the image by feath-
ering the paint or by dragging a spatula or hard edge across the surface and smearing it while
it was still wet. The second was his reliance on grisaille. Almost immediately, blurring the
image came to be seen as a trademark of his work—the signature device he had tried to avoid.
Consequently, Richter went to some lengths to play down its importance: "I don't create blurs.
Blurring is not the most important thing, nor is it an identity tag for my pictures."[97] How-
ever, even if he was unsuccessful in convincing people of this, they could not help but notice
that the methodical, even mechanical, way he achieved this effect was the antithesis of the
forceful and heartfelt expressionist gesture that declares itself and proclaims the painter's
involvement. In fact, for Richter, this indirect way of working back into a partially painted pic-
ture served to eliminate lesser details without any editorial judgment being made, to elide
forms and ease transitions, unifying the surface in a more-or-less even spread of pigment and
sealing the whole image under a skin that gave it the look of something "technological, smooth
and perfect"—like a photograph.[98]

The variety of blurrings, or unpainting techniques, Richter deploys is actually con-
siderable. In some pictures, in *Horst and His Dog*, for example, or *Small Nude* of 1967, the
results are of an exquisite refinement, in others, such as *Student* and, even more so, *Olympia*
of 1967 they are comparatively broad or loose. In *Cathedral Square, Milan*, meanwhile,
the blurring present from the start of the process is made up of complex patterns of repet-
itive strokes, which, fitted together, give off a destabilizing shimmer. By contrast, in oth-
ers, such as *Townscape Madrid*, the overall slightly out-of-focus impression of the image
is arrived at by the application of boldly contrasting but abbreviated strokes none of which
was later modified by the swipe of a wider brush or tool. Thus, for all the emphasis that
can and has been placed on the homogenized appearance of particular paintings, the truth
is that the painterly license he spurned when it was granted only on the condition that it
be used to evoke specific kinds of strong emotion, Richter reissued to himself when the
same viscosities and frictions, the same drawing, scumbling, erasing, wiping, blending,
smearing, and reworking of the surface were harnessed to the detached realization of an
apparently generic image. Within those self-imposed limits however, Richter came into his
full powers as a virtuoso in oils.

Although Richter painted several monochrome canvases in blue, green, magenta, and
other tints, most of his early paintings were gray. Of his decision to work in grisaille, Richter
has said: "It makes no statement whatever; it evokes neither feelings nor associations: it is
really neither visible or invisible. . . . It has the capacity that no other color has, to make
'nothing' visible. To me, gray is the welcome and only possible equivalent for indifference,
noncommitment, absence of opinion, absence of shape."[99] "But," he was quick to add, "gray,
like formlessness and the rest, can be real only as an idea. . . . The painting is then a mix-
ture of gray as a fiction and gray as a visible, designated area of color."[100] Of course, full
color entered into the equation from the start in his paintings such as *Mouth* and *Egyptian*

ROBERT STORR

Landscape, but it was color without vitality or atmosphere, the washed out, artificial color of magazine reproductions and faded snapshots. Instead of creating the illusion that the thing represented and its environs are within our reach, such color made them seem doubly remote. Gray does this even more insistently. Moreover, in the aesthetic context of the time, where vibrant color was the common currency of expressionism, depleted color or the colorless colors of the tonal spectrum operate as a rhetorical rejoinder, which is to say they retain an expressive function by announcing their expressionlessness. For an artist eager to portray himself as "inconsistent, noncommittal, passive," gray strongly recommended itself. As is true of the variousness of Richter's paint handling, so too his palette of grays is surprisingly wide in scope and subtly calibrated, from blueish, purpleish, and earthen tints to untinted shades that span the black-to-white scale, from dense shiny anthracites to pale dry eggshell tones.

The limited vocabulary of critical discourse tends to betray such perceptual distinctions, and the consequences have seriously affected the ability of many observers to see what Richter has really done. For those whom the artist tried to address when he denied that the blurring or his use of gray were an "identity tag for my pictures," the problem is a fairly straightforward, but in the long run probably insurmountable, one of getting people accustomed to looking at a painting only for so long as it takes to register its stylistic hallmarks to spend more time with a work, and thus become aware of the formal nuances that loosen the constraints of style. [101] But those inclined to forget that "gray, like formlessness and rest, can be real only as an idea," that is, can exist absolutely only at the level of abstraction, must nevertheless come to terms with qualifications that "gray as a visible designated area of color," lends to such an abstraction. In the history of modern art, the ambiguities embodied in the painterly cancellation or obscuring of the image and in the transformation of full natural hues into unnatural twilight tones range as greatly as differences between the intentions and the technical modes of execution of Alberto Giacometti and Jasper Johns. What can be said about each of them conceptually or philosophically is worth saying, but what the paintings themselves tell us one by one amplifies, rather than tidies up, the ambiguities that prompted the artist to make them. No matter how persuasive the generalizations applied to his work can be, Richter has further complicated the already complex traditions into which he projected his own contradictions and his own painterly solutions.

256 Colors [256 Farben]. 1974.
Synthetic polymer paint on
canvas, 7' 3" × 14' 5" (221 ×
439.5 cm). GR 352-2. Private
collection, San Francisco

Shadow Painting [Schattenbild].
1968. Oil on canvas, 26⅜ × 34¼"
(67 × 87 cm). GR 209-8.
Museum of Contemporary Art,
Pôrto, Portugal. Serralves
Foundation Collection

Opposite, bottom: **Gray Streaks
[Grauschlieren].** 1968. Oil on
canvas, 6' 6¾" × 6' 6¾" (200 ×
200 cm). GR 192-1. Private
collection

ROBERT STORR

Seascape (Cloudy) [Seestück (bewölkt)]. 1969. Oil on canvas, 6'6¾" × 6'6¾" (200 × 200 cm). GR 239-1. Private collection, Berlin

Red-Blue-Yellow [Rot-Blau-Gelb]. 1972. Oil on canvas, 59¹⁄₁₆ × 59¹⁄₁₆" (150 × 150 cm). GR 330. Di Bennardo Collection

ROBERT STORR

Seascape (Sea-Sea) [Seestück (See-See)]. 1970. Oil on canvas, 6'6¾" × 6'6¾" (200 × 200 cm). GR 244.
Staatliche Museen zu Berlin, Preußischer Kulturbesitz, Nationalgalerie, Berlin

Un-Painting (Gray) [Vermalung (grau)]. 1972. Oil on canvas, 6'6¾" × 6'6¾" (200 × 200 cm) GR 326-4
Jung Collection

Detail (Brown) [Ausschnitt (braun)]. 1970. Oil on canvas, 53³⁄₁₆ × 59¹⁄₁₆" (135 × 150 cm). GR 271. Museum Folkwang, Essen

Eagle [Adler]. 1972. Oil on canvas, 27⁹⁄₁₆ × 19¹¹⁄₁₆" (70 × 50 cm). GR 322-1. Private collection

Two Sculptures for a Room by Palermo [Zwei Skulpturen für einen Raum von Palermo]. 1971. Cast bronze, gray paint, and marble; two parts, each, 68 ¼ × 8 ⅛ × 10 ¼" (173.4 × 20.6 × 26 cm). GR 297-3. Private collection

48 Portraits. 1971–72. Oil on canvas; 48 paintings, each, 27⁹⁄₁₆ × 21¹¹⁄₁₆" (70 × 55 cm). GR 324-1 through 324-48. Museum Ludwig, Cologne.

1. Mihail Sadoveanu, 1880–1961. 2. José Ortega y Gasset, 1883–1955. 3. Otto Schmeil, 1860–1943. 4. Gustav Mahler, 1860–1911. 5. William James, 1842–1910. 6. Arrigo Boito, 1842–1918. 7. Jean Sibelius, 1865–1957. 8. Igor Stravinsky, 1882–1971. 9. Hans Pfitzner, 1869–1949. 10. Pyotr Ilich Tchaikovsky,

ROBERT STORR

1840–1893. 11. Frédéric Joliot, 1900–1958. 12. Herbert George Wells, 1866–1946. 13. James Chadwick, 1891–1974. 14. Alfredo Casella, 1883–1947. 15. Max Planck, 1858–1947. 16. Paul Adrien Maurice Dirac, 1902–1984. 17. James Franck, 1882–1964. 18. Paul Claudel, 1868–1955. 19. Manuel de Falla, 1876–1946. 20. Nicolai Hartmann, 1882–1950. 21. Paul Valéry, 1871–1945. 22. Thomas Mann, 1875–1955. 23. Enrico Fermi, 1901–1954. 24. John Dos Passos, 1896–1970.

25. Alfred Mombert, 1872–1942. 26. Patrick Maynard Stuart Blackett, 1897–1974. 27. Bjørnstjerne Bjørnson, 1832–1910. 28. Franz Kafka, 1883–1924. 29. Giacomo Puccini, 1858–1924. 30. Louis Victor de Broglie, 1892–1987. 31. Saint-John Perse, 1887–1975. 32. Graham Greene, 1904–1991. 33. Paul Hindemith, 1895–1963. 34. Alfred Adler, 1870–1937. 35. Albert Einstein, 1879–1955. 36. Hugo von Hofmannsthal,

ROBERT STORR

1874–1929. 37. Wilhelm Dilthey, 1833–1911. 38. Émile Verhaeren, 1855–1916. 39. Isidor Isaac Rabi, 1898–1988. 40. Oscar Wilde, 1854–1900. 41. François Mauriac, 1885–1970. 42. Anton Bruckner, 1824–1896. 43. Rainer Maria Rilke, 1875–1926. 44. William Somerset Maugham, 1874–1965. 45. Karl Manne Siegbahn, 1886–1978. 46. André Gide, 1869–1951. 47. Anton Webern, 1883–1945. 48. Rudolf Borchardt, 1877–1945.

Annunciation after Titian [Verkündigung nach Tizian]. 1973. Oil on linen, 49⅜" × 6'6⅞" (125.4 × 200.3 cm). GR 343-1. Hirshhorn Museum and Sculpture Garden, Smithsonian Institution, Washington, D.C. Joseph H. Hirshhorn Purchase Fund, 1994

Betty. 1977. Oil on panel, 11¹³⁄₁₆ × 15¾" (30 × 40 cm). GR 425-4. Private collection

ROBERT STORR

Abstract Picture [Abstraktes Bild]. 1976. Oil on canvas, 25⅞ × 23¾" (65 × 60.5 cm). GR 398-1. Courtesy Barbara Mathes Gallery, New York

Abstract Picture [Abstraktes Bild]. 1977. Oil on canvas, 7'4⅝" × 6'6¾" (225.1 × 200.5 cm). GR 417. Art Gallery of Ontario, Toronto. Purchase, 1980

Clouds [Wolken]. 1982. Oil on canvas; two parts, overall, 6'7" × 8'6⅝" (200.7 × 260.7 cm). GR 514-1. The Museum of Modern Art, New York. Acquired through the James Thrall Soby Bequest and purchase

Barn [Scheune]. 1984. Oil on canvas, 37⁷⁄₁₆ × 39⅜" (95 × 100 cm). GR 550-1. Courtesy Massimo Martino Fine Arts and Projects, Mendrisio, Switzerland

Marian. 1983. Oil on canvas, 6'6¾" × 6'6¾" (200 × 200 cm). GR 544-2. Collection Maria Rosa Sandretto

Meadowland [Wiesental]. 1985. Oil on canvas, 35⅝ × 37½" (90.5 × 94.9 cm). GR 572-4. The Museum of Modern Art, New York. Blanchette Rockefeller, Betsy Babcock, and Mrs. Elizabeth Bliss Parkinson Funds, 1985

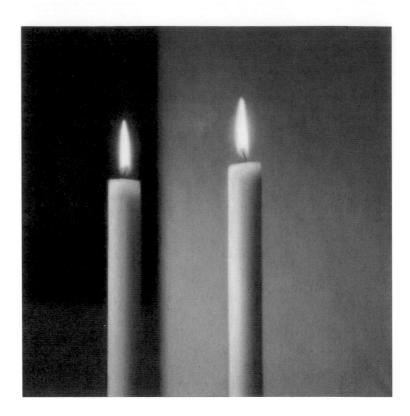

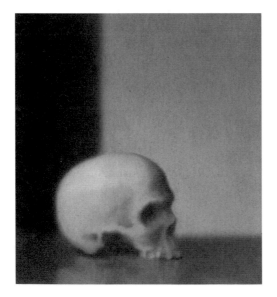

Two Candles [Zwei Kerzen].
1982. Oil on canvas, 55 ⅛ × 55 ⅛"
(140 × 140 cm). GR 512-2.
Collection Lise Spiegel Wilks

Skull [Schädel]. 1983. Oil on can-
vas, 21 ¹¹⁄₁₆ × 19 ¹¹⁄₁₆" (55 × 50 cm).
GR 548-1. Private collection

ROBERT STORR

Betty. 1988. Oil on canvas, 40⅛ × 23⅜" (101.9 × 59.4 cm). GR 663-5. The Saint Louis Art Museum. Funds given by Mr. and Mrs. R. Crosby Kemper, Jr., through the Crosby Kemper Foundation, Arthur and Helen Baer Charitable Foundation, Mr. and Mrs. Van-Lear Black III, Mr. John Weil, Mr. and Mrs. Gary Wolff, Senator and Mrs. Thomas F. Eagleton; Museum Purchase, Dr. and Mrs. Harold Joseph, and Mrs. Edward Mallinckrodt, by exchange

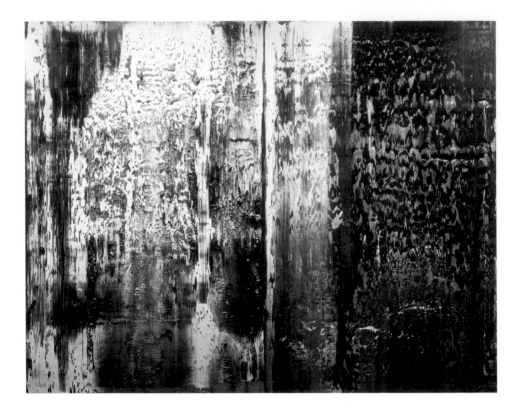

January [Januar]. 1989. Oil on canvas; two parts, overall, 10'6" × 13'1½" (320 × 400 cm). GR 699. The Saint Louis Art Museum. Funds given by Mr. and Mrs. James E. Schneithorst, Mrs. Henry L. Freund and the Henry L. and Natalie Edison Freund Charitable Trust; and Alice P. Francis, by exchange

December [Dezember]. 1989. Oil on canvas; two parts, overall, 10'6" × 13'1½" (320 × 400 cm). GR 700. The Saint Louis Art Museum. Funds given by Mr. and Mrs. Donald L. Bryant, Jr., Mrs. Francis A. Mesker, George and Aurelia Schlapp, Mr. and Mrs. John E. Simon, and the Estate of Mrs. Edith Rabushka in memory of Hyman and Edith Rabushka, by exchange

November. 1989. Oil on canvas; two parts, overall, 10'6" × 13'1½" (320 × 400 cm). GR 701. The Saint Louis Art Museum. Funds given by Dr. and Mrs. Alvin R. Frank and the Pulitzer Publishing Foundation

ROBERT STORR

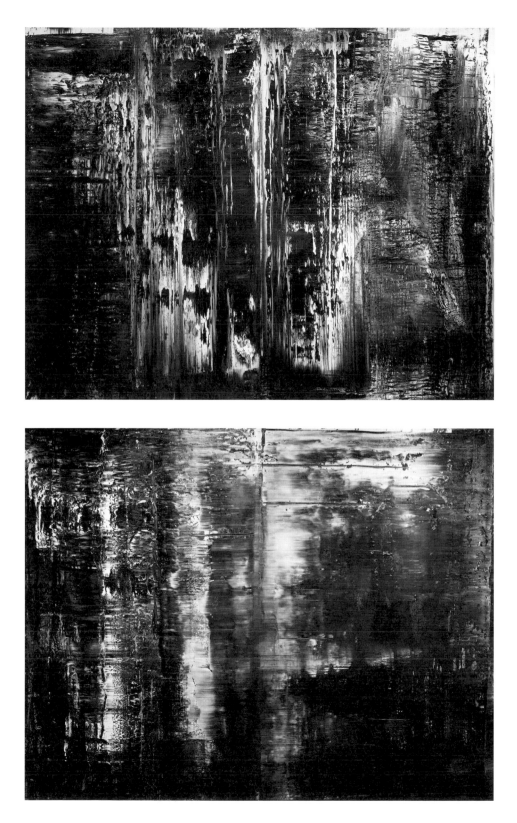

II: OPENINGS AND CULS DE SAC

Art historians write, for the most part, with the benefit of hindsight. Basically, they are encouraged by the commonplace predicates of retrospection to think that things turn out the way they did because they had to. Otherwise, of course, they would have turned out differently. This tendency to align all the facts with the outcome—and to choose which ones matter and which do not accordingly—is compounded if the writer is operating from a theoretical model that says, This is how things should have happened. In such a case, he or she will choose not just the facts that suit the end of the story, but the artist who fits the preconception of what the story should be and how it should conclude. In this context, *modernism* is an empty category, which competing schools of thought have sought to fill. It is an idea awaiting substance but one that, if the various contenders are accepted on their own terms, cannot accommodate all the proposals for what its substance should be. Or, if modernism is understood as a construct that does indeed encompass all of these mutually exclusive hypotheses, then it is understood on the condition that modernism is and always has been the name for a certain class of assertions and arguments about the aesthetic, political, social, and cultural content of modernity.

"WE MUST BE ESPECIALLY WARY OF THE PRESENT INSUFFERABLE TENDENCY TO DRAG OUT AT EVERY SLIGHTEST OPPORTUNITY THE CONCEPT OF IDEOLOGY. FOR IDEOLOGY IS UNTRUTH— FALSE CONSCIOUSNESS, A LIE. IT MANIFESTS ITSELF IN THE FAIL- URE OF ART WORKS, IN THEIR OWN INTRINSIC FALSEHOOD, AND CAN BE UNCOVERED BY CRITICISM. . . . THE GREATNESS OF WORKS OF ART LIES SOLELY IN THEIR POWER TO LET THOSE THINGS BE HEARD WHICH IDEOLOGY CONCEALS."

—Theodor Adorno [1]

Some artists have participated directly in these debates by offering their own predictions or models for how society and art ought to or must inevitably develop. These teleologically minded practitioners have reinforced the tendency of like-minded critics to treat all art as if it explicitly or implicitly foresaw an ultimate goal, a definitive statement of the way things will be in the future. When events fail to follow the prescribed course then the fall-back position is that a misunderstanding or mistake has detoured history from its true path or, worse, that some monolithic negative force has steered humankind away from its proper destiny. In the first decades of the twentieth century, manifesto-driven art of this kind was rife, and ideological forms of criticism that spoke in the name of modernism grew out of it. Such criticism survives today long after the vanguards it championed have ceased to produce innovative work. Postmodernism in art and postmodernism in criticism, to the extent that they exist at all as currents outside of modernism's ongoing debate about what modern culture will be, are all too frequently exercises in nostalgia or Monday-morning quarterbacking, and often both. Between reactionary postmodernism (with its dreams of restoring the old aesthetic order by dressing art up in thrift-store styles retailed for the carriage trade) and radical postmodernism (refighting battles lost and revolutions gone wrong in an attempt to stave off full recognition of the dangers and futility of apocalyptic or utopian thinking) stretches an almost unbreakable chain of conservative assumptions and emotions. Reactionaries want the past back; aging vanguardists guardedly

ROBERT STORR

extrapolating from history want a present and future consistent with the past, as they have conceived it.

The position of most artists is different from that of critics, even for those artists given to concocting their own theories. For them, possibility takes precedence over reasoned necessity. For artists who must start over each day without any assurance that the success or failure of the previous day's work will reliably indicate what comes next, possibility is the product of intuition, trial and error, and an instinctive trust in the voice that says Yes or No to each option that presents itself. This voice does not address art in general, but the artist in that moment of decision. Against this tentative sense of what can be done stands the constant threat of options suddenly being closed. This may happen as a result of misuse by others or of a restrictive codification of formerly productive uses, or it may be the consequence of the artist having used them well but, at the same time, having temporarily exhausted the freedom of maneuver they initially afforded. But while aesthetic prognosticators are prone to declaring certain artistic practices obsolete based on their waning power in a given period, artists, whatever their public positions might be, seldom write off any possibility once and for all. On the contrary, the ability to see fresh opportunity in neglected or abandoned models is one of the basic ingredients of innovation. No serious artist downs his or her tools because historians and critics have deduced that nothing remains to be done; instead that he or she may pick them up to probe for previously ignored openings. Moreover, such practitioners know that inasmuch as the value of any chosen convention cannot be disproven logically, neither can it be proven; the only thing that finally matters is whether its imaginative potential can be shown and whether the works it engenders supersede the paradigm and assume a life of their own.

The drama of Gerhard Richter's artistic life has consisted of repeated encounters with totalizing systems of thought that dictated how he should conduct himself and what his painting should be. First, these ideological mandates were issued by authoritarian political regimes. By the time he had achieved art-world recognition in the late 1960s, they issued from the avant-garde in whose midst he had landed. Those pressures have yet to abate, but insofar as they have sometimes exacerbated his deep-seated doubts and made it hard for him to proceed, his responses to them—from direct defiance and verbal dodging and weaving to transforming the tension they generate into a source of energy—have had a profound impact on the outward appearance and inner dynamics of his work.

Between 1962, when Richter was still a student at the Düsseldorf academy and painted his first mature paintings, and 1971, when he was appointed to the academy faculty in recognition of the place he had carved out for himself in the burgeoning German art scene, much changed. By the mid-1960s Pop art and neo-Dada had ceded their positions on the cutting edge to Minimal, Process, and Conceptual art. When, in 1967, the painter Konrad Lueg became the dealer Konrad Fischer, the artist whose work he selected to open his gallery was the American sculptor Carl Andre. The choice was indicative of the new temper of the times. The year before, Alfred Schmela—who in 1964 hosted Richter's first one-man show in Düsseldorf, closely followed by another mounted by Heiner Friedrich in Munich—had temporarily closed his doors. To mark the occasion, Schmela gave each of his artists a one-day one-man exhibition; for his, Richter made an installation "honoring" one Volker Bradke. It consisted of wallpaper with Bradke's name emblazoned on it, a portrait banner, a pointedly large portrait canvas of a person Richter remembers as a nondescript "small-time" art-world hanger-on, and a fifteen-minute black-and-white film in which the images were blurred.[2] Meanwhile, the two-year contract Richter had signed in 1963 with Heiner Friedrich,

ensuring his basic living expenses, had expired. Friedrich continued to exhibit his work until 1974, but like Fischer, who did not show Richter until 1970, he was drawn into the orbit of the new reductive art. For several years before securing his professorship at the academy, Richter taught in secondary school to make ends meet. Although he was a recognized member of his generation of artists, the market for contemporary German painting was still small.

For his own part, Richter felt more at home with much of this new work than he did with that of other painters then on the rise, for example Georg Baselitz, another East German come to the West, whose meaty figurative works of early 1962–63, and Hero paintings of 1965–66 were harbingers of neo-Expressionism. Although they would eventually exhibit together in 1981, in an attempt to reconcile warring camps in the German art world, nothing could have been further from Richter's sensibility or way of thinking than Baselitz's and Eugen Schönebeck's intentionally scandalous "First Pandemonium Manifesto": "We have blasphemy on our side. . . . In my eyes can be seen the altar of Nature. In me the brewers of poison, the annihilators, the degenerates have attained a place of honor. Euphoria deep-ends abysses."[3] Richter had a greater affinity with the rigor and reserve of Andre, Walter de Maria, Dan Flavin, Sol LeWitt, Bruce Nauman, Robert Ryman, and Lawrence Weiner. With the exception of de Maria, all of these American artists showed sooner or later at Fischer's gallery. Feeling once again as if he were on the outside looking in, as he had been when he and Polke first met—and all the more so because the worldly third member of their group, Fischer, was responsible for bringing these internationally renowned exponents of Minimalism and Conceptualism to Düsseldorf—Richter appreciated the willingness of some of these artists to meet their local counterparts. Recalling the opening of Andre's show, Richter said: "I was sitting with Polke and Palermo, apart from the main group, and Carl came to our table and said 'Hello, I'm Carl.' And I thought this is a good artist, this is a nice guy."[4]

Richter's and Polke's most intense collaboration occurred in 1966–68. This first manifested itself in the joint exhibition at Galerie h, Hannover, in 1966, which was also the first major presentation of Polke's works. There were photographs of the two painters clowning around; their 1968 print, *Hotel Diana*, showing Richter and Polke in separate beds in a shared room, and another, *Transformation*, in which a mountain mutates into a moonlike ball. There was also a sardonic mock interview with Richter by Polke from 1964, which gives insight into their relationship; it was based, in some measure, at least, on the stigma attached to being a German artist in the postwar era, the alienation from mainstream art they both felt, and the taboos they dared each other to break. Responding to a question about his work from his interlocutor, Mr. Thwaites (Polke), the character representing Richter is quoted as saying: "And if you saw my new pictures, Mr. Thwaites, you would collapse! . . . Because they are so good! You've never seen such good pictures in your life, No one has ever seen such good pictures, and I can't show them because everyone would collapse. So in the first place I hung clothes over all the pictures, and then in due course I overpainted them all white. And now I don't paint anymore, because I don't want to have the whole human race on my conscience. It was more interesting earlier on, when the big death camps in Eastern Europe were using my pictures. The inmates used to drop dead at first sight. Those were still simple pictures, too. Anyone who survived the first show was killed off by a slightly better picture. I haven't done at lot [of drawings]. Buchenwald and Dachau had two each, and Bergen-Belsen had one. Those were mostly used for torture purposes."[5] Thwaites then asks: "And the Russians?" Richter replies: "Stalin mounted his reign

of terror with two pictures. After killing millions of Russians, it is said that he caught an accidental glimpse of one of your pictures, just for a fraction of a second, and immediately dropped dead."[6]

Although the words are not Richter's own, the inclusion of this text in his collected writings lays at least partial claim to the sentiments they express. It would be difficult to come up with a more perverse way of explaining Richter's reasons for blurring or painting over his pictures. Nevertheless, this exchange offers a glimpse of the anxiety and bravado with which both artists approached their work and the world.

Less extreme, but similarly satiric qualities appear in the explanatory note for *Transformation:* "The mountain was transformed into a ball on April 26, 1968, for a period of two hours. Well aware that the power of the picture is no greater than the faith that moves mountains, the artists conceal the misery of their never ending powerlessness by imagining a temporary dematerialization, as if to say, at long last reality did us the favor of excelling itself."[7] The collaborative work had been intended as a lampoon of the much-touted Conceptualist dematerialization of art and, simultaneously, according to Jürgen Harten, as a send-up of the euphoria of the "revolutionary" year, 1968. By that time, longstanding tensions arising out of student unrest over the war in Vietnam, the conservatism of government policy generally, and of the educational system in particular erupted into confrontations between the authorities and the young across Germany, elsewhere in Europe, the Americas, and in Japan. It was the simultaneous collapse of the old independent socialist, labor, and antiwar coalitions, and the hardening of the traditional Right that lay the groundwork for this crisis, which produced the new Left. This, in turn, gave rise to armed bands of militants, such as the Baader-Meinhof group, and the hard-line response of officials. That polarization precipitated Joseph Beuys's full transition from an aesthetic agitator to an activist for all seasons. In 1968 he declared that art *was* life and, in the spirit of that declaration, stepped up the campaign to turn the academy into a laboratory for testing his utopian theory of "social sculpture."

Richter's and Polke's skepticism toward such fantastic notions of global change is apparent in *Transformation,* and although Beuys loomed ever larger on the national and international scene from this time onward, both kept their distance from his anarchic mystical proselytizing. As a refugee from the Communist German Democratic Republic, Richter felt even less sympathy for the political radicals who began to influence discourse in the art world and academic circles around the same time: "I had a big shock coming to West Germany and finding that every intelligent person was on the Left."[8] Richter can be quite caustic on the subject of dogmatic Leftism, and he became more rather than less so as the Soviet bloc fell apart and whatever threat orthodox Communism had posed all but vanished. In notes to himself of 1992, when *October 18, 1977* (1988) was still a topic of intense debate (pages 188–197), Richter wrote: "Because Marxist intellectuals refuse to own up to their own disillusionment, it transforms itself into a craving for revenge. And so they turn their own ideological bankruptcy into the utter bankruptcy of the whole world—mainly the capitalist world, of course, which they vilify and poison in their hatred and despair."[9] However, Richter was neither inclined to starry-eyed views of Western-style free-market democracy, nor had he been tempted by doctrinaire anticommunism. Instead, he has been the odd man out between two opposing ideological forces, and while crucial friendships were sealed with the "intelligent" people on the Left, he remained in fundamental, sometimes anguished, disagreement with them on basic political and artistic questions.

Well before these changes in his immediate situation and the convulsions in the culture at large, Richter had been trying out new ways to make a picture. In 1965, he made a

series of five paintings of rippling curtains, and one installation work on the same motif consisting of freestanding cylinders on which were brushed the same gradations of gray that gave volumes to the folds in the paintings. They were the first of his mature works that did not have a specific photographic source. In 1967 he experimented in much the same way with the related theme of rows of doors open or ajar in which one-to-one scale representation and schematic formatting competed. The largest of his curtain paintings also dates from that year, as do two polyptychs of corrugated metal in which he used the simple technique of shading to suggest low relief in what are nevertheless essentially abstract, almost Op-art, compositions.

Also in 1967 Richter created *4 Panes of Glass,* a sculptural installation in which four vertical sheets of glass framed in metal swing on a central axis between four floor-to-ceiling poles. Unique in his oeuvre, the piece is a precursor of subsequent paintings on glass and framed mirrors. In one respect, this work is a deft critique of the truthfulness of realist painting, insofar as what one sees behind the glass is not a representation but reality itself. At the same time, however, it stands as a backward compliment to painting, since, as Richter explained it, looking through the glass the viewer is able to "see everything but grasp nothing," although it must be conceded that Richter's paintings often hold the image so tenuously that in the end it escapes our grasp as well.[10] In his later mirrored paintings on glass, the problem is given a tautological twist in the sense that the subject of the image is a reflection of the subject who looks, and that subject is in a position to recompose the picture by moving or by shifting the focus of his or her eyes. This annexation of ambient space has a precedent in Michelangelo Pistoletto's work, beginning in 1962, in which the Italian artist painted life-size Photo-Realist figures on mirrors and polished steel. Richter, in effect, removed the depictive element and therefore the obvious conflict between illusion and reality, leaving only the literal but contingent likeness of the person standing in front of the mirror. In that respect, he turned the tables on painting yet again, intending this visual trap as a "polemic: devaluing of all other pictures; [a] provocation of the viewer, who sees himself instead of a picture."[11] Rather than gratify the viewer's desire to see something artful, fixed, and pictorially complete, he provided a void for the viewer to fill in however he or she could.

On the other hand, in *Gray Mirror* of 1992 (page 123) the reflective surface of the tinted glass is split in two, and the separate halves are hinged so that they can be rotated. When the paired panels are turned toward each other they double the image of the spectator, and when they face away from each other the spectator, in effect, disappears into the crack between them and sees only the surrounding room. Thus Richter creates a revolving-door effect in which the absence of the painted image one expects to see when approaching the work from a distance perceptually and psychologically alternates with the narcissistic presence of a self-image, but one which, with a simple repositioning of the mirrors, may vanish into a smoky gray void. Like the Curtains and Doors that preceded them, and the window paintings that follow, *4 Panes of Glass* and the mirrors that came after them play with the idea of the relation between the architecturally or structurally implied figure and the actual perceiving body. All have a disquieting emptiness or, in the case of the curtains, a hidden quality; and all pose oblique unresolvable questions about the limits of human perception or apperception. Looking back on them in 1971, Richter wrote: "Perhaps the Doors, Curtains, Surface Pictures, Panes of Glass, etc. are metaphors of despair, prompted by the dilemma that our sense of sight causes us to apprehend things, but at the same time restricts and partly precludes our apprehension of reality."[12] It is a common

Gerhard Richter. **4 Panes of Glass [4 Glasscheiben].** 1967. Glass and steel, each, 6'2¹³⁄₁₆" × 39⅜" (190 × 100 cm). GR 160. Collection Anton Herbert

trick of traditional painters to check for distortions in their work by looking at it in a mirror trained over their shoulder. Richter's use of mirrors amounts to something close to this; however, his aim was not to eliminate distortions but to draw attention to them and to the discrepancy between what one sees firsthand and what happens to that image when it is re-created pictorially. Not that Richter privileged the real over its representation; to the contrary, his whole enterprise is intended to undermine the belief that we have direct access to truth by any means: "I don't mistrust reality, of which I know next to nothing. I mistrust the picture of reality conveyed to us by our senses, which is imperfect and circumscribed. Our eyes have evolved for survival purposes. The fact that they can also see the stars is pure accident."[13]

As much as *4 Panes of Glass* posed a challenge to painting, it was also a shot across the bow of neo-Dada. Comparisons between Richter's spare sculptural ensemble and Marcel Duchamp's intricately etched, inlaid, and symbolically encoded *The Bride Stripped Bare by Her Bachelors, Even* (the *Large Glass*) of 1915–23 came quickly after the work was shown in Heiner Friedrich's Cologne gallery. Richter seems to have courted the association only in order to push off from it: "Something in Duchamp didn't suit me—all that mystery-mongering—that's why I painted those simple glass panes and showed the whole windowpane problem in a completely different light."[14] He reinforced this in his comments to Benjamin Buchloh: "I can say that my *Panes of Glass*, like the *Nude on the Stairs*, involve something of an anti-Duchamp attitude, because they are so plain and deliberately uncomplicated."[15]

Inspired and irritated by Duchampian conceptualism, Richter felt a corresponding ambivalence toward the neo-Platonic aspects of Minimalism. Adopting the supposed pure conventions of the grid, he made a series of pictures that, for the most part, resemble window frames with cast shadows. In some instances, the positive white of the frame, which optically advances, is in actuality the primed canvas, while the negative space behind the frame and the offset fretwork of the frame's shadow are layered between these unpainted bars. In *Shadow Painting* of 1968 (page 64) Richter blocked in heavy seams and rectangles of pigment, but the pictorial pun is the same. Reductive as they may at first appear, by virtue of their tonal shifts and structural overlaps, such paintings retain their representational aspect, wreaking havoc both on the Renaissance notion of painting as being a window on the world—in the case of Richter's work, it is a window on a window on nothing—and on the high formalist pursuit of a type of painting detached from any referent outside itself. Pushing the point still further, Richter addressed himself to Frank Stella, whose adamantly

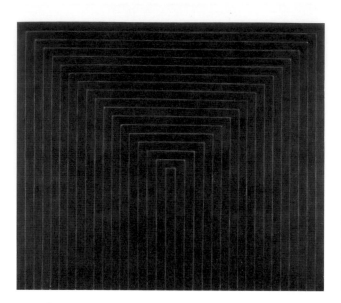

Frank Stella. **Getty Tomb (first version).** 1959. Enamel on canvas, 6 × 8' (213.4 × 243.84 cm). Los Angeles County Museum of Art, Contemporary Art Council Fund

anti-illusionistic Black Paintings had been based on the positivist axiom, "What you see is what you see."[16] Richter, of course, had no such faith in the self-evidence of visual phenomena. Appropriating one of the nested arch forms found in such works by Stella as *Getty Tomb* and *The Marriage of Reason and Squalor* (1959), he bled the contrasts of black enamel and white canvas out of it and gave the gray result a vertiginous wobble, as if Stella had been dizzyingly reinterpreted by Bridget Riley.

Of all Richter's redepartures in the uncertain interval of the mid- to late 1960s, the one that produced the largest number of paintings over the longest period of time was his Color Charts. Once again, it would seem, he had modernist precedents in the back of his mind: the abstract work of the Bauhaus color theorist Josef Albers (for whom he professed little regard), the Constructivist tradition of the 1920s and 1930s, postwar neo-Constructivists such as Max Bill and Richard Paul Lohse, the monochrome canvases by Yves Klein, the high-polish planks and boxes of California sculptor John McCracken, and the striped paintings and installation pieces of the conceptually oriented French artist Daniel Buren. It appears, however, that Richter was unaware of the randomly arranged color-swatch paintings made by Ellsworth Kelly between 1951 and 1953, or that artist's spectrum panels of 1968 and after; nor was he consciously responding to the color bars that were a feature of Jim Dine's work in 1963–64 and of Jasper Johns's in 1964–65.

If Richter's approach closely corresponded to that of any of his contemporaries, it was to Sol LeWitt's, not so much in the sense that his paintings resembled LeWitt's work but, rather, in the manner in which they parallel LeWitt's use of systems to discipline sensibility, preempt taste, and sublimate the artist's drive to assert himself. Although LeWitt published his seminal essay "Sentences on Conceptual Art" in 1970, five years after Richter embarked on the Color Charts, one can profitably read them for insights into Richter's own working premises. LeWitt wrote: "The artist's will is secondary to the process he initiates from idea to completion. . . . His willfulness may only be ego. . . . The process is mechanical and should not be tampered with. It should run its course."[17] Even more thought-provoking in this context, however, are the first three sentences, which are rearranged here to form an aesthetic syllogism: "3. Rational judgements repeat rational judgements. 2. Irrational judgments lead to new experience. 1. Conceptual artists are mystics rather than rational-

ists. They leap to conclusions that logic cannot reach."[18] By this definition, Richter was and is a Conceptual artist not merely by virtue of method, but by poetic aspiration.

Color Charts preoccupied Richter three times during this period, beginning in 1966, then again in 1971, and finally in 1973–74. At first he approached the problem much as he had the use of photographs—by reproducing a standard commercial paint sample card on a vastly enlarged scale. Circumventing spiritual notions of color as epitomized by Vasily Kandinsky's theories and the more scientific methods of Albers and the Constructivists, Richter's new use of the ready-made also set aside the issue of composition, and contained and suppressed gesture in favor of a blandly impersonal facture, even more so than in his photo-based paintings.

Executed in glossy pigments, each rectangular element had sharp, taped edges and each was filled with a consistently blended hue. Of the eighteen works in the 1966 group, there are three gray-scale paintings, two large-format pictures composed of only six color blocks, and the rest are made up of at least nine color squares and at most of one hundred tinted bands. Of the large pictures, the first is all shades of yellow, and the second, *Six Colors*, includes the three primaries plus a muted green, brown, and pale tan. The 1971 group consists of only five large works, four of them the same size with the same 180 units fitted into a white grid, and the fifth a mural-scale work made up of twenty sections with nine color units each. This time Richter abandoned the sampler as a pretext, along with the improvised changes he had rung on that formal given, and replaced them with a mathematical system for mixing the three primary colors in graduated amounts so as to dramatically expand the number of combinations and refine the distinctions among them.

Taking that system to extremes in the Color Charts of 1973–74, Richter added a fourth, fifth, and sixth component—a light gray, a dark gray, and later a green—and multiplied the admixtures exponentially while arriving at chromatic nuances that were at times nearly impossible to differentiate from each other. In his final burst of activity in this mode, Richter further sublimated his hands-on involvement as a painter by hiring assistants to participate directly in the process. The twenty-six canvases that grew out of these technical and procedural adjustments—which in some cases also included the elimination of the white grid—range in size from the 4-color canvas or the 16-color canvas to, in arithmetic progression, the 64-color, the 256-color, the 1,024-color, and finally the 4,096-color canvas. In a text explaining the project, Richter teasingly declared: "If I had painted all the possible permutations, light would have taken more than 400 billion years to travel from the first painting to the last," but what interested him more than this science-fiction speculation was what he described as the paintings' "artificial naturalism."[19]

In light of this comment, it is best perhaps to look at these pictures as the painted equivalent of one of Carl Andre's variegated metal plate carpets—Richter's "idea of a powerfully realistic work"—because like them his painting represents neither a physical nor a metaphysical entity outside itself.[20] The difference, of course, is that no matter how many pieces might conceivably go into their creation, Andre's checkerboards are symmetrically patterned, whereas the arbitrary arrangement of part to part in Richter's paintings distributes his tonally uneven color and chromatic contrasts of adjacent units irregularly across the field. Only the white armature retains a uniform surface tension throughout, and it is optically destabilized where the lines intersect, resulting in a black retinal pop (much like staring at a red spot and then seeing green when your eyes move to an empty space), a phenomenon that, in reverse, first became a factor in Piet Mondrian's modernist black-gridded paintings. However, Mondrian's work was, for the most part, based on pure primary colors plus black and white. By

contrast and in keeping with his general avoidance of absolutes, virtually all of the colors in Richter's paintings of this type are modulated by the traces of others or by grays located in the intervals between black and white. Thus, for example, *256 Colors* of 1974 (pages 64–65) is a feast for the sharply discerning eye, but each of the "flavors" is a melange, and each consists of ingredients whose exact proportions are known to the maker but can only be guessed at by the viewer.

Between the first and second group of Color Charts Richter's work manifested a previously uncharacteristic disparateness; indeed, it is from this time (1966 to 1971) that his habit of tacking from format to format against the main currents of contemporary art really can be dated. Casting about for subjects for his photo-based paintings, he turned to pornography, producing *Student* and *Olympia* of 1967 along the way, as well as his townscape and mountain pictures, among them *Himalaya* of 1968. In the meantime, Richter also painted the Door and Shadow paintings and the last of the Curtains, although in the final analysis, he professed his dislike for these exceptions to the use of ready-made motifs.[21] In the midst of these big projects, he also made four small landscapes based on his own snapshots, three taken on vacation in Corsica, and a fourth, *Bridge (by the Sea)* of 1969. There had been intimations of Richter's affinity for landscape before—for example, *Egyptian Landscape* of 1964, and the mountain paintings and two moonscapes (1968)—but nothing quite like these delicately brushed, overtly picturesque scenes had thus far appeared. They were the seeds of what later was to become a dominant strain in Richter's output.

As modest as these landscape canvases may have seemed, at first glance, they could not have been more provocative. After all, who else in vanguard circles at that time dared to paint a holiday souvenir, much less one so enchanting or with such a picture-postcard allure. From this juncture, Richter had to deflect critics of his new direction from applying the label neoromantic to his work. Some of them, like the dealer René Block, were former supporters hostile to what he was doing, and some were critics who welcomed the new style, often out of a naive desire for the return of romanticism, which Richter had no intention of reviving. Nevertheless, even his opening the door to a reassessment of romanticism offered a serious challenge to the antipictorial, antipainting factions that dominated art discourse in the late 1960s and early 1970s, especially given the fact that Richter's landscapes themselves lacked even a hint of the kind of irony to be found in Morley's crystalline Photo-Realist renderings of tourists and ocean liners. Nor had Richter's *sfumato* been manipulated in the obvious manner of Richard Hamilton's beach scenes, similar as those were to Polke's raster dot pictures. Instead, Richter caused a disturbance by quietly making paintings that resisted every attempt to fit them into existing categories or to explain them away as deliberately insincere exercises in formal and pictorial anachronism.

Part of the difficulty Richter built into these works stems from the fact that *as* pictures they were not anachronisms but, rather, thoroughly contemporary photographically impersonal views of the land, sea, and sky. In some, for example, *Bridge (by the Sea)*, the setting is plain and plainly modern, with the sparest detail in the description of the viaduct, flat countryside, still water, and hazy horizon of nowhere in particular. This feeling of having looked out the window of a car—or airplane—in motion or of having stopped on the road between points of interest is fairly common in Richter's landscapes. It is as if what has caught his attention are the anonymous places where roads are engulfed by nature, but nature, in turn, is implicitly bracketed by the cities, towns, and urban infrastructures the roads connect. No matter how sublime the vista, the highway or the airport are near. That said, the vistas are frequently sweeping. Devoid of any human element—except for

the presence of the viewer—and absent any *repoussoir*, or visual break, in the foreground, the waves in *Seascape (Cloudy)* of 1969 (page 66) advance toward the edge of the canvas as the horizon disappears into a bank of menacing clouds. The subject is potentially melodramatic, but with its off-key prestorm aspect and suave paint handling, the treatment is almost meteorological. Another work, *Cloud* of 1970, part of a triptych, almost dares viewers to project their sentiments onto the image—this time, for example, the hope of transcendental release—but offers nothing in the way of painterly inflection to which such sentiments might attach themselves. These pictures are as beautiful as are their natural subjects and beautiful as painted artifacts, but they withhold any invitation to empathy. Whereas romantic paintings generally meet viewers halfway—usually by means of a surrogate figure in the landscape that intensifies their associations and emotions while offering to lift them out of themselves—Richter's paintings of this type are indifferent to the viewer's needs, acknowledging by that pointed indifference that the viewer and his or her needs exist. Thus they portray natural phenomena without symbolic amplification. In *Seascape (Sea-Sea)* of 1970 (page 67) Richter goes out of his way to denature nature by hinging two images of choppy water to a glowing horizon line, one in its proper position and one inverted above it, so that where the sea meets the sky, the sea meets itself. Seen across the room, it could well be mistaken for a conventional seascape, triggering all the responses customarily experienced in looking at such a sight. But the viewer is brought up short when the calculated artificiality of its symmetry reveals itself, breaking the thrall of reflex awe just as it takes hold. But not entirely, for the desire to lose oneself in the image remains, and the radiant light and the subtly rendered flux of the waves continue to beckon and lull, leaving one caught between the trick question that has been asked and the longed-for answer. If Richter had truly been intent on burning out all the circuits connecting the image to traditional landscape, it would have been sufficient to diagram the reversal upon which it rests. That he went further in order to *evoke* an impossible reality suggests that he had reasons for keeping those circuits in operation.

Interspersed with Richter's landscapes of 1970–71, and recurring on a grand scale in 1973 and 1979, were paintings based on photo-enlargements of brushstrokes or whirling pools of mottled pigment. This is the only case in which the artist's early interest in Roy Lichtenstein's work seems to have had a direct bearing on his own. But whereas Lichtenstein's translation of the Abstract Expressionist gesture into heavy cartoon outlines and static Ben Day dots contradicts the impetuous thrust of the marks depicted, Richter's handling of closeups of similar marks puts them under the microscope and lends them added dazzle predicated on a flat, meticulous, blatantly illusionistic rendering of what in the presumed original was a quick, viscous, physically assertive swipe of paint. Some of these blown-up simulations of the bravura gesture are opulent in color and texture. However, *Detail (Brown)* of 1970 (page 68), for all its disproportionate size, tactility, and succulence is comparatively austere. In essence, it is a one-shot monochrome or, insofar as the horizontal ridges of dead brown suggest a specific correspondence, a giant Manzoni-like "Achrome" with a blush of earth tones. In all of these paintings the actual brushmarks that create the effect are blended away leaving the macrocosm of the image to represent their microcosmic actuality. Over the years Richter has returned to this idea more than once. In 1978, he documented 128 details of the surface of a painting in raking light. The model for the project would seem to have been Man Ray's famous photograph of dust collecting on Duchamp's *Large Glass*, but the resulting black-and-white images published as an artist's book resemble moonscapes or topographical studies of a desert.

Having taken color charts and photo-enlargements as his first two jumping-off points on the way to abstraction, Richter then tried a third, which he called *Inpainting*. The process originated in several paintings of trees and a meadow or park where the verdure is laid in via bundles of relatively thick impasto strokes that obscure the shapes where they run together. Previously, Richter had painted over landscapes with similarly blunt, greasy marks. The Inpaintings themselves consist of thickets of such lines with no apparent image underneath them. Some are in shades of gray, others in shades of shoe-polish brown; the largest of the series is a grid composed of 120 separate panels painted this color. The rest are made of the three primary colors mixed together on the canvas much as children do when finger-painting. And, as anyone knows who has watched a child at work in this way, the pure hues with which the child started soon turn to mud. In the same fashion, Richter's three-into-two-into-one fusions vary from the lustrous Rubens-like skeins of crimson, gold, burnt umber, and burnt sienna in *Red-Blue-Yellow* of 1972 (page 66) to almost sickening combinations of dirty reds, yellows, and blues with greens, grays, and violets in between. Where the clash among the colors is most localized, one is reminded of Johns's mottled and deliberately mislabeled spectrum paintings and in others of the curlicue paint application of some of Robert Ryman's work of 1961–62, but there are no specific debts to them. Rather, the Inpaintings are the often uningratiating, purposely muddled extensions of the clean and orderly Color Charts. They are paintings about painting by an artist aware that the walls were closing in around him.

Richter's arrival at complete abstraction coincided with the almost total eclipse of painting as contemporary art's dominant medium. "I was out of fashion for a long time after the early 1960s work, and painting itself was unfashionable too," he told an interviewer in the 1990s.[22] Elsewhere, he ascribed the decline in painting's importance to the broad cultural tensions of the period: "At the end of the 1960s the art scene underwent its great politicization. Painting was taboo, because it had no 'social relevance' and was therefore a bourgeois thing."[23] The exception to this consensus among advocates of emphatically material Minimal and process sculpture, and of dematerialized Conceptual art was the special status accorded artists such as Alan Charlton, Robert Mangold, Brice Marden, Agnes Martin, and Robert Ryman, most of whom at one time or another showed at Konrad Fischer's gallery and many of whom, along with Richter, were included in the 1975 survey *Fundamental Painting* at the Stedelijk Museum in Amsterdam. Employing the word *fundamental* to describe this type of work is preferable to labels like *reductive* (which presumes that the new art involved boiling down an existing model of painting rather than starting from scratch) or *minimal* (which suggests that the point is "lessness," while also confusing an intuitive approach to painting with systems-based sculpture). But the term *fundamental* still conflated the divergent intentions and achievements of individual artists under a loosely formalist rubric. It lumped together Marden, the precocious exponent of a tradition-minded gesturalism subsumed by the monochrome; Martin, a puritan mystic for whom diluted tonality, and exquisitely imperfect mark-making created a meditational field; and Ryman, an empiricist of delight for whom paint in all its variety opened up new visual territory where only a void has been thought to exist.

Richter fits none of these descriptions, although his first abstract paintings sometimes display skidding surface currents similar to those in Marden's most heavily worked encaustics, and his sensibility has deep affinities with Ryman's dispassionate pursuit of objective beauty. But whereas these two painters—and many others associated with this long-standing tendency—chose categorically nonrepresentational painting, and approached the

problems it posed as an affirmation of painting's essential self-sufficient and open-ended future, Richter backed into abstraction. Initially, it wasn't even his aim to paint monochromes as such. Rather, they seem to have resulted from two discoveries, one positive and the other negative. First came the realization that the transitional intervals in the paintings on which he was working—the zones of ambiguity within or around the image—were of greater importance to him than the image itself. Thus, as early as 1965 he wrote: "All that interests me is the gray areas, the passages and tonal sequences, the pictorial spaces, overlaps and interlockings. If I had any way of abandoning the object as the bearer of this structure, I would immediately start painting abstracts."[24]

Saying this, Richter had already characterized the kind of abstraction toward which he was heading, and it was not the realm of pure formalist painting (clear-cut constructs, consistent gesture, well-defined color, with a preference for black, white, or primary hues) but a murkier painterly dimension where none of the compositional elements of a work fully declares itself, no matter how schematic the design or systematic the paint application might be or how evenly blended the varying shades of gray being used. Richter's second discovery was overpainting or, as he also referred to it, inpainting or un-painting.

As previously mentioned, cancellation plays a large role in postwar art, from the erasures and redrawing of Alberto Giacometti, to the scraping-down and repainting of Willem de Kooning. And as these examples suggest, cancellation has often been a combination of subtraction and addition. Richter's method is basically additive or at least cumulative, the covering up of one layer by another, although this frequently involves the deliberate skinning of a painting's surface with a hard-edge tool, smearing the top coat, and mixing it with the still-moist undercoat, which is kept that way by the liberal use of carnation oil and other mediums that retard drying. In that sense, Richter nearly always paints *a la prima*, or wet into wet, with the result that the sometimes heavily sedimented canvases seem all of a piece because they "cure" slowly, ensuring that the enriched pigment retains a uniform freshness. Thus, even his most subdued gray paintings possess a palpable immediacy that qualifies their austerity and remoteness and, ultimately, their intimations of depression and despair.

The earliest all-gray painting in Richter's oeuvre is a small-format townscape of 1968 in which the usual chiaroscuro contrasts have been reduced to a middle tone that suffuses the whole image, leaving only the brushstrokes to distinguish the shapes of what might be buildings. That same year, Richter painted two more all-gray abstractions, one in which the pasty oil color is stirred by looping marks and another in which similar marks crisscross the rectangle and overlap in the middle, giving the impression that they are all radiating from a common source. The title of one of them, *Gray Beams*, suggests that it is a light source, but the painting absorbs or reflects light rather than emits it, as if it were a gray, rather than black, hole. In 1970 Richter embarked on a suite of four large-scale gray monochromes with fleshy, gestural surfaces, and also painted eleven other gray pictures in different, mostly smaller, formats. Then in 1972–73 he painted a group of still larger gray canvases; those completed in 1972 belonged to his Inpainting series, while the subsequent works were simply titled *Gray*. The next and largest group of gray paintings was made in 1974, and the final group—painted on aluminum and wood panels rather than stretched canvas—was completed in 1976.

Not counting image paintings—townscapes and star pictures—that are almost but not quite abstractions, or the baked-enamel-on-glass mirror paintings, Richter has, to date, painted over one hundred gray monochromes. That is roughly one tenth of his entire production;

and most recently he has gone back to making gray, or nearly gray, abstractions in significant numbers. However, within the larger body of work, the gray monochromes of 1970–76 represent a distinct and critical episode in Richter's development, a period in which he struggled against active hostility to painting on the part of many of those around him and, on his own part, a fear of diminishing returns and the ultimate failure of his own efforts to keep painting going.

Since the first decades of the twentieth century, when Kazimir Malevich created *Composition: White on White* (1918–20), along with his black squares, crosses, and circles (often interpreted as paradigmatic of painting's terminus) and Aleksandr Rodchenko made his triad of monochromes *Pure Red Color, Pure Yellow Color, Pure Blue Color* (1921), shortly thereafter setting easel painting aside for the sake of more radical Constructivist practices, painting had been thought to be nearing the end of its usefulness—or past it. A decade later the Surrealist, soon-to-be Stalinist poet and critic Louis Aragon argued in *Challenge to Painting* (1930) that collage and montage had preempted painting's representational functions as well: "Painting has not always existed. . . . Absolutely nothing in the world will be changed if one ceased to paint altogether, although such a view cannot be advanced without alarming the conservative spirit of art lovers. Let them be reassured; we are not so optimistic as to assert that the day will come when no one paints any longer, but what one can propose is that painting, with the ensemble of superstitions it carries with regard everything from the subject to materials, from the decorative sensibility to the illustrative one, from composition to taste, etc., will in the near term certainly pass for an anodyne diversion reserved for young girls and elderly provincials, as is the case today with verse, and tomorrow with the writing of novels."[25]

The rebellious ferment of the late 1960s and early 1970s revived these attitudes toward the medium and further entrenched their totalizing assumptions in art historical and theoretical discourse, sometimes phrased with the dripping sarcasm of the young Aragon. Parenthetically, it should not go unremarked that such attitudes persist to this day even though the apocalyptic changes once predicted have not come about, and the predictions themselves are seventy to eighty years old—in other words, antique visions of the new. Nor should it be forgotten that, in addition to becoming a champion of the most aesthetically *retardataire* forms of Socialist Realism in his capacity as spokesman on cultural affairs for the French Communist Party, Aragon also devoted considerable energy to writing about Picasso, Matisse, and other leading painters of the School of Paris. Depending on one's perspective, this may be seen as a betrayal of his previous, unimpeachably avant-garde position or a tacit admission that painters had proven him wrong. In any event, Richter found himself immersed in a climate of opinion in which it was more or less taken for granted that *this* time around painting could no longer avoid revealing that its aesthetic reserves were spent.

Under these circumstances, the path of least resistance—and the one most likely to secure his reputation in avant-garde circles—would have been to reenact the painting of what Ad Reinhardt once called, "the last painting anyone can make."[26] Unsure of how long he could sustain the effort of postponing painting's predicted demise but equally unwilling merely to illustrate it, Richter set his course between the symbolic absolutes available to him in the Manichean world of all-white nothing or all-black nothing. Gray was the obvious, but also surprisingly broad, middle term. "I just went on painting," Richter recalled, but it was never a question of going through the motions out of mere stubbornness, as the scope and variety of his gray paintings show.[27] For example, *Gray* of 1973 is distinguished

ROBERT STORR

by an implacable opacity and surface regularity reminiscent of the enervating interiors of institutional buildings. With its horizontal slabs of grained pigment, another work called *Gray* of the same year has a density and solidity that exude the oddly comforting feel of masonry. Others, such as *Un-Painting (Gray)* of 1972 (page 67), display a furious animation, as if the painter had been thrashing about inside a gunny sack or a sealed tent. Employing a roller in the first work, a heavily loaded brush in the second, and repetitive gesture in the third—as well as using different tones of gray in each—Richter represents the tonal range and even greater diversity of painterly effects encompassed by these otherwise somber monochromes.

Except initially, Richter was not actually obliterating representation with abstraction but, rather, starting with an empty canvas he was simultaneously attempting to picture negation and fullness, trying to give them substantial definition in the hope of forestalling entropy. The fact that the paintings are manifestly different from one another—not only in the most obvious aspects of format or technique but also in the nuances of their individual facture—vindicated Richter's strategy, although it took a while for him to be fully confident that this was true. The fact that separately and collectively they carry the emotional weight of his anxious neutrality proves that they are more than simple holding actions. With some distance, Richter gradually came to appreciate their distinctive qualities, and reevaluated their psychological content. Speaking to the critic Coosje van Bruggen, he invoked John Cage's "Lecture on Nothing," to explain how the nihilistic motive turned into something positive, even beautiful: "It was the ultimate possible statement of powerlessness and desperation. Nothing, absolutely nothing left, no figures, no color, nothing. Then you realize after you've painted three of them that one's better than the others and you ask yourself why that is. When I see eight pictures together I no longer feel that they're sad, or if so, they're sad in a pleasant way."[28] This is the voice of a maker rather than a theoretician, someone more committed to the particular than the general; but had Richter not been half-persuaded that the theoreticians were right and that his own frustrations supported the charges brought against painting, then his attempts to elude the predicted outcome of the crisis that confronted him would have had far less meaning. Ultimately, though, he won more than a reprieve for his medium, he won a judgment against those who had condemned it on flawed and insufficient evidence.

Richter's isolation from the rest of the contemporary art world during the late 1960s and early 1970s was alleviated by his friendship with Blinky Palermo. It was a friendship that grew as the distance between Richter and Polke increased, a distance partially accounted for by the comparatively rapid recognition that had come Richter's way, while the response to Polke's protean output of paintings, sculptures, installations, photographs, and conceptual projects had been much slower. Their rift was further exacerbated by a crisis and pause in the work of the extravagantly talented but erratic Polke. Like Richter and Polke, Palermo was East German in origin. Born Peter Schwarze in Leipzig in 1943, he was almost immediately adopted and given the surname of his new parents, Wilhelm and Erika Heisterkamp. In 1952 he moved with his family to West Germany, and in 1962 he enrolled at the Düsseldorf academy—the same year Richter did. In 1963 he entered the class of Joseph Beuys who treated him as a favorite and in effect became his artistic father. Beuys suggested the pseudonym Blinky Palermo (the moniker of a minor gangster and boxing promoter associated with Sonny Liston), which his protégé assumed in 1964. Gifted with the subtlest of artistic sensibilities, but emotionally volatile and self-destructive—he died at thirty-four while in the Maldives after years of hard drinking and drug abuse—Palermo was something

of a romantic figure, but his art was resolutely contemporary, and the lyricism that infused it was the product of a keen sensitivity to materials and a deft, matter-of-fact touch. In addition to working in oil, enamel, and acrylics on canvas, wood, and metal, Palermo drew extensively, made watercolors, wall reliefs, graphic architectural interventions, and so-called *Stoffbilder*, or cloth-paintings, in which fabrics were stretched over wood stretchers with the harmonious juxtaposition of dyed colors recalling the chromatic "zone" compositions of Mark Rothko or Ellsworth Kelly. In Beuys's words, Palermo was "very permeable."[29] Although quiet and not given to debating ideas, he was alert to what was going on around him, as Lueg was. Unlike Lueg, he was able to absorb it and make it his own. Richter's bond with Palermo was predicated on this combination of refinement, reticence, and openness. And yet, commenting on his affinity with Palermo, Richter explained that it was in part based on the differences in their inclinations and abilities. Speaking to the Swiss curator Dieter Schwarz, Richter said: "His constructive pictures have remained in my memory because they particularly appeal to me, because I can't produce such a thing. I always found it very good how he made it and that he made it—this astonished me. There was an aesthetic quality which I loved and which I couldn't produce, but I was happy that such a thing existed in the world. In comparison, my own things seemed to me somewhat destructive, without this beautiful clarity."[30] It was Palermo who brought postwar American abstraction back to Richter's attention, including the work of Rothko, Willem de Kooning, Morris Louis, and especially Barnett Newman, who came to occupy a prominent place in Richter's mind. Comparing Rothko to Newman in 1998, Richter recalled the mood of that early moment: "I only identified with [Rothko's] seriousness, which was absolutely to be admired. At that time, in the 1970s, Barnett Newman, with his nonhierarchical structures, his nonrelational Color Field painting, seemed more interesting because his work was less pretty."[31] It was with Palermo that Richter made his first trip to New York in 1970. Taking a room in a tourist hotel on Forty-second Street while doing the rounds of jazz bars, galleries, and parties, they stayed ten days and left, "feeling we were Europeans, and we were a little bit proud. We have the right to exist, [we were] not afraid of this superpower."[32] In subsequent years, Richter returned to New York many times, and in 1973, Palermo moved there. Yet, even after Richter's first American exhibition at the Reinhard Onnasch Gallery in Manhattan in 1973, when James Rosenquist toured him around in an open convertible and he met other artists, Richter has always regarded New York with a mixture of amazement, distaste, and wariness. In notes written during a 1984 visit, he purged that ambivalence, which is the mirror-image of a deeper ambivalence toward his own country: "This city of the elect and the privileged, of wielders of power and decision-makers, which implacably raises up and destroys, producing superstars and derelicts; which is so merciless and at the same time so beautiful, charming, dreamlike, romantic, paradisal. The city that exerts such a deadly fascination; the city that killed many others besides Palermo. . . . I envy the New Yorkers, and I think with discontent of Germany, the stifling fug of its society, its affluent philistinism, its all-smothering, oppressive ugliness. I shall rebook tomorrow and fly home early."[33]

Richter's relationship with Palermo—more so than that with Polke—was based on a common approach to the problems in their work: "We could really just speak about painting. The main thing was about the surface of color or the proportion of color. It was impossible for me to talk to Polke about the opacity of color. With Palermo, yes. We supported each other, we comforted each other a little bit. We thought this really could not be true that everything was supposed to be over. Art had to be relevant, and our art was not rele-

vant."[34] "Of course," Richter added, "we remained strangers to each other, but we shared the same judgments."[35] Richter's collaborations with Palermo were also more direct than those with Polke. The simplest of these projects is a beautiful print of 1971 in which two abutting photographs chosen by Richter—a telephone and a closeup of a lightbulb—are set into a wide field of mustard yellow chosen by Palermo. The most important project they undertook together was the creation of a room in 1971 at the Cologne gallery of Heiner Friedrich, where the walls were covered with a dark yellow ochre, and at the center of which were two busts with tall pedestals facing each other several feet apart. The walls were painted by Palermo, the busts, full plaster casts of the two artists' heads painted gray, were by Richter.[36]

The layered meanings of the piece depend more than usual on the specific cultural experience brought to it, the consequent assumptions made, and the social, political, and aesthetic context within which it is finally located. For many reasons, the Pop sensibility of Richter and his cohort differed considerably from that of their English and American counterparts. These differences were not confined to attitudes toward consumer society and the mass media—the givens of Pop—but also toward the emblems of the artistic past. While Johns, Lichtenstein, Rauschenberg, and others quoted works by everyone from Picasso and Léger to Rubens, the household gods and civic monuments to tradition familiar to Europeans played no part in their thinking because, as a rule, Americans do not grow up surrounded by such tokens of established culture. Germans, however, are more likely to have lived in a world where writers, composers, and philosophers are commemorated in garden sculptures, and where uniform editions of the works of eighteenth- and nineteenth-century authors fill a shelf or two in someone's house. Thus, it was not just commercial goods, advertising, and movie images that attracted the eye of the German Pop artists but also the mass-produced, or at least ubiquitous, icons of the bourgeois, aristocratic, and bureaucratic ideals of *Kultur*. For example, no American would have thought to paint a row of leather-bound books with the painter's name in gilt letters on their spines, because almost no one in the United States in the 1960s had collected works of Sir Walter Scott or Charles Dickens next to the fireplace in their high-rise apartments or suburban ranch houses. But in 1969 Polke painted just such a set of books with his name on each volume because the collected work of Goethe or Schiller had recognizable symbolic value, and virtually any German could understand the humor of the ploy—and the provocation. If the essence of Pop art is to objectify the commonplace or standardized things that clutter modern life so as to interrupt passive acceptance of them and hold them up to fresh scrutiny, then to the extent that high culture appears in the contemporary environment as if it were just part of the furniture, it too can be re-presented with the critical irreverence used in the Pop appropriation of low culture.

Richter and Palermo's simulation of neoclassical interior design and decorative sculpture is of the same order. Busts like those made by Richter are a familiar sight in the parks around old official buildings and stately houses of the eighteenth and nineteenth centuries just as they are in the drawing rooms where the walls are often painted colors similar to the one Palermo used. For Richter and Palermo to have insinuated themselves into these conventions is, at one level, both a parody of good taste, and a joke at their own expense insofar as they have assumed the demeanor of artist-heroes in a spiritual or poetic trance—the antithesis of the revolutionary role-playing of vanguard artists like Jörg Immendorff (another Beuys favorite) in that period.

A basically political reading of this ensemble has been offered by Benjamin Buchloh,

Sigmar Polke. **Polke's Collected Works [Polkes gesammelte Werke].** 1969. Lacquer on canvas, 15 × 56"
(40 × 150 cm). Collection Lise Spiegel Wilks

who sees it as a critical "restaging of the myth of the hero and the leader" in the neoclas-
sicist manner promoted by Hitler and Stalin. Pointing to Richter's own experience of those
regimes, while acknowledging the artist's "claims not to have worked with any particular
model in mind," Buchloh argues that "it is rather evident," that the uncanny similarity
between *Two Sculptures for a Room by Palermo* of 1971 (page 69) and certain fascist pro-
totypes—Arno Breker's bust of Hitler, in particular—involves a reprise of totalitarian tropes
that points toward Germany's incapacity to address its Nazi past and mourn the devasta-
tion it caused.

Buchloh is not wrong in making these connections insofar as the neoclassical impulse
does account for a cultural continuum stretching from the late eighteenth century to the
Third Reich and the consolidation of the Soviet empire. But, why, one asks, would Richter—
who has made very few self-portraits—use his own visage or that of an artist he admired to
recapitulate the rhetorical falsehoods of authoritarian art? The answer must be: that was not
what he and Palermo had in mind. Instead, it would seem that they were cautiously, but seri-
ously, hinting at the possibility that this perennial style might not be a permanent hostage
to its most corrupt incarnations, and that it could still be re-created in its own semisatirical
image. At odds with an increasingly radicalized art world, they chose to "immortalize" them-
selves at just the moment when their own place in history seemed most tenuous. Practi-
tioners of so-called outmoded forms of modern art at the respective ages of thirty-nine and
twenty-eight, they donned the conservative guise of venerated masters. Yet, even though
they were plainly flirting with the tainted connotations such memorial sculptures had (and
bearing in mind that the musty if not morbid atmosphere Palermo's ocher evoked is not far
removed from the palette of his mentor Beuys, and in particular from Beuys's *Braunkreuz,*
a homeopathic recycling of fascist brown), there is a calm and equipoise to the room and to
the busts themselves that at least partially transcends the negative precedents Buchloh cites.
This is evident even in the bronzes cast from the plasters, which are covered by a dark brown
patina flecked by oxidization. They preserve the texture of the heavy gray brushstrokes of
the original painted plasters, making them facsimiles of what amount to three-dimensional
paintings as much as they are life masks—or premature death masks—of the artists. Sym-
metry and sculptural restraint account for the serenity these heads possess, but so too do the
strange expressions on the faces of the two friends who confront each other, with eyes closed.
They seem withdrawn into themselves and, at the same time, of one mind; the current that
passes between them is not telepathic or mystical but rather an internalized exchange of sym-
pathy and intelligence.

Another artist whose work and character struck a chord with Richter in this period
was the Belgian Marcel Broodthaers. Broodthaers is too elusive a personality to deal with
here in any detail, and his work is too important and too complex to encapsulate in simple
formulas. Furthermore, Richter's contact with him, although significant, was relatively

limited. Suffice it to say that Broodthaers, a former member of the Resistance, lapsed Marxist, dedicated bohemian, protégé of the Surrealist René Magritte, former poet, and Conceptual polymath, was the sly scourge of institutional aesthetics in every form. He turned his hand to art in 1963 after seeing an exhibition of Jim Dine's work in Brussels and one of George Segal's sculptures at the Sonnabend Gallery in Paris—the same year Richter saw work by Lichtenstein there. "I, too, wondered if I couldn't sell something and succeed in life," Broodthaers said. "For quite a while I had been good for nothing. I am forty years old. The idea of inventing something insincere finally crossed my mind and I set to work at once."[37] Broodthaers's mixed feelings about American Pop art in some ways echoed those of Richter, and their attitudes toward the widespread politicization of art also corresponded in many ways, as did their leeriness about the transformation of Beuys the neo-Dada agitator into Beuys the guru and activist. Indeed, in a characteristically oblique polemic Broodthaers compared Beuys to the self-aggrandizing Richard Wagner, while likening himself to the light-opera composer Jacques Offenbach. Such a deliberate anachronism was an essential part of Broodthaers's own neo-Dada strategy. Using nineteenth-century objects, texts, graphics, and typography in his drawings, prints, films, and installations, Broodthaers created a parallel universe in which the old mirrored the new in absurd ways, and antique kitsch mocked the certainties of modernity. This mockery had an implicitly political dimension; Broodthaers had not forgotten his Marx. But, rather than make tendentious progressive art that repeated the mistake of conservatives who assumed that visual and verbal language are a self-evident and reliable means of communication, he rested his anthropological reconstruction and deconstruction of bourgeois society on exhaustive inventories of its popular symbols and the adroit subversion of their formal and ideological codes. "All human action is political. That is false," Broodthaers affirmed, but went on to say: "It becomes true when the image of natural objects is constructed and guided by a social class that intends it to serve the preservation of its privileges. What is political in the profession of art or of other things is to reveal this way or in any case not to conceal it. The method I have employed is to introduce and establish falsehoods in (artistic) reality."[38]

Richter concurred with Broodthaers's mistrust of natural appearances, although he was disinclined to create semiotic "booby-traps" as Broodthaers called them, for the sake of exposing the social privilege implicit in such fictions.[39] Broodthaers's skeptical wit and his willingness to go against the tide of the times appealed to Richter: "He was an incredibly likable and fascinating man; we always greeted each other warmly . . . but to this day I still don't understand what he was doing."[40] When he was invited to contribute to Broodthaers's magnum opus, *The Museum of Modern Art, Department of Eagles, XIXth Century Section,* he readily accepted. The "museum" that Broodthaers had initially created in his apartment with a display of packing crates, signs, and postcards of nineteenth-century paintings consisted of a series of taxonomic installations that parodied museological, economic, and artistic systems. This then expanded at other locations to include "departments" of Cinema, Documentation, Figures, Finance, Publicity, and Modern Art, with the eagle representing the metaphorically exalted view of art enshrined in cultural institutions inherited from the past. At Broodthaers's prompting, Richter painted two eagles, one of which was added to the museum's collection of some three hundred examples. The first version, *Eagle* of 1972 (page 68) is blurry and relatively subdued, the second more painterly and well-defined. Both raise the same questions as *Two Sculptures for a Room by Palermo,* because they recall an idealized notion of the artist—this time as an all-seeing bird of prey— and both raise the specter of imperial power, if not the specifically Nazi use of such emblems.

Gerhard Richter. **Untitled (Portrait of Henry de Montherlant).** 1971. Oil on canvas, 27⅝ × 21⅞" (70.2 × 55.5 cm). The Museum of Modern Art, New York. Gift of Ronald S. Lauder

But like the two busts, *Eagle* is more than a device; it is a picture, which in its austere rendition of a majestic, if menacing, subject acknowledges the abiding potency of such images, even as it took its place in Broodthaers's exhaustive catalogue of similarly questionable emblems of authority. While Richter willingly offered the painting as a target for speculation on, and demystification of, aesthetic myths, he did not make it an easy target.[41]

Both *Eagle* and *Two Sculptures for a Room by Palermo* prefigure Richter's *48 Portraits* of 1971–72 (pages 70–73), the most sustained and unified series of painting the artist had so far undertaken. Richter planned the work to represent his country at the 1972 Venice Biennale and to fit the grand neoclassical spaces of the German national pavilion. The selection of Richter is a reminder that no matter how much he may have felt out of step with his contemporaries around this time, he was still very much an artist to reckon with in the minds of many people in the art world. Slightly smaller than *Eagle* but similar in format—a centered image with little space around it—each of the forty-eight heads that comprise the group was based on a photograph of a famous man found in an old encyclopedia. This was just the sort of "style-free" reference image for which Richter had earlier declared his preference, but which he had never before quoted so explicitly. While the organizational paradigm of the inventory suggests Broodthaers's influence, it is also true that Richter had already begun work on the paintings the year before he painted *Eagle*. His first essays in this format include two portraits of Sigmund Freud, one partially un-painted by a flurry of lines that blots out the psychiatrist's features like an uncontrollable eruption, the other a fuzzy but more faithful likeness. An additional five trial runs, or out-takes, from the final series of forty-eight are known to exist, among them a portrait of the French writer Henry de Montherlant, which is not listed in Richter's catalogue raisonné, and there are eight pages of *Atlas* containing 270 clipped images that were candidates for inclusion.

Much has been made of who was finally painted and who was not. In *Atlas* the subjects range from Gabriel García Lorca to Chou En-lai and from Niels Bohr to Jacob Burckhardt. The most historical figures are Edgar Allan Poe, Charles Baudelaire, Stephen Melville, Charles Darwin, Henrik Ibsen, Ivan Turgeniev, Richard Wagner, Giacomo Puccini, and Karl Marx; the most contemporary as of that time are Ho Chi Minh, Eugène Ionesco, Jean Genet, Truman Capote, and Samuel Beckett (who appears twice, as does Bohr), Jean Anouilh, Dag Hammarskjöld, and Bertrand Russell. Among prominent Germans not already mentioned are Bertolt Brecht, Hermann Hesse, Paul Hindemith, Thomas and Heinrich Mann, Ludwig Mies van der Rohe, and Richard Strauss. Notably absent, with the exception of the architect and painter Le Corbusier, are visual artists. There are no women. Of those thus far named only Thomas Mann and Puccini take their place in the completed pantheon. The others are a curious assortment of the internationally renowned and the all but forgotten; starting with H. G. Wells and ending with Anton Bruckner, they proceed

ROBERT STORR

Gerhard Richter. **48 Portraits.** 1971–72. Oil on canvas; 48 paintings, each, $27\frac{9}{16} \times 21\frac{11}{16}''$ (70×55 cm). GR 324-1 through 324-48. Museum Ludwig, Cologne. Installation view at the Venice Biennale, 1972.

by way of Mikhail Sadoveanu, William James, Hans Pfitzner, Paul Claudel, Franz Kafka, Patrick Maynard Stuart Blackett, Isidor Isaac Rabi, Saint-John Perse, Graham Greene, and Karl Manne Siegbahn. If this sampling runs long, it still remains only a fraction of the people Richter considered painting or painted. If a pattern fails to emerge that, too, is characteristic of the whole, which, ultimately seems not to have one but instead is an arbitrary enumeration with the potential for willful editing or infinite expansion.

Judging from the results, Richter's most sweeping decision was to eliminate all political thinkers and leaders, although a collotype print of Mao Tse-tung, produced in a large unsigned edition in 1968, anticipates *48 Portraits* and represents that social sphere. (Besides Chou En-lai, Ho Chi Minh, Hammarskjöld, and Gustav Stresemann, the other readily recognizable statesmen in the *Atlas* group are David Lloyd George, V. I. Lenin, Mao, Mahatma Gandhi, and Leon Trotsky.) The absence of artists effectively constitutes Richter's refusal to provide any information that might be interpreted as an aesthetic genealogy (at least until the 1990s: a recent print titled *Survey* of 1998 features a markedly idiosyncratic selection of artists, architects, writers, composers, and philosophers who have contributed to Western culture from the Middle Ages to the present). After that, it is harder to divine Richter's motives for excluding certain possibilities, unless we assume that his overall purpose in the work—anonymity and indifference—would have been undermined if he had permitted his personal tastes or intellectual preferences to be discernable in the final array.

Richter has offered few clues about what he may have had in mind, but he has spoken several times of a need to identify father figures. In purely private terms, the issue of fatherhood is an admittedly unresolved one. Uneasiness about his own father is clear from remarks made about his family situation as he was growing up. "Why should I have painted only this photo of him?" he asked himself with reference to *Horst and His Dog* of 1965 (page 21), where his father appears as an amiable tipsy buffoon.[42] Moreover, three recent portraits of his own son, titled *Moritz* (2000–2001), have an uncanny atmosphere about them, while expressing a bewilderment seemingly at odds with the scrap-book cuteness of their subject (page 132). Whatever Oedipal drama they foretell, Richter has acknowledged that "it wasn't until Moritz was born that I started to know what a father is."[43]

Nevertheless, in *48 Portraits* the psychological compulsion to establish a cultural paternity is inextricably connected to the historical disasters of National Socialism and Stalinism. This is true not just in the sense that such pictorial halls of fame are a staple of totalitarian

art, and it is important to recall that Richter himself had once painted Stalin's likeness on banners, while serial portraits of Marx, Engels, Lenin, Stalin, and Mao were frequently seen on the mastheads of Communist newspapers published by the student Left in the West as well as in news photographs. (In his capacity as a Maoist agit prop artist, Immendorff painted such a line up around 1973.) In other words, Richter had chosen a format that evoked not only the library but the assembly hall and the street. Then, reversing that model, Richter expelled all politicians and concentrated instead on writers, composers, scientists, and philosophers whose achievements in almost every case represented a humanist tradition intolerable to authoritarian regimes, even when, as in the case of Tchaikovsky or Bruckner, their works were co-opted by the Communists or the Nazis.

The word *humanism* is, of course, a suspect term in postmodern discourse; however, it is not being used ironically, nor did the artist intend his pictures to been viewed ironically. Richter's panorama of faces neither advocates any particular view of culture, nor condemns any. (The distance separating the world view of the deeply conservative Catholic poet and playwright Paul Claudel and that of innovative modern allegorist Franz Kafka could hardly be greater, as is that which lies between the composers Puccini and Hindemith.) In this context, rather than signaling the *pro forma* celebration of passively agreed upon values, the invocation of the Western tradition and the concept of humanism opens a debate about the content of those terms in relation to specific examples. Nevertheless, in the most antideclamatory way, *48 Portraits* makes intellectual and artistic endeavor its subject, and did so at a time when the cultural past was under widespread attack. Standing between his youthful experience of societies in which intellectual and artistic work were routinely denigrated unless it served the party in power and the ongoing culture wars of the 1960s and 1970s, Richter compiled a pictorial roster of the kind of men who had been or might be sacrificed to the imperatives of ideology.

The fact that they are *all* dead white males has exposed Richter's selection to criticism from several quarters. His less-than-satisfying justification has been that in the 1960s feminist—or for that matter multicultural—awareness was not so developed, and that in any case the inclusion of women—Virginia Woolf or Eve Curie, for example—would have broken the formal compositional unity of his parade of men in dark suits.[44] The more obvious explanation is that the cultural legacy of the West is or, until recently, has been overwhelming if not overbearingly patriarchal, and that aside from the fact that Richter is not a reformer, his purpose was to represent that heritage. His way of doing so—by projecting an aggressively neutral Pop, almost Warholian, appropriation of mass-produced imagery back into history (his frieze is unlike Warhol's multiple portraits of celebrities in every other respect)—is hardly reverential. (Warhol's *Thirteen Most Wanted Men* again comes to mind.) Nor was the initial installation of the piece in Venice, where the images were symmetrically arranged in a single row around the curved walls of the German pavilion, with Kafka in the middle staring straight ahead, and the heads to his left and right gradually turning as nearly frontal poses flowed into three-quarter poses. Since then, Richter has laid them out or ranked them in ways that avoid such visual gags, emphasizing instead the primitive system of the list or grid as a means of bringing order to the disorder of history.

Once again, Buchloh's interpretation focuses narrowly on the Nazi past and the psychological transference effected by "the destruction of the paternal image" and "the adulation of the image of the male *Führer*."[45] Using Freud as a stalking horse for his own antagonism toward any reconstitution of old hierarchies, Buchloh writes of the dilemma confronting Germans who came of age in the 1930s and 1940s: "For any subsequent construction of a

ROBERT STORR

paternal image or national legacy to be accepted, it would have to bear the marks of that traumatic experience and its subsequent secondary elaborations. That is, it would have to shift continuously between negating the 'natural' paternal image of the Germans as fascists and laboring to construct a radically different *paternal* legacy and a post-traditional *national* identity—while emphasizing at the same time the artificiality of any such retroactively constructed positive paternal identification. . . . (It is simply not possible to construct a cohesive cultural canon out of these figures. . . .) The resulting instability, if not actual breakdown of this fiction of a transnational liberal-humanist community was, then, as integral to its constitution as were the careful omissions that guaranteed its success as an acceptable fiction of paternal history. . . . Richter's pandemic collective functions simultaneously, then, as a secondary elaboration of the process of identity construction and as a manifesto of disidentification."[46] To some extent, Richter's own comments on *48 Portraits* confirm Buchloh's reading. Acknowledging the hostility with which some have responded to these enigmatic images, Richter has said: "In addition, you have the psychological or subjective moment of the father problem. This affects all of society. I am not talking about myself because that would be rather uninteresting, but the absence of the father is a typical German problem. That is the reason for such agitation, why it has such a disquieting effect."[47]

Moreover, Richter has spoken of the series as being emblematic of a break in tradition which cannot be mended. In that light, *48 Portraits* is "not a restoration. It is a reference to this loss. It is a question of whether or not we do something. I don't believe it comes back."[48] But the difference in tone between his commentary and Buchloh's is striking, representing a difference in generational experience and perspective. On the one hand, Richter lived through National Socialism and Communism and emerged with a longing to fill the gaps that totalitarian culture created. On the other, Buchloh looks back on history with unmitigated horror and an ineradicable antipathy toward anything that might be construed as a figure of authority. In that sense, Buchloh resembles Richter's characterization of "people [who] are always upset when confronted with something traditional and conservative. It's not considered to be part of our time . . . reactionary."[49] Whether or not that description fits Buchloh, it is obvious that Richter has neither painted a "manifesto of disidentification" nor a manifesto of any kind. He is not an ideologue, and Buchloh's essentially ideological cooptation of his work is too narrow to account for the regret and pessimism that cling to these otherwise impassive images—regret at having been deprived of the chance of identifying with any part of the cultural legacy that fascism and Communism suppressed or distorted, pessimism over the prospects of reconnecting with and extending that legacy in the context of reflex hostility to anything "traditional and conservative."[50]

For many postmodernists, the philosopher Walter Benjamin's ideas about "the work of art in the age of mechanical reproduction" and Theodor Adorno's critique of the "culture industry" have been rephrased to promote agendas that press the cause of artistic tendencies that capitalize on previous ruptures with the past and anticipate even more definitive ones, in the interests of theoretically post-traditional aesthetic practices. Anything short of this is dismissed as nostalgic, melancholic, and retrograde. Although Richter is in no sense a Marxist, his understanding of what has been lost to culture and his often melancholy, though never nostalgic, feelings about the predicament in which art now finds itself are closer in spirit to the Marxist writings of Benjamin and Adorno than those of many contemporary polemicists who selectively quote them. One might even go so far as to say that as phantoms they bracket *48 Portraits*: Benjamin's "loss of aura" being the vacuumlike

anti-aura in which the series as a whole hovers and Adorno's insistence on difficulty being the demand that these works—like the whole of Richter's oeuvre—address in an equally uncompromising way to all who labor in the culture industry, including critics on the Left made uncomfortable by Richter's intransigent ambiguities.

The measure of Richter's ambivalences and of his determination not to succumb to the temptations of nostalgic pastiche—a major tendency in conservative postmodern art from Francesco Clemente to Anselm Kiefer, to name only its most skillful exemplars—can be found in Richter's *Annunciation after Titian* of 1973 (page 74). There are five versions of this painting. The first, where the image is clearly legible but diffuse and overly saturated with warm tones, is the closest to the original. In the second, the image has been almost totally obscured by un-painting. The third, fourth, and fifth versions, uniformly larger than the others, are also un-painted, but the blurring is never so complete as in the second. Richter's motive for making a work based on the Titian was a common one among artists with a gift for copying: the wish to live with a favorite painting. It should also be remembered that copying has long been a basic component of traditional studio education and, prior to the twentieth century, was a means of disseminating unique images by the masters. Richter undertook the anachronistic project of reproducing the Titian, he recalled, "simply because I liked it so much. I saw it in Venice and thought: I'd like to have that for myself. To start with I only meant to make a copy, so that I could have a beautiful painting at home and with it a piece of that period, all that potential beauty and sublimity."[51] But the act of painting quickly made the change in historical circumstances apparent, and not because of any technical deficiency on his part, but because of changes in the artist's relation to the process of painting and to the presumed inviolability of the perfect model. "Then," Richter said, "my copy went wrong, and the pictures that finally emerged went to show that it just can't be done any more, not even by way of a copy. All I could do was to break the whole thing down and show that it's no longer possible."[52] In hindsight, one might assume that this "failure" was a foregone conclusion, or that Richter in some way set out to demonstrate the impossibility of reviving the paintings of the glorious dead, but the truth is that Richter had to arrive at this impasse. Moreover, his point of departure was unselfconscious admiration, and his desire was to possess a work manifesting certain qualities that he wanted to introduce into his art, if only by overt emulation.

Two additional factors enter in. "The central problem of my painting is light," Richter wrote in the early 1960s.[53] Although he had already painted light sources—a lamp, a chandelier, the morning or evening sky—Richter had never before chosen an image whose *theme* was light. Furthermore that theme was metaphorical and the light divine. This is the first of his pictures with an unequivocally religious iconography. Given the results, Richter's decision to copy an Annunciation was unexpectedly, or perhaps intuitively, appropriate. A standard medieval explanation of the Immaculate Conception was that God's insemination of the Virgin resembled the passage of the sun's rays through clear glass. It was in the literal sense an act of pure inspiration, akin to the inspiration artists were said to receive from powers higher than they. Not only are reports of virgin births rare in our day, such direct transmissions of creative energy are similarly uncommon. Communication between divinity and genius has ceased, and communication between the demiurges of art history and contemporary artists is tenuous at best. The vessel of painting has clouded and the images projected into it are refracted, fragmented, and dissolved. Richter, thus, looked at Titian's Annunciation "as through a glass darkly," and we, looking over his shoulder, contemplate the once radiant masterpiece in the same smudged lens.

ROBERT STORR

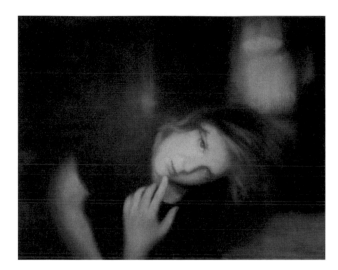

Gerhard Richter. **Brigid Polk.**
1971. Oil on canvas, 40 × 50"
(101.6 × 127 cm). GR 309.
Private collection, San Francisco

Richter's apparent detour into art history or art-historical ways of seeing earned him the enmity, or at least the suspicions, of a number people in the contemporary art world. Even the portrait he made in 1971 of the burnt-out Warhol superstar *Brigid Polk* has a remoteness that is warm and atmospheric rather than coolly technological, especially in contrast to Warhol's gratingly intense silkscreen pictures of denizens of the Factory such as Polk. Nevertheless, this new-old dimension to Richter's painting found favor with some, notably the English Conceptual artists Gilbert & George, whose "living sculpture" performances had been anticipated by Richter and Lueg in their "Demonstration for Capitalist Realism." Avowedly "reactionary" artists who affected out-of-date bourgeois clothes and proper manners and, in 1970, had depicted themselves in bucolic settings with a text that archly declared, in the age of anti-aestheticism, "To be with Art is all we ask," Gilbert & George were the first to take a positive interest in his landscape paintings.[54]

Although he began painting landscapes for his own pleasure, much as he had tried to copy Titian, Richter was well aware that this "subversive attempt to paint beautiful pictures" represented something more than a private digression from avant-garde practice. It was, instead, a quiet act of defiance directed at those who traditionally claimed a monopoly on "subversive" means and ends.[55] Richter's explanations of why he did the "unthinkable" can be disarmingly straightforward. Asked about his interest in a genre that many of his contemporaries were certain was a thing of the past or, worse, a pastime, Richter answered: "Just because landscape is beautiful, it's probably the most terrific thing there is. . . . I felt like painting something beautiful."[56] His refusal to be pigeon-holed has further stymied those who have pressed hard to question his motives. "By using so many Romantic motifs—clouds, water, infinite spaces without a foreground or background—are you deliberately inviting the suspicion that you're a neo-Romantic," one incredulous interviewer inquired. "No, certainly not," the artist replied. "To do that, I would have had to think things out before I painted, and that's just not possible."[57]

There is an evasiveness to these responses, perhaps, but they are essentially truthful. Richter knew what he was doing and knew that it had broad implications, yet he was not about to fall into the trap of discussing of his work in terms that immediately consigned it to predefined aesthetic categories. Undoubtedly the German Romantics of the eighteenth and nineteenth centuries—the Dresden-born Caspar David Friedrich, in particular—had a profound

Caspar David Friedrich. **The Sea of Ice.** c. 1823–25. Oil on canvas, 38½ × 50½" (96.7 × 126.9 cm). Hamburger Kunsthalle, Hamburg

impact on Richter when he was still a student, but the Romantic influence goes deeper than surface resemblances between Friedrich's scenic views and Richter's. The differences between the two have less to do with how the paintings look than with what we are encouraged to read or discouraged from reading into them. Friedrich's works are sharply focused, linear, almost brittle and usually contain a stand-in for the viewer, whereas Richter's are diffuse and seldom portray such surrogates for the viewer. The crucial distinctions, therefore, rest on assumptions the artist and the public make about the worlds these paintings ostensibly depict and about humanity's possible place in them. Thus, when Richter says, "A painting by Caspar David Friedrich is not a thing of the past. What is past is only the set of circumstances that allowed it to be painted. . . . It is therefore quite possible to paint like Caspar David Friedrich today,"[58] he is simultaneously defending his right to paint as he sees fit and preparing the way for a fundamental reinterpretation of the type of painting he has seemingly resuscitated.

On occasion, Richter can sound very much like his Romantic antecedents: "I believe that art has a kind of rightness, as in music, when we hear whether or not a note is false. And that's why classical pictures which are right in their own terms are so necessary for me. In addition to that there's nature which also has this rightness."[59] Left unstated in this equation, however, is an important aesthetic possibility: the *intentional* wrongness of an image that apparently strives toward rightness, the false note deliberately struck to disrupt a prevailing harmony. Thus, where Friedrich and the artists of his era imbued nature with human emotions—indulging in what John Ruskin called the Romantic fallacy—Richter stresses a simultaneous and disconcerting awareness of nature's inherent beauty and its complete disregard for human needs, desires, and fears.

Tourist (with 1 Lion) of 1975 is the most graphic expression of this implacable indifference—one of a group of pictures based on published film stills of a person being killed by a lion at a French safari park. One can barely make out the legs and torso of the victim and the head and shoulders of the lion in the hazy off-key, off-register reds, yellows, and greens. We are watching death at work, but not cruelty, since the predator is doing what comes naturally, attacking the unfortunate individual who has crossed the line designed to protect people from a dangerous reality. The artificiality of the color effectively highlights the catastrophic falseness of the circumstances. Nothing in the manner in which the image is rendered

ROBERT STORR

Gerhard Richter. **Iceberg in Fog [Eisberg im Nebel].** 1982. Oil on canvas, 27½ × 39⅛" (70 × 100 cm). GR 496-1. Private collection, San Francisco

invites pity, or exploits horror. What is disturbing is how reasonable and unstoppable the mauling seems to have been under the circumstances.

Likewise, when Richter painted a man killed by a block of ice in *Dead* of 1963 (page 19), no special emotion was attached to the image, nor does ice symbolize anything specific in the evocative but still straightforwardly photographic *Iceberg in Fog* of 1982, despite the degree to which it recalls Friedrich's famous painting of a sailing vessel sundered by mounding ice floes, *The Sea of Ice* (1923–25). And yet that parallel contributes much to the aura and meaning of Richter's work. Such was Richter's fascination with that canvas, he said, that in 1981: "I even went all the way to Greenland, because C. D. Friedrich painted that beautiful picture of *The Wreck of the 'Hope.'* I took hundreds of photos up there and barely one picture came out of it."[60] Richter's inability to capture the essence of that scene photographically is indicative not only of differences in technical approach but of the discrepancies between Friedrich's aesthetic expectations and his own. Friedrich's theme was awesome forces greater than humankind, but it is a human presence that gives them scale and imbues them with meaning. The emotional power of Richter's treatment of the same situation derives from the mesmerizing lifelessness— the total un-humanity—of the subject. Whatever feeling we may try to invest in these inanimate objects is returned to us intact, like a shout or cry without a transforming echo, making the inappropriateness of our attempt to link those objects to psychological states unnervingly manifest.

Thus, no matter how picturesque an image may be, a barrier imposes itself between the scene depicted and the viewer's longing to make himself or herself a part of it and at home in nature. To a lesser extent this also holds true for the bucolic *Barn* of 1984 (page 76) and *Meadowland* of 1985 (page 77), the beckoning remoteness of *Davos S.* of 1981, or even the miragelike *Venice (Staircase)* of 1985. The *Davos S.* canvas is a seamlessly illusionistic reprise of the iconography of Richter's mountain paintings of 1968. Perceptually, the image involves a photographic flattening of volumes and perspectival depths, and the smoothing out of the painted surface so that we can neither enter the space nor visually grasp painterly details within it. Conceptually, Roland Barthes's definition of the photographic condition as "the that has been" of experiential reality is once again germane. These vistas never were and never will be there for us; they were there for the artist just as long as it took to snap the

Gerhard Richter. **Venice
(Staircase) [Venedig (Treppe)]**.
1985. Oil on canvas, 20 × 28"
(50.8 × 70.1 cm). GR 586-3.
Stefan T. Edlis Collection

picture and are only available to him now through the combination of that imperfect documentation and his equally imperfect memory.

In traditional landscape painting, as in traditional still life or portraiture, duration becomes a salient part of the image, which embodies evidence of the time it took the artist to see and record his impressions. Losing oneself in painterly time is the sensuous and imaginative catalyst for losing oneself in painterly space, be it the naturalistic landscapes of Friedrich and Camille Corot or the stylized ones of Vincent van Gogh and Georges Seurat. For Richter, where the camera intercedes, one reality is incrementally synthesized into its facsimile by traditional procedures and telescoped into an instant. The execution of the painting itself is subordinated to that mechanical abbreviation of the process of looking. This temporal implosion of the image and the psychological interruptions that accompany it were precisely what Richter wanted when he initially turned to snapshots and media clippings; but his subjects also tended to be easily recognizable as inherently photographable. This was also the case with his postcardlike landscapes in which the gap between two pictorial situations—the photographic and the painterly—is maintained but accentuated in the later landscapes. There, the tensions increase between the desire for one thing (a beautiful imaginary place to which the viewer might escape) and the actuality of another (a beautiful painting that checks that escape and makes the viewer acutely conscious of its impossibility).

The viewer is thus left in a state of perpetual limbo bracketed by exigent pleasures and an understated but unshakable nihilism. Those who approach Richter's landscapes with a yearning for the exotic or the pastoral are greeted by images that first intensify that desire and then deflect it. This is by design: "Of course, my landscapes are not only beautiful or nostalgic, with a Romantic or classical suggestion of lost Paradises, but above all 'untruthful.'. . . By 'untruthful' I mean the glorifying way we look at Nature—Nature, which in all its forms is always against us, because it knows no meaning, no pity, no sympathy, because it knows nothing and is absolutely mindless: the total antithesis of ourselves."[61] Still, the yearning persists, and the more lovely the painting the more likely it is to touch sophisticated viewers who already take nature's uncaring for granted but seek comfort in art. Richter anticipated that response, as well. Speaking for his audience as well as himself, the artist has said: "What I lack is the spiritual basis which undergirded Romantic painting. We have lost the feeling of God's omnipresence in Nature. For us, everything is empty. Yet, these

ROBERT STORR

paintings are still there. They still speak to us. We continue to love them, to use them, to have need of them."[62] Under these conditions, painting does not attempt to re-create the sense of divine or transcendent order upon which centuries of art were based but, rather, provides aesthetic solace for those it simultaneously disabuses of all metaphysical hope.

For critics or observers of the scene still convinced that modern art is a sequence of ruptures, each one more radical than the last, Richter's landscapes may seem at best a kind of fence-sitting between the old and the new, and at worst an intellectually adroit and technically masterful form of backsliding. However, these paintings are no more a throwback to lapsed aesthetic conventions than they are an ironical recapitulation and then dismantling of them. The Janus-like position Richter occupies, recognizes that those who work fully in the present always enter history in medias res. Looking both ways from such a position affords us a clearer perspective on the continuities and discontinuities of artistic practice than those available to anyone craning his or her neck to see the present from a vantage point in the hypothetical future or the reconstructed past. Richter's unwillingness to sacrifice tradition to the new is therefore based on an appreciation of the uses tradition retains and those it acquires in the here-and-now, rather than on a desire to emulate or hold onto a former understanding of it. Furthermore, his refusal to turn his back definitively on tradition is explicitly qualified by the knowledge that what has been done in one time cannot be repeated in another. On the contrary, as Richter made plain in notes to himself in 1983, the aesthetic proximity of the past stands as a challenge to living artists to respond on their own terms: "Traditional, supposedly old works of art are not old but contemporary. So long as we 'have' them, in the broadest sense of the word, they will never be outworn: neither are we setting something of equal stature alongside them, nor shall we match or surpass their quality. Their permanent presence compels us to produce something different, which is neither better nor worse, but which has to be different because we painted the Isenheim Altar yesterday. . . . This is not to say that it would be pointless to produce something similar to traditional work. But the better we know tradition—i.e., ourselves—and the more responsibly we deal with it, the better things we shall make similar, and the better things we shall make different."[63]

If Titian and Friedrich represented two models for painting that haunted Richter in the mid-1970s and drove him to test the limits of their actual viability, then modernist abstraction represented the third. From 1968 through 1976 the monochrome preoccupied him, but by the latter part of the decade it became apparent to him that there was no way he could paint himself out of the gray corner he had been led into by the example of minimalism and his own anti-expressive inclinations. As frequently happens in art history, the only alternative for an artist caught in such a *cul de sac* is to permit himself to do all or some of the things previously proscribed by creative habit, temperament, or aesthetic ideology. Willem de Kooning said it best. Confronted with a theoretical ban on figuration in the 1950s, de Kooning, having already spent several years painting pure abstractions, reasoned: "If you take the attitude that it is not possible to do something, you have to prove it by doing it."[64] Richter's dissatisfaction with the *grisaille* world in which he had lingered and his frustration with the orthodoxies that grew up around reductivism pushed him at first tentatively and then forcefully in the opposite direction. According to him: "The gray monochromes were the most complete ones I could imagine. The welcome and only correspondence to indifference, to a lack of conviction, the negation of commitment, anomie. After the gray paintings, after the dogma of 'fundamental painting' whose purist and moralizing aspects fascinated me to a degree bordering on self-denial, all I could do was start all over again. This was the beginning of the first color sketches."[65]

These sketches consisted of subtly brushed renderings of sections of richly textured Art Informel paintings that have not survived. The hues are generally saturated, the value contrasts extreme. Working from photographs in between sessions devoted to his last gray abstractions, Richter called these canvases and those that followed Abstract Pictures. The choice of title is significant in that it reinforces the impression conveyed by the illusionistic description of shoals, riptides, and cresting waves of pigment that these are pictures of gestural paintings not of the spontaneously eventful real thing. To spectators enthralled by formalist notions of pure opticality here were paintings that unabashedly lured the eye—and unapologetically deceived it. The first of these canvases, *Abstract Picture* of 1976 (page 75) demonstrates this bait-and-switch technique in a small format, while *Abstract Picture* of 1977 (page 75), which reproduces a detail from the top part of the former picture in greatly increased scale, shows how the same technique operates on a large one, with almost Rothko-like expanses of harmonious reds and browns. Another *Abstract Picture* of 1977 introduces further complications, as Richter incorporates a collage technique in these nonobjective works that he had generally avoided in his figurative images. In it he has pieced together painterly passages, shapes, layers, perforations, and shadows from several photographic sources much as James Rosenquist had done in his billboard-inspired Pop paintings of the 1960s but without the mass-media referents. Late that same year and into the next Richter turned in his spare time to watercolors for the first time since his youth, and the floating quality of the forms in his oils and the seemingly translucent depth of the intervals between them reproduce the effects of that aqueous medium.

As with his landscapes, Richter was initially reluctant to exhibit the new Abstract Pictures (Beuys was among the few colleagues to have seen and approved of them), and finally did so in 1978 at a place as remote from the art world he knew as could be imagined, the Nova Scotia College of Art and Design, in Halifax, on the northeast coast of Canada, where he had been invited to teach on the recommendation of Buchloh, who was also an instructor there. During the late 1970s through the 1980s Richter's association with Buchloh (combined with his ongoing relationship with Konrad Fischer) brought him into contact with a wide group of conceptually oriented artists among whom he was the only painter. They included Lawrence Weiner, Dan Graham, Jeff Wall, and Isa Genzken whom he had met briefly through Buchloh in the early 1970s when she was a student. Richter and Genzken met again in 1977—in the final days of the "German Autumn" that saw the deaths in prison of three members of the Baader-Meinhof group, a subject Richter would return to a decade later when he painted *October 18, 1977*—and in 1982 they married.

The tension between Richter's sensibility and that of his circle of friends coupled with his own uneasiness about "showing his hand" in painting, informed his new work in essential ways. Speaking of his figurative works, Richter said: "Painting is the form of the picture, you might say. The picture is the depiction, and painting is the technique for shattering it."[66] While his Abstract Pictures were also based on ready-made images, painterly affect engendered by the history and mythology of modernism clung to them; and he was determined to detach it. In contrast to his other works, Richter recalled: "I didn't quite dare to consider them regular paintings. I looked at them as purely subjective. That is why I copied them to objectify them."[67] For eyes accustomed to emotionally heated Action Painting or exultant Color Field abstraction, Richter's masterful but abrupt cooling down of the rhetoric of postwar art can be even more disconcerting than Pop or Minimalism because it seemed at first glance to have employed that rhetoric. But Richter had, in effect, removed the body as the agency of the psyche or spirit, and confined its duties to that of image maker in a

puzzling iconoclastic enterprise, which exploited reflex feelings of existential or transcendental identification only to quell them with a dazzling display of painterly ability conspicuously free of any drama, struggle, or ecstatic abandon. In contrast to Pollock, the painter was never "in" his painting nor, given Richter's opinions on the matter, did he ever think of himself as "nature." In contrast to Rothko, the absolute was not merely veiled by Richter, it had retreated beyond reach—into painting.

In conversation with Buchloh, Richter described his abstractions as, "An assault on the falsity and the religiosity of the way people glorified abstraction, with such phony reverence."[68] "Devotional art," he called it, "all those squares—Church handicrafts."[69] But despite these scathing remarks, Richter was, as always, of two minds about the fundamental issue of abstraction's capacity to represent the unrepresentable. Furthermore, his thinking on the subject evolved even though some critics, stuck in the period when Richter took a hard line, have been loath to acknowledge that evolution. Thus, in response to questions about Rothko from the art historian and curator Mark Rosenthal he explained his simultaneous admiration for Rothko's "seriousness" and his earlier distrust of his work, which Richter had considered "both too holy and too decorative," although he also confessed that, "I am less antagonistic to 'the holy,' to the spiritual experience, these days. It is part of us, and we need that quality."[70] In short, Richter is prepared now, as he was not then, to entertain the idea that the sentiments abstraction awakens need not be judged on logical grounds, but rather on their psychological resonance. Abstraction cannot claim to embody the absolute as it did from Kandinsky, Malevich, Mondrian, to the Abstract Expressionists, but it can lend substance to otherwise elusive aspects about our makeup. In the late 1970s and early 1980s, however, Richter remained uncomfortable with Rothko's transcendental approach. "While I certainly prefer that to cynicism," he said, "there was a kind of science fiction coming from Rothko's darkness that was Wagnerian or had a narrative side, which bothered me."[71] His answer was to further fictionalize this science fiction, and thereby make all the artifice and suspension of belief involved explicit.

In this regard, Richter made a distinction between Newman and Rothko that hinged on the comparative austerity and materiality of Newman's canvases—their ability to comprise both aesthetic fact and metaphysical fiction. He said: "Barnett Newman was always important. . . . Newman was an ideal, because he created these big, clear, sublime fields that I could never have managed. He was my complete opposite."[72] Nevertheless, in 1979 Richter painted two huge mural-sized canvases—*Brushstroke (in Blue)* and *Brushstroke (in Red)*, as well as two smaller but by no means small sketches for them—that resemble the "zips," or painted lines, of the kind Newman used to bifurcate his paintings. Like the "Detail" painting of 1971, though, Richter's two Brushstrokes are vastly enlarged representations of oil paint traveling across the surface rather than the gargantuan marks they appear to be, simulacra of a stripped-down Abstract Expressionist gesture that amaze by their sweep and their impossible trompe l'oeil effects but do not—and were not intended to—inspire awe in the manner of Newman's mammoth painting *Vir Heroicus Sublimis* (1950). Indeed, the orientation and scale of the strokes—horizontal rather than vertical—reverses the equation set by Newman's anthropomorphic play of upright bands against a horizon of color. Richter's exaggerated blow-up of a seam of pigment violates the classical ideal of the sublime as an experience of the infinite because it is impossible to imagine this line going on forever. Once again Richter's paintings constitute a deliberate contradiction in terms that simultaneously energize and lock those terms into a perplexing but evocative stalemate.

Before Richter began painting Abstract Pictures most people would not have thought of him as a colorist, although his grays were finely calibrated and sometimes blushed with pale blue, violet, or earth tones. Since then, it is hard to think of him as anything other than one of the great colorist of late twentieth-century painting. Whatever resistance to that designation there might be may be explained by the *kind* of color Richter favors and the role it plays in enhancing the disquieting psychological effects of his work. When Richter talks about the relation between music and painting he has two extremes in mind, Bach and Mozart on the one hand, and on the other, Schönberg and more unexpectedly the "noise" composer Glenn Branca. For anyone predisposed to judge musicality by harmony, and an artist's gifts for color by soothing optical chords, Richter's preferences among composers stand as a warning. None of the available precedents or labels—most obviously Fauvism and Expressionism—account for the stridency of Richter's combinations of chlorophyll greens, sulfuric yellows, ice-cool blues, raw vermilions, and all the ragged and gritty combinations they achieve when dragged across one another, or when slate grays and dirty whites are dragged over them. For Americans habituated to French color, from Impressionism to Henri Matisse, Richter's clashing hues sting the eye, but you will not really find them in works by Ernst Ludwig Kirchner or Franz Marc either. The painter and critic Stephen Ellis hit the mark when he drew a connection between Richter's palette and the "luminous, acid color of Dürer, Altdorfer and Grünewald,"[73] masters of the German Renaissance in all its uneasy, frequently violent, and occasionally somber glory. In that context and particularly in the abstractions of the 1980s and 1990s, Richter's clear, corrosive Danube School colors are often called upon to cut through the dense, chromatically saturated curtain of paint that sometimes mimics the thickness and light absorbency of fuel oil or tar. The light in Richter's painting is northern rather than Mediterranean, complete with the heavy darkness that alternates with crystalline brightness during the long nights and short days of Northern European fall and spring. In the 1970s, the art historian Robert Rosenblum argued that Abstract Expressionism had its origins not only in the School of Paris, but also harkened back to the German Romantics. If so, then Richter's response to Newman, Pollock, and de Kooning may be seen as that American strain of the Northern Sublime repatriated by photographic and painterly means that further mutate Romanticism's generative poetic and pictorial traits.[74]

By 1980, the technique in Richter's Abstract Pictures had shifted from rendering alone to the direct application of paint with a brush or hard edge over rendered passages, and from there progressively toward paintings whose visible layers were almost entirely gestural or pigment loaded. This gradual obliteration of the illusionistic underpainting can be seen in the sequence of works that begins with *Clouds* of 1982 (page 76) and continues on through *Marian* of 1983 (page 77), the two Abstract Pictures of 1984, *Bush* of 1985 and *AB, St. Bridget* of 1988. The atmospheric quality of these paintings ranges from summery pyrotechnics and autumnal tempests to a crepuscular winteriness. Some, like *Marian*, are ravishingly beautiful; others, like *Bush*, are almost off-putting in their churning brushmarks and turgid contrasts of green and violet, as if Richter had set out to demonstrate that compelling "ugliness" was not only within his grasp, but a condition that painting and lovers of painting must accept in exchange for the more easily digested products of his new way of working.

"Constructions, not expressions," was how Ellis described Richter's abstractions, and the distinction holds, especially in the context of the "New Wild," or neo-Expressionist, work that flooded the galleries in Europe and America in the 1980s. Richter's engagement

ROBERT STORR

with expressionist-type painting antedates this movement by several years, but he was doubtless aware of this current as it began to well up around him and as he was lumped together with its exponents in a number of exhibitions as the tendency crested. As ever, his reactions were at once self-protective and laissez-faire, caustic and understanding: "I'm no 'wild one.' [I] find it irritating when the most obvious stupidity too is washed high on the 'wild' wave . . . but it has always been that way in times without orientation. One thing will still be visible in the 'wild' paintings even in Kassel; that they have broken out of something that was totally ossified. With an audacious stroke of the hand, they have destroyed dogmas that appeared to be internationally unshakeable. I certainly think that's very good. And seen in this way, I regret the process of domestication of the wild ones that sets in now, and promotes so much harmlessness."[75] Thus, Richter discreetly nodded to the rising generation in the process of brushing aside the settled aesthetic wisdom of Minimal, Conceptual, and other "progressive" postmodernisms. If he did not care for the work they produced—indeed, he found most of it distasteful—he at least acknowledged its appearance as a vital sign, though one that was unlikely to survive the embrace of art world institutions.

But while the atavistic "wild ones" ostensibly mined raw feeling, Richter's paintings were not only well "cooked" but carefully prepared. Richter never simply went at the canvas, brush in hand. For him spontaneous invention always required a foil. To explain his method he contrasted it to that of Pollock, Newman, and company: "The Abstract Expressionists were amazed at the pictorial quality of their productions, the wonderful world that opens up when you just paint. . . . But the problem is this: not to generate any old thing with all the rightness and spontaneity of Nature, but to produce highly specific pictures with highly specific messages (were it not for this, painting would be the simplest thing in the world, since in Nature any old blot is perfectly right and correct). Even so, I have to start with the 'blot,' and not with the new content."[76]

Lest anyone suppose that Richter's blots are kernels or spontaneous eruptions of new content, it should be underscored that many are painted in styles categorically different from the final image, and some are painted this way in anticipation of radical changes. In numerous cases, for example, Richter has sacrificed fully developed figurative works on his way to making abstract pictures. In most instances overpainting of the original image is complete, promising that art historians, conservators, and forensic aestheticians of the future will have a field day X-raying Richter's canvases in search of what lies buried under their heavy sediment of pigment. In *Blanket* of 1988 (page 238), however, one can clearly make out in the margins of the predominantly white painting the shadowy forms of the second version of *Hanged* (1988) from *October 18, 1977*—a picture of the Baader-Meinhof group member, Gudrun Ensslin, as she was found dead in her cell. The sheet of white paint that has been pulled across the surface functions as a shroud, and in that sense contributes new meaning to the appropriated photographic subject matter. But more often than not, additional layers have no such metaphorical relation to what lies beneath, as Richter obliterates the original image in successive sweeps of his scraper.

In other instances, photographic documentation of Richter's studio shows him boldly blocking in abstract compositions keyed to the brightest hues that, by turns, resemble Al Held's dynamic perspectival pictures; the patched-together compositions of contemporary artists such as Jerry Zeniuk (who exhibited with Konrad Fischer in the 1980s); or hard-edge color grids reminiscent of Bauhaus and Constructivist art that represent the next phase of Richter's Color Charts. None of these styles is characteristic of Richter's own finished work, and it is impossible to tell whether direct or indirect references to them at this

stage in his process are the expression of an affinity for the diverse modes of abstraction represented or of a competitive drive to do and then undo various types of contemporary painting. Richter's motives may well have involved a little of both, but in the end these schematic preliminaries disappear under progressively denser coats of dragged paint that eliminate virtually all traces of improvisatory form building, for which they served as pretexts in the artist's creation of homemade modernist ready-mades.

Richter's laconic explanation of this procedure does not emphasize the destruction of what is there for destruction's sake so much as the erasing of something overly familiar and dissatisfying in the hope that erasure will open the way toward problematic painterly phenomena with unforeseen and unforeseeable consequences. And it bears repeating that anti-art is not his vocation. Richter's former comrade, Polke, has for many years capitalized on the mistakes photomechanical devices make, and in recent years he has taken to manipulating Xerox copiers to create distortions that are analogous to the warping effects of Richter's scraper. But whereas Polke's approach is akin to that of the Surrealists in privileging stylized transformations of the known, Richter is on the lookout for visual anomalies that free him from stylization while raising the stakes attached to recognition and acceptance.

A severe judge not only of the clichés of his metier but of his own facility, Richter effectively crosses out anything that pleases too easily or fails to match the highest historical standards of whatever manner he is pushing off from. As he put it: "People speak of my work in terms of virtuosity. That is an absolute exaggeration. Unfortunately I am not a virtuoso at all. I have a little taste. I have an eye for bad things."[77] In effect, Richter's practice rests not so much on skill as on connoisseurship and rigorous editing. And while it is untrue that he "mindlessly" copies photographs, or is "clumsy," as he has said, the standards he has set for himself are impossibly high, and his inability to meet them results in violence aimed not at the image itself but at his inability to capture it.

The more exquisite the paradigm and the more vulnerable the subject, the more alarming this violence can be. The portraits Richter has recently painted of his wife Sabine and their child Moritz are perhaps the most striking examples of this. The paintings are tender images of a babe in arms in generally delicate tints; however, all but two of them have been skimmed or scored by a blade. "They are a little damaged," he said. "I really want to make beautiful paintings, [but] I couldn't quite hold it; they're not as beautiful as Vermeer."[78] And so he attacked them with a palette knife: "I had no choice. I didn't want to."[79] One might argue that under these circumstances stripping away or smearing paint is a studio expediency, but something other than gimmicks are at issue.

Elsewhere, Richter has described beauty as being a quality of "uninjured" things. In this case, the inadequacy of the image as it was originally painted was hidden by surface appeal that could not equal that of Richter's ideal, Vermeer—making that appeal a kind of inverse blemish that could only be corrected by explicitly wounding the picture and thereby exposing the anxiety that went into its creation and the pathos that attends any painful discrepancy between an imagined perfection and a flawed reality. In these examples that pathos is intensified by the intimacy of the theme and Richter's relation to the two people—sometimes naked—to whom the injury is done.

Richter's frustration must be taken seriously, not only when it comes to paintings of those near and dear to him but to paintings of others as well, and to abstraction. In this light, Richter's comments about Jasper Johns and the painterly tradition to which he belongs are revealing, as is his greater sympathy for Warhol. When Buchloh asked Richter about Johns, he answered: "Johns retained a culture of painting, which also has something to do

with Paul Cézanne, and I rejected that."[80] The something that connects Johns to Cézanne is painterly touch. Richter's work does not depend on what Cézanne called his "little sensation" by which he meant the translation of increments of perception into discrete marks; nor does it exploit the nuances of superficially similar but subtly dissimilar brushstrokes as Johns's paintings do. Moreover, Richter is not, as he himself has been the first to admit, a virtuoso in this sense. As noted, the early phases of most paintings are quite broad or schematic. But every positive application of paint awaits its invigorating negation, a seemingly arbitrary adjustment that pulls the edges of the alternately meticulously or perfunctorily laid-in, but never completely resolved, forms together while throwing globs and viscous strings of oil color off like mud from the window of a car whose windshield wipers battle against muck spit up from the road. That same arbitrary action also sheers ridges of oil color in staccato patterns and opens up crevices in still-wet pigment; it trims the margins of the primed canvas to reveal the layered accumulation covering it and drags solid particles that cut channels into the moist paint; it skips over hollows accentuating the edges surrounding them, and lends a washboard roughness to other areas. In myriad ways it thus creates material and visual events that substitute themselves for the effects achieved by an artist whose work is based on touch without the intrusion of the self as the embodiment of such a talent or such methods. Warhol's silkscreening techniques did much the same for his work, and the squeegees Richter uses are rigid variants of the pliable ones Warhol employed. In that regard, both have brought to painting the kind of metamorphic alterations of the image that traditional printmakers calculate into their work. For painters who rely on touch, everything that matters happens as the paint goes down; for Richter as for Warhol, the transforming moment is when the second stage of the process selectively reinforces or diminishes details of the first stage, while giving rise to pictorial by-products that instantaneously become part of the final result (unless they are revised by yet another pass of the squeegee). In Warhol's oeuvre these procedural dividends provided grist for a keen graphic sensibility intent on dominating viewers with unavoidable, unforgettable yet disturbingly vacant emblems of visual power. In the work of Richter, who possesses perfect pitch for controlled accident, they can be lavish, hyperkinetic, harrowing, or lyrical. In any form they are the stuff of visual poetry.

From 1977 through 1987, Richter concentrated his efforts on Abstract Pictures, interspersed with occasional landscapes or clusters of landscapes. Between 1982 and 1983, two other subjects preoccupied him: candles singly, in pairs, or in groups of three, and skulls, always one at a time and once in combination with a candle. The candles, with one exception cropped above the candle-holder, burn against a muted background in two tones of brown or gray. The skulls, bathed in what appears to be natural light that is alternately warm and cool, sit on a barren table top or sill, right-side up or upside down. The ambience of both subjects is still and austere. The skull has an alabaster or ivory sheen. The flames seem to tilt ever so slightly, and the molten wax below the wick glows. Although the candles might have come from a restaurant table, neither they nor the skulls seem contemporary, yet they are not obviously of any other time either. One hesitates to state the obvious logical conclusion because it sounds so trite, but in the most problematic ways possible Richter has made them timeless, as if the only way to achieve that point without sentimentality (while simultaneously suggesting the brevity of life) is to seem to be quoting the old-master *vanitas* painters such as Georges de La Tour and Francisco Zurbarán yet to side-step exact correspondences. Different from his landscapes, in their iconic emptiness as well as in the accent they place on motion (the flickering taper) or its absence (the shell

of bone), they are the antithesis of his agitated abstractions of the period. The candle and skull paintings are serene, meditative, overtly classical, and eerie. Richter has said little about these works—although it is perhaps telling that he began painting them as he turned fifty—and they garnered little attention when they were first exhibited in Germany.[81] However, in retrospect they were plainly forerunners of the much darker reflection on mortality that comprises the *October 18, 1977* cycle.

The date from which this cycle of fifteen paintings takes its title marked the mysterious end of a prolonged struggle between a small group of student radicals turned armed revolutionaries, and the police, courts, political establishment, and large parts of the population of the German Federal Republic. It was, in the word of the German novelist and Nobel laureate Heinrich Böll, a war of "six against sixty million." The six stood for a loose confederation of youthful activists—mostly anarchist and Communist—who in turn represented a much larger segment of their disaffected generation, a generation for the most part born after the war and at odds with that of their parents who had acquiesced to, if not supported, Hitler. Alienated by their society's refusal to come to terms with the Nazi past, by the rampant materialism of the booming postwar German economy, by the specter of another hot war on European soil brought on by the cold war being waged between the Soviet Union and the Warsaw Pact and the United States and NATO, and finally by Germany's involvements with the Shah of Iran and with the escalating American campaigns in Southeast Asia, students and others began to organize and protest with increasing fervor and effect in the late 1960s. Their initially peaceful actions soon triggered a violent response from authorities, which pushed parts of the Left toward violent countermeasures and finally toward a decade and more of underground urban guerilla attacks. Of the many who participated in such tactics, the Red Army Faction (RAF) became the most notorious. Its principal members were a rebellious street hustler with a streak of bandit-like bravado named Andreas Baader and a morally severe radical journalist and former pacifist, Ulrike Meinhof. Added to this mismatched pair, for whom the Baader-Meinhof group was named, were another antiwar organizer and sometime publisher Gudrun Ensslin (Baader's lover and Meinhof's ideological adversary), a sociologist of the counter-culture and filmmaker, Holger Meins, and two others who shared their fate, Jan Carl Raspe and Irmgard Möller. In varying degrees and capacities, all were involved in a two-year string of robberies, shootings, escapes, and bombings, which ended in 1972 with their arrest and imprisonment and eventual trial, a five-year-long battle of wills between the German legal system at its worst and the radicals at their worst. Over the course of their incarceration, Baader, Meinhof, Ensslin, Meins, and the others resisted the state in every way possible; the state broke or rewrote its own laws to pursue their prosecution while maintaining a police presence in the Federal Republic that was in many respects uncomfortably similar to that of Germany's authoritarian past.

Meanwhile, outside Stammheim prison near Stuttgart, where the radicals were kept in virtual isolation, other members of the RAF and allied groups of European and Middle Eastern terrorists kidnapped hostages, hijacked planes, invaded embassies, sequestered high government officials, exploded bombs, and retaliated for the deaths of their comrades-in-arms. Inside Stammheim, among the methods of protest followed by the prisoners were hunger strikes, the longest of which physically and emotionally exhausted Meinhof and claimed the life of Holger Meins. On May 9, 1976, Meinhof was found hanged in her cell; the official and probably accurate verdict was suicide but circumstances bred widespread suspicion that she had been murdered. On the night of October 18, 1977, the last and most desperate attempt to free the prisoners in exchange for hostages on a plane hijacked by terrorists and flown to Mogadishu, Somalia, ended in a raid that killed all but one of the

hijackers, and released the passengers. The following morning, Baader was found dead in his cell with a bullet wound in his head; Raspe was found dying, also of a bullet wound; Ensslin was found dead in her cell hanging from a grate; and Möller, the only one of the core group to survive, was found with stab wounds in her chest. Once again, the official verdict was suicide, but the situation was even more fraught with suspicion and more mysterious than at the time of Meinhof's death. The question of whether the three who died took their own lives as a last act of revolutionary defiance or out of despair, or whether they were executed by agents of the state has never been settled, although some combination of the first two explanations is the most probable answer. In any event, the "civil war" started by the Baader-Meinhof group continued to flare into violence as late as the 1990s.[82]

October 18, 1977 of 1988 (pages 188–197) consists of fifteen paintings depicting people or scenes from the Baader-Meinhof story. With one exception—*Youth Portrait* (page 188), based on a studio photograph of Ulrike Meinhof taken shortly before she abandoned her career as a political essayist and public spokesperson for the Left and went underground—all are based on video footage, press images, and evidentiary pictures from the police archives, which Richter clipped from news magazines, or copies of which were made available to the artist by friends. *Arrest 1* and *Arrest 2* (page 188) show Meins surrendering to an armored car whose gun is trained on him while he strips to prove that he is unarmed. *Confrontation 1*, *Confrontation 2*, and *Confrontation 3* (page 190) follow Ensslin as she passes in front of the camera on her way to or from her cell. *Hanged* (page 191) centers on Ensslin's corpse as it was discovered the morning of October 18. *Cell* (page 193) reveals the book-lined corner of Baader's quarters in Stammheim; and *Record Player* (page 193) zeros in on the phonograph that was supposedly the hiding place for a smuggled gun with which police claimed Baader shot himself. *Man Shot Down 1* and *Man Shot Down 2* (page 192) are two versions of the same forensic image of Baader dead on the floor of his cell. The three versions of *Dead* (pages 194–195) are likewise based on a single photograph of the hanged Meinhof, cut down and laid out, with the ligature still around her neck. The final and largest canvas, *Funeral* (pages 196–197), depicts a procession of three coffins containing the remains of Baader, Ensslin, and Raspe as they moved through a crowd of thousands of sympathizers—interspersed with and surrounded by a thousand armed police officers—on their way to a common grave in a cemetery on the outskirts of Stuttgart.

Episodes from a much longer narrative, the paintings Richter completed and preserved make use of only a handful of the dozens of pictures he had amassed. (At least two, a portrait of Meins on his deathbed and the second version of *Hanged,* which became *Blanket,* were overpainted.) Moreover, he bypassed all documentation of the RAF's terrorist acts as well as all pictures of their victims, their trial, and the secondary members of the RAF such as Raspe. Instead, Richter concentrated on the terrible denouement of their destructive, self-destructive, and ultimately futile efforts at toppling the German power structure and transforming Germany.

Although Richter had implicitly painted history when he tackled the subjects of Allied war planes in action—*Bombers* of 1963 and *Mustang Squadron* of 1964 (page 20)—and probed his own relation to events in such works as *Uncle Rudi* (page 20) and *Mr. Heyde* (page 59), both of 1965, and, on a more abstract level, *48 Portraits* of 1971–73 (pages 70–73), nothing in his oeuvre had fully anticipated *October 18, 1977*. Neither its topical nature nor its ambitious reappraisal of the reliability of photomechanical imagery in relation to the problems of representing what we know about the past and what we believe about its significance had any precedent. Not only did Richter, in effect, inventory photographic

genres in selecting sources for the imagery, he also examined the nature of the elusive "facts" the camera records and memory ostensibly preserves as well as make use of the classic painterly genres (portrait, still life, interiors, and figure composition). Additionally, he reprised history painting, a lapsed genre but once the most celebrated in Western tradition; he invoked and then utterly reconceived it in the cycle as a whole. Further, he pushed to new expressive limits his use of *grisaille*, which he had set aside a decade before and had not expected to take up again.

Thus, the gradual dissolve of the three images of Meinhof's head and the two of Baader's body suggest the simultaneous fading away of life and memory, just as the equally cinematic progression of images of Ensslin traces the fleeting smile of an all but condemned woman spontaneously responding to the regard of another person, only to record her final turning and the hardening of her face as she prepares to walk out of view and out of time. In *Hanged* the vapors surrounding Ensslin's faint, husklike form gently hold her in suspension as they envelop her; in *Cell*, the striated pigment reinforces the feeling of being immured by books—metonymic symbols of ideological possession—while they also create the vertiginous impression that the floor has fallen away like a trap door. In *Arrest* the pull of Richter's brush across the wet surface mimics the lateral breakdown of a picture on a television screen, while in the chiaroscuro lighting of the formally composed *Youth Portrait* Richter appropriates a manifestly artificial likeness of the thirty-six-year-old Meinhof taken at the fatal moment of decision when she joined Ensslin in springing Baader from jail and became an outlaw herself. This effect renders the image more artificial while rejuvenating the subject and conjuring up an innocence for Meinhof that was long since lost when she sat for this picture. Finally, in the large panoramic *Funeral* the artist amalgamates individuals within the crowd as if they formed a human tide bearing the coffins along. In the upper margins of the canvas he adds a subtle horizontal bar to the top of a tree, discreetly introducing into the composition a crucifix not present in the source photograph.

In sum, the painterly alterations—of size, proportion, tonal nuance, properties of pigment, manner of application, manner of revision or un-painting—of the photographic source call into doubt the pretense that such documentary sources can be trusted to testify to the truth of the situations or events they ostensibly register faithfully and without visual distortion or bias. At the same time, these alterations edit out nonessential details and add pictorial accents to those that remain, leaving us with inflections that tap into uncertainties about overly familiar ready-made images and the intense, contradictory feelings that may be absent from the original but are deeply rooted in the media-saturated consciousness of the viewer who recalls seeing the pictures before, yet is suddenly confronted with the ambiguity and instability of the information they contain, and, by extension, with the gaps in the stories they purport to tell.

The impulse for painting the series came some ten years after the events it describes. By that time, the wounds inflicted on Germany by both sides in the conflict had scarred over, leaving a dull throb. Richter reopened and probed them at just about the time that summaries of what had happened had been fully codified by the main ideological camps (those of normalizing order and those of stalled dissent) threatened to overtake firsthand recollection and become contending versions of the "official story." At the heart of the project was Richter's own ambivalence toward the opposing parties involved. Having left the East after living for thirty years under crusading dictatorships, Richter was thoroughly disenchanted by the apocalyptic romance that had seized the Baader-Meinhof group and so many people in his milieu; but he had equally few illusions about the stultifying self-

satisfaction of West German society with its old hierarchies, new materialism, and dispiriting conformity. On the one hand, Richter admired the RAF for its naively hopeful convictions, but rejected the philosophical and social premises upon which those convictions were based and the violence that was their consequence. On the other hand, he sided with capitalist democracy as the lesser of political evils but scorned its inertial smugness and philistinism: "I was impressed by the terrorists' energy, their uncompromising determination and their absolute bravery; but I could not find it in my heart to condemn the State for its harsh response. That is what States are like, and I have known other, more ruthless ones."[83] In this regard, Richter's position is neither one of Olympian detachment nor one of unquestioning partisanship. Rather, the paintings speak from a confusion that more accurately defined the reality of the situation than any view that presupposed an unclouded perspective, a logical or moral high ground, or individual view of the contested field that did not inherently limit or skew one's understanding.

The truth suffusing the shadows of *October 18, 1977* is that truth is fragmentary, that its enemy—ideology—is ultimately murderous, and that history is irremediable and, for the most part, irretrievable. Good does not necessarily rise from the ashes; it more likely evaporates into them and is blown by the wind leaving behind a damaged consciousness that must endure not only the sharp pain of specific losses but the constant ache that reminds us of the self-deception and error that are the origins of tragedy. Contrary to the critics who attacked Richter's commemoration of the lives and deaths of the members of the Baader-Meinhof group on the grounds that it celebrated them as martyrs to Leftist causes, and contrary also to commentators who questioned Richter's right as a "bourgeois" artist to address himself the issue of revolution, or to those who took him to task for failing to point an accusing finger at German authorities whom they were sure had executed the prisoners in Stammheim, Richter never intended to lay a wreath at the tomb of self-sacrificing heroes nor play the part of a Zola and condemn official injustice. Indeed, few critics seem to have troubled themselves to read Richter's unequivocal dismissal of Communism and the disastrous folly of radical adventurism, nor did they ever come to terms with the fact that Richter thought the Baader-Meinhof group was desperate and deluded, not heroic.

Richter's aim was more complex than hagiography and by far harder to achieve. First, he sought to make a series of modern paintings that would do the work of traditional history painting in a period when photography, film, and television had taken over as the chroniclers and preservers of public memory, and to do it in a way that instilled critical doubts about the memories we harbor and those that are handed down to us by professionals in the media, government, and academy. Second, he wanted to give a human face to the victims of ideology who, for ideology's sake, created victims of their own, and to free the suffering they experienced and caused from reductive explanations of their motives and actions, and from political generalizations and rigid antagonisms that triggered the events in the first place. Richter's third purpose in painting *October 18, 1977* was to mourn.

Identifying with the idealism but not the ideals of the RAF, Richter painted a lament for the mesmerizing, unrealistic, and potentially ruinous visions to which critical reason gives rise. "The deaths of the terrorists, and the related events both before and after, stand for a horror that distressed me and has haunted me as unfinished business ever since, despite all my efforts to suppress it." Richter wrote in preparation for a press conference held when the cycle was first exhibited.[84] "It is impossible for me to interpret the pictures. That is: in the first place they are too emotional; they are, if possible, an expression of a

speechless emotion. They are the almost forlorn attempt to give shape to feelings of compassion, grief and horror (as if the pictorial repetition of the events were a way of understanding those events, being able to live with them)."[85] This reckoning runs directly counter to the assumption of many postmodern critics that painting had once and for all forfeited its claims to speaking to the public on public matters but, even more, had given up on doing so in ways that could bring about genuine catharsis, which is the culminating effect of tragedy. By word and deed Richter insists that this cathartic function, though not a symbolic resolution to social and political dilemmas, remains within painting's scope. He wrote: "Art has always been basically about agony, desperation and helplessness. (I am thinking of Crucifixion narratives, from the Middle Ages to Grünewald; but also of Renaissance portraits, Mondrian and Rembrandt, Donatello and Pollock.) We often neglect this side of things by concentrating on the formal, aesthetic side in isolation. Then we no longer see content in form. . . . The fact is that content does not have a form (like a dress that you can change): it *is* form (which cannot be changed). Agony, desperation and helplessness cannot be represented except aesthetically, because their source is the wounding of beauty (Perfection)."[86] The utopian dreams of the 1960s and 1970s were emblematic of an impossible perfection. The wounding of their beauty was both inevitable and in large measure self-inflicted, but such knowledge does not diminish the "agony, desperation and helplessness," to which Richter responded in spite of himself and to which he gave morally disquieting and profoundly moving artistic expression.

Many Americans have never heard of the Baader-Meinhof group, just as many will have forgotten their nearest equivalent in this country, the Weather Underground, and the angry period in our own history that produced it and other violent splinter groups of the new Left. However, the reality of terror and its dynamics are anything but remote. Quite the opposite: the September 11, 2001, attack on the World Trade Center in New York has made terrorism horrifically of the moment and chillingly promises that it will also be a part of our future. In light of recent events, then, the reflex response to paintings of terrorists from another time and place may be to withdraw in fear or hurt or contempt and refuse to engage with such images on the premise that to do so would show compassion toward people who would seem to have lost all claim to it. If the choices were so simple and the people who perpetrated such acts were essentially alien to us, such a turning away would be understandable. However, the lesson of the Baader-Meinhof group and its rebellion is that men and women who make war on the society from which they come are not driven by demons or individual perversities but, rather, by soul-destroying despair over the perceived evils of the world into which they were born and the irrational hope that symbolic violence can remake that world anew. This is no less true of Timothy McVeigh who struck out at the U.S. government and killed hundreds of his fellow citizens or of the foreign kamikaze who imploded an icon of the system they abhor, killing innocent individuals from countries around the world, including their own.

The day the World Trade Center was destroyed a journalist noted that in the dust on a car near the site someone had traced the words: "Oppression produces monsters." Wittingly or unwittingly, this is a paraphrase of the legend on the first image of Francisco Goya's phantasmagorical suite of etchings, the *Caprichos*. It reads: "The sleep of reason produces monsters." In the *Caprichos* and in Goya's other masterwork, the *Disasters of War*, antirational forces are embodied by superstition, religion, and the oligarchy of Spain, while oppression is personified by the armies of Napoleon, which invaded Spain in the name of revolutionary enlightenment. Whatever the cause in modern times, oppression or the sleep of reason, the fact is that monsters are not freaks of nature, they are created

ROBERT STORR

in our midst out of destructive inclinations we subliminally share, misguided beliefs to which we are also susceptible, and extreme pressures we experience. Richter's paintings do not excuse and certainly do not glorify the things the Baader-Meinhof group did, nor do they presume sympathy for the people portrayed, but powerfully and inexplicably they draw such sympathy from the depths of the viewer's conflicted being. They are not pictures of an absolute political, psychological, or cultural other but of an otherness that we can recognize if only we look inward as long and hard as the paintings themselves demand to be looked at. An avid reader of Nietzsche throughout his life, Richter knows that what is there to be seen in either direction is "all too human." Our recent experience with terror on a truly appalling scale makes such knowledge imperative.

While working on *October 18, 1977*, Richter made a color portrait of his daughter. The photograph on which *Betty* of 1988 (page 79) is based shows her facing away from the camera and staring into a dense amorphous expanse of gray. The source image dates from the late 1970s when the Baader-Meinhof drama was still unfolding and Richter was grappling with avant-garde hostility and the dwindling hope for painting that the monochrome represented to him. In short, he was confronted on all sides by orthodoxies. Returning to this photograph while in the process of painting the October cycle was a delayed response to that earlier moment of desperation. At the center of the RAF were two women—Meinhof and Ensslin—who impressed Richter the most among all the other members of the group. An alternating psychological current of anxiety and vitality runs through *Youth Portrait*, the *Confrontation* triptych, and *Betty*, connecting Richter's thoughts about one generation to those about another. The grim reality faced by two women—one of them, Meinhof, having been his near contemporary—is reflected in the murky horizon that lies over the shoulder of a young girl becoming a woman. *October 18, 1977* was painted in tones of death; *Betty* is comparatively lifelike, but grayness threatens to engulf her; an implicit competition in one's mind between optimism and pessimism fills the image with a gentle pathos.

A year later, Richter made another series of paintings, this time abstract and on a heroic scale. They are three diptychs titled *November, December,* and *January* (pages 80–81), the months following October. It is as if, after a hiatus, Richter had shifted gears aesthetically to record the rising anguish of the "German Autumn" of 1977 as it passed into a long dark winter of discontent. Heavily encrusted with anthracite black and cold white pigment that has been raked so that in spots reds and yellows crackle like embers, these raw but masterful canvases suck up all the oxygen in the rooms they occupy and occlude any view of the world beyond. Punctuating a decade that began with painterly fireworks, and heralding a new generally harsher variety of allover abstraction, these paintings are a coda to *October 18,1977*, a majestic dirge for a bitter era.

Flowers [Blumen]. 1992. Oil on canvas, 16⅛ × 20⅟₁₆" (41 × 51 cm). GR 764-2. Private collection

ROBERT STORR

Gray Mirror [Grauer Spiegel]. 1992. Oil under glass; two parts, each, 7' 2¾" × 31½" (220 × 80 cm). GR 765. Statens Museum for Kunst, Copenhagen

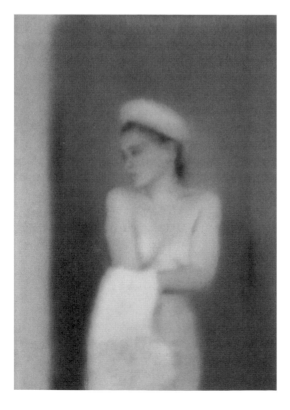

Abstract Picture [Abstraktes Bild]. 1992. Oil on canvas, 69" × 8' 2½" (175 × 250 cm). GR 757. Joseph Hackmey Collection

Small Bather [Kleine Badende]. 1994. Oil on canvas, 20⅟₁₆ × 14³⁄₁₆" (51 × 36 cm). GR 815-1. Private collection

ROBERT STORR

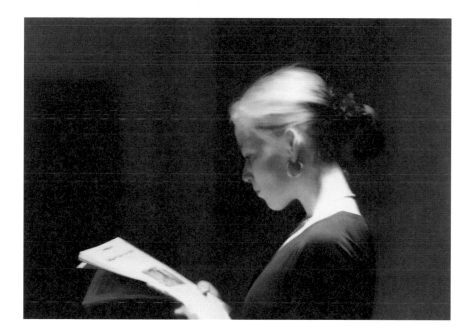

Reading [Lesende]. 1994. Oil
on linen, 28½ × 40¼" (72.4 ×
102.2 cm). GR 804. San
Francisco Museum of Modern
Art. Purchased through the gifts
of Mimi and Peter Haas and
Helen and Charles Schwab, and
the Accessions Committee Fund

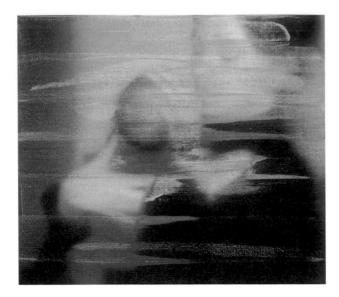

S. with Child [S. mit Kind]. 1995.
Oil on canvas, $14\frac{3}{16} \times 16\frac{1}{8}$"
(36×41 cm). GR 827-1.
Eigentum der Stiftung zur
Förderung der Hamburgischen
Kunstsammlungen, Hamburg

**Abstract Picture [Abstraktes
Bild].** 1992. Oil on aluminum
panel, $39\frac{1}{2} \times 39\frac{1}{2}$"
(100×100 cm). GR 778-4.
Private collection

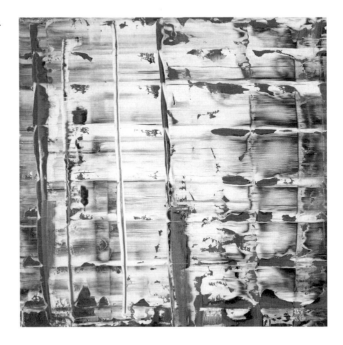

ROBERT STORR

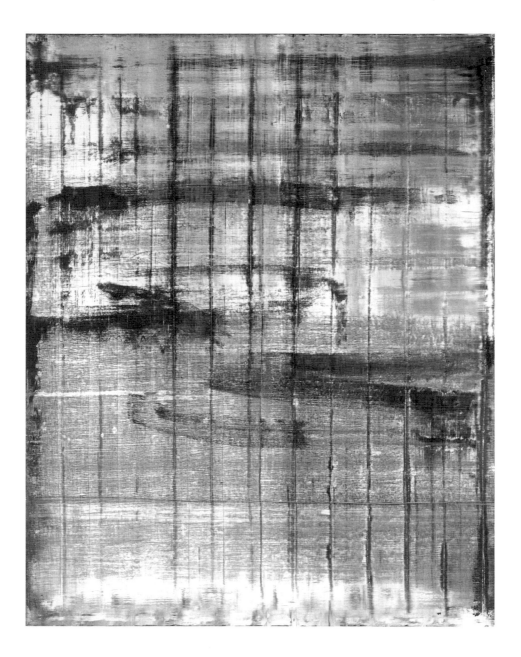

March [März]. 1994. Oil on
canvas, 8' 2⁷⁄₁₆" × 6' 6¾"
(250 × 200 cm). GR 807. Private
collection

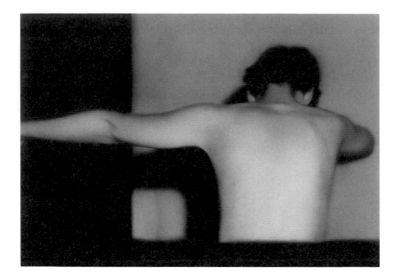

I.G. 1993. Oil on canvas, 28⅜ × 40⅛" (72 × 102 cm). GR 790-4. Private collection

Abstract Picture, Kine [Abstraktes Bild, Kine]. 1995. Oil on linen, 48¹³⁄₁₆ × 35⁷⁄₁₆" (124 × 90 cm). GR 832-3. Collection Isabel and David Breskin

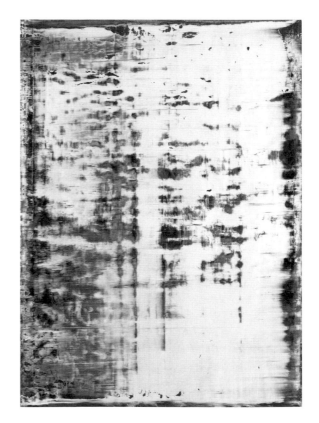

ROBERT STORR

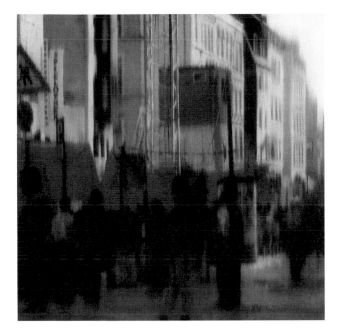

Demo. 1997. Oil on canvas, 24⁷⁄₁₆ × 24⁷⁄₁₆" (62 × 62 cm). GR 848-3. The Rachofsky Collection

Abstract Picture [Abstraktes Bild]. 1999. Oil on aluminum panel, 21¹¹⁄₁₆ × 18¹⁵⁄₁₆" (55 × 48 cm). GR 857-4. Private collection

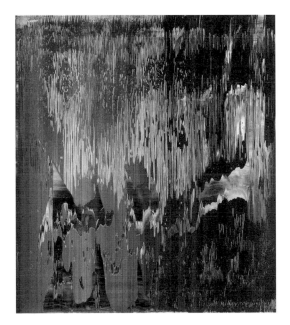

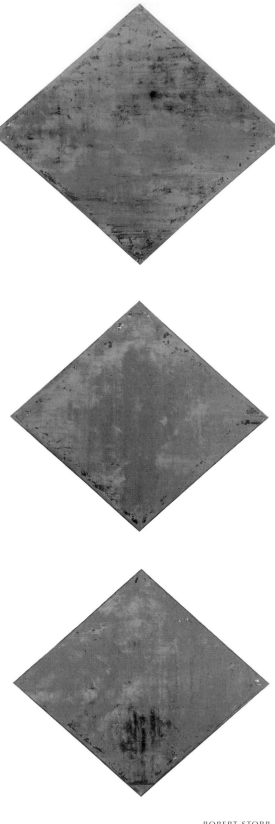

**Abstract Picture (Rhombus)
[Abstraktes Bild (Rhombus)].**
1998. Six paintings; oil on canvas,
various dimensions. GR 851-1
through 851-6. The Museum of
Fine Arts, Houston. Gift of
Caroline Wiess Law in honor of
Peter C. Marzio, Director, The
Museum of Fine Arts, Houston
(1982–present)

top: 7'6¼" × 8'5⅛" (229.2 ×
256.9 cm). GR 851-1

center: 6'1⅛" × 6'10⅛" (185.7 ×
208.6 cm). GR 851-2

bottom: 6'1" × 6'11¾" (185.4 ×
211.8 cm). GR 851-3

opposite, top: 6'1⅛" × 6'10⅛"
(185.7 × 208.6 cm). GR 851-4

opposite, center: 6'1⅛" × 6'10"
(185.7 × 208.3 cm). GR 851-5

opposite, bottom: 6'1¼" × 6'10"
(186.1 × 208.3 cm). GR 851-6

ROBERT STORR

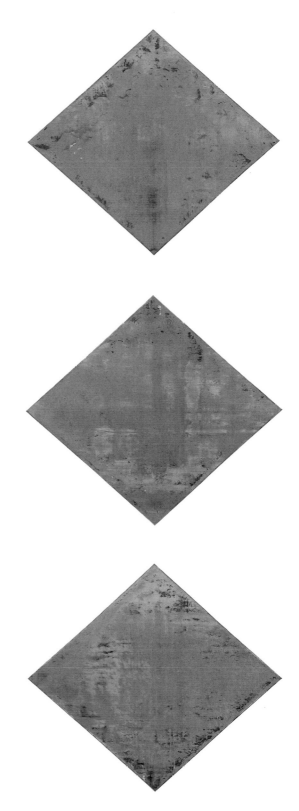

Moritz. 2000–2001 (work in progress). Oil on canvas, 24⁷⁄₁₆ × 20½" (62 × 52 cm). GR 863-3. Private collection

Self-Portrait [Selbstportrait]. 1996. Oil on linen. 20⅛ × 18¼" (51.1 × 46.4 cm). GR 836-1. The Museum of Modern Art, New York. Fractional and promised gift of Jo Carole and Ronald S. Lauder and Committee on Painting and Sculpture Funds, 1996

**Court Chapel, Dresden
[Hofkirche Dresden].** 2000. Oil
on canvas, 31½ × 36⅝" (80 ×
93 cm). GR 865-3. The Museum
of Modern Art, New York.
Promised and fractional gift of
Donald L. Bryant, Jr.

Seascape [Seestück]. 1998. Oil on canvas, 9'6⅛" × 9'6⅛" (289.9 × 289.9 cm). GR 852-1. San Francisco Museum of Modern Art. Fractional gift of an anonymous donor

ROBERT STORR

Abstract Picture (Abstraktes Bild). 2000. Oil on canvas, 68¹⁵⁄₁₆" × 8'2⁷⁄₁₆" (175 × 250 cm). GR 867-3.
Private collection, Chicago; courtesy Marian Goodman Gallery, New York

III: PERMISSION GRANTED

"SINCE THERE IS NO SUCH THING AS ABSOLUTE RIGHTNESS AND TRUTH, WE ALWAYS PURSUE THE ARTIFICIAL, LEADING, HUMAN TRUTH."

—Gerhard Richter[1]

Since the late 1980s Gerhard Richter's work has assumed a fairly steady rhythm, oscillating between photo-based pictures and abstractions. Virtually all of the former are in color, *October 18, 1977* having been the climax and summary statement of his prolonged ambivalence, after which gray ceased to be the metaphorical noncolor of choice. When grays reappeared as the dominant hues of Richter's abstractions of 1998 to 2001, they are generally suffused with other hues and sometimes—as in *Abstract Picture* of 2000 (page 135)—achieved a purely tonal vibrancy unprecedented in his lead- and pewter-gray paintings of the late 1960s and early to mid-1970s. Richter's new subject matter reflected this same shift in emphasis. Previously the proponent of an impersonal and dispassionate art, Richter began to produce works of startling intimacy, although, in the past, he had frequently scattered images of family and friends among the facets of public modernity he chose to paint. Thus, *Betty* of 1988 (page 79) had been preceded by another portrait of his daughter, *Betty* of 1977 (page 74). She is roughly the same age in both works, since the photograph used for the later painting was taken around 1977. But the hard, almost Flemish old-master quality of the earlier full-face picture contrasts strikingly with the softer turned-away head that came after it. This contrast is also seen in *Ema (Nude on a Staircase)* of 1966 (page 27), Richter's portrait of his first wife and Betty's mother, painted the year their child was born. Before that, in 1965, there were portraits of Richter's uncle in a soldier's uniform, *Uncle Rudi*; of his clowning father, *Horst with His Dog*; of himself as an infant with his aunt, *Aunt Marianne*; and numerous other pictures, which, although not specified as scenes from his own domestic life, resonate subliminally with private feeling. However, Richter's paintings of his second wife, the sculptor Isa Genzken, of his present wife Sabine Moritz, whom he married in 1995, of Sabine with their son Moritz, of Moritz by himself, and, most surprisingly perhaps, two self-portraits (one of which includes his critical supporter and aesthetic sparring partner, Benjamin Buchloh), which collectively represent a new, psychologically charged, though still psychologically ambiguous, direction in his work.

Altogether, Richter seems to have made seven portraits of Isa Genzken: two frontal head-and-shoulders images dated 1990 that are atypically brushy in their un-painted portions were published in a 1996 book on Richter's work, but do not appear in his catalogue raisonné, and five half-length nudes of 1993 simply titled *I.G.*, of which the last two are the most striking and the most severe in the series (page 128). In them, Genzken's pale bare shoulders and close-cropped black hair set up a sharp tonal contrast that is echoed in the semiabstract arrangement of gray panels and black molding in the background and what appears to be the black frame of the photographic print in the foreground. Against this stark setting, Genzken's lean body softens, even when, in the first of the pair, she stretches her arms laterally as if she were exercising and in so doing presses outward against the picture's edge. Facing away from us in both paintings, she is as inaccessible as she is exposed,

ROBERT STORR

as lost in her own reality as she is vulnerable to the objective gaze of the camera that captured her likeness and the reticent but hardly objective hand that transcribed it onto canvas. Here, the very detachment Richter assumes becomes the inverse sign of emotion, of a distance between two people that is not just aesthetically imposed but rather the expression of two solitudes.

Of Sabine alone, Richter has thus far painted three paintings. Two are titled *Reading* and are from 1994. The first is an exquisitely diffuse view from the back of a young woman looking down at the page of a magazine. Her hair is bound in a tight bun by a dark cloth or fastener at the apex of the pyramid of light and shadow that is her neck, while her ear and the side of her face blush orange-red, and her cheekbone and jaw are silhouetted by a delicate violet. The image floats before the eyes in space and time, having nothing about it that identifies the place or period from which the woman comes and with only the subtlest stylistic indicators of when it was made. Equally refined but in sharper focus, the second version is a full profile of a singularly beautiful person unconcerned by her beauty and wholly engrossed by the text in her hands (page 125). Although frustrated in the past by his inability to paint like Vermeer (to the point of mutilating his own pictures), the fact of the matter is that in this instance Richter came astonishing close to that model, but no closer than he should have for it to still be his own work and one that is unmistakably of its moment. The same holds true for *Small Bather*, his third portrait of Sabine of that year (page 124). This diminutive, pastel-like oil on paper recalls turbaned odalisques in the seraglios of the French painter Jean-Auguste-Dominique Ingres, but the turban is a towel and the nude wearing it appears to have just stepped out of the shower. She is lovely, to be sure, but also pensive and modest in her nakedness, not the explicitly alluring eternal female in Oriental garb but something closer to Mme Bonnard just out of the tub, as seen through the consolidating lens of Richter's subdued neoclassicism.

The eight 1995 paintings of Sabine that make up the series of works titled *S. with Child* (page 126) revert to Richter's earlier practice of defacing his pictures for reasons previously discussed. Here, the primary ones are his insistence on artifice in opposition to assumed realism, his preference for ugliness over mere attractiveness, and for anti-facture over the easy resolution of conventional pictorial finish. However, despite the more-or-less radical erasures that mark all but one of the series, the motif itself remains shocking in the context of his work as a whole and in that of late twentieth-century painting. After all, what other major artist of the last fifty years has dared to paint anything so overtly suggestive of a Madonna and Child? For that matter, who has painted anything so like family-album baby pictures as the three versions of *Moritz* that Richter completed between 2000 and 2001 (page 132). In the world of gendered perspectives that we have inherited from feminist critical discourse beginning in the 1970s, Richter's paintings of Sabine are plainly examples of the male gaze at work, albeit the gaze of a man experiencing love and mature contentment of an almost palpable tenderness. By the same token, it may take a father's eyes to read these pictures accurately, or the capacity to appreciate how a new but older father who had little involvement with his own father might look at his first-born male child. From that vantage point, Richter's response embraces an elusive mix of fascination, bemusement, and uneasiness, which is an adult manifestation of the devoted, puzzled, and wary gaze a child might direct at its parents. Even for someone like Richter, who places little stock in Freudian ideas, but whose familiarity with the German Romantic painter Philipp Otto Runge's race of moon-faced children should be taken into account, the specter of the Oedipal other hovers over this plump cherub, whose cheeks are smeared with food as if he

were an uncanny poster boy for baby food. And if the first version of *Moritz* is the most nuanced and the most complex in its painterly disturbance of verisimilitude, and the third version is the least, then the second, with its abbreviating *sfumato* making a halo around the child's haunted, saucer eyes and clutched hands is the one in which Richter's paternal apprehension most obviously matches that of his offspring.

The countenance Richter offers the world in his 1996 *Self-Portrait* (page 132) also has a somewhat haunted aspect, although without the heightened emphasis on the eyes found in the paintings of Moritz. Indeed, Richter's glance off to the left side of the picture breaks with the tradition of self-portraiture in that he does not stare straight ahead, as into a mirror, and by thus breaking anticipated eye contact with himself and with the viewer, he creates distance, interrupts reflex empathy, and underscores the photographic dimension of the image. As in his portraits of Genzken, Richter positions himself in front of a wall vertically divided into tonal zones that is bisected horizontally by his blue shirt, lending the symmetrical composition a spare formality reminiscent of the Spanish baroque realists Diego Velázquez and Francisco Zurbarán. The painting reminds one as well of the artist's early comments on the genre. "A portrait must not express anything of the sitter's 'soul,' essence, or character," Richter said. "Nor must a painter 'see' a sitter in any specific, personal way; because a portrait can never come closer to the sitter than when it is a very good likeness. For this reason, among others, it is far better to paint a portrait from a photograph, because no one can ever paint a specific person. . . . I never paint to create a likeness of a person or of an event. Even though I paint credibly and correctly, as if the likeness were important, I am really using it only as a pretext for a picture."[2] There is no melodrama in this self-portrait, but in the tension between his deadpan pose and the self-examination to which he submits himself much of the artist's character and something of his anxiety come through. In the tug-of-war in his own mind between the hidden motive for making a particular picture and its visible pretext, Richter's motionless but not quite emotionless face becomes the scene of the contest.

Similarly, *Court Chapel, Dresden* of 2000 (page 133), a double portrait of Richter and Buchloh, slowly reveals as much as it seems to conceal initially. Based on a snapshot, it shows the slight artist smiling tentatively in front of the larger, almost hulking form of the critic who also seems to be smiling but is looking away from the camera and from his companion. As to the significance of the historic site used as background we can gather little other than what the title tells us, that it is a church and it is in Dresden. By all appearances, then, a commonplace travel picture, the painting is, in fact, a portrait of the friendship between two men whose views of the world are almost diametrically opposed, except for their shared resistance to social conformity and their distaste for complacent art. For every one of Richter's doubts, Buchloh has a carefully worked out position. To Richter's hostility toward ideology in all its forms, Buchloh has responded by trying to adapt his own ideological assumptions to the demands of Richter's art, only to reassert them in the end. To Richter's devotion to painting, Buchloh counters with a deep hostility toward aesthetic conservatism of which painting is, for him, exemplary. The list goes on, although the bond between them has endured all manner of disagreement. But note where Richter has staged this encounter between the radical scourge of bourgeois false consciousness and the painter who has tested his faith in art and his own skeptical humanism against every possible challenge: in the portal of a church—as in a Gothic niche—in his native city, symbolizing a double homecoming in an age when we can never go home again, but must always remain the outsiders we have become.

ROBERT STORR

In the meantime, Richter's increasingly numerous abstractions have ranged greatly in scale, material presence, and mood. In many the thick alternately buttery or pasty layers of pigment have accumulated to the point where the slippages caused by Richter's scraping techniques result in rich marblings, like those on the endpapers of antique books, although the tactile quality is more like moving lava with trace elements of different minerals providing the attenuated elastic patterns. In other instances, Richter has taken to flaying the painted skin of his canvases with a spatula in broad strokes or long, wavering stripes leaving behind abraded, shimmering surfaces that at their sheerest and most luminous look like the Aurora Borealis suspended above variously red, orange, yellow, green, blue, or violet planets. Inevitably, the vertical, lateral, and sometimes crisscross striations of his hard-edge tool recall—and undoubtedly are meant to recall—the classic modernist grid of Piet Mondrian and his heirs. But in the unstable painterly terrain saturated hues run together and smear in aggressively impure, sometimes lurid, sometimes garish combinations while the grid itself wobbles and shudders in the ebb and flow of viscous pigment. And between the chromatically rich paintings, such as *Wall* of 1994, with its scorching reds, and *Abstract Picture* of 1992 (page 124), with its charcoal latticework, spreads a spectrum wider, more nuanced, and more disconcerting than that of any other contemporary artist. Seldom have colors so luxurious and so punishing appeared in the same painting, and seldom has the medium's hedonistic potential been so closely tied to its capacity for creating discomfort. For much of his career, Richter fended off or argued with abstraction; now it seems he has surrendered to it but never with abandon and always with a determination to paint past the anticipated gratification of a method fully under his control for the sake of haptic or purely optical sensations that veer toward the unpleasant as often as they coalesce into works of stunning beauty. In these paintings, the awkward materialism of his earlier experiments in building up the surfaces of his Art Informel paintings with torn or rumpled fabric and heavy pigments achieves a long sought-after fluency.

To attribute natural qualities to painting is not in any way to suggest that the geological, astronomical, or organic correlations alluded to are on the artist's mind while he works, much less the actual subject of the work. The procedural strictures Richter has laid down for himself are designed to avert painting by analogy in the romantic manner. Nevertheless, drawing correspondences between Richter's work and its formal precedents is unavoidable, and in some cases clearly intended by the artist. Among his abstractions, the outstanding example is the cycle of six canvases that he completed in 1998, all titled *Abstract Picture (Rhombus)* (pages 130–131). The project was initiated by representatives of the Catholic Church, who approached him with the idea of painting the stigmatization of Saint Francis for a modern church designed by the architect Renzo Piano. It would not have been the first time that a secular artist had undertaken such a commission; Henri Matisse created the windows and murals for the Chapel of the Rosary of the Dominican Nuns of Vence, France, without being much of a believer, and Communist artists such as Giacomo Manzù and David Alfaro Siqueiros had at different times made works at the behest of the Pope. Then, of course, there were the myth-obsessed but agnostic Jackson Pollock who planned to make paintings on canvas and on glass for a Catholic church conceived by the architect, painter, and sculptor Tony Smith, who was a religious man; and there are Barnett Newman's *The Stations of the Cross: Lema Sabachthani* (1958–66), a series of fourteen abstract canvases with a Christian theme by a Jewish anarchist with Cabalistic leanings, whom Richter greatly admired.

Richter's first response was to decline the offer, largely because he did not want to commit himself to illustrating a story with a figurative picture in his "style." He was

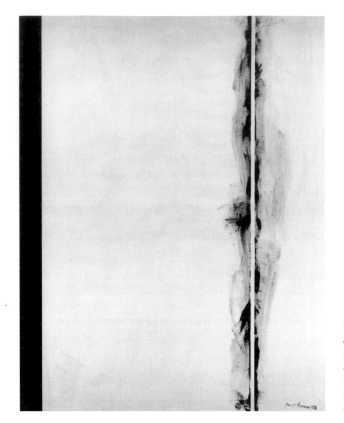

Barnett Newman. **The Stations of the Cross: Lema Sabachthani. First Station.** 1958. Magna on canvas, 6'5⅞" × 60½" (197.8 × 153.7 cm). National Gallery of Art, Washington, D.C. Robert and Jane Meyerhoff Collection

sufficiently interested in the suggestion, however, to propose making a series of abstract pictures instead. The solution to the problem of giving a nonobjective pictorial space the iconographic content of traditional religious art involved rotating and squeezing the rectangle of the stretcher and executing a suite of virtually monochrome paintings on the diamond-shaped canvas ground. Following the example of Mondrian, whose rhomboid paintings were made early in the twentieth century, Richter thus created an anthropomorphic format in which the vertical and horizontal coordinates of the body—the trunk and arms—are implied in the axial orientation of the picture plane. Working off this implicit axis, Mondrian had reapportioned space with linear elements and blocks of color or tone; Richter dispensed with the depicted grid in favor of the variegations of surface achieved by his customary layering of pigments—in this case, a glaring orange flecked with blue, yellow, green, and white. The technique employed tends to "underline" the actual edge of the canvas with abrasions and sequential "skips"—distant cousins of Newman's "zips"—that follow the pressure of his scraper along the hard stretcher bar and reinforce the outer contours of the forms and with that its presence as the template of a human being standing straight with arms extended. Under other circumstances, one might have presumed this to be a variation of Vitruvius's proportional diagram, best known from Leonardo da Vinci's drawing of a man inside a square tracing a circle with his arms and legs, but given the nature of the commission it can only be one thing, an abstract crucifix. That interpretation has been confirmed by the artist and is further justified by the existence of a multiple of a Christian cross that Richter cast in silver and gold two years before the church commission became an issue, as well as by

ROBERT STORR

Gerhard Richter. **Cross [Kreuz].** 1996. Gold, 7⅝ × 7⅝ × ⅝" (19.5 × 19.5 × 1.5 cm). Private collection. Courtesy Anthony d'Offay Gallery, London

the cross that appears in *Funeral* (1988), the last painting in the Baader-Meinhof cycle completed ten years earlier.

When asked by the author about his own relation to the Church, Richter noted that his parents were Protestant, rather than Catholic, and that he had renounced religion in his mid-teens, but then he added: "I was very moved when our two children were baptized. . . . That is my culture, my history, the last 2000 years were Catholic and it was not so bad."[3] Asked about the unorthodox configuration of the sculptural crucifix, with its elongated horizontal element and the high intersection point of the two cross bars Richter explained: "Any person proportioned according to the traditional cross would be deformed. They would have a very long head and really short arms, that is not a human proportion. I wanted to spare myself the figure of Christ and then came up with this idea. I stood against the wall and measured myself and that's how I did it. I put the man and the cross in one shape," adding with laughter, "I tried to make it my shape. It's not everybody's shape." [4] Simultaneously whimsical, hubristic, and serious, Richter's crucifix is, to this extent, yet another discreet self-portrait. Pressed to spell out his level of religious commitment, Richter finally declared: "I am a sympathizer."[5] When it was pointed out that the term had been applied to people who tacitly supported the revolutionary Marxist Red Army Faction, Richter made it plain that he had chosen it with care, was well aware of the ironic and ideologically problematic connotations he was invoking, and said: "The term 'sympathizer' is very much rooted in that history."[6]

Richter's words have the ring of a confession, but also of a characteristic inconclusiveness. Over the years Richter has been famously noncommittal on many topics, and has even seemed to encourage contradictory readings of his paintings, especially insofar as his Fluxus-inspired anti-art leanings in the 1960s and 1970s were concerned. However, Richter never considered himself part of this or any other avant-garde, nor was neo-Dada's tongue-in-cheek subversion of aesthetic values a primary means or an end of his own work. "I never think that way," he told an interviewer in 1990, "If I ever did admit to any irony, I did so for the sake of a quiet life."[7] Rather, he elaborated: "My own statements about my lack of style and lack of opinion were largely polemical gestures against contemporary trends that I disliked—or else they were self-protective statements, designed to create a climate in which I could paint as I wanted."[8] From the beginning, then, Richter's strategy has been one of what he calls "evasive action."[9] Using ready-made imagery to avoid ready-made artistic identities, he has invited association with movements and tendencies while at the same time distanced himself from them by rephrasing the tropes he has appropriated and insisting on the plurality of his affinities. Some observers have viewed this activity as an across-the-board travesty of styles and an articulation of a thoroughgoing aesthetic nihilism. During the 1960s and 1970s in an art-world context where Duchampian ideas prevailed, buttressed by a political critique of Richter's chosen medium, which left little room for a painter to explore

his own intuitions, Richter took refuge in such interpretations because they shielded him from alignment with traditionalist exponents of the conventions with which he experimented. By the end of the 1980s, though, the ready-made identity that most threatened to distort the understanding of his art was the one that had provided him cover. By the 1990s he began to disengage himself from it, challenging postmodernist critics hostile to much that interested him to play catch-up as he headed in directions they shunned. Indeed, the critical injunctions taken for granted by his supporters in this camp seemed to have spurred Richter into going the other way.

Thus, a year after Richter exhibited *Abstract Picture* of 1992 (page 124), and *Gray Mirror* of the same year (page 123) in a pavilion at Documenta 9, along with thirteen other abstractions and a small image of a bouquet, *Flowers* of 1992 (page 122), Buchloh wrote: "Not even the category of the portrait seems ever to have attained the profound level of painterly decrepitude that still life would attain in the sinister harmlessness in the work of Matisse or Maurice de Vlaminck in the twentieth century."[10] Then he cut Richter enough slack to paint his own still lifes with the crabbed excuse that: "Richter's decision to search out the most obsolete of all still-life types might originate in an inverted gesture of opposition to the universal spectacularization to which all avant-garde models are now incessantly subjected."[11] Rebuttal of such arguments would be rated as little more than intramural squabbling among writers were it not for the fact that Richter criticism has been dominated by just this kind of tortured logic, and it has confused and alienated many who are nonetheless drawn to the work and prepared to deal with it in a more straightforward and complex way. Compare Richter's current account of his motives to those that presume such convoluted aims: "That was an attempt at self-protection—saying that I was indifferent, that I didn't care, and so on. I was afraid my pictures might seem too sentimental. I don't mind admitting now that it was no coincidence that I painted things that mattered to me personally—the tragic types, the murderers and suicides, the failures, and so on."[12] To the list of things that mattered to him one must now add flowers, his wife and children, and perhaps the cross.

Borrowing the tactics of their adversaries, reactionary artists have often tried to shock the avant-garde for their own amusement and that of others, but Richter is no more ironic in this regard than any other, nor is he in any way a reactionary. Yet, having upset philistines and conservatives for decades, Richter has now turned his attention to the progressives who have championed him, and to the dated ideas of modernism they apply with increasing scholasticism. Kitsch is the enemy of true feeling, and in the first phase of his career Richter employed every painterly method at his disposal to strip images of clichéd associations and emotions. Now he is doubling back to see if those same images can be painted in earnest and to see if sentiment can fill the space that sentimentality once occupied, and from which it had been expelled by his efforts. What *sentiment* connotes here is more than just the way Richter feels about the people, places, or things he chooses to paint, but how he feels about painting itself and how he responds to the unstoppable need to paint that he shared with Palermo and Polke but found wanting in the more worldly Lueg. In that connection, one is reminded of a remark reportedly made by Franz Kline to the effect that artists distinguish themselves from nonartists by their high threshold for embarrassment. Richter's increasing candor about his reasons for doing what he does raises that threshold in a period when the critical discussion of art is more skittish than ever where ordinary human desires, longings, or states of fulfillment are alluded to without disclaimer.

That said, the word *sentimental* is used advisedly, inasmuch as it has special significance in German aesthetic discourse as a result of the distinction made by the poet, playwright, and

ROBERT STORR

essayist Friedrich von Schiller in his seminal essay "On Naive and Sentimental Poetry." In Schiller's construct, which discriminates between the two types of poetry only in terms of their qualities, without questioning their respective artistic or philosophical validity, the naive artist is at one with nature or, in the sense that Jackson Pollock meant it, *is* nature. By contrast, the sentimental poet regards nature and the incarnations of the ideal engendered in his own mind at equal remove, and critically assesses the disparity between them. While forthright expression is available to the naive poets, sentimental poets are necessarily self-conscious when they speak. "Since the naive poet only follows simple nature and feeling, and limits himself solely to imitation of actuality, he can have only a single relationship to his subject, and in this respect there is for him no choice in his treatment."[13] At the other extreme, "The sentimental poet is . . . always involved with two conflicting representations and perceptions—with actuality as a limit and with his idea as infinite; and the mixed feelings he excites will always testify to this dual source."[14]

Within this framework, Richter would be classified as a sentimental poet increasingly drawn to the prospect of being a naive one, that is, one capable of the direct representation of images, thoughts, and emotions but aware of the impossibility of ever losing his self-consciousness. The two artistic modes in which the sentimental poet excels, according to Schiller, are satire and elegy, both of which focus on the gap between the world as it is and the world as it can be imagined, the first by using the ideal to criticize the real, the second by celebrating the ideal through mourning for its loss. To fit Richter into Schiller's schema without adjusting it would require viewing his works as ironic or melancholy displays of disillusionment, but this skews perceptions considerably. However, if one factors in the contributions of two other German thinkers, both of whom Richter read attentively in his youth, the formula becomes more accommodating, though less comfortable, and Richter's place in it easier to define. On the one hand, there is Arthur Schopenhauer's reasoned and relentless pessimism, his preoccupation with suffering and his striving to subjugate egotistical will and, thereby, limit its power to distort perception. On the other hand, there is Nietzsche's refutation of the Enlightenment's claims for the existence of unitary Truth in favor of the proposition that what we call truths are human constructs that have been ratified by custom and are not genuine representations of reality, which is always hypothetical and ultimately unknowable. While Schopenhauer believed that with art "we keep the sabbath of the penal servitude of willing,"[15] Nietzsche wrote: "What then is truth? A mobile army of metaphors, metonymies, anthropomorphisms, a sum, in short, of human relationships which, rhetorically and poetically intensified, ornamented, and transformed, come to be thought of, after long usage by a people, as fixed, binding, and canonical. Truths are illusions which we have forgotten are illusions, worn out metaphors now important to stir the senses, coins which lost their faces and are considered now as metal rather than as currency."[16] Art, it follows, consists of illusions that declare themselves as such but in so doing sharpen understanding of our uncertain relation to truth, even as it offers glimpses of Apollonian (rational and orderly) or Dionysian (instinctual and cathartic) transcendence. And so, the philosopher Arthur Danto wrote of Nietzsche's relativist doctrine of Perspectivism: "We score the blank surface of reality with the longitudes and parallels of concepts, but the concepts and ideas are ours, and they have not the slightest basis in fact."[17]

In much the same way, Richter's statements and paintings assert the arbitrariness of pictures as representations of their ostensible subjects as well as our capacity for using images to conjure things that transcend our quotidian experience. Pure seeing is therefore an unreliable index of things as they are, although heightened scrutiny can, on occasion,

Gerhard Richter. **Bridge: February 14, 1945 [Brücke: 14. Februar 1945].** 2000–2001. Photolithograph, 18⅛ × 13⁹⁄₁₆" (45.9 x 34.5 cm). Private collection

partially reveal obscured dimensions of reality. But, at the same time, the same compulsion to render reality out of the materials at hand may offer insights about realms that escape our ordinary understanding. Sense data are, by this measure, always illusory; but the senses, in their speculative production of images, do allow us to project intuitions onto reality. We cannot be sure of anything we look at with the naked eye any more than we can be sure that the edited version of a thing reconstituted by art captures its essence; but we can learn about the limitations of our knowledge by repeated attempts at grasping the ungraspable. This holds true equally for commonplace objects within our reach as for remote phenomena—for the faces of those closest to us and the facts of history or the stars.

In this connection, Richter's recent multiples accent the poignant elusiveness and metamorphic flux of vision. Over the past several years he has made numerous photographic editions of his earlier photo-based paintings. Skeptics have suggested that the artist was simply taking advantage of popular demand for these images by disseminating copies of them. This, of course, is hardly an aesthetic crime if you consider that the history of printmaking in Germany began with Albrecht Dürer and his contemporaries making affordable woodcuts and engravings for the sake of people who could not afford paintings. But Richter seems, instead, to have been prompted by the desire to "repair" or somehow repossess key works that had left his hands: for example, *48 Portraits* and *Ema (Nude on a Staircase)*, which had been damaged; and others, such as *Betty* (1988) and *Small Bather*, which he no longer had about him. What is striking about these copies, however, is how different they are from the originals, not in their obvious details but in their overall presence. Just as the camera deliv-

ROBERT STORR

Foto Universität Augsburg

Erster Blick in das Innere eines Atoms

Mit einem Rastertunnelmikroskop konnten jetzt erstmals Details innerhalb eines einzelnen Atoms sichtbar gemacht werden. Auf diesem Bild sind die Elektronenwolken eines Siliziumatoms zu erkennen. Vom Halbleiter Silizium ist bekannt, dass an seiner Oberfläche einige Atome hervor- | Stiel haben, erklären die Physiker als Artefakt, das durch die Technik des Abbildens entsteht („Science", Bd. 289, S. 422).
Die höhere Auflösung erreichten die Forscher, indem sie einen verbesserten Sensor verwendeten. Er besteht aus einer „Stimmgabel" aus einkristallinem Quarz.

Gerhard Richter. **First Look at the Inside of an Atom [Erster Blick in das Innere eines Atoms].** 2000. Photolithograph, $7\frac{1}{8} \times 5\frac{15}{16}$" (18.2 × 13.2 cm). Private collection

ers a likeness of the object of its attention by impartially screening the information before it, it also reduces the quantity and quality of that information to what can be photographed, thereby distorting the image while seeming to reproduce it. Rather than try to restore the missing information by painting it back in from the model, Richter made those distortions more explicit by a variety of painterly manipulations. The effect of rephotographing the painting is to smooth out those manipulations and, where they remain, ascribe them to photographic causes. Thus, *Ema (Nude on a Staircase)*, *Betty*, or *Small Bather* assume an atmospheric naturalness that is, in truth, the height of unnaturalness insofar as it is the compound result of un-painting with a brush and un-painting (removing texture and other signs of painterly materiality) with a lens. The end product, beautiful as it is, is a telescoped sequence of simulacra, an inviting reality triply removed.

The two recent print multiples bracket this same issue with pointedly different subject matter. The first is an aerial shot of a bend in a river that embraces terrain dotted by houses and crisscrossed by roads, highways, and an elegantly winding clover-leaf interchange. Between our overhead vantage point and the ground below are clouds; it is a bird's-eye view of a landscape in which the modern infrastructure and the pastoral seem to coexist in harmony. However, careful inspection exposes a telltale pattern of circles scattered in all directions: bomb craters. Returning to the theme of mechanized warfare three decades after he painted B-52s, Mustangs, and Stukas, Richter chose a reconnaissance photograph taken by an Allied plane flying over the Rhine near Cologne in 1945, erased the cracks in the original print, deleted the caption identifying the source and date of the image, and subtly evened

out the panorama so that only hard looking would seize upon the evidence of the destruction being represented. The second print is a facsimile of an item torn out of the newspaper in which light and dark blobs resembling an Art Informel painting cluster in an out-of-focus haze; the text headline explains that they are magnifications of an atom. Macrocosm and microcosm. Origin and end. Ready-made Alpha, ready-made Omega. Figuratively speaking, all the rest of the images in Richter's *Atlas*, and all the mundane things, places, and people in his paintings lie between these two subjects.

The poignancy inherent in this juxtaposition is fundamental to Richter's entire enterprise. In it one finds curiosity and moral gravity, fatalism and amazement. Above all, one feels along with the artist the tensions of a fragmented existence, of a richly, frighteningly various life lived in the absence of wholeness or a unifying principal or system of thought that promises its eventual achievement—but a life for which the idea of wholeness (a beautiful "uninjured" reality) remains, despite all doubt, the necessary compensatory counter-term. Modern or postmodern theories of art that promise utopian resolutions to this conflict between what is and what might be, based on the systematic negation of all illusions, are alien to Richter, inasmuch as the Schopenhauerian artist sees horror and vanity all around him, and the Nietzschean in him has renounced the quest for absolute truth as the last and most treacherous of illusions. What then of the man who, standing next to his primary postmodernist interlocutor at the door of the church he turned his back on after reading Nietzsche's devastating refutation of Christianity, declares himself Catholic "sympathizer," a man so moved by the secular passion of the Baader-Meinhof group that he devotes fifteen works to the violent advocates of ideas he categorically rejects because their belief in a false hope of resolving social injustice and ending human suffering is so compelling?

Reconciling Richter's preoccupation with belief—and religious belief in particular—and his stated loss of faith is not a new problem, and neither is it merely a personal one. While the majority of commentators have skirted the issue, it has, to their consternation, been central to his thinking from the very outset; repeated references to religion and God in his writings and interviews make this inescapably plain. Consider two examples, one from 1962, the other from 1988. Newly arrived from the East, where he had painted for the state, and arguing against the lack of purpose in Western-style art-for-art's-sake, Richter entered the following into his notes: "Picturing things, taking a view, is what makes us human; art is making sense and giving a shape to that sense. It is like the religious search for God. We are well aware that making sense and picturing are artificial, like illusion; but we can never give them up. For belief (thinking out and interpreting the present and the future) is our most important characteristic."[18] Twenty-six years later, having just completed work on *October 18, 1977*, he said: "Art is the pure realization of religious feeling, capacity for faith, longing for God."[19]

Such declarations—and there are many—cannot be glossed over. However, the fundamental question is not Richter's private, presumably constantly changing, relationship to Christianity or the Church, but the parallels with painting it suggests and the metaphorical richness of such correspondence. Working in a context where critics and colleagues had proclaimed painting dead with the same liberating but disorienting effect that followed Nietzsche's pronouncing the same sentence on God, Richter could only continue working as if no further harm would be done to the medium he had chosen since, in any event, there was nothing else for him to do. "Strange though this may sound," he wrote in 1962, "not knowing where one is going—being lost, being a loser—reveals the greatest possible faith and optimism, as against collective security and collective significance. To believe, one must

ROBERT STORR

have lost God: to paint one must have lost art."[20] Moreover, he wrote some four years later, even as he struck alternately indifferent, defiant, or irreverent poses in public: "Art is not a substitute religion: it is a religion (in the true sense of the word: 'binding back,' 'binding' to the unknowable, transcending reason, transcending being). This does not mean that art has turned into something like the Church and taken over its functions (education, instruction, interpretation, provision of meaning). But the Church is no longer adequate as a means of affording experience of the transcendental, and of making religion real—and so art has been transformed from a means into the sole provider of religion: which means religion itself."[21]

Call this affirmation Richter's wager. In the face of modern nihilism, whose pull he responds to instinctively as well as intellectually, Richter has persisted in the conviction that art *has* an ethical and transcendental function, much as Blaise Pascal's exemplary believer retains a faith in God in spite of God's refusal to answer human entreaties, in spite of the superior arguments of convinced rationalists who argue for or against his existence, and in spite of the rhetorical brilliance of skeptics who discount him altogether. In this regard, he shares much with Samuel Beckett whose protagonists incarnate blind faith and tragicomic futility. They are perhaps best exemplified by the first-person narrator of *The Unnamable* (1958), who ends his novel-length soliloquy with the words: "I'll never know, in the silence you don't know, you must go on, I can't go on, I'll go on."[22] In the same vein, the existential dimension of Richter's work mirrors that of Alberto Giacometti—another master of shivering but inertial grayness, another dedicated, sometimes desperate taxonomist of the erosion of impressions—whose paintings and sculptures are condensed dramas of contingent appearances. However, Giacometti's tunnel-vision art is narrow in its formal parameters if broad in its implications, whereas Richter's, equally broad in the latter regard, is encyclopedic in scope as well as formally disparate in its always ambiguous effect. Furthermore, while Giacometti is implicitly present in all his work—perspectival armatures that track his glance locate him behind the easel, and the marks he makes bridge the distance between him and the canvas, drawing board, or modeling stand—Richter's is for the most part only a specter in his work.

This last point bears reiteration and amplification in the light of the role assigned to the artist in this narrative of his art. In choosing to integrate Richter into the analysis of his work's unfolding, it is not my intention to reduce his paintings to biography in the manner all too frequently applied to interpretations of Vincent van Gogh, Pablo Picasso, Jackson Pollock, Eva Hesse, and other modern innovators of form and metaphor, nor is it to suggest that the ultimate key to even the most personal pictures in his supposedly impersonal oeuvre lies in his direct relation to the subjects he selected. To do so would violate his own well-founded reservations about the intrusiveness of ego—and its Trojan horse, signature style—on vision and the experience of things that in their own domains ignore the artist's existence. If much of his work consists of a duel between classicism and romanticism, with photography aligned to the former and painterliness to the latter, then Nietzsche and Schopenhauer are the seconds, and neither promoted an aesthetic of the anecdotal self. This said, however, it is impossible to account for Richter's achievement if we take the critical conceit of "the death of the author" literally. Richter is the author of his images, and those images are informed by the time and circumstances in which they were made. They are not integers in a conceptual equation but pictures of objective and subjective worlds that defy definitive depiction.

Richter is acutely aware of the insurmountable discrepancy between what can be seen and what can be shown, what can be imagined and what can be represented: "Of course I constantly despair at my own incapacity, at the impossibility of ever accomplishing anything,

of painting a valid, true picture or of even of knowing what such a thing ought to look like. But then I always have the hope that, if I persevere, it might one day happen. And this hope is nurtured every time something appears, a scattered, partial, initial hint of something which reminds me of what I long for, or which conveys a hint of it—although often enough I have been fooled by a momentary glimpse that then vanishes, leaving behind only the usual thing. I have no motif, only motivation."[23] This holds as true of abstraction (which is intuitional) as of figuration (which is empirical); rather than replicating fixed, verifiable phenomena, both constitute visual hypotheses about the world. Richter has written: "Every time we describe an event, add up a column of figures, or take a photograph of a tree, we create a model: without models we would know nothing about reality, and would be like animals. Abstract paintings are like fictitious models because they visualize a reality which we can neither see nor describe but which we nevertheless conclude exists. We attract negative names to this reality: the un-known, the un-graspable, the infinite, and for thousands of years we have depicted it in terms of absolute images like heaven and hell. With abstract painting we create a better means of approaching what can neither be seen nor understood because abstract painting illustrates with the greatest clarity . . . with all the means at the disposal of art, 'nothing.'. . . This is not an artful game, it is a necessity; since everything unknown frightens us and fills us with hope at the same time, we make these images as a possible explanation of the inexplicable or, at least, as a way of dealing with it. Of course, even representational paintings have this transcendental aspect: since every object, being part of the world whose last and first causes are finally unfathomable, embodies that world, the image of such an object in a painting evokes the general mystery more compellingly the less 'function' the representation has."[24]

Thus, Richter's identity is manifest throughout his work, not so much as a character in his own story (though there is a story worth telling) or as an individual seeking self-expression (though he conveys and elicits complex emotions) but as a force field whose powerful, shifting, and precariously balanced centrifugal and centripetal forces have proven capable of holding together the dispersing but not yet entropic fragments of modern experience and consciousness. The psychology of his art in all its extremes and contradictions is "impersonal" only in the sense that it is not limited to his private preoccupations but expands to encompass those of anyone who accepts that his or her reality—if he or she pays attention to all that it contains—is as plural, as unsettling, and as wondrous as Richter's.

In order for the public, for which he intended his work, to understand that it is looking at facets of its own manifold situation, Richter began his career by stepping aside. In recent years, he has edged closer to his paintings and to their audience, but he still refrains from placing himself between them, even when he has transformed himself and those dear to him into pictures. Nor does his work encourage viewers to impose their own unselfconscious sympathies onto the people, places, things, or states of being his paintings portray or evoke. In the 1960s and early 1970s, the austerity of his means blocked entry; in the late 1970s and 1980s, it was their explosive energy matched by a cool deliberateness. Although, in recent years, Richter's subject matter and gestural manner have seemed to beckon with a previously uncharacteristic intimacy, the painterly veil he drops over his photographic models and the slippages that obscure his abstractions continue to fend off would-be trespassers. The result is a privileged glimpse—a "slipping glimpse" to borrow Willem de Kooning's phrase—of a situation that may exclude even the artist himself, leaving behind the exquisitely isolated receptacle of painting partially filled by an evanescent image. Thus, whether laid down in opaque grays, flat colors, exuberant strokes, or diaphanous tints,

Richter's canvases typically stop the eye at the surface of the paint and push viewers in the habit of projecting themselves into pictures back onto their feet and back into their actual surroundings.

A master at keeping his distance, Richter has created a vast and diverse body of work haunted by a fundamental alienation, of which art can be a finely calibrated gauge, and for which it is a consolation but not a remedy. Eschewing the histrionics and solipsisms that vulgarized the worst postwar era existentialist art, though plainly cognizant of the positive examples set by the best, he makes us aware at every turn of the gaps between viewers and his pictures, and between the pictures and the world, with wit, sensitivity, and uncompromising precision, and he offers that awareness and the intensified but never fully satisfied desire to overcome it as a token of shared knowledge. Indeed, the basic loss of bearings toward which all his paintings point may barely show itself at all, except as a constant subliminal tremor that subtly warps vision and casts an estranging light on the mundane and the marvelous. Once accustomed to this effect, and to the filter it places between perceptual objectivity and critical subjectivity, one may find the distance created has opened up vertigo-inducing vistas that routine inattention or fear normally hide from sight. Rather than lament reality's refusal to explain itself or struggle to force meanings upon it, we become aware that a kind of detached clarity of the mind and of the senses takes over. Keeping our own counsel in the fashion epitomized by the artist, it becomes possible to observe and record the distortions and ambiguities that dogmatic thought censures and from which consensus experience distracts us. A broadly philosophical painter, more than a strictly conceptual one, a radical thinker and often traditional maker, among the great artists of the second half of the twentieth century, and a frontline explorer of the twenty-first, Richter is an image-struck poet of alertness and restraint, of doubt and daring.

NOTES

Introduction

1. Friedrich Nietzsche, "Beyond Good and Evil," *The Philosophy of Nietzsche* (New York: Modern Library, 1937): 83.
2. Roberta Smith, "Flirting with All Styles but Embracing None," *The New York Times*, August 23, 1987.
3. Both Kiefer and Immendorff were born in 1945, both grew up in West Germany, and both were students of Beuys, with Immendorff being a special favorite. With these circumstances in common their divergent trajectories from Beuysian actions to painting represent two extremes of German neo-Expressionism. Kiefer synthesized Jean Fautrier, Jean Dubuffet, and Jackson Pollock and applied this fusion to mythic subject matter with heavy Wagnerian overtones, while Immendorff allied Max Beckmann, Renato Guttuso, a cartoony Socialist Realism, and eighteenth- and nineteenth-century caricature and put that lively admixture at the service of a scene-stealing Brechtian humor.
4. The anomaly of Richter's place in the lineup of German painting in the 1980s was apparent in *Refigured Painting: The German Image, 1960–1988*, organized by Thomas Krens at the Guggenheim museum. There, a cross section of Richter's Photo-Realist paintings shared space with examples of his abstract work, but the surrounding company they kept was overwhelmingly Expressionist.
5. Willem de Kooning, speaking to Rudolph Burckhardt, as quoted in Harry F. Gaugh, "De Kooning in Retrospect," *Artnews* 83, no. 3 (March 1984): 94. Pollock, who was convinced at times that Picasso was waiting for him around every artistic corner, shared de Kooning's sentiments.
6. Pat Gilmour, "Gerhard Richter and Hamish Fulton," *Arts Review*, April 13, 1979: 186.
7. Even those who accepted his implicit critique of style have come to this conclusion: "I like looking at these paintings, which is a lot as far as I am concerned, but I've never bought the theoretical groundwork that goes along with them. . . . I saw in [their] versatility a flexibility of thinking and guts to paint whatever [Richter] wanted. But today the variations look like empty moves, skittish-ness, a lure more than a trick on the market." Barbara Flynn, [Review] *Artforum* 16, no. 8 (April 8, 1978): 62.
8. Diedrich Diederichson, Isabelle Graw, Tom Holert, Jutta Koether, and Felix Reidenbach, "Richterrunde," *Texte zur Kunst* 4, no. 13 (March 1994): 124.
9. Like a number of other exhibitions in this country, the Onnasch show was initiated by the gallery without the artist's knowledge or approval, but when it became apparent that the dealer's ownership of or independent access to the paintings he was presenting would make it impossible for Richter to stop the project, Richter then added works in his control to round out the selection in accordance with his own ideas about the work.
10. Peter Frank, "Gerhard Richter (Onnasch)," *Artnews* 72, no. 9 (November 1973): 100.
11. Ibid.
12. Roald Nasgaard, "Gerhard Richter," in Terry A. Neff, ed., *Gerhard Richter: Paintings* (London: Thames & Hudson, 1988): 33.
13. The critic Douglas Crimp represents such attitudes, and while *Pictures,* an exhibition he organized at Artists Space in 1977, was a prescient and eye-opening presentation of emerging appropriation art of the period, his equally influential criticism at the time was polemical in tone and dogmatic in substance. Crimp's article, "The End of Painting," published in *October* magazine in spring 1981, is typical of the style of argument in which he and his postmodernist cohorts, specialized. In it, Crimp cites qualified exceptions to his anti-painting doctrine in the work of Robert Ryman and Frank Stella. He also quotes Richter selectively: for example, he cites Richter's statement that painting is "pure idiocy" entirely out of the context in which it was written in 1973. The full Richter quote, which attempts to defend painting, is the following: "One has to believe in what one is doing, one has to commit oneself inwardly, in order to do painting. Once obsessed, one ultimately carries it to the point of believing that one might change human beings through painting. But if one lacks this passionate commitment, there is nothing left to do. Then it is best to leave it alone. For basically painting is [pure] idiocy." Gerhard Richter, "Notes,

ROBERT STORR

1973," in Hans-Ulrich Obrist, ed., *Gerhard Richter: The Daily Practice of Painting. Writings and Interviews, 1962–1993* (Cambridge, Mass.: MIT Press; London: Anthony d'Offay Gallery, 1995): 78.

14. Benjamin H. D. Buchloh, "Interview with Gerhard Richter," in Neff, *Richter: Paintings*: 21.

15. Ibid.

I: Beginnings

1. Ad Reinhardt, "The Artist Is Responsible," in Barbara Rose, ed., *Art as Art: The Selected Writings of Ad Reinhardt* (New York: Viking Press, 1975): 136.

2. Gerhard Richter, interview with the author, conducted with the assistance of Catharina Manchanda, on April 21–23, 2001; trans. Philip Glahn. Some portions of the interview appear in this volume. Hereafter, the unpublished portions of the interview will be referred to as RSGR, 2001.

3. Ibid.
4. Ibid.
5. Ibid.
6. Ibid.
7. Ibid.
8. Ibid.
9. Ibid.
10. Richter, "Interview with Hans-Ulrich Obrist, 1993," *Daily Practice*: 251.
11. RSGR, 2001.
12. Ibid.
13. Ibid.
14. Gerhard Richter, unpublished interview with the author, conducted with the assistance of Isabelle Moffat, in 1996.
15. RSGR, 2001.
16. Ibid.
17. Gerhard Richter, "Auseinandersetz-ungen halfen mir weiter," *Sonntag: Wochenzeitung für Kultur, Politik und Unterhaltung* 16 (April 20, 1958): 12.
18. RSGR, 2001.
19. Ibid.
20. Ibid.
21. Ibid.
22. In contrast, one might consider the situation of Ralf Winkler, better known by his pseudonym, A. R. Penck. Born in Dresden in 1939, he was repeatedly rejected by the art academies of Dresden and East Berlin, and painted in obscurity while eking out a living working as a boilerman, night watchman, and postman, rarely showing his work until 1961, when an exhibition at the East Berlin academy and contacts with galleries in the West eased his situation somewhat. Having crossed back into the GDR in 1961, shortly before the Wall went up after a visit with his friend Georg Baselitz, Penck was unable to leave the GDR until 1980.

23. RSGR, 2001.
24. Richter, "Interview with Benjamin H. D. Buchloh, 1986," *Daily Practice*: 132. In a recent conversation (RSGR, 2001), the artist partially backed away from this much publicized "Road to Damascus" version of his visit to Kassel: "The story has gained so much substance and truth it becomes hard for me to depart from it. I have memories, of course. I see myself walking through Documenta and making slides and slides and slides of the whole Documenta. And I looked at these slides in the evening later in Dresden, and I don't know where they are now. It would help to know what we liked. We were not looking for artists as daring and as awful as Fontana and Pollock, but works where one could recognize something, where something was said and felt. But simply to go like that [a cutting, or brushstroke, gesture] we thought that was a little dumb. [But] it was unbelievable. To see something like that was an explosion in your brain. I wish I was more open, and that this legend did not exist. Then maybe I would be free enough to remember. But now this story is so dominant. It is like a photograph; you don't remember actually what happened, you remember the photo."

25. Stephen Ellis, "The Elusive Gerhard Richter," *Art in America* (November 1986): 132.
26. Richter, "Interview with Buchloh," *Daily Practice*: 136.
27. Ibid.
28. Elizabeth Armstrong, "Fluxus and the Museum," in idem and Joan Rothfuss, *In the Spirit of Fluxus* (Minneapolis: Walker Art Center, 1993): 34.
29. Ibid.: 16.
30. Pierre Restany, "Preface for the Exhibition *40 Degrees above Dada*," in *1960: Les Nouveaux Réalistes*, Intro. Bernadette Contensou (Paris: Musée d'Art Moderne de la Ville de Paris, 1986): 266–267.
31. Joseph Beuys, "A propos de Palermo: Entretien de László Glozer avec Joseph Beuys," in *Palermo: Oeuvres 1963–1977* (Paris: Musée National d'Art Moderne, Centre Georges Pompidou, Galeries Contemporaines, 1985): 77.
32. Richter, "Interview with Buchloh," *Daily Practice*: 133.
33. RSGR, 2001.

34. Ibid.

35. Richter, "Interview with Wolfgang Pehnt, 1984," *Daily Practice:* 114; idem, "Letter to Jean-Christophe Amman, February 1973," ibid.: 80; idem, "Interview with Obrist," ibid.: 259.

36. Idem, "Notes, 1964," ibid.: 22. Around this time, Richter also painted the image of a dead person photographed through glass, which he framed and glazed to create a partial illusion that one was seeing the image the same way. The experiment anticipated his work with framed panes of painted and unpainted glass as well as his framed mirrors.

37. Asked about how the catalogue began, Richter said: "I was always a little bit nervous or in despair about the fact that I was so unorganized. So I decided to photograph whatever I was working on. And suddenly I didn't find it to be chaotic anymore. Before, I had the feeling that everything was very chaotic and that I didn't know what I wanted." RSGR, 2001.

38. Ibid.

39. Ibid.

40. Ibid.

41. Ibid.

42. Ibid.

43. "Johns was holding on to a culture of painting that had to do with Cézanne, and I rejected that. That's why I painted from photographs, just in order to have nothing to do with the art of 'peinture,' which makes any kind of contemporary statement impossible." Richter, "Interview with Buchloh," *Daily Practice:* 139.

44. RSGR, 2001.

45. Richter, "Notes, 1986," *Daily Practice:* 124.

46. Idem, "Notes, 1964," ibid.: 24.

47. RSGR, 2001.

48. Coosje van Bruggen, "Gerhard Richter: Painting as a Moral Act," *Artforum* 9 (May 1985): 84.

49. Richter, "Text for Exhibition Catalogue, Galerie h, Hannover, 1966, written jointly with Sigmar Polke," *Daily Practice:* 45.

50. Idem, "Letter to a Newsreel Company, 29 April 1963," ibid.: 15–16.

51. Prior to planning their exhibition at Berges, Richter and Lueg had prepared a proposal to show work on the roof of the Galeries Lafayette department store in Paris, but nothing came of it. RSGR, 2001.

52. Less than a month after the exhibition, Kennedy was shot, and the Sunday following his assassination Kasper König—a close friend of Lueg and Richter at that time and later an important curator and museum direc-tor—borrowed the sculpture and in Dadaesque gesture drove from Düsseldorf to Münster with it tied to the top of his car. RSGR, 2001.

53. Richter, "Program and Report," *Daily Practice:* 20.

54. RSGR, 2001.

55. Richard Hamilton, "Letter to Peter and Alison Smith" (1957), in Kristine Stiles and Peter Selz, eds., *Contemporary Art: A Sourcebook of Artists' Writings* (Berkeley: University of California Press, 1996): 297.

56. In an interview with G. R. Swenson, Andy Warhol was asked what Pop art was all about, and he replied: "It's liking things." See John Russell and Suzi Gablik, *Pop Art Redefined* (New York and Washington, D.C.: Frederick A. Praeger, 1960): 116.

57. Richter, "Notes, 1962," *Daily Practice:* 13.

58. Interestingly, the most Richter-esque of Artschwager's early paintings, *Portrait I* (1962), is in the collection of Kasper König.

59. Richter, "Notes, 1964," *Daily Practice:* 22.

60. Idem, "Notes, 1964–1965," ibid.: 35.

61. Ibid.: 31.

62. Idem, "Galerie h, Hannover," ibid.: 55.

63. Idem, "Notes, 1964–1965," ibid.: 35.

64. John Cage, "Lecture on Nothing," in *Silence: Lectures and Writings by John Cage* (Middletown, Conn.: Wesleyan University Press, 1939): 109.

65. Roland Barthes, *Camera Lucida: Reflections on Photography*, trans. Richard Howard (New York: Hill & Wang, 1981): 15.

66. Richter, "Interview with Rolf Schön, 1972," *Daily Practice:* 73.

67. Ibid.

68. *Roland Barthes by Roland Barthes*, trans. Richard Howard (New York: Hill & Wang, 1977): 43.

69. Richter, "Interview with Pehnt," *Daily Practice:* 117. In recent criticism, there has been a tendency to confuse the opportunity a work affords to open up legitimate questions about the social and political context surrounding that work with an unstated and undemonstrated intention to do so on the part of the artist. Thus, a writer might say that Andy Warhol's *Campbell's Soup Cans* critiques consumer society, or that his *Gold Marilyn* critiques the cult of celebrity, when there is, in fact, no evidence that Warhol thought in such terms. Moreover, such formulations beg the question of what ideological point of departure the artist might have had. Such assumptions implicitly co-opt the authority of the artist in support of interpretations that must stand or fall on the theoretical constructs of the writer or critic. Rigorous

critiques—Freudian, Marxist, post-structuralist, postmodernist, or any other—must proceed by rigorous adherence to the basic rules of the argument. Broad cultural critique cannot be pursued, and it certainly cannot sustain its powers of persuasion, in ignorance or in defiance of verifiable facts. Moreover, the most complex aesthetic and sociopolitical analysis may be derailed by semantic neutralization of the contradictions that may exist between what an artist meant and what the observer sees. Warhol was very far from being an anticapitalist, but his art does provide material for thinking critically about capitalism. In writing about Richter we must be particularly sensitive to these issues, especially as he has, in most cases, clearly stated his intent with regard to a given body of work and clearly rejected ideologically inspired readings of it. The gap between what he says about his work and the things critical theory suggests might be said about it does not disallow exploration of the latter but such criticism cannot proceed on the assumption that Richter, an anti-Marxist, with little interest in Freud or post-structuralist thought, has wittingly or unwittingly followed a program allied to such positions.

70. Idem, "Notes, 1964–1965," ibid.: 33.
71. Christiane Vielhaber, "Interview mit Gerhard Richter," *Das Kunstwerk* 2, no. 39 (April 1986): 41–43.
72. Ibid.
73. Richter, "Notes, 1964," *Daily Practice*: 24.
74. The sources for the first version of *Toilet Paper* can be found in panel 14 of *Atlas*; the source used for versions two and three is in panel 15. Richter's treatment of the second and third versions dramatically softens the illumination in the photographic source, suggesting that he intended, if not to make a poetically atmospheric painting out of this unlikely subject, then at least to lend it greater subtlety. It should also be noted that cropped images of version three have been incorrectly substituted for versions one and two in the *Catalogue Raisonné 1962–1993* (Paris: Musée d'Art Moderne de la Ville de Paris, 1993).
75. Richter, "Interview with Sabine Schütz," *Daily Practice*: 211–212.
76. Ibid.: 211.
77. The difference between the "cocky" Richter who made the papier-mâché JFK, and the reticent Richter who painted *Women with Umbrella*, can be heard in the artist's explanation of why he selected the image: "I was embarrassed to paint Jacqueline Kennedy. It

was such a beautiful photo of a woman crying." Van Bruggen, "Painting as a Moral Act": 86.
78. *Eight Student Nurses* appears to have been partially influenced by Warhol's *Thirteen Most Wanted Men* (1964). Richter has said he prefers victims to killers as his subjects. Exceptions to this are his atypically Pop *Oswald* (1964), and *Mr. Heyde* (1965).
79. Van Bruggen, "Painting as a Moral Act": 86.
80. Bernard Blistène, "Mécanique et manuel dans l'art de Gerhard Richter," *Galeries Magazine* (April–May 1988): 90–95, 132, 141.
81. Dieter Hülsmanns, "Das perfekteste Bild: Ateliergespräch mit dem Maler Gerd Richter," *Rheinische Post* 102 (May 3, 1966). Despite this disclaimer, Richter not only painted numerous pictures of family and friends at the beginning of his career, but also several commissioned portraits. Among these were paintings of the art historian Arnold Bode, the art dealer Alfred Schmela, a professor Zander, and the artist Paul Wunderlich.
82. Richter, "Notes, 1964–1965," *Daily Practice*: 31.
83. Idem, "Interview with Buchloh," ibid.: 138.
84. Chuck Close's portraits of 1967–68 come the nearest, in that they were based on photographs of family and friends, but Close's process-based formalism gives these images a very different cast.
85. RSGR, 2001.
86. Ibid. Richter's other maternal uncle was also killed early in the war.
87. Between June 9 and 10, 1942, the male population of Lidice (some 200 men) was killed, its women sent to concentration camps, and its children to German institutions, and all its buildings burned. This was done in reprisal for the assassination in nearby Prague of Reinhard Heydrich, German Deputy Reich Protector for the region, second in command to the SS chief Heinrich Himmler, and a principal planner of the Holocaust.
88. RSGR, 2001.
89. *The Murderers Are Among Us* (1946), directed by Wolfgang Staudte. The film tells the story of a concentration camp survivor who returns home to find that the Nazi commander of his camp is living nearby in relative prosperity.
90. Richter, "Interview with Schütz," *Daily Practice*: 212.
91. Idem, "Notes, 1964," ibid.: 23.
92. Idem, "Notes, 1966," ibid.: 58.
93. Idem, "Notes, 1964," Ibid.: 23. Mangelwurzel is a kind of root vegetable.
94. Idem, "Notes, 1964–1965," ibid.: 33–34.

95. Charles Baudelaire, "The Painter of Modern Life," in *Baudelaire: Selected Writings on Art and Artists*, trans. P. E. Charvet (Cambridge: Cambridge University Press, 1972): 402–403.

96. Van Bruggen, "Painting as a Moral Act": 86. At the end of these remarks Richter says of his associating his paintings of reconstructed Germany to the bombing that preceded it: "But I never said I meant anything with them." I think he did, but wanted at all costs to avoid the appearance of making pictorial speeches.

97. Richter, "Notes, 1964–1965," *Daily Practice:* 35.

98. Ibid.: 37.

99. Idem, "Letter to Edy de Wilde, 25 February 1975," ibid.: 82–83.

100. Ibid.

101. Idem, "Notes, 1964–1965," ibid.: 35.

II: Openings and Culs de Sac

1. Theodor Adorno, "Lyric Poetry and Society," in Martin Jay, *Adorno* (Cambridge, Mass.: Harvard University Press, 1984): 155.

2. RSGR, 2001.

3. Georg Baselitz and Eugen Schöne-beck, "First Pandemonium Manifesto" (1961), in Klaus Schrenk, ed., *Upheavals, Manifestoes, Manifestations: Conceptions in the Arts at the Beginning of the Sixties, Berlin, Düsseldorf, Munich* (Cologne: DuMont, 1984): 171.

4. RSGR, 2001.

5. Richter, "Interview with John Anthony Thwaites and Sigmar Polke," *Daily Practice:* 26–27. John Anthony Thwaites, the improbable pseudonym that Sigmar Polke chose for his mock interview with Gerhard Richter, was, in fact, the name of the English cultural affairs officer at the British Embassy in Munich. Thwaites was also an art critic who wrote a short monograph on the sculptor Norbert Kricke that was published by Harry N. Abrams in New York. A relatively conservative constructivist sculptor and the first German artist of the postwar generation to be given a one-person show at The Museum of Modern Art, New York, in 1961, Kricke was a member of the faculty of the art academy in Düsseldorf. In that capacity, he was the relentless enemy of his colleague Joseph Beuys, whom he attacked for indulging in what Kricke called, "Jesus kitsch." Making Thwaites a figure of fun would thus seem, in the context of the mock interview, to have been a polemical gesture aimed at the mod-ernist art establishment of the Rhineland by two young artists eager to dissociate themselves from it.

6. Ibid. This is not the only instance of such gallows humor on Richter's part. In the photo album he compiled before leaving for the West there are two pictures of the artist with Ema and a friend under what appears to be a metal tube in the disjointed pose of people hanging. Whatever prompted this particular jest, one cannot help but think of the lynchings that occurred during the war and the trauma they must have caused anyone who saw them or saw pictures of them.

7. Jürgen Harten, "The Romantic Intent for Abstraction," in idem, *Gerhard Richter Bilder, 1962–1985* (Cologne: DuMont, 1986): 28.

8. Richard Cork, "Gerhard Richter: A Divided German," *Apollo* (London) (January 1992): 49.

9. Richter, "Notes, 1992," *Daily Practice:* 245–246.

10. Harten, *Richter Bilder:* 32.

11. Richter, "Notes, 1981," *Daily Practice:* 99.

12. Idem, "Notes, 1971," ibid.: 64.

13. Idem, "Interview with Schön," ibid.: 73.

14. Idem, "Interview with Jonas Storsve," ibid.: 225.

15. Idem, "Interview with Buchloh," ibid.: 137.

16. Bruce Glaser, "Questions to Stella and Judd," in Lucy Lippard and Gregory Battcock, eds., *Minimal Art: A Critical Anthology* (New York: E. P. Dutton, 1968): 158.

17. Sol LeWitt, "Sentences on Conceptual Art," in Alicia Legg, ed., *Sol LeWitt* (New York: The Museum of Modern Art, 1978): 168.

18. Ibid.

19. Richter, "Text for Catalogue of Group Exhibition Palais des Beaux-Arts, Brussels, 1974," *Daily Practice:* 82.

20. Idem, "Interview with Peter Sager," ibid.: 69.

21. "In 1962 I found my first escape hatch: by painting from photographs, I was relieved of the need to choose or construct a subject.... My appropriation of photographs, my policy of copying them without alteration and without translating them into a modern form (as Warhol and others do), represented a principled avoidance of the subject. This principle has been maintained, with few exceptions (doors, windows, shadows, all of which I dislike) to this day." Idem, "Notes, 1986," ibid.: 130.

22. Cork, "Divided German": 49.

23. Richter, "Interview with Storsve," *Daily Practice:* 223.

24. Idem, "Notes, 1964–1965," ibid.: 37.

25. Louis Aragon, *La Peinture au défi* [The Challenge to Painting] (Paris: Librairie José Corti, 1930): 15–16; trans. by the author.

26. Reinhardt, in Glaser, [Interview] *Art International* (December 1966): 18–21.

27. Richter, "Interview with Storsve," *Daily Practice:* 223.

28. Van Bruggen, "Painting as a Moral Act": 88.

29. Beuys, "A propos de Palermo": 77.

30. Gerhard Richter, "About Watercolors and Related Things: Gerhard Richter in Conversation with Dieter Schwarz. Cologne, June 26, 1999," in Dieter Schwarz, ed., *Gerhard Richter: Aquarelle/Watercolors, 1964–1999* (Winterthur: Kunstmuseum; Düsseldorf: Richter Verlag, 1999): 21.

31. Mark Rosenthal, "Interview with Gerhard Richter," in idem, ed., *Mark Rothko* (Washington, D.C.: National Gallery of Art, 1998): 363–366.

32. RSGR, 2001.

33. "Notes, 1984," *Daily Practice:* 108–109.

34. RSGR, 2001.

35. Ibid.

36. After Palermo's death, a modified version of the room originally created for the Heiner Friedrich gallery in Cologne was permanently installed at the Städtische Galerie im Lenbachhaus, Munich.

37. Michael Compton, "In Praise of the Subject," in *Marcel Broodthaers* (Minneapolis: Walker Art Center, 1989): 24.

38. Ibid.: 55.

39. Neither, for that matter, was Broodthaers interested in explicitly political counter-discourses. "The way I see it," he wrote, "there can be no direct communication between art and message, especially if the message is political, without running the risk of being burned by the artifice. Foundering. I prefer signing my name to these booby traps without taking advantage of this caution." Ibid.: 44.

40. Richter, "Interview with Doris von Drathen," *Daily Practice:* 239.

41. An analogous situation arose when Robert Rauschenberg requested a drawing from Willem de Kooning so that he could erase it in a gesture intended to symbolize his independence from the Abstract Expressionist aesthetic. De Kooning obliged, even though he was the Oedipal father being ritually dispatched, but reportedly he gave Rauschenberg a really good drawing and also one that had been heavily worked into the paper to make it harder for the younger artist to sacrifice the image and harder for him physically to unmake it.

42. RSGR, 2001.

43. Ibid.

44. Van Bruggen, "Painting as a Moral Act": 91. See also Susanne Ehrenfried, "Gespräch mit dem Maler Gerhard Richter am 8. August 1995" (in idem, "'Ohne Eigenschaften': Das Portrait bei Gerhard Richter." Diss., Munich: Ludwig-Maximillian-Universität München, c. 1995: 180), in which Richter answers a question about Buchloh having chided him for excluding women from *48 Portraits:* "Buchloh's remark is a reproach absolutely in keeping with the times. It couldn't have been made when I painted '48 Portraits.' At that time one did not think in this way. . . . The fact that only men were included reflects this notion of homogeneity. If women had been included the formal principles would no longer have been matched. In addition, it certainly had to do with a search for a father figure. After all I'm not in search of an image of a mother."

45. Benjamin H. D. Buchloh, "Divided Memory and Post-Traditional Identity: Gerhard Richter's Work of Mourning," *October* 75 (winter 1996): 73.

46. Ibid.: 75.

47. RSGR, 2001.

48. Ibid.

49. Ibid.

50. In the late 1970s Anselm Kiefer made several works that would seem to have been prompted by the example of *48 Portraits.* They are the painting *Ways of Worldly Wisdom* (1976–77) and a woodcut and multimedium work *Ways of Worldly Wisdom—Arminius's Battle* (1978–80). Kiefer assembled a portrait gallery of writers and philosophers, that included Enlightenment figures such as Emmanuel Kant but also romantics such as Heinrich von Kleist and the existentialist thinker and Nazi academic Martin Heidegger. Kiefer thus attempted a symbolic recovery of the past that was buried or contaminated by the Nazis. By contrast with Richter's work, which is internationalist, all of Kiefer's culture heroes are German. Moreover, rather than present them in a reportorial fashion as Richter does, he sets the stage for them with the maximum of painterly *Sturm und Drang.* Although not without its complexity, this amounts to affirmative cultural restoration as distinct from Richter's probing of cultural doubt. Also, in the late 1970s the American painter Leon Golub made a large number of portraits of political leaders of the Left and Right Generalissimo Francisco Franco, Mao Tse-tung, Fidel Castro, John Foster Dulles,

and Richard Nixon, among them. Although painted in a graphic expressionist manner, these pictures are close to Richter's work in their lack of painterly editorializing, leaving the viewer unsure of what to think but more acutely aware than before of what power looks like.

51. "Interview with Storsve," *Daily Practice: 226.*
52. Ibid.
53. Idem, "Notes, 1964–1965," ibid.: 39.
54. In 1975 Richter painted six portraits of Gilbert & George on a commission arranged through Konrad Fischer.
55. Harten, *Richter Bilder: 47.*
56. Richter, "Interview with Rolf Gunther Dienst, 1970," *Daily Practice*: 64.
57. Idem, "Interview with Schön," ibid.: 75.
58. Idem, "Letter to Ammann," ibid.: 81.
59. Van Bruggen, "Painting as a Moral Act": 83.
60. Richter, "Interview with Obrist," *Daily Practice: 268.* (Photographs from Richter's trip to Greenland were later used as the basis for a 1981 artist's book, *EIS,* published in Rome by Edizioni Galeria Peroni.) Friedrich's painting, *The Sea of Ice,* is also known as *The Wreck of the "Hope."*
61. Idem, "Notes, 1986," ibid.: 124.
62. Irmeline Lebeer, "Gerhard Richter ou la Réalité de l'Image," *Chronique de l'Art Vivant* 36 (February 1973): 16; trans. by the author.
63. Richter, "Notes, 1983," *Daily Practice: 101.*
64. Willem de Kooning, "A Desperate View, " in *Willem de Kooning: The Northern Light, 1960–1983* (Amsterdam: Stedelijk Museum, 1983): 67.
65. Gérard Audinet, "L'age d'oeuvre: Early and Late," *Kanaleurope* 3 (1992): 45.
66. Richter, "Interview with Storsve," *Daily Practice:* 227.
67. Dorothea Dietrich, "Gerhard Richter: An Interview," *Print Collectors' Newsletter* 16 (September–October 1985): 128.
68. Richter, "Interview with Buchloh," *Daily Practice:* 141.
69. Ibid.
70. Rosenthal, "Interview with Richter": n.p.
71. Ibid.
72. Richter, "Interview with Obrist," *Daily Practice*: 262.
73. Ellis, "Elusive Richter": 186.
74. Richter responded to Mark Rosenthal's questions about his relationship to Rothko and Romanticism saying: "For me romanticism is the likes of Philipp Otto Runge, that is, an artist who presents a tortured view of himself. Maybe in the widest sense of the word Rothko might be a romantic, as Robert Rosenblum suggested in his book, *Modern Painting and the Northern Romantic Tradition: From Friedrich to Rothko."* Rosenthal, "Interview with Richter": n.p.
75. Ellis, "Elusive Richter": 186.
76. Richter, "Notes, 1985," *Daily Practice: 122.*
77. RSGR, 2001.
78. Ibid.
79. Ibid.
80. Buchloh, "Interview with Richter," in Neff, *Richter: Paintings*: 18. (I have cited this version of Buchloh's interview, rather than the one published in *Daily Practice,* because of differences between the two translations that affect nuances of meaning.)
81. In 1995 Richter agreed to allow one of his candle paintings to be blown up and reproduced on a fabric sign that covered the entire side of a large building in Dresden near the edge of the Danube River: "I don't know any longer who in Dresden thought of the idea of having a picture by me covering this large facade. I think it was Dr. Schmidt from the museum and it was also he who suggested the candle motif. Then I collaged different candle pictures onto a photo of the facade, and that's how the two candles came about, that appeared to be the one that worked best. At the beginning it was supposed to be a pretty sight, but later one discovered that the candle picture also served as a useful political expression. That was due to the celebrations that took place in front of it on February 13, fifty years after Dresden was destroyed. Candles were always an important symbol of the GDR as a silent protest against the regime, and that was already very impressive. It naturally remains an unusual feeling to see that something quite different can come from such a small candle painting, something that I never intended." Hans-Ulrich Obrist, "Interview with Gerhard Richter" (1995), unpublished.
82. For an indication of how far the ramifications of what might seem to be the incomprehensible extremism of a tiny minority reach, how complex the dynamics of that period were, and how closely linked it is to the present, consider the aftermath for several individuals involved: Horst Mahler, a lawyer and Baader's early rival for leadership of the budding RAF is now legal counsel and ideological apologist for the far Right, arguably pro-Nazi, German Democratic Party; Otto Schilly, who helped shape the defense of the Baader-Meinhof group in the 1970s is now Minister of Justice in the government of the Social Democratic Chancellor Helmut Schröder; Joschka Fischer, the current Foreign Minister and Vice

Chancellor was a radical activist in the same circles as Baader and Meinhof, although he publicly advocated setting bombs aside for paving stones; and Bettina Röhl, Meinhof's daughter and a journalist, is responsible for recently publishing images that exposed Fischer's attack on a policeman during a street-fighting incident in the 1970s.

83. Richter, "Notes for a Press Conference, November, December, 1989," *Daily Practice:* 173.
84. Ibid.
85. Ibid.: 174.
86. Idem, "Notes, 1983," ibid.: 102.

III: Permission Granted

1. Richter, "Notes, 1962," *Daily Practice:* 15.
2. Idem, "Interview with Dieter Hülsmanns and Fridolin Reske," ibid.: 57–58.
3. RSGR, 2001. (Moritz's sister Ella Maria was born in 1996.)
4. Ibid.
5. Ibid. The ideological nuances of the word *sympathizer* were noticed by Catharina Manchanda, who was present as a translator throughout the conversations between Richter and the author; it was she who fastened on the implications of the term and prompted these clarifications on the subject from him.
6. Ibid.
7. Richter, "Interview with Schütz," *Daily Practice:* 211.
8. RSGR, 2001.
9. Benjamin H. D. Buchloh, "Allegories of Painting," in *Gerhard Richter: Documenta IX, 1992* (New York: Marian Goodman Gallery, 1993): 13.
10. Ibid.
11. Ibid.
12. Richter, "Interview with von Drathen," *Daily Practice:* 233.
13. Friedrich von Schiller, "On Naive and Sentimental Poetry," in H. D. Nisbet, ed., *German Aesthetics and Literary Criticism: Winckelmann, Lessing, Hammna, Herder, Schiller and Goethe* (Cambridge: Cambridge University Press, 1985): 195.
14. Ibid.: 196.
15. Arthur Schopenhauer, cited in Paul Edwards, ed., *Encyclopedia of Philosophy*, vol. 7 (New York: Macmillan and The Free Press, 1967): 329.
16. Friedrich Nietzsche, as quoted in Arthur C. Danto, *Nietzsche as Philosopher: An Original Study* (New York: Columbia University Press, 1965): 38–39.
17. Ibid.: 67. I am much indebted to Professor Danto for his critical account of Nietzsche's thought.
18. Richter, "Notes, 1962," *Daily Practice*: 11–12.
19. Idem, "Notes, 1988," ibid.: 170.
20. Idem, "Notes, 1962," ibid.: 15.
21. Idem, "Notes, 1964–1965," ibid.: 38.
22. Samuel Beckett, *The Unnamable,* (New York: Grove Press, 1958): 179.
23. Richter, "Notes, 1985," *Daily Practice*: 118.
24. Gerhard Richter, [Catalogue text] in *Documenta 7*, vol. 1 (Kassel: Paul Dierichs, 1982).

Gerhard Richter, c. 1992

PART TWO

INTERVIEW WITH GERHARD RICHTER

by Robert Storr

This interview was conducted in German and English over several days in April 2001. Catharina Manchanda both participated in the discussions and assisted with translation when necessary. The tapes were transcribed and translated by Philip Glahn.

ROBERT STORR: In the United States in the 1980s there was a burst of gallery activity, and a lot of attention was given to art coming from Europe, and from Germany, in particular. Many Americans first discovered your work all at once and, for the most part, they saw your gestural abstractions from the 1970s and 1980s next to the paintings inspired by Pop art from the 1960s without knowing much about how these different bodies of work from a single artist were related. The assumption was that you were taking painting apart, style by style, by doing different things at the same time. So I wonder just how you understood the reception that you got back then; how comfortable or uncomfortable did you feel with this view of you as a kind of destructive painter?

GERHARD RICHTER: I didn't notice that view. Perhaps I was glad to receive any attention at all. Some people would even claim that it was pretty smart. There was a demand for paintings that I satisfied, and at the same time there was this conceptual notion against painting—and so I served both sides. That was rather smart, a legitimation to enjoy them.

Yes, pleasure without remorse. Because with this intellectual, conceptual background, you would always have an excuse. They are colorful and painterly but they are also very intellectual. Be careful! [*Laughter*]

RS: You laugh now, but in America at that time, these battles were fought very seriously. There was no laughter at all. Under the name of *politics* there was a puritanical belief that pleasure was bad, that the aesthetic was suspect, and that only by making anti-aesthetic, unpleasurable things could there be a justification for making paintings at all.

GR: I remember an opening party at Marian Goodman's [in the 1990s] when Lawrence Weiner gave a speech that said: "Painting is not possible anymore, but Gerhard shows us that it is possible. . . . We all knew it was over, that one could not paint abstract paintings anymore. But here it is!" He got a lot of applause.

RS: But that, in a sense, is the easy answer. The harder problem is that this rhetoric was used to say that the only way for painting to be serious was for the painter to think of it as a time-bomb that the painter had planted—you had planted—to explode the reasons for painting, one by one, until at the end of this process painting would be finished. So people said: "It's great that he's doing this, and for now it's okay to like painting like that; but when he's done, there will be no more painting."

GR: Nice. [*Laughter*] I didn't know that.

RS: There is a precedent in American painting—Ad Reinhardt said: "You must understand that I am making the last paintings possible." As a logical gambit that's very elegant. But there is a difference between taking such a position for the challenge that it provides and actually believing it to be true.

GR: People often declare the end of painting.

RS: Yes, but is there a difference between how an artist says something like this—uses it as a point of departure—and how a critic arrives at and argues such a conclusion?

GR: I don't know because I always have thought, "This is my end." During every crisis I have thought, "This is it for me, but everything else will go on." I never generalized this to be the end of painting, even though I realized that it [painting] didn't do so well at certain points. But I conceived those times as breaks.

RS: Back in the 1980s, Douglas Crimp wrote a famous article called "The End of Painting" in which (in addition to misrepresenting your statement "painting is pure idiocy") he proposed that what a painter—such as you or Daniel Buren—does under

the circumstances is simply to go through the motions and critically "enact" painting in order to prove its futility.

GR: That is presumptuous and arrogant—or useless—because then you have to take a look at all of life. When somebody goes shopping that's an idiotic act. Even feeding the kids is an idiotic act. From that perspective, everything is meaningless. You have to believe in the idea that it does make sense. It doesn't matter whether it is painting or working in your backyard, most of these things are so meaningless, you can't even watch them.

RS: Well that was one interpretation, but there was also the strong view that you were a very important painter because what you were up to was undoing painting in the most masterful way. Is that true?

GR: Yes.

RS: Another thing I have heard sometimes in conversation is: "Richter is no good because he always avoids taking a position. He says Yes and No, and No and Yes, in a way that suggests he is an aesthetic cynic."

GR: I believe that it would be a misunderstanding to call what I do cynical. I'd rather call it sentimental. I wouldn't call it professional because being cynical is not professional. Rather, what I do is naive.

Also, my work has been accused of being cold and distant. In retrospect I think, "How could they say that about me, about somebody who exposes himself much more than others? More than Ellsworth Kelly." Nobody ever accuses them of being distant. I open myself up, shamelessly sometimes, and then I am told that I am cynical and that nothing means anything to me. That's why, for me, the word *cynical* is absolutely out of place.

RS: Why do you think people have such reactions?

GR: One reason is that people sometimes talk about my work in terms of virtuosity.

That is an absolute exaggeration. Unfortunately I am not a virtuoso at all. I have some taste. I have an eye for bad things. But in terms of making things I am not a virtuoso, and that has always been my flaw. Today, there is almost nobody (or only a few bad examples) who has the virtuosity to draw something. I depend on the photograph and mindlessly copy what I see. I am clumsy in that regard, even though I seem very skillful. But I do have the ability to judge whether something is good or bad.

The second reason could be that I made a few remarks that have circulated, things like: "I don't believe in anything"; "I don't care about anything"; and "the motifs in my paintings have no meaning whatsoever, I might have just as well painted cabbage." These remarks gave people a certain impression of me. That's how they saw me. People still claim that only painting has an important story, never the subject.

RS: Why did you say those things? What was the context?

GR: I made those statements in order to provoke and in order not to have to say what I might have been thinking at that point, not to pour my heart out. That would have been embarrassing. I didn't know why I painted *Uncle Rudi* or *Aunt Marianne*. I refused to admit any kind of meaning that these paintings could have had for me. Therefore, it was much easier to say what I said.

RS: There are personal stories attached to these images, then, but there are also historical issues too. If you look at the date of these paintings— 1965—you see that it was very early for a German artist to be making pictures about World War II that were not simply rhetorical. There were political artists making antifascist paintings, but to make a personal image of something connected to the war was almost unheard of. And there you were

making pictures that bring that past into the open and very close to home. Did you feel as if you were in a no-man's-land when you made those paintings?

GR: Maybe that is the main reason why the audience, as well as myself, had to fall back on a strategy of laughter. That's how it worked; people thought it was mischievous and prankish and not too serious and, therefore, it was so much easier to deal with it.

RS: It is striking, though, that almost nobody has written about your pictures of 1962 to 1965, for example, when you made eight paintings of military aircraft—Allied bombers, fighters from the 1940s, and new German jets—with regard to the specific situation in postwar Germany. These paintings were an incredibly strong statement at that time. Yet, because you worked in a manner that looked neutral, it seems as if people just ignored what was in front of their eyes. But, in fact, the images were much more pointed—and in some cases more poignant—than what anybody thought then, or even now.

GR: We [artists influenced by Pop art] refused to take anything seriously. That was important for survival. We were unable to see the statement in the work, neither the audience nor me. We rejected it; it didn't exist. Part of the reason was that there existed a different kind of painting, and [Georg] Baselitz was the right man for that German tradition. People thought my painting was somehow modern, but they couldn't admit that it had any kind of quality. Instead, it was somehow funny but copied from the Americans. So people thought that we were traitors. Baselitz said to me: "You have betrayed your fatherland."

RS: What did he mean by that?

GR: That I was giving in to the international style, but he remained a German. That's how it was. That was also [Sigmar] Polke's fate because he was painting raster dots like [Roy] Lichtenstein. People said that it was lousy plagiarism.

RS: But let's shift from style to subject matter. If Lichtenstein made pictures from World War II comic books with G.I. Joe fighter planes going "Bang" that's one thing. It is very different if you are a German artist and make a picture of American planes over Germany. And it is very different to make a painting of a German soldier, such as *Uncle Rudi*, which is neither a Hero picture like Baselitz's nor a cartoon of a soldier like Lichtenstein's, but, rather, the image of a real soldier who is also your uncle.

GR: But this painting *Bombers*—American bomb—was forbidden. You were not allowed to take it seriously. You could only take it as a joke.

RS: You didn't paint it as a joke.

GR: No, but I was satisfied that it was taken as such. I would have been embarrassed if it were too serious. It was not an accusation; I wasn't accusing the Americans. I never wanted to accuse anything, except life maybe and how shitty it is. But never . . . after all, they were right. Everything was fine. [*Laughter*] I would have been attacked as a prosecutor.

RS: You've explained your position to avoid declarations, to avoid rhetoric, but even without commentary, painting American Mustangs or a postwar German fighter squadron against a social background where memories of the Allied bombings were vivid and debate over German remilitarization was in progress must have stirred many emotions and raised a lot of questions.

GR: But there is only one painting of a German plane—the Schärzler.

RS: Yes, but here we have a picture of American bombers, and a picture of fighter planes, one of the Luftwaffe Stukas, and then the Schärzler. Altogether, there are eight pictures of military aircraft.

GR: I am a specialist in airplanes. [*Laughter*]

RS: What I am trying to say is that I understand and accept the idea that you did not make them for polemical reasons, but the choice of subject cannot have been arbitrary. The planes are specific—none, for example, is a commercial passenger plane—and the paintings have their moment in the 1960s when Germany was beginning to look at the recent past, but also when Germany was at the center of the Cold War and starting to rearm.

GR: What am I supposed to say to that?

RS: Well, you must have been aware that while you were making neither political art nor mythological art about the ravages of war, like Baselitz, you were touching a nerve. After all, you have said: "The *Mona Lisa* is not a turnip." There are hierarchies of subject matter; a cow, which you have also painted, is not a 1940s fighter plane or a 1960s fighter plane.

GR: I never knew what I was doing. What am I supposed to say now? Now I could lie here, like I am on an analyst's couch, and try to figure out my actual motives with the help of others and make sense of them. Is that what we want to do now?

RS: I don't want to put you on the couch, but there must have been some level on which these images had meaning attached to the actual situation around you or to the past that you and others had experienced. What might have been historical denial in 1960 or 1965 is connected in an odd way with the postmodernist notion that images are just signs, arbitrary fragments of language, in a no longer functioning system of signs. In that manner, one kind of denial, which was historically motivated, connects with another kind of denial, which is ideologically or aesthetically driven; and yet there you were making pictures that were very, very strong about things that were very, very real. When people in 1988 were surprised that you painted the October paintings and said, "Wait, this is different, this is a Richter unlike the one we know

because he has never painted paintings with so much emotion and so much historical specificity before," I think, "Now wait a minute, that's not true."

GR: Yes, you are right. The October paintings came after a period when I had done very different things and people like [art dealer] René Block accused me of giving in to the fine arts and losing my political edge. He said that I had been political during the 1960s and then turned to the fine arts, beaux-arts. After he said that I was really "established" and colorful and aesthetic, so the Baader-Meinhof paintings came as a surprise.

RS: Actually, my position is not at all to be a psychoanalyst but, rather, to be a close reader of pictorial texts. And there is a sense now that texts are completely open, that anything can be read in any way the reader chooses. I'm supposing that perhaps this is not the right way to go about things—or at any rate not the most productive or interesting way to read images—and that there may be intentions expressed in bodies of work of which the artist is only partially conscious or aware, which nevertheless emerge very powerfully through reiteration, and that such latent intentions have to be closely examined and seriously considered. So my question is more about now than the past, how you think about them now, how you relate these images to each other. Does such a relation stand out?

GR: All right, I understand. That makes the questions very interesting. Sometimes I am surprised that I have never asked myself something, and sometimes one can discover something.

RS: For example, take the painting *Mr. Heyde*. The man in the wide-brim hat whose face is turned away from the viewer was, in actuality, Dr. Werner Heyde, who was responsible for killing mentally retarded, mentally ill, and chronically sick hospital patients as a part

of a euthanasia program that pioneered the techniques of the "Final Solution." In 1959, the date included in the picture, he was exposed after having lived and worked for years in Germany under an assumed name. When you painted this picture, six years after his arrest, virtually no one had dealt in this direct way with the issue of hidden war criminals. Weren't you aware of the significance of his arrest, and wasn't it also significant that your aunt Marianne, who was a schizophrenic, was a victim of the system of medical murder he set up?

GR: Out of my mind, of my consciousness. I was surprised myself when many years later—I believe it was on the occasion of the exhibition *Deutschlandbilder*—somebody told me that he was a war criminal.

RS: So you didn't know who Heyde was?

GR: I am sure I knew it. But I repressed it right away, and it became a picture like every other. I tried to show that this was a guy like every other guy that gets arrested. You can see those two policemen. I did not want to be part of the faction that accuses. I do not belong to those who present themselves as antifascists, because I am not. I am also not a fascist. I was disinclined to be conscious of too many things; I just wanted to let myself go. And it is still the same today.

At the time I do something, I really don't know what I am doing. Afterwards I think, "Oh that's why you did that, now I understand." It's the same with the paintings. But I was much more introverted back then, and I would have refused any connection between Heyde and myself. I would have said, well, it's a nice picture; it doesn't mean anything.

RS: So was there no conscious connection between Heyde's program during the Third Reich and your aunt's death?

GR: Absolutely never, not even once. It did not exist. There are no conscious connections within me at all. [*Laughter*] But

I am certain that I knew of it because I read it somewhere.

RS: This raises the issue of what can be painted and what can't be painted. In *Atlas*, there are images of the concentration camp—of prisoners and bodies—and at one point you thought about making an exhibition with the pictures of the camp next to the porno pictures. Finally, you decided that it was not possible to juxtapose such things nor even to make paintings from the documentary photos of the Holocaust. Why wasn't it possible?

GR: I'd say that it would have been impossible for *me*. I saw no possible moral or formal solution for how to exhibit the camp and the porno pictures as Konrad [Lueg] and I had planned. We had this plan in a Düsseldorf gallery, and we each collected photos; then we gave it up. It didn't work. We didn't find a way. We would have gotten a lot of attention, but it would have been unproductive and inadequate—at least inadequate.

RS: What is the difference between an image that you can look at, incorporate into your visual memory, and one that you can paint? The camp pictures appear in *Atlas*, and one sees them as part of a much wider array of pictures, yet they are not paintable. What determines that something is unpaintable?

GR: I believe that there is no picture that can't be painted. But there are personal limits and limits of the time, situations where the reception would go so predictably wrong that it doesn't work. It is also the personal inadequacy to not be able to give something the right form. Three years ago, I tried to use the camp pictures again, and again it didn't work. But that was my fault.

RS: In other words, there is no such thing as an image that is absolutely taboo, there are only images that an individual cannot paint at a particular time?

GR: Yes. I still have some photographs in the

studio that I am thinking about. Who knows? There are only unfinished themes. There are some that have simply become uninteresting. A painting that is unpaintable is a painting I know would go wrong—something I can't do—one that would cause people to say: "He meant well, but maybe, he's getting old." [*Laughter*] That is the only criterion. Other than that nothing is unpaintable.

RS: What qualities make an image that already exists in a photograph fascinating or substantial for you once it becomes a painting?

GR: That is impossible to answer. I don't know why I like things. [*Looking at a book of images*] I like this or this. This has too much to do with Courbet, but nevertheless I like it.

RS: I am not so much asking why a photograph makes you want to paint it, but what happens in the process of painting an image that makes the result interesting or acceptable, so that you don't destroy it or paint over it?

GR: That is also an impossible question. [*Laughter*]

RS: That won't stop me from asking.

GR: Why doesn't it work like that? Why can't I let this go? Why can't I do this better? Why don't I know that? Like this one. [*Pointing to a canvas on the studio wall*] I don't like this one. But I don't know why. One can't answer that, at least I can't.

RS: Speaking from the outside, I would think maybe it's the point at which there is a specific quality or experience that was not in the photograph that suddenly appears in the picture.

GR: Yes, sounds pretty good.

RS: And is there any way of describing or saying how this happens or even what happens?

GR: No. But it also works the other way around. Sometimes I make a print from a painting, a multiple, using photography, and that takes a lot of time. First I have a reproduction and it looks horrible. Then I begin to change it, make it out of focus or something, or put it under plexiglass, so that it somehow becomes an independent object.

RS: I don't think anybody anticipated this doubling back to photography as a medium. In the past there had been a one-way street from the photograph to the painting, where you added and subtracted qualities from the source image. When you photograph a painting such as *Uncle Rudi* or *Cathedral Corner*, what kind of transformations are you looking for?

GR: In the photograph, I take even more focus out of the painted image, which is already a bit out of focus, and make the picture even smoother. I also subtract the materiality, the surface of the painting, and it becomes something different.

RS: The effect of removing the materiality from the image is very interesting, but how is that important or significant?

GR: I wouldn't know how to say that—to say how the new quality of the photographic work is different from a reproduction.

RS: That wasn't what I was asking, but it is an interesting question because I think some people see these works as "just" a multiple.

GR: The painting is better. [*Laughter*]

RS: Yes, but what matters is that the visual experience is different. From your point of view what are the significant differences?

From my perspective, each stage of this process seems to have a different relation to light, to the form that light assumes. In a sense, a photograph is the direct record of light, whereas a painting represents light. The second-generation photograph that comes after the painting and is the third generation of an image holds or emits light in a very different way both from the painting and the original photograph. The visual phenomenon it captures is, in a way, further

refined, not better or worse but perceptually different.

GR: I am sure that's right. But I have a problem with the term *light*. I never in my life knew what to do with that. I know that people have mentioned on some occasions that, "Richter is all about light," and that, "The paintings have a special light"; and I never knew what they were talking about. I was never interested in light. Light is there and you turn it on or you turn it off, with sun or without sun. I don't know what the "problematic of light" is. I take it as a metaphor for a different quality, which is similarly difficult to describe. Good.

RS: This astonishes me because it not only seems so central to what you do but to what was done by the painters that you like: Velázquez, Manet, and Vermeer.

GR: That I don't understand either. Velázquez and light. Of course, we have light, here. Without light we couldn't see each other. There is something lacking in me.

RS: I don't mean light as a kind of metaphysical thing, I mean light as a phenomenon.

GR: Yes, we have beautiful light, cold light, warm light, southern light; people in Italy have a different light. I do see all that. I once got into trouble with [Norbert] Kricke when he told me that I had to understand his sculptures in spatial terms, that they dealt with space. And I replied that there's space even in the smallest house. And he was very mad at me for being so dismissive about space, the elementary medium of sculpture. That always comes to mind when I hear the word *light* in conjunction with painting. *Appearance,* that to me is a phenomenon.

RS: Let me give you an example.

GR: Now I am curious.

RS: Okay, these are the first and the last versions of *Toilet Paper*. The first one has a strong shadow, which makes the image very volumetric, and that is reinforced by the direct way it is painted. In the third version the shadows and the overall touch are softened, and the form has a kind of glow to it. In the first version, the treatment is very objective, but in the third it is atmospheric.

GR: Right.

RS: These paintings have the same subject, same tonality, same technique, but the difference is the difference of light. Much later the candles and the skulls are painted in more or less the same manner as the third version of *Toilet Paper*. Now, that shift in emphasis must mean something. I am not saying that it means the same thing for you as it means for me, but these two examples represent different realities or different attitudes toward reality.

GR: Yes, I like that because you look at the light from a practical, pragmatic perspective. Yes, I can see that. That's true. I agree. Then the light in the photograph is different. Sometimes the light is harder as, for example, in *Small Bather*. In that case, the painting is much softer and more atmospheric, while the photograph has more contrast, has a harder light, is crisper. That was the only solution. I couldn't do it softer, maybe. If I made it any softer, it would have disappeared. And I needed to spice it up. It was also good for the viewers. If it is too soft you have to be so sensitive in order to appreciate it. That would not have been possible in a photograph.

RS: It means that you are thinking about the viewer.

GR: The audience, yes.

RS: When you say only the most lyrically inclined people can handle this, it is as if you are saying, "I can see trouble coming if I make things too lyrical," as if there were a group of people who could take this lyricism, while the rest all want something more cut-and-dried.

GR: This edition is for a hundred people who want to have something solid. Painting is looking for just that one person. But

ROBERT STORR

one hundred people get that which is a bit more ephemeral and a little crisper.

RS: It is as if you are projecting onto your audience a preference for something tough. It this true?

GR: Yes.

RS: You happen to be the owner of this painting, and you like something soft.

GR: In this case.

RS: There is an interesting discrepancy between your acceptance, if you will, of the gentler image, and your view that in the public discourse the images have to be tougher.

GR: Yes, stable; and I have to maintain that. The multiple has not turned into a hard picture; it has merely become a little more lively.

RS: That's the practical answer. The buyers of this work are somewhat different.

GR: It became a completely different object with a frame, with a sheet of plastic over the image which hangs so freely; you see the fragility. It was a substitute for the fragility of the painting. It showed all these interesting qualities that the painting does not have. I had to explain all of these relations to Dieter Schwarz who once wanted to reproduce them just as they were. But I said that he needed to include the frame and the distance produced by the glass and so on. That's all part of it. It has become an object, not just a picture. That's why we can't reduce it to the perkiness; it became a whole other thing.

RS: In the beginning, you talked a lot about how important it is that the pictures you worked from are givens, ready-mades, pictures from an album, or from a magazine. What you do is to alter that given by painting it.

GR: Why am I changing the qualities of the photograph? Because it is too small. [*Laughter*] I am a painter, I love to paint. Using photographs was the only possible way to continue to paint. I couldn't just have used a model. That was impos-

sible and an untimely endeavor that would have cut everything short. I can't do that. Not even Mr. [Lucian] Freud could to do that. I had to use photographs. They provided new contents that were relevant to me and to others. That was my conviction.

RS: What contents were those?

GR: What touches us.

RS: But the range of subjects goes from things that are totally banal, like *Toilet Paper*, to images that are not so banal, like *Mr. Heyde*.

GR: To make a photo from a painting that you can put up on the wall again is comparable to making a painting from a photo. But these are the old questions where one only has excuses. Take music as an example, how some simply hear when it's right. In painting, think of the Bob Ryman exhibition in Bonn, where you suddenly find a painting that has something, that looks "right" and nobody knows why.

RS: No, but could you describe certain qualities that give you this feeling of rightness?

GR: I don't know how to describe that. Whether or not it has been fulfilled or how wrong it went is a different question, but the demand was, and remains, to address the things that are most important, that concern us all. And so in relation to the history of art, where nobody had ever painted toilet paper, it was time to paint toilet paper, which is not really banal.

RS: Why?

GR: It's important; it cannot be banal. Then there's the "banality of evil." It's a beautiful term—what Hannah Arendt said about [Adolf] Eichmann. And the same for *Mr. Heyde*. This is important.

RS: Now I am confused. In a sense, *Mr. Heyde* and the toilet paper are both banal and, in another sense, evil is also banal.

GR: And both are important. I just want to get away from the label: "He paints the

banalities of life and that's all," or "He is one of those people who are not interested in anything." For a while that was just fine with me. At least I was being left alone.

RS: But now you want to get rid of that characterization?

GR: Yes. I want to at least correct it. *Banality* means a little bit more than *unimportant*.

RS: What does it mean?

GR: Just more. I mentioned "the banality of evil" in order to show that banality has at some point been described as something horrific. It can be a concern to describe the banal as something terrifying. The chandelier [*Flemish Crown*] is a monster. I don't need to paint a monster; it is enough to paint this thing, this shitty, small, banal chandelier. That thing is terrifying. I've already said some time ago that in order to dissociate myself from Francis Bacon, I didn't have to distort faces. It is much scarier to paint people's faces as banal as I find them in photographs. That is what makes the banal more than just banal.

RS: How do you mean something monstrous?

GR: It is more terrifying to me.

RS: I'm interested by what you said in a couple of ways. First of all, in American Pop art, the emphasis was on ordinary commercial goods, things you buy in a store, images in magazines, and so on. More recently, Jeff Koons made a whole show dedicated to banality. But it was banality in a grotesque way, an exaggerated banality. And you are also talking about the grotesque or the monstrous, in a form that is very detached, subdued, not exaggerated. It is not a rhetorical statement that you make the image in a certain way that is very . . .

GR: Well, modest. Very small and quiet. Yes, I'd say that it is small, modest, quiet. I hope that it functions like that. That something is heard although it approaches quietly. That was my hope. That was the trick.

RS: Are the paintings supposed to have a certain uncanny quality?

GR: No, but you are reminded of something. In the ideal case, somebody looks at the work and asks what this is supposed to be and why anybody would paint such a banal object. And then the person comes to think that maybe there is something more to it, that maybe the object is not that banal after all, that maybe it is horrible. It stands for something . . . maybe for a terrible living room.

RS: But not as a symbol?

GR: No, not as a symbol. But the longer you see it, the more it becomes frightening.

RS: For example, the *Flemish Crown* is a piece of a larger reality that is frightening, not a symbol of something but part of the thing itself.

GR: It is an image of this horror, a detail of it.

RS: Of ugliness?

GR: Of the misery of this world. [*Laughter*] Perhaps this special culture.

RS: Which special culture?

GR: A petit bourgeois culture. But I refuse to discuss it in those terms because now it turns into social criticism where I attack a certain class, the petit bourgeois, those who had this thing in the middle of their living room, the Flemish crown. That was part of our culture, and I don't want to attack that even though I myself might have suffered under it. And although it was terrible, it was never meant to be an accusation. Now those people are all gone. There was nothing but crime and misery in those living rooms. There is only crime and misery in general. [*Laughter*]

RS: So you didn't want to make a critique?

GR: No, it's a report. Remember people; don't forget, please. [*Laughter*]

RS: In general, American Pop art concentrated on public imagery and commercial culture. But previously you told me that as German Pop artists Polke, Lueg, and you wanted to represent a broader experience, a wider view of reality. I won-

dered if you could say something more about this larger vision in relation to the focus of American Pop art.

GR: Maybe we didn't even have a chance. The message of American Pop art was so powerful and so optimistic. But it was also very limited, and that led us to believe that we could somehow distance ourselves from it and communicate a different intention.

RS: So, where does that difference lie?

GR: It was not possible for us to produce the same optimism and the same kind of humor or irony. Actually, it was not irony. Lichtenstein is not ironic but he does have a special kind of humor. That's how I could describe it: humor and optimism. For Polke and me, everything was more fragmented. But how it was broken up is hard to describe.

RS: Are you talking about a historical experience or a personal experience of fragmentation?

GR: They come together, right? I don't know why. Otherwise, we would have had to play a role. Some people did that; they really participated. They imitated the Americans: optimistic, big, colorful, strong.

RS: Lueg is more like the American Pop and you are much more . . .

GR: Broken? Yes, maybe.

RS: One American Pop artist who is definitely broken is [Andy] Warhol.

GR: Yes, that's true.

RS: Do you feel a particular affinity to Warhol?

GR: I always liked him the most. But there is a huge difference between us, and that was the freedom that he had. People here in Germany are all very uptight. But he was not. His life story, his homosexuality—that was not possible here. Polke took some liberties, but those were very different from the freedom that Warhol had. You have to have a basis for being received like he was. That did not exist for us.

RS: One aspect of Warhol that is very strong is his morbidity. Do you identify with that quality?

GR: Those are paintings by Warhol I like the most, the Disaster paintings. And also some of the films. But everything else, like his huge production of commissioned portraits, was not my cup of tea.

RS: I am less interested in Warhol than I am in you, but I think there are some telling parallels to be pointed out, and some telling contrasts. For example, when Warhol selected and transposed an image, he took things away from it, he removed information. Now you have said yourself that you have many tools at your disposal, but elimination is perhaps the most important one. Could you talk about what it means to eliminate or reduce elements of an image?

GR: I believe that the quintessential task of every painter in any time has been to concentrate on the essential. The hyperrealists didn't do that; they painted everything, every detail. That's why they were such a surprise. But for me it was obvious that I had to wipe out the details. I was happy to have a method that was rather mechanical. In that regard I owe something to Warhol. He legitimized the mechanical. He showed me how it is done. It is a normal state of working, to eliminate things. But Warhol showed me this modern way of letting details disappear, or at least he validated its possibilities. He did it with silkscreening and photography, and I did it through mechanical wiping. It was a very liberating act.

RS: Is the process of elimination an arbitrary one, where the results are a surprise, or did you anticipate what would be removed before actually doing it?

GR: Well, it's in between. You can imagine what has to be wiped out, smeared away. And then there were also accidents. In any case, it was a wonderful utopian way to do this mechanically and not to

consciously decide what has to go and what can stay. It fit the climate of the time to make everything easy and simple and happy—the utopian climate of the 1960s. It was part of the *Zeitgeist* to say: "I want to be like a machine." I don't even remember who said that. Polke said something like that, and Warhol did too. Today that's unthinkable. Now all of these paintings seem handmade, painterly, imperfect. It was different then. People only saw the similarity to the photograph, the technical perfection, which by now is outdated. Because of their age, the paintings have become so painterly and now look like old handmade paintings. Back then, they were provocative, as if produced by a machine: "Richter paints with such perfection that the surface is like that of a photograph."

RS: So there's a difference in reception?

GR: Yes.

RS: But are you talking mostly about the critical response?

GR: No, overall. I remember those paintings as being much more perfect. The ability to do that so perfectly was my trademark. But when you look at them today, they are far from perfect. It is rather the earlier ones that are more perfect, and maybe the later landscapes. Do you agree with this?

RS: No.

GR: Maybe in the 1960s one didn't see this mechanical quality, one wasn't able to see this. In terms of reception, they were said to be "as perfect as the Americans." And then after a while it became obvious that compared to the Americans they were not perfect but had a very European handmade quality to them.

RS: That's true. But I also think that either there is an evolution in the work or a paradox that was always there, which is the fact that, on the one hand, technically they belong to the tradition of fine studio painting and, on the other hand, that something apparently arbitrary or

mechanical has been done to pictures made in that tradition. After all, you are a master of the disruptive technique as well. The thing that makes it blur is not a machine but a bigger brush or squeegee. It was never so mechanical; it was never so arbitrary, correct?

GR: Yes.

RS: And then again, you said earlier that what separated you from other artists was not simply that you have this technical command but that you have the ability to recognize when a work has achieved a certain rightness.

GR: Yes.

RS: So the defining quality of what you do is both a matter of the mastery of materials and a question of recognition and decision. It was never about violence done to the picture in the same way that some people have seen this kind of disruptive physicality as aggression, pure and simple.

GR: Yes, that's true.

RS: In some ways, what you're up to is closer to what [Alberto] Giacometti did than to the kind of painting that is usually described as wild or violent. It is about working away at the image and at the paint until you can see something.

GR: Yes.

RS: So, in that respect, your approach is similar to Giacometti's but involves a different formal language with a different set of conventions, and is being pursued at a different time.

GR: Yes, that sounds good.

RS: The other day, you said that when you were in East Germany you and your friends wanted to find a "third way" between the Russian and the American models. Together, you identified your efforts with certain artists, and Giacometti was one you mentioned. Now Giacometti comes out of [Paul] Cézanne and a tradition you have avoided, yet, at the same time, you seem to have strived

for a certain quality that was in those paintings. Is it fair to say, then, that you invented a different way of painting in order to arrive at the same place?

GR: And this commitment to quality still clings to me like a clubfoot and makes me unfree, unproductive, and impotent.

RS: If you are impotent, the rest of us are really in trouble. [*Laughter*] But I didn't mean quality with a capital Q, as in a hierarchy of values but, rather, a certain feeling, a certain type of visual and emotional experience. Let's go back to basics: you paint ordinary life in a revealing but undramatic light, you use painterly languages that belie style. In a way, Giacometti attempted to do something quite similar— to capture the appearance of things that kept retreating or disappearing and then partially clicked and snapped into focus. The other day when I watched you working, the same kind of thing seemed to be happening. You have a process in which you rough in, or state, the image, then blur, or unstate, it. And after this has gone on for a while, an image becomes visible that is fundamentally different from what you started with. I don't want to force the comparison with Giacometti, but the existential aspect of his work wasn't a matter of expressive style so much as it was this pursuit of an elusive reality, a pursuit carried on without melodrama.

GR: Yes. I would be very embarrassed if I were staging some sentimental drama here.

RS: It is existential and it is humanist but it is not sentimental and it is not melodramatic.

GR: Yes. Only a bit. [*Laughter*]

RS: You admit it! [*Laughter*] That is interesting because it is as if, by way of Pop art and mechanical reproduction that was very much of that moment, you were able to come all the way back around and answer some of the questions that con-fronted artists of your generation in the 1950s, except that the answers you provided don't look like anything that would have issued from the tradition in which those questions were posed.

GR: Good.

RS: There are three basic critical explanations for deliberate elimination or erasure in modern painting. The first one is destruction. Do you see what you do as a destructive act?

GR: Yes, very often I have the feeling that what I do is very destructive, born out of the need and inability to construct. It is my wish to create a well-built, beautiful, constructive painting. And there are many moments when I plan to do just that, and then I realize that it looks terrible. Then I start to destroy it, piece by piece, and I arrive at something that I didn't want but that looks pretty good. Therefore I understand if somebody calls it destructive. I find that congenial but maybe it is just . . . I don't know.

RS: That makes me think, for example, of [Lucio] Fontana. It was said of him that in cutting and puncturing the canvas, he was attacking it, but, the result is very beautiful. Does this paradox in Fontana's work relate in any way to what you do?

GR: Maybe. I find him to be much more productive. Because even though at the beginning he and Polke and others destroyed their work out of rage and anger, later on they were able to direct those actions. I was never able to do that. I can't plan to make something look out of focus in a certain way. That doesn't work. For example, this painting [*Snow*] was created out of a different initial impulse; and this gray painting was intended to be very different from what it eventually turned into. That's why it is impossible for me to re-create them. But that's another topic. However, I already have to revise that statement I just made: there are many abstract paintings that I did plan and

execute. They are mostly small and part of some sort of multiple work. For instance, I once made one hundred small paintings for Munich. They simply flowed one after the other and all of them perfect. Fontana would have been amazed.

RS: For *October 18, 1977* you did several versions of some images.

GR: Yes, those were planned like that and made according to the plan.

RS: A second explanation for erasure or elimination is that the image is not about the act of the destruction that left it in its ultimate state, but about loss. What you see in such paintings is an absence.

GR: I believe that Dieter Schwarz once mentioned something like that. I feel very close to this idea of seeing the pain and the loss in the work. I can't paint as well as Vermeer—we have lost this beautiful culture, all the utopias are shattered, everything goes down the drain, the wonderful time of painting is over. It is an inclination of mine to see it that way. I don't know anybody else who is so attached to the history of art and loves the old masters as much or wants as much to paint like them. There are examples where I have tried to reincarnate Titian and others, but of course it didn't work out. I wanted to paint the Annunciation for myself. That is an example of how it is impossible to paint like that today. I understand why people see it that way.

RS: So, the subject of these works is a reality that has not yet entirely disappeared but which is retreating?

GR: It is a reality that is unreachable. It is a dream. It's over. But I am old-fashioned enough or stupid enough to hang on. I still want to paint something like Vermeer. But it is the wrong time and I cannot do it. I am too dumb. Well, I am not able to.

RS: But I think more about visual phenomena that can be captured than the historical precedents for capturing it. What

happens when the subject is not Titian but a toilet paper roll? Does that mean that reality itself, everyday reality, is something we've lost the ability to hold onto in a picture?

GR: No, that's never the problem. I never wanted to capture and hold reality in a painting. Maybe at a weak moment I did, but I don't remember. However, that was never my intention. But I wanted to paint the appearance of reality. That is my theme or my job.

RS: The third explanation for erasing or paring down an image is that what you are left with in the end is something irreducible and basic. Rather than performing a symbolic act of destruction or painting loss, you arrive at a distillation of the image's essential qualities.

GR: I hope that's the case. You can say that, I can't.

RS: But if that's the purpose of working in this way then what you finally have is neither the depicted object in itself nor a clear mirror image of the subject struggling to perceive that object, but a strange in-between entity representing the exchange of appearance between the object painted and the subject looking at it, the thing and the viewer.

GR: That is something for intellectuals. [*Laughter*]

RS: I am actually trying to describe an experience and not just a logical abstraction. The book in front of me has its own reality, and I have mine. They are separate. But when I pick it up and look at it and I try to grasp an image on the page with my eyes, those realities overlap and are confounded. Visually, I step part way out of myself and part way into this other world, but I can also lose my bearings and be stranded between self-awareness and awareness of the things represented in the picture.

GR: Yes.

RS: And that's where painting happens, at

any rate, one kind of painting. If I want to make paintings about what is going on inside me then I become a surrealist or an expressionist. But I am talking about a kind of painting that is neither totally reflexive nor totally objective.

GR: That's probably right, but you overestimate me.

RS: You have talked about how working with photographs freed you from certain expectations. You didn't have to have style; you didn't have to have a theme in the traditional sense of the term; you could paint all kinds of disparate things. But in these early statements, you also made an issue of photography's apparent neutrality. Could you say a little bit about why seeming to be detached in this manner was so crucial for you then?

GR: Yes, it was my wish to be neutral. I saw it as an opportunity. It was the opposite of ideology. And to be as objective as possible offered a legitimization for painting since you were being objective and doing what was necessary, enlightening, and so on.

RS: In the 1930s, the English novelist Christopher Isherwood cast the narrator of his "Berlin Stories" in a similar role by having him say, "I am a camera," by which he meant that he was not taking positions but merely recording what was going on around him. When you first appropriated photographs to make paintings were you also assuming such a cameralike objectivity?

GR: The paintings have the advantage that I can still add a little something—because the notion of neutrality and objectivity is an illusion, of course. That is somehow impossible. Every painting automatically includes my inability, my powerlessness, my relation to reality, things that are subjective. Therefore, it was legitimate to be painted. It was not about absolute purity but about the greatest possible purity.

RS: In many respects, Isherwood's stance was the literary equivalent of *Neue Sachlichkeit* in painting during the same period, but in fact *Neue Sachlichkeit* pictures could be extremely editorial.

GR: That was very often the case.

RS: And you were looking for something that was more neutral, more . . .

GR: Complex.

RS: *Neue Sachlichkeit* art was in part a reaction to earlier forms of modernism, in particular, Expressionism, Cubism, and Dada, and their fracturing and reconfiguration of traditional picture-making. A lot of Pop art in America used modernist methods for breaking up images and recombining the pieces. For example, this happens in Warhol and [Robert] Rauschenberg. By contrast, your paintings are almost always whole.

GR: Yes, that is true.

RS: So even though you cut or crop images and reframe them inside the rectangle you paint on, you treat those edited details as complete pictorial units and, with only a couple of exceptions, you've never collaged or juxtaposed images from different sources in the same work.

GR: I can't explain why I have such an aversion to collages. To me it always seemed cheap, and it was too sloppy, too loose. I always wanted to make a painting.

RS: What is the appeal of making a painting, in this sense?

GR: Well, it is somehow my duty and my task to fill the space of painting, to make a whole out of it, and everything else seems inappropriate.

RS: Of course, Polke is a maker of collages, and your sensibility is very close to Polke's in some respects, but on this issue you are very different.

GR: Yes, I am also the more classical one. Somebody once said that I am Goethe and Polke is Schiller; or I am Thomas Mann and he is Heinrich Mann.

RS: Could you explain to an American audience what this distinction means?

GR: The classical is what holds me together. It is that which gives me form. It is the order that I do not have to attack. It is something that tames my chaos or holds it together so that I can continue to exist. That was never a question for me. That is essential for life.

RS: In terms of the situation here in the Rhineland in the 1960s, with the impact of Fluxus and Joseph Beuys, almost everybody else in your circle found themselves on the other side.

GR: Yes, it seems as if Beuys was on the other side, and also [Nam June] Paik and [John] Cage. But Cage is really a classical man—so scrupulous in the way he holds his things together, does so little, and makes that beautiful. He never even thinks about being sloppy. Sometimes he pretends to be but he never is. He is probably even more uptight than I am and maybe more scrupulous.

RS: You've said that in the 1960s you were very impressed by Cage's "Lecture on Nothing," in which he at one point said: "I have nothing to say and I am saying it." How did you understand that paradox then, and how did you relate it to your own desire to avoid making big declarative statements in your own work?

GR: I thought that this was born out of the same motivation that makes him use the notion of chance, which is that we can't know or say very much at all, in a very classical philosophical sense: "I know that I don't know anything."

RS: Back then, when you talked about your use of photographs as the source for paintings, the range of choices you had, and the disparateness of your selection, were you thinking of the apparent arbitrariness of Cage's procedures as a model?

GR: Cage is much more disciplined. He made chance a method and used it in constructive ways; I never did that. Everything here is a little more chaotic.

RS: Chaotic in a sense of more arbitrary or more chaotic in a sense of more intuitive?

GR: Maybe more intuitive. I believe that he knew more what he was doing. I might be absolutely wrong about this, but that was my impression.

RS: You mean a more rigorous aesthetic philosophy?

GR: Yes, the fact that he had a theory that he could name and describe. He could talk or write about what he was doing.

RS: And you proceeded by . . .

GR: From accident to accident. [*Laughter*]

RS: But let's suppose that it was not a question of going from accident to accident but from intuition to intuition. That means that you have a hunch, you don't know the answer, and you don't know exactly why you chose certain images, and yet in some way they were connected in your mind, in some way that suggested each other or created associations as you considered them. Certainly by the time of the *48 Portraits* there was deliberateness in your choices. What kind of instinct or motivation did you have in order to move from making images of contemporary reality to making images of historical figures?

GR: I can only say that that's the way it was. Polke drifted away into the psychedelic direction and I into the classical. I found support in Gilbert & George where I discovered the same tendencies. And then in [Blinky] Palermo who was also retrieving the classical.

RS: And [Marcel] Broodthaers, too?

GR: Yes, but I couldn't understand him—ever.

RS: But virtually all the things he refers to all belong to the nineteenth century.

GR: But that was nineteenth century, and I wanted something more classical.

RS: In America, Pop addressed the present. Even though Lichtenstein painted Mickey Mouse as he had looked forty years before, still he was painting Mickey Mouse. However, in Europe, artists used a pictorial lan-

guage that developed out of Pop to look at historical things. For example, Broodthaers catalogued cows in a manner that simultaneously derived from Warhol's enumeration of Coca-Cola bottles, soup cans, movie-star smiles, and old-fashioned diagrams. And when Polke painted a row of books labeled *Polke's Collected Works,* he made them look like they came off the shelf of an old library. When you went from making pictures of speed boats, cars, planes, and Jackie Kennedy, to making the *48 Portraits* something of the same anachronism entered into the equation. You say that what you are striving for is a kind of classicism, but it has more dimensions than that.

GR: *48 Portraits* was supposed to be many things. Those were the typical neutral pictures that one finds in an encyclopedia. The issue of neutrality was my wish and main concern. And that's what they were. That made them modern and absolutely contemporary.

RS: That's true. But who are the people in this index? They are all scientists, philosophers, writers, musicians.

GR: Yes, clever people.

RS: There is no painter, no artist.

GR: That would be too close to me. People would have tried to figure out why I included that painter but not the other one. I chose figures that I had the least to do with. Of course I also had some connection to musicians and writers but there are a lot missing who I like much more than those portrayed—[Sigmund] Freud and Nietzsche, for example. But I didn't want to portray my favorites but the typical, the leveling; that's the reason all that was contemporary, the neutrality of the encyclopedia, which neutralizes everything and all ideology. That's why I chose many that I didn't know and took out many that I did know. It was the opposite of truth. [Theodor] Adorno said: "Every art work is the arch-enemy of

another." They can't exist next to one another. The encyclopedia makes that possible. We can do it in the world. That is the present situation.

RS: So were you arguing against exalting cultural figures as heroes?

GR: Not really. No, it was not my ambition to be against heroes. I love them too much. I am happy that those people exist.

RS: Were you arguing in favor of a plural culture?

GR: Yes, that's what it is, without endorsing it. It is a fact: we make everything the same. But it is not an attack. It is ambiguous because I hung them in a wonderfully classical way, like a shrine. This is its classical aspect, and that had to do with Gilbert & George.

RS: In this sense, the casts that you made of Palermo and yourself [*Two Sculptures for a Room by Palermo*] almost seem to belong to the row of heads in *48 Portraits*?

GR: Yes, at least they have the same formal style. But we never wanted to join that lineup or saw ourselves like that. It was a formal matter. Maybe it was a polemic against the *Zeitgeist* of egalitarianism, pluralism, and this whole anti-aesthetic debate. Maybe because art was irrelevant. Maybe we made those heads and lauded the classical in order to be polemical, against the time.

I remember seeing those pieces in Munich, where I also visited an exhibition called *Italian Art Today*, with people like [Giulio] Paolini who made similar classical stuff. And suddenly I realized how substantial my two heads were compared to what Paolini had produced, this decorative game. I suddenly understood how dead serious mine was. That it was somehow inconsistent with the humor of Pop art. If it was humorous, it was that way in a tragic manner.

RS: Of course every work of art of any value has multiple levels of meaning; one can

be funny and one can be serious at various levels. Paolini is funny and serious in his love affair with classical art, but the intensity of the ambivalence is lower.

GR: Yes.

RS: But your situation was different. Your evocation of the classical was basically a response to the whole mood of the late 1960s, early 1970s, where the general rules were: Away with the old; Everything must be relevant; and Everything must be a cultural critique.

GR: Yes, exactly.

RS: But that interpretation differs from what many people seem to think this work is about.

GR: Oh, really!

RS: Some critics seem to regard the *48 Portraits* as an empty, almost postage-stamp-like array of cultural icons. Why do you think it has had such a strong response?

GR: If it was only postage stamps it wouldn't be as elaborate and there wouldn't be as much trouble. It is too big and there is too much presence, and always people wonder what it is about. Women are angry because there are no women. It keeps upsetting people again and again. People are always upset when confronted with something traditional and conservative, and therefore they don't want it. You're not allowed to do that; it is not considered to be part of our time. It's over, reactionary.

RS: Some critics explain it to themselves—make it okay to like—by arguing that it's an exercise in rhetoric, the rhetoric of a certain kind of representation of culture that questions or nullifies that culture's authority.

GR: And as I mentioned, you also have the psychological or subjective timeliness of the father problem. This affects all of society. I am not talking about myself because that would be rather uninteresting, but the absence of the father is a typical German problem. That is the reason for such

agitation; that is why this work has such a disquieting effect.

RS: So it is about restoring a sense of history that has been broken or truncated.

GR: It's not a restoration. It is a reference to this loss. It takes account of the fact that we have lost something. It asks the question of whether or not we need to do something. It is not about the establishment of something.

RS: A question of whether what has been lost can be brought back or not?

GR: Yes, but I don't believe that it comes back.

RS: Was making the paintings a way of putting those images out to see whether they still exerted power on their own?

GR: That was not my intention. My intention was to get attention. [*Laughter*] I wanted to be seen.

RS: Bruce Nauman once made a neon with the text, "The true artist helps the world by revealing mystic truths," which he put in the window of his studio like a beer sign. That piece was addressed both to himself and to the public.

GR: That's good!

RS: And what appeared to be a declaration was really a question: "Do you believe this? Do I believe this?" Is there any parallel between what he was doing and what you're after?

GR: Yes, I believe that there is something like that. That's possible. But I have too much respect for Bruce Nauman to simply claim that we share the same concern, that we are thinking about the same things. It doesn't work like that.

RS: Another way of approaching the problem might be to talk a little bit about your decision to copy Titian's *Annunciation* or your interest in landscape.

GR: It is all the same motivation.

RS: In other interviews, you've suggested that using nostalgia or using an anachronism was a way of being subversive. But painting in traditional modes can also involve an assimilation of traditions. Were you

employing these images as a tool for upsetting the fixed ideas of the avant-garde, or were you reaffirming the basic paradigms to which you resorted? Were they primarily a tool, or a goal?

GR: That is too difficult.

RS: Alright, but take the landscapes and the Titian copy: not only was the style in which they were painted a departure from modernism, but so were the images. The idea of someone in your position painting a Titian or painting a beautiful landscape in a somewhat romantic way was bound to get a reaction, was bound to make people say, "What is he doing?"

GR: On the one hand, it was a polemic against this annoying modernist development that I hated. And, of course, the assertion of my freedom: "Why shouldn't I paint like this and who could tell me not to?" And then the affirmation was naturally there, the wish to paint paintings as beautiful as those by Caspar David Friedrich, to claim that this time is not lost but possible, that we need it, and that it is good. And it was a polemic against modern art, against tin art, against "wild art"—and for freedom, that I could do whatever I wanted to.

RS: Tin art?

GR: Much modern stuff looked like aluminum. Modern, pure. Minimalism was going on at that time. I remember just a little story that took place when I was first in New York with Palermo. We had some photographs of our work—just in case. And we showed them to someone— I think it was Bob Ryman—and I thought that he would, of course, prefer the abstract paintings, but he was only interested in my first landscape, which was *Corsica (Fire)*.

And I was so surprised that he liked this painting. I thought, he is a modern artist, a real artist, not like me. But he liked it.

RS: Well, he is a modern artist and he is a real artist, which is precisely why he would

have liked it. But in that period from the late 1960s to the middle 1970s, one gets the impression that things were very hard for you.

GR: Yes, it was at that time I lost the ground under my feet.

RS: How so? Because the world changed on you or because you began to doubt what you were doing?

GR: I didn't know what to do but to paint. I was "out."

RS: But if I understand the situation correctly to be out and to choose an entirely unexplored direction can also be a kind of freedom?

GR: Well, the freedom and the comfort gained from being out were not very substantial. Being out didn't have such a positive effect. After all, I wanted to be on the inside. I don't know where I was.

RS: But, in fact, being in that position opened up a whole different way of thinking about the work, didn't it?

GR: I don't remember it being so different. Anyway, only much later did I realize that these crises were not something to get agitated about but that they were the normal way of working. Everybody has them. Well, maybe it is not as simple as that. There are people who work with more confidence and others who stumble from crisis to crisis. It was somewhere in between. But I don't know if it was a special crisis, maybe it was.

RS: I am not so much asking how you felt about it or about the immediate circumstances. I am only thinking that if you step back and look at the larger picture, here was someone associated with the avant-garde who suddenly was making pictures of traditional subject matter and making them in a classical style. That went against the grain of just about everything that was going on then, and it also went against what was expected of you in particular. And it went against what many of your supporters valued.

Somehow, given these factors, you must have had some understanding of the necessity for doing all of that.

GR: Alright. But that's what I don't know. I wouldn't know how to reply to that. Certainly the situation animated me to try different directions so that I would find something of more substance and importance. I was very sure that the big "Detail" paintings I had been making were not the direction.

RS: Okay, let's talk about the shift toward more abstract pictures. In one statement, you have said: "If abstract paintings show my reality, then the landscapes and still lifes show my yearning." In what sense do you mean that the abstract paintings show your reality?

GR: That was later, and the reality of abstraction was what could I make directly—mentally, physically, psychologically. This was my daily challenge and those were normal difficulties; it has no relation to any kind of yearning or dream. And if it did, it would be hard to recognize it as such and I wouldn't call it a yearning. But the figurative ones were some sort of a break and recovery from everyday work. That's why I called it a yearning because there I could afford to do something romantic or nostalgic. That was a polemical remark; it has never been just like that. But in order to de-emphasize them I said they were nostalgic—a luxury.

RS: In what sense, that the making of the abstract pictures was less about an illusion and more about a physical process?

GR: Yes, exactly. Like a musician who has to know his stuff and has to work and to make the music, to build it.

RS: Robert Ryman has also talked about abstract painting as being the most realist kind of painting, because everything that counts is right there in front of you—the materials, the surface. The experience doesn't depend on anything outside or beyond the painting but only on what can be directly perceived, what is "real." Do you mean something similar when you talk about the reality of abstract pictures?

GR: Yes, but his reality, the one he is talking about, is different. To him it is a physically present reality, and he would probably deny any imaginary relations. At some point I said polemically that Ryman reminds us of something, tells us something. There is always some sort of narrative or reference, though I believe that he would deny that and say that to him it's all about structure or whatever.

RS: What kind of narrative quality was in your abstract painting in the mid- to late 1970s, for example? How do you mean the narrative when you look at pictures like this?

GR: This reminds me of a time when Buchloh asked me the same thing, and I said that I saw red rain falling here [*pointing to an abstract work of the early 1970s*] and a sea behind it, and there are broken cliffs and poles running around and one floats through spaces. He was appalled and said, "You can't be serious! That's not true!" And I replied, "No, it's true!" As if a child said, "Look mom, that's red rain, those drips right there."

RS: Well, first of all, I think that you can be serious about this. However, I am surprised that you see qualities so directly associated with nature. When you are making those paintings, are you actually thinking in metaphors all the time?

GR: No, never. And I also try to avoid that something in the painting resembles a table or other things. It's terrible if it does because then all you can see is that object.

RS: So you allow for aspects or suggestions of images in the abstract work but not actual pictures?

GR: Not actual pictures. I just wanted to reemphasize my claim that we are not able to see in any other way. We only find paintings interesting because we

always search for something that looks familiar to us. I see something and in my head I compare it and try to find out what it relates to. And usually we do find those similarities and name them: table, blanket, and so on. When we don't find anything, we are frustrated and that keeps us excited and interested until we have to turn away because we are bored. That's how abstract painting works. That was my argument with Buchloh because I said that's how Malevich and Ryman work as well. And only like that. You can interpret the *Black Square* of Malevich as much as you like, but it remains a provocation; you are compelled to look for an object and to come up with one.

RS: It is important whether an artist actually gives you an indication that there is such an object or teases you with the possibility that there might be one or whether the artist, in effect, lets you know that there isn't actually an image of that sort; there is something there but it is not a representation.

GR: I just wanted to insist on the way we function. Basically we always try to identify a relation of a picture to some sort of appearance. It's not about the recognition of a particular subject matter.

RS: Of course Leonardo da Vinci talked about looking at patterns on the ceiling and finding faces, and maybe there is a basic human tendency to do this, but whether the artist encourages or discourages this tendency is a huge issue for abstract painting.

GR: Most artists have tried to avoid that. And still they cannot escape this mechanism. Even those paintings that are supposed to be nothing but a monochrome surface are looked at in that searching manner. The effect of these paintings depends on that mechanism. I don't even know how it could work otherwise.

RS: In a way it does relate your abstract pictures to your figurative ones because in the figurative paintings people are reassured when they see a certain kind of image. They crave the verification of the object and long to see what they know about or bring to the object, and yet you create a distance in which that object becomes ambiguous. People want a picture that adds up to their expectations, and you do things that remove qualities from the image or cancel it out. You make paintings at the expense of pictures, or at least at the expense of the depicted object.

GR: I don't know if you are right about that or whether I could agree. But I also don't know if I understood you correctly.

RS: I am just saying that you use painting as a way of making it difficult for people to just read the image.

GR: Yes, that's right.

RS: Many of the gray abstract pictures that preceded the color abstractions had quite painterly surfaces. By comparison, the first full-color abstractions were anti-painterly, but the combination of hues was often very strident. In these ways the contrast between the two groups of work in touch, texture, and achromatic versus chromatic effects was very dramatic. How did you first arrive at this use of color; how was it supposed to operate in contrast to the monochrome gray paintings?

GR: It was very sudden because I thought that it couldn't go on like that. The gray didn't work any more. That was the end. And then I started with a weird color abstract painting that was very big and not very good and then I did the small ones. The transition was easy to make because I was working off a photo that I could enlarge.

RS: What was the impulse behind this jump into very dramatic color?

GR: To do the opposite, to free myself of any constraints. I asked myself, "Why not?" Do we want some psychoanalysis? [*Laughter*]

RS: No. If you want to offer some psycho-analysis, I'll take it, but that is not what I am asking. I was wondering about formal impulse.

GR: Well, I never dared to show these paintings anywhere. I thought they were crazy. The early ones that is, which, after all, I made as copies from parts of other paintings. I found that by copying those paintings I was able to construct them in an acceptable manner. You can't just show this wild stuff, those helpless smears that are absolutely random and senseless, against all rationality and taste, against everything. But then, after I had painted copies of the originals I felt comfortable enough to show them—in Halifax, Nova Scotia. It was a test and I realized that people took them seriously, and then I continued to make them.

RS: That was also the time when you made your artist's book, *128 Details from a Picture*, which is basically a catalogue of black-and-white photographs of the surface of an abstract painterly painting.

GR: Yes.

RS. Among the last of the photo-based color abstractions you made before you started to make direct, gestural abstraction, was a picture called *Faust*. Did you think at that time that assuming the role of gestural painter in some way involved a Faustian bargain?

GR: That was pure smugness. It was a very big and boisterous picture, and I don't remember if anything reminded me of Faust. It was a conscious decision to never declare it as being either one thing or another. Of course, in the back of my head I thought that hopefully people would understand it as Walpurgis Night in Goethe's *Faust*.

RS: I am wondering how many different levels we are dealing with here. After all, Faust makes a deal with the devil. Who is the devil in this case?

GR: Part of it was the fear of my own courage. It was very important for me to create a painting like this. That's why I gave it such a title. But at the same time I knew it was pretentious, that it was not quite right.

RS: But also that it was going the right direction.

GR: But it was the last of the translations or copies. After that, all the other abstractions were painted directly.

RS: This jump from indirect to direct painting coincides with a general turn toward painterly painting in the late 1970s and early 1980s, and to the advent of the neo-Expressionist work that came out of Europe and America.

GR: To the *Zeitgeist*.

RS: Were you conscious of this general shift? Did you feel you were a part of it or independent from it? Does the term neo-Expressionist have any positive value with regard to what you were doing?

GR: No, I was absolutely sure that I had nothing to do with that. They were mute and I was not. Silent and bad and terrible, but not me.

RS: How do you mean silent?

GR: Mute, dumb, dull; they had all the bad qualities. But, yes, I was certainly a child of the *Zeitgeist*. There's absolutely no doubt about it. One is affected by what is going on at the time. But I have always been a little different from the others and somehow always stood apart from the center.

RS: I am using the word with a little "e" not a big "E"; but did you intend your paintings to be read as expressive or expressionist in a particular way?

GR: Not expressionist, no. Expressive, yes. But more in the sense of "artificial" or something like that. That was the first time that I had the feeling that those types of paintings were cold and distant and clear—that they were not sentimental.

RS: And the color, the stridency of the color was chosen to create that effect?

GR: I believe so. It is part of a general feeling or attitude toward life, a desire to conquer such an artificial space for oneself.

RS: Now *I* am confused.

GR: I had the hope, carried by a fresh wind, to make something free, clear, open, crystal, visible, transparent, a utopia.

RS: Talk a minute about the Candle paintings, which could hardly have been more different from your abstractions of the early 1980s. If I am not mistaken, they were not very well received when you first exhibited them.

GR: Of the six I showed, none sold. They later became so expensive. [*Laughter*]

RS: Meanwhile, the critical response to the work was mixed, as it had been with the abstractions. At the time, it was assumed that either you were engaged in a direct satire of specific historical styles of painting or, as we discussed before, that you were engaged in a more general postmodern demolition of painting's conventions in which every style you touched on was exposed as empty.

GR: Buchloh said *rhetorical*. Well, there is nothing I can say to that. But I have to take back what I said about the abstractions being free from all meaning and opinion, that they are merely a crystal-clear dynamic world. That is not quite right. That would be reductive because it has to do with atmospheres and contents. They are narrative and sentimental. There are certain principal intentions that are part of all the paintings. It is not that big a difference. Yet they have the character of something more clear, free, dynamic, and so on.

RS: You seem to be saying, on the one hand, that these paintings are not to be read as traditional, serious, melodramatic gestural painting, but, on the other hand, that they still contain some ambitions for painting within the tradition to which they refer. They are neither "retro," nor "neo," nor part of a Duchampian game.

GR: No.

RS: In the final analysis, they are meant to be looked at as abstract painting.

GR: Yes. I am reminded of when I showed my paintings in the Netherlands and I talked to a critic and she said: "It is not possible that these are real paintings; they just pretend that they are." She liked them very much but she said that the real quality of these paintings was that they pretended to be paintings. I believe that somehow that was her question; she did not know how to handle the paintings. That's why she said something similar to what Buchloh was talking about when he talked about "rhetoric," that these are not really paintings.

RS: And what did you think of that?

GR: I am struck by the fact that these paintings are viewed according to three different standpoints: you say that the paintings are neither this nor that, Buchloh says, the paintings are not paintings but rhetoric, and the woman said that they are not paintings but play at being paintings. Therefore, there has to be some truth to it.

RS: But I am not agreeing with either of the two.

GR: But there is something right about the woman's question, something about these paintings that sometimes look like great gestural painting but it also suggests that there is a lack of conviction that it is possible to paint like that. Unlike people like [Franz] Kline and others who could paint an expressionist painting with conviction—the same kind of conviction in every stroke that he paints. They had the conviction that what they were doing was good and right. And that's it. I lack that in every stroke.

RS: In a way, though, these paintings are much more like those of [Jackson] Pollock than Kline or [Willem] de Kooning because Pollock's big allover paintings are no longer symbolist or narrative, and

the energy in them is no longer that of muscular struggle. In the great allover works, the painting becomes, in a sense, independent. The distance that opens up between the painter and the painting is a space the viewer also can share, but the painting itself has become both intensely stimulating and formally self-sustaining, so that its persuasiveness no longer depends on the conviction or latent presence of its creator.

GR: You are absolutely right, and now we are on a different level because I don't believe that the paintings merely pretend to be paintings. But at the time it was not possible to accept them as paintings, at least not in Europe.

RS: But there is a big difference between a painting that is made in order to deal with convention, either satirically, critically, or analytically and a painting that accepts that conventions exist but tries to create a physical and visual reality that is as free of those conventions as possible. Does that make sense?

GR: Yes, absolutely! The paintings have nothing to do with the articulation of theoretical conventions, of painting itself, but they have a different intention. That is absolutely right. That's why I refused to accept when anyone tried to attribute such intentions and motives to my work.

RS: True classical art—as distinct from conservative classical or neoclassical style—may be defined as an art that accepts its own conventions, but does not simply repeat them formulaically. Rather, it uses them to transform itself and extend its range. A crucial dimension of such classical art, though, is that it is deeply impersonal. Pollock, when he painted the big allover abstractions of the late 1940s and early 1950s, was, for perhaps the only time of his life, free of himself as a painter and thoroughly involved with the paint and the space and the process. In that sense, his was a classical art. [John] Cage and Merce Cunningham are classical artists in the same way. In your case, there is an irony in the fact that the painterly abstractions you started in the 1970s and continue to make have been referred to as either being expressionist or polemically anti-expressionist, but the term *expressionist* doesn't fit either usage.

GR: The only thing that is polemical is that I took the liberty and made the paintings the way they are, without regard to whether they were reminiscent of something explosive or expressionist.

RS: From my perspective, though, the irony is that you have approached a style—expressionism—which for many people cannot, by definition, be classic, and you have demonstrated the contrary, that it is possible to make a visually exciting, physically expansive, even aggressive picture that is classical in that it is not about the painter in any obvious way, and not emotional in the most banal sense.

GR: Yes, that sounds very good.

RS: The other model we inherit from the early modernists is that of Kandinsky, the idea of abstraction as a metaphysical or transcendentalist art. Now at one point you said: "Abstract paintings are fictive models that make visible a reality we can neither see nor describe but whose existence we can postulate." Do you in fact view your abstract paintings—either the gray paintings, the color paintings, or both—as being as much about the yearning for transcendent states of being as the landscapes are about a yearning for the beauty found in nature?

GR: If I understood you correctly, I would say that the landscapes are closer to such an intention than the abstract paintings. They are further removed from a stated intention to be models of a reality. You mentioned Kandinsky—I can't stand any of his paintings or the work of most artists similar to him who have said: "I am like a child," as if they could invent

ROBERT STORR

the world from the very beginning. I don't relate to any of that stuff. I was not interested in anything of the kind. I thought they were all stupid.

RS: But I wasn't talking specifically about Kandinsky's words or his style but of the kind of aspiration for modern abstract art with which he was associated. It's a tendency with which Mondrian, Rothko, and Newman were also connected, a drive to find a pictorial means for referring to philosophical or spiritual ideas, for representing things that, in essence, cannot be represented. Does that make sense to you at all?

GR: Yes, but you put it somehow in a naive way. It's not that simple. But every art, whether it is philosophy, literature, music, or painting, can touch something; it can't depict, never depicts. And I believe the painters you mentioned were talking about depiction, and that's impossible.

There is some truth to the idea of the paintings being models of a world, but the word *model* seems to be the wrong term. Because one might really take it for a model in the sense that "this is what it looks like in a different world" and that is not how it is meant. I have to distance myself from the concept of the *model*.

RS: But apart from your own painting, do you think that this is something art can do?

GR: Yes. A painting can help us to think something that goes beyond this senseless existence. That's something art can do.

RS: And you think it can still do that despite everything you've said?

GR: Yes, absolutely.

RS: And do you think it does happen?

GR: Yes, from time to time. And I am certain that we will find different forms and maybe then painting becomes obsolete, but we will always need something, right?

RS: But many people seem to think that the possibility of making art that is significant in that way has simply been used up. They believe too much of his-

tory and too much experience argues against such idealism.

GR: Our time looks as if we finally got over all of the nonsense, got rid of our need for a larger scheme, forgot history, rejected art, and rejected our fathers so that everything will be free and animalistic, techno-animalistic. I don't believe in any of that. That's just a movement. It is probably unavoidable. We now have the techno-animalistic age. It begins. But what will we do when everything is needless and meaningless?

RS: Do you think that there is actually such a dramatic change going on right now, a change more dramatic than what went on in the 1960s?

GR: Maybe, yes. Today there are more *facts* that are changing. All the great things such as the computer world, the Internet, and genetic engineering are very real and very important. Compared to that, the 1960s were just a dream. The 1960s were nothing real, only dreams—strawberry fields. [*Laughter*]

RS: Maybe that is the occasion to talk a little bit about the October paintings. After all, the idealism of the Baader-Meinhof group and how it went wrong are the subjects of the work, and the act of completing the works was implicitly idealistic as well insofar as it set a high standard for what painting could do, how much it could communicate. You seem to believe that idealism in an aesthetic context is possible but that in a practical, political context it is dangerous. Is that a fair summation?

GR: It is impossible to exist without idealism. I always imagined that I was one of the few who could live without idealism in order to discover later that all that time I was full of illusions. Even when I was against it, I *believed* in my opposition to it. It's a difficult subject.

RS: When did you think of yourself in these terms, of having no illusions?

GR: Maybe during the time I made the October paintings when I dealt with the subject matter and took notes and cursed the ideologues. When I realized that I myself *believed*, that I was euphoric, that I was carried by belief, I realized, this is wrong—it is merely a belief itself.

RS: To whom did you find yourself opposed in this situation?

GR: The opposition were primarily the terrorists, but it was also the faction of the art world that was possessed by big beliefs. I remember the kind of worship around Malevich and others. I could never participate in that. I was never interested in that. I never shared any of those beliefs. For me the government was the smaller evil because it believed the least. They were merely gangsters, of the sort that are always around in any period. But those who were full of beliefs, they were dangerous. I was convinced that the government had no ideology whatsoever, whether it was [Helmut] Schmidt or [Helmut] Kohl. I was against believing, as such, against the fact that one could poison so many brains and have such power. I thought I was free from belief.

RS: But in a way your resistance converted you to a kind of belief even though you didn't accept the opinions of the members of the Baader-Meinhof group whom you were painting. You were forced to acknowledge that belief of an intensity such as theirs has value.

GR: In the end I was just as unfree. I was carried by some sort of belief.

RS: In many ways *October 18, 1977* marks a turning point in your work. The landscape paintings, the Titian paintings, even the *48 Portraits* are still engaged in a game of hide-and-seek with tradition, but after the October paintings you seem to paint your subjects with less distance. Take the flower paintings, for example. They are less shy about being beautiful paintings than the early landscapes. Likewise, the

portraits that you have done of Sabine are very different from previous portraits you've painted of people close to you. There's an intimacy to these images that is different in quality from earlier works.

GR: What about Ema? The staircase?

RS: Yes and no. It is a very beautiful picture, but . . .

GR: But it is also a demonstration.

RS: Yes, there's something between you and the picture. An idea.

GR: Yes, it is staged. And the little nude of Sabine [*Small Bather*] is not staged.

RS: I am not thinking of the nude so much as the pictures of her reading. Those are really in a realm with Vermeer, not in style, not historical reference, but because it allows the viewer to look into a private situation—with great reserve, but one can look. Do you think such a change has occurred?

GR: If I could take an impartial look at myself I would say: "That guy has matured a little, he has gained some sovereignty, he is older." That sometimes happens in painting. If I would not be sitting here, that's what I would say. Same with Velázquez: when he became older his paintings became better. Nice. Thank you for this. [*Laughter*]

RS: As you get older, you paint better, but you paint better not for technical reasons, not for formal reasons, but because you have a different understanding.

GR: With a little more ease.

RS: Or, to choose a different word, with greater permission. When you are young, people around you say, No, you can't do this or that, and then also a voice inside says No to the things that matter most. But it is as if, after the Baader-Meinhof paintings, you gave yourself permission to make pictures with a different quality. Is that true?

GR: Yes, even though there were a lot of backlashes, and I produced a lot of garbage in between. For example, the difficulties I am

having now. I can see this beautiful quality that you just described in a few paintings, once in a while, and then suddenly it disappears and then it resurfaces again. It is not as if this quality has become the rule now. That would be wonderful.

RS: I guess I am not talking about beauty alone, but also about the overall resistance to change abating in some degree.

GR: Yes, but that's not true either. If I could count on that being a constant feature now, then all paintings would be much more relaxed—but they are not. There are always exceptions. But you are right; something has changed, but not enough.

RS: So what is it? What is the obstacle?

GR: The constraints persist. You said that when one is young that there are a lot of restrictions, and I still am subject to those restrictions. Only sometimes am I free of them, maybe more often than before, I don't know. I wish that I could give myself those permissions and that freedom on a more regular basis, but I can't. Otherwise there wouldn't be as many forced paintings.

RS: These pressures are?

GR: I don't know where they come from. They exist. Yesterday we saw the catalogue of Goya drawings, and I realized that when Goya was very old he made much more relaxed drawings. He was allowed to make things that way. Or there is somebody like Matisse. And I was a little bit jealous because I have not yet achieved this permission. But now we have talked much too long about this, and this is not even our topic. I am sorry.

RS: Along with granting oneself permission to do certain things, there can also be an element almost of defiance. For example, in the last five years you've made a number of images that raised the hackles of the avant-garde.

GR: I don't know.

RS: You made a series of pictures of Sabine with your son—almost as if she were a Madonna and Child. And you made a multiple of the cross.

GR: Oh yes. [*Laughter*]

RS: Did you anticipate the negative reactions that those works received in some quarters?

GR: Well, I don't know much about that. People don't tell me these things. Sometimes I simply hear something through others. I only came across it once myself in a critical review of the *Small Bather*. That's where I finally read it. The review was titled "Holy, Holy, Holy," and then it went off. I understand why they get upset, but when they tell me that this is reactionary, I don't understand it.

RS: I don't agree with it, but I think I understand it. This is a period when there is almost no room for the kinds of words that you have used recently to discuss the October paintings, like *faith* or *belief*, or as far back as the early 1960s when you talked about art as being a substitute *religion*. Using such vocabulary or making allusions to such traditional symbols or iconography is extremely provocative, given its misuse by fundamentalists or people in positions of power. You can be misunderstood in many, many ways. And perhaps the question is not how many ways you can be misunderstood but how would you like to be understood?

GR: I don't know how I would like to be understood. Maybe as the keeper of tradition. [*Laughter*] Rather that than any other misunderstandings.

RS: As a guardian of an aesthetic tradition or as a guardian of a philosophical and moral tradition?

GR: Whatever you can get. [*Laughter*]

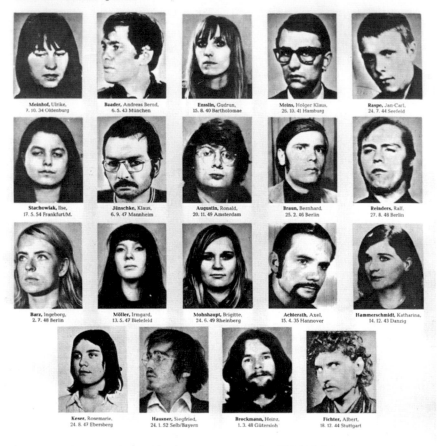

Wanted poster: "Anarchist Violent Criminals—Baader/Meinhof Gang," c. 1972

PART THREE

GERHARD RICHTER: OCTOBER 18, 1977

by Robert Storr

October 18, 1977 [18 Oktober 1977]. 1988. Fifteen paintings, oil on canvas, installation variable. The Museum of Modern Art, New York. The Sidney and Harriet Janis Collection, gift of Philip Johnson, and acquired through the Lillie P. Bliss Bequest (all by exchange); Enid A. Haupt fund; Nina and Gordon Bunshaft Bequest fund; and gift of Emily Rauh Pulitzer

Youth Portrait (Jugendbildnis). 1988. Oil on canvas, 28½ × 24½" (72.4 × 62 cm)

ROBERT STORR

Arrest 1 (Festnahme 1). 1988. Oil on canvas, 36½ × 49¼" (92 × 126.5 cm)
Arrest 2 (Festnahme 2). 1988. Oil on canvas, 36½ × 49¼" (92 × 126.5 cm)

**Confrontation 1
(Gegenüberstellung 1).** 1988.
Oil on canvas, 44 × 40¼"
(112 × 102 cm)

**Confrontation 2
(Gegenüberstellung 2).** 1988.
Oil on canvas, 44 × 40¼"
(112 × 102 cm)

**Confrontation 3
(Gegenüberstellung 3).** 1988.
Oil on canvas, 44 × 40¼"
(112 × 102 cm)

ROBERT STORR

Hanged (Erhängte). 1988. Oil on canvas, 6' 7⅛" × 55⅛" (201 × 140 cm)

ROBERT STORR

opposite, top: **Man Shot Down 1 (Erschossener 1).** 1988. Oil on canvas, 39½ × 55¼" (100.5 × 140.5 cm)

opposite, bottom: **Man Shot Down 2 (Erschossener 2).** 1988. Oil on canvas, 39½ × 55¼" (100.5 × 140.5 cm)

Record Player (Plattenspieler). 1988. Oil on canvas, 24⅝ × 32¾" (62 × 83 cm)

Cell (Zelle). 1988. Oil on canvas, 6' 7⅛" × 55⅛" (201 × 140 cm)

Dead (Tote). 1988. Oil on canvas, 24½ × 28¾" (62 × 73 cm)
opposite, top: **Dead (Tote).** 1988. Oil on canvas, 24½ × 24½" (62 × 62 cm)
opposite, bottom: **Dead (Tote).** 1988. Oil on canvas, 13¾ × 15½" (35 × 40 cm)

ROBERT STORR

Funeral (Beerdigung). 1988.
Oil on canvas, 6' 6¾" × 10' 6"
(200 × 320 cm)

ROBERT STORR

INTRODUCTION: SUDDEN RECALL

In mid-winter 1989 a quiet tremor shook Germany. Judged from the outside, the extent of its impact might initially have seemed out of all proportion to the actual cause. But as a long delayed and wholly unexpected aftershock to the much greater upheavals of a decade earlier, the jolt caught people off guard, and reawakened deep-seated, intensely conflicted emotions.

The epicenter of this event was in Krefeld, a small Rhineland city near Cologne where, between February 12 and April 4, 1989, a group of fifteen austere gray paintings were exhibited at Haus Esters, a local museum designed in 1927–30 as a private residence by the modernist architect Ludwig Mies van der Rohe. The author of these works was the fifty-seven-year-old painter Gerhard Richter, well known for the heterogeneous and enigmatic nature of his art, which ranged from postcard-pretty landscapes to minimal grids, alternatively taut or churning monochromes to crisp color charts, and heavily textured, even garish, abstractions to cool black-and-white photo-based images. The ensemble on view at Haus Esters belonged to this latter genre, which had preoccupied Richter from the outset of his career in 1962 until 1972 but which he had seemed to abandon since then. However, the subject of the new paintings was unlike anything he had addressed before. Both the subject and the fact that an artist of Richter's indisputable stature had chosen to paint it stirred Germany and, in short order, sent reverberations around the world.

Richter's theme was the controversial lives and deaths of four German social activists turned terrorists: Andreas Baader, Gudrun Ensslin, Holger Meins, and Ulrike Meinhof. The collective title, *October 18, 1977*, commemorates the day the bodies of Baader and Ensslin— along with their comrades, the dying Jan-Carl Raspe and the wounded Irmgard Möller— were discovered in their cells at the high-security prison in Stammheim, near Stuttgart, where they had been incarcerated during and after their trials for murder and other politically motivated crimes. Almost exactly three years earlier (October 2, 1974) Holger Meins had died from starvation during a hunger strike called by the jailed radicals to protest prison conditions. Ulrike Meinhof had been found hanging in her Stammheim cell (May 9, 1976) shortly before she and the others were sentenced to life terms. Her death was ruled a suicide, as were those of Baader, Ensslin, and Raspe the following year (October 18, 1977), although there was widespread suspicion that the four had been murdered.

The fifteen paintings in the cycle *October 18, 1977* comprise four pairs or suites of images and five canvases that stand alone within the larger group. Although the works have no fixed installation order, the first painting in the series in terms of the chronology of the story is a likeness of the young Ulrike Meinhof (*Youth Portrait*), and the last is a panorama of the public burial in which Baader, Ensslin, and Raspe were interred in a common grave (*Funeral*). The three other individual canvases depict, first, a coat and bookshelves in Baader's empty prison quarters (*Cell*); second, a spectral figure of Ensslin dangling from the bars of her cell (*Hanged*); and third, a 1970s LP on an inoperative turntable inside which Baader was supposed to have hidden a smuggled pistol with which it was said he shot himself (*Record Player*). Meins's earlier capture by police, during which he was forced to strip, with an armored-car training its gun on him, is shown in two sequential paintings (*Arrest 1*

ROBERT STORR

Gerhard Richter, Cologne, 1988

and *Arrest 2*); and a likeness of Baader lying dead on the floor appears twice, with subtle but significant differences in the way the photograph on which it was based has been translated into paint (*Man Shot Down 1* and *Man Shot Down 2*). Three other paintings are glimpses of Ensslin's passage before a camera on her way to or from confinement after her arrest, and another three progressive smaller canvases portray Meinhof laid out after she was discovered hanging in her cell with the rope still around her neck.

The contrast between the starkness of the reality Richter chose to describe and the lack of definition resulting from his technique—feathering the edges of his forms or dragging his brush across the wet, gray pigment-loaded surface of the canvas so that shapes and spaces elide—created a muffled dissonance between what the viewer can make out "inside" the picture and what he or she actually perceives as an otherwise visually accessible painting. So far as the explicit but obscured subject is concerned, it is as if an all but unbearable truth had suddenly been brought forward into the light only to be screened by shadows in a condition where the impossibility of seeing clearly is both frustrating and a kind of reprieve. Thus each canvas is an insistent reminder of what one may have forgotten or heretofore successfully avoided paying attention to as well as a refusal to satisfy simple curiosity or the naive satisfactions of supposing that tangible "facts" speak unequivocally for themselves. Studied separately, but even more so together, the fifteen paintings are among the most somber and perplexing works of art in modern times.

Richter's cycle appeared on the walls of Haus Esters without warning and without fanfare. In deference to the families of the deceased and to avoid further sensationalizing the story of the so-called Baader-Meinhof group (for years a staple of print and media journalists, whose photoarchives Richter had drawn upon in selecting the images he finally painted), strict limits were placed on what paintings could be used to accompany articles

on the work. For example, the six harrowing images of the dead that dominated the series could not be reproduced out of context. In the same reticent and respectful spirit, no celebration for the unveiling of the new paintings was held. At the time, the artist noted: "The relatives and friends of these people are still alive. I neither wanted to hurt them, nor did I want an opening with people standing around chatting and drinking wine."[1] Richter also made it clear that the paintings were not to be sold piecemeal as might be the case with those in an ordinary exhibition. Moreover, he declared that he had no intention of selling them at all in the near term, and that at such time as he thought it appropriate to let go of them they would be destined for a museum rather than any private collector.[2] In every way, Richter signaled that *October 18, 1977* had special standing within his overall body of work, and a status of its own within postwar German art. Though essentially intimate in scale, and anti-rhetorical in their mode of pictorial address, these paintings were public works not only because they described well-known incidents of the recent past but because they in large part depended for their meaning on the horrid fascination, anxiety, ambivalence, and denial experienced by the nation that had lived through them, and by a generation worldwide for whom Baader, Meinhof, Meins, Ensslin, and the others were emblematic of the reckless idealism and bitter failure of youthful revolt in the Cold War era.

Critical response to Richter's emphatic and elusive suite of paintings was immediate, far-flung, and divided. Those divisions not only followed obvious political and aesthetic fault lines within German society, but also the subtler cracks that radiated from them and separated one camp from another within the larger groupings. Thus Ingeborg Braunert, reviewing the show in *Die Tageszeitung*, a left-wing national newspaper founded in the aftermath of the crisis of the German Autumn of 1977—a time of kidnappings, hijackings, and heightened terror that polarized the country—emphasized the uncanny feeling engendered by these partially abstracted reworkings of images made familiar by the media, but fixed her attention on the jarring first impressions of encountering them in the serenely bourgeois surroundings of Haus Esters: "The beautiful space, the elegant and interested visitors, the friendly personnel—in the service of virtuoso oil paintings on the subject of Stammheim—do not fit our memories."[3]

The German-born, American-based writer Benjamin H. D. Buchloh also made an issue of the show's location but noted an incidental fact that lent the site a positive importance: "That this group of paintings was first exhibited in a building by Mies van der Rohe seems an appropriate historical accident, for Mies is the architect who constructed the only German contribution to public monumental sculpture in the twentieth century, devoting it to the memory of the philosopher Rosa Luxemburg and the revolutionary Karl Liebknecht, both of whom had been murdered by the Berlin police. This coincidence establishes a continuity between a bourgeois architect in the Weimar state of the 1920s and a bourgeois painter in West Germany of the 1980s. And indeed both artists differ from most of their contemporaries in their ability to tolerate, in public view, the challenges to the very political and economic system with which they identify as artists."[4]

Early reactions to *October 18, 1977* often centered on the irony of an established painter setting out to represent the fate of enemies of the society in which he thrived. Some on the Left challenged his right to do so, and some questioned his timing and professional motives. Thus, the critic Sophie Schwarz attacked Richter for not choosing sides when doing so was consequential: "There is a puzzling timidity to his approach. In the case of the prison deaths, no one really believes in the suicide hypothesis anymore, and as shocking, accusatory images, political images, the works arrive too late, too blurred, fitting into Richter's

total oeuvre with too facile a logic. . . . The quality most evident in Richter's treatment of these still disturbing images is a dark and totally staged pathos."[5] Others, accepting his attempt in principle, pondered the contradictions this match of artist and subject raised. Speculation about the degree of sympathy Richter had for the individual members of the Baader-Meinhof group, despite his explicit rejection of their theories and acts, is a common feature of these articles. As a middle-aged German with firsthand knowledge of the totalitarian orthodoxies of both National Socialism and Eastern Block Communism, Richter was adamantly anti-ideological almost in inverse proportion to the dogmatism of the members of the Red Army Faction (RAF)—as the larger entity to which the Baader-Meinhof group belonged called itself—yet he appeared to relate to them in certain respects, especially with the women, and with Ulrike Meinhof, who was only two years younger than he, in particular.

How much sympathy, and, as a political litmus test of that sympathy, how much resistance to the official version of the Stammheim deaths Richter's painting actually showed were other topics of intense disagreement. From that vantage point the theater director Hansgünther Heyme was perhaps the most critical of the initial commentators: "Revelation is needed, not mourning or the over-painting of that which remains unclear but the opening of wounds. Not clemency. . . . People's opinions are being influenced. Etched into our minds are the verdicts of the media. Art has to confront these distortions of reality, should reveal not conceal."[6] Answering this insistence that art undo the lies and evasions of the media were those critics who perceived Richter's cycle not as historical document but as something almost opposite; for these interpreters the work was a complex and thoroughgoing demonstration of the limitations of traditional history painting in the modern age, and of difficulties inherent in trying to resolve social contradictions by aesthetic means. At this point Buchloh reenters the fray. The political underpinnings of his argument are strictly partisan. Flatly declaring the deaths of the RAF members in the small hours of the morning of October 18, 1977, to have been "murders," he also maintains that the group's "supposed crimes remained to a large extent unproven," although hard evidence, probability, the rationale of their manifestos, and the political logic of their courtroom defense make this technical exculpation seem pointless.[7] Buchloh's primary aim, however, is to make the case for the paintings on the grounds that they reverse the national tendency to repress knowledge of damning historical episodes, and stand in accusatory contradistinction to what he calls the "polit-kitsch" of other contemporary artists involved in the recovery and reconstruction of the buried past.[8] In spite of these views, however, Buchloh concludes that the larger and perhaps more lasting significance of these works is their role in the terminal crisis of painting, in which they and the artist's production as a whole are a last effort at demonstrating the reach and power of an art form that has lost its cultural function.

In a 1989 essay, Stefan Germer essentially concurred with Buchloh, carrying the argument a step further without Buchloh's polemics against other artists or his defense of the RAF. Following Richter's lead, Germer pinpoints the tension between distance and empathy as the basic dynamic of the paintings: "It is a matter of recognizing something of oneself in others, but relying neither on pre-existing interpretations nor on a naive desire for identification in responding to that recognition. For this reason, Richter defines his artistic procedure as a dialectical mediation of proximity and distance, which follows the logic of remembering, repeating and working through."[9] In the final analysis, though, Germer fastens on Richter's chosen mode of expression and its predicament as the defining issue

of the works, which embody a compound failure to transcend or bring to closure a chain of disasters that still resists all social remedies. He writes: "These paintings shockingly reveal that painting is dead, incapable of transfiguring events, of giving them sense. Painting in the present tense becomes the victim of the historical reality that it had sought to examine. They state pictorially that any attempt at the constituting of meaning via aesthetic means would be not only anachronistic but cynical. . . . If nothing can be altered, because all representation must necessarily end up asserting the inadequacy of the medium, what is the point of these paintings? In Richter's work history paintings must be seen as monuments of mourning: as a lament for loss, which paintings cannot alleviate or even soothe, but must rather assert in its full brutality."[10]

That these paintings had international, as well as national, importance was apparent from the moment they were first exhibited in Krefeld. Their potential impact elsewhere was promptly confirmed by the fact that the cycle subsequently traveled for two years, first to one other stop in Germany, the Portikus gallery in Frankfurt, and then to the Institute of Contemporary Art in London, and from there to Museum Boijmans Van Beuningen in Rotterdam, the Saint Louis Art Museum in Saint Louis, the Grey Art Gallery in New York, the Musée des Beaux-Arts in Montreal, the Lannan Foundation in Los Angeles, and the Institute of Contemporary Art in Boston. After the tour, Richter's paintings were deposited at the Museum für Moderne Kunst in Frankfurt as a ten-year loan; and the Frankfurt museum has lent the works for special exhibitions in Madrid, Jerusalem, San Francisco, and Berlin.

Critical response abroad generally echoed the initial reactions in Germany in range and intensity, though in most cases without the same lingering political partisanship. Indeed, confusion about the people and incidents Richter had painted began to cloud descriptions of the work—in several articles Ensslin is mistaken for Meinhof or vice versa—inadvertently pushing the discussion away from matters of dramatic reportage toward a more general meditation on political violence in the confrontations between rebellious youth and conservative authority in the 1960s and 1970s. That shift in interpretation played a crucial part in deciding the ultimate destination of the paintings.

In June 1995, to the surprise of close observers of the scene as well as to the public at large, it was announced that *October 18, 1977* had been acquired by The Museum of Modern Art in New York for an undisclosed sum. The paintings, by a readily reached agreement between the artist and The Museum of Modern Art, were to remain in Frankfurt until the end of the ten-year loan, in keeping with Richter's original commitment. The eventual expatriation of the works caused almost as much of a stir in Germany and in the art world generally as had their debut exhibition. Once again, skeptics questioned the artist's good faith, some of them inferring American money had lured him into a deal that effectively deprived his country of part of its historical and cultural heritage.[11] Initially, Richter had indicated that he expected the cycle's permanent home to be a German institution. "Yes, I think it is better," he told Gregorio Magnani, who interviewed him for *Flash Art* in 1989; and the director of the Frankfurt Museum für Moderne Kunst, Jean-Christophe Ammann, had often expressed his strong desire to have the paintings.[12]

However, according to Richter, no concrete offer from Frankfurt was forthcoming.[13] Not only did Frankfurt lack the funds necessary, they had trouble raising them because of the RAF's history in that city, where second-generation members of the group—that is to say, members who took action after the arrests of Baader, Meinhof, Meins, and Raspe— were responsible for the 1977 murder of Jürgen Ponto, head of the Dresdner Bank, a major patron of the museum, which withdrew its support when *October 18, 1977* was

accepted as a loan. In addition, Alfred Herrhausen, head of Deutsche Bank, another of the museum's corporate sponsors, had been killed in 1989, just as the paintings were being exhibited in Krefeld.

Richter's change of heart was based less on these practical difficulties than on the issue of the appropriate political and aesthetic context for the work. Ammann, speaking after the decision to send them to New York had been made, protested that their relocation to America would render the paintings "ineffective," a sentiment shared by a considerable segment of German opinion. Others, including a journalist from *Die Tageszeitung* who interviewed the artist on the occasion of The Museum of Modern Art acquisition, questioned the American public's ability to grasp the meaning of the paintings, given its lack of knowledge of the RAF, its supposed obsession with 1980s-style "political correctness," and the hostile response of right-wing commentators. Such voices were audible.[14] "MoMA Helps Martyrdom of German Terrorists," was the title of neoconservative critic Hilton Kramer's article on the purchase in *The New York Observer*, in which he rambled on about curatorial folly and "liberal guilt among the affluent," and ended with the pointed suggestion that the Museum benefactor whom Kramer assumed had paid for the work was, "precisely the kind of figure who would have been earmarked for assassination by these terrorists in their heyday."[15] David Gordon, writing in the international edition of *Newsweek*, challenged what he perceived as the Museum's dubious emphasis on the ambiguity of the pictures, and he chastised Richter on the grounds that if he "had truly wanted to take a neutral stance, he might have included portraits of the Baader-Meinhof victims."[16] Richter took this attack philosophically, telling another interviewer, Hubertus Butin, that "it would be rather un-normal, even awful, if complete praise erupted over there."[17]

In fact, reception of the cycle during its 1990 tour of the United States had been good. In *The New York Times*, Michael Brenson seized upon Richter's desire "to paint the unpaintable" and upon an essential conceptual aspect of the work to which conservatives and leftists were both willfully blind: its fundamental critique of the temptation and ultimate price of ideology, a temptation to which the Baader-Meinhof group succumbed and for which they paid a high price.[18] In *Art in America*, Peter Schjeldahl drew the connection between Richter's "Saturnian gravity" and Warhol's obsession with death and disaster, concluding that "Richter's distinctive tone—a depressive density resulting from a head-on collision of irresistible estheticism and immovable moralism, the fire of the voyeur and the ice of the puritan—may baffle American viewers, who tend to be relatively untroubled by pleasures of the imagination."[19] Perhaps more gratifying still were the comments made to critic Michael Kimmelman by Richard Serra (whose aestheticism and moralism are a match for Richter's) when Serra saw the *October 18, 1977* cycle on exhibit in New York just after it had been acquired and before it was returned to Frankfurt for the duration of the loan: "I don't think there's an American painter alive who could tackle this subject matter, and get this much feeling into it in this dispassionate way. . . . These paintings aren't like late Rembrandts, exactly, but they're disturbing in a way the Rembrandts are. There's despair in them. And both the Richters and the late Rembrandts are about people recognizing their own solitude through the paintings, which is what we respond to in them."[20]

Richter had come to think of America as a hospitable environment for his paintings, rather than an alien one, in several unanticipated but significant ways. The fact that The Museum of Modern Art had sought out the paintings mattered to him a good deal. "The address," Richter said, "was certainly a decisive issue."[21] What he meant was not institutional prestige but the breadth and depth of the collection of which *October 18, 1977* would

become a part, and by so doing enter into a complex art-historical discourse. All along, Richter's hesitation about finally committing them to a German museum had been based on his fear that in such a context they would always be regarded as of interest more for their topicality than for their status as works of art. This was especially true in Frankfurt, where so much RAF history had taken place. In this respect, he was worried not only about short-term prospects but about long-term ones as well. "The meaning of the paintings will only develop in an art context," Richter said shortly after he had made up his mind. "This means that they are documents and they are not illustrative materials. . . . The reviews [in the United States] were inspiringly different from the German ones. Here one was so affected by the subject matter that the paintings were almost exclusively viewed in polit- ical terms—or even as a kind of family affair. . . . People abroad did not let their expecta- tions and bias obscure their view of the paintings."[22]

Furthermore, contrary to the assumption of some German observers—and quite a few Europeans generally—that the American experience of the period was so different from theirs that they could not fathom the true historical meaning of these images, Richter con- sidered that relative difference a positive advantage. Speaking to Butin, who had raised doubts about the American readiness to deal with the work, Richter took a much broader view: "Due to their distance from the RAF, maybe the Americans can see the overall aspect of the subject that affects almost every modern or even non-modern country: the general danger of belief in ideology or fanaticism or madness. This is a current [issue] in every country, including the United States that you so lightly call conservative. But I can also see a direct relation between the United States and the RAF, not only the Vietnam War against which Baader and Ensslin protested in 1968. . . . I also see a relation between the Ameri- can influence on the attitude and the beliefs of the so-called 68ers. Even their anti-Amer- icanism was not only a reaction to American influence; to a certain degree it was itself imported from the United States."[23]

The nuances apparent in this retort should prompt caution in Europeans who persist in treating the Atlantic as a fundamentally unbridgeable cultural divide, and also serve as a warning to Americans who underestimate European attentiveness to the paradoxical love- hate relations this country inspires in them and others. Certainly Richter has a fine appre- ciation of such critical ironies, and at no time were these ironies more in evidence, more convoluted, or more influential than during the years when the drama of the RAF played itself out to its awful end.

Yet, it remains true that on the whole Americans are unaware of the specifics of what happened in Germany and elsewhere on the Continent in the 1960s and 1970s, and they are fast forgetting—if they are old enough to have known—what went on in their own backyards during the same period. Indeed, Richter is one of the very few artists who has made it his business to force remembrance of this acrimonius and still undigested era. Although the video artists Dennis Adams, Dara Birnbaum, and Yvonne Rainer have each made works that refer to the Baader-Meinhof episode, the dearth of art that attempts an appropriately disabused reexamination of the social, political, and cultural conflicts of that period is striking. From the Left there is weary silence; from the Right hollow harangues. Denial is not just a German problem; however, it is a German painter who has best shown how denial dissolves in the face of images that forswear traditional rhetoric.

When *October 18, 1977* was shown at the Lannan Foundation and the Grey Art Gallery in 1990, separate spaces were devoted to photo albums and texts narrating and analyzing the history of the RAF. Precisely because the paintings are *not* mere documents, such infor-

ROBERT STORR

mation is needed if one is to fully understand them and absorb their impact. After all, the events they describe occurred over two decades ago. More than one generation has come of age since then, and it cannot be assumed that they have learned about what happened in any degree of detail, if at all. Nor can it be counted on that all of those who witnessed the turmoil of those days, and should remember it with some vividness, still do. For these reasons, Richter accepted the existence of the study rooms and provided his source note-books for display, but he wryly noted: "The only disadvantage is that people spend more time reading than looking at the pictures."[24]

For The Museum of Modern Art's presentation of *October 18, 1977*, the publication of this volume is partly aimed at preempting any contest in the galleries between printed words and photographs and Richter's evanescent paintings—between declarative sentences and uncertain perceptions, between apparently clear-cut images and assertively ambiguous ones, and between the easy work of assimilating facts and the hard intellectual, emotional, and poetic labor of imagining how faint, imprecise tones and tints spread over fifteen canvases can encompass realities that seem irretrievably remote from contemporary existence. And yet, like a hecatomb of burnt-out car wrecks in a placid lake, these realities sit close to the surface of our collective consciousness and are perilous to anyone who, ignorant of their presence, dives in deep.

I: WHAT HAPPENED

When Michael "Bommi" Baumann, an independent activist and sometime ally, but later severe critic of the Red Army Faction, wrote of the movement, he was speaking for a generation. The German Extraparliamentary Opposition (APO)—a loose amalgam of student organizations, counterculture groups, political factions, and anarchists in which Baumann played a prominent role—was in many respects identical in its origins and makeup to other emerging constituencies that exploded into rebellion in France, Great Britain, Italy, Japan, Mexico, the United States—all those places where broad challenges to established institutions and governmental systems were mounted with near revolutionary intensity during the 1960s and 1970s. There was one exception: only in Germany did those in youthful revolt against entrenched authority confront elders over whose heads hung direct knowledge of, and possibly direct responsibility for, the century's most horrifying totalitarian regime. Only there did a largely unspoken legacy of incalculable suffering and moral corruption connect the first half of the century to virtually every aspect of the second, like an invasive thornbush.

> "PERHAPS YOU SHOULD ATTEMPT TO SEE THE WHOLE MOVEMENT AS A TOTALITY. YOU HAVE TO SEE IT AS A WHOLE STORY, AS THE STORY THAT STARTED AFTER THE SECOND WORLD WAR, IN ALL ITS BREADTH."
> —Michael "Bommi" Baumann[1]

In 1959, when the first signs of restlessness with Germany's postwar status quo began to register, the twelve-year Reich had been a thing of the past for longer than it had lasted. Germany had been a nation defeated, occupied, partitioned, and impoverished. It was also a nation shamed.

The economic and administrative recovery of the western sector of the country had come with remarkable speed, in large measure because the victorious allies had learned from the harsh treaties that ended World War I that political humiliation and punitive reparations were a recipe for future instability in Europe. Hitler had exploited Germany's sense of victimization at the hands of the victors in that conflict; the second time around, those on the winning side in the West were determined not to make the same mistake, especially with their former comrade-in-arms (but future adversary) the Soviet Union looming large in the eastern zone. By the time the Federal Republic of Germany was founded in 1949, currency stabilization had been put in place to avoid inflation of the kind that had stampeded many Germans into the ranks of National Socialism after World War I, and the Marshall Plan was in full swing helping to rebuild the nation's industrial infrastructure. Meanwhile, after a period of highly selective "denazification," governmental bureaucracies were back in operation, and a new constitution on an American model had been drawn up. Based on an essentially two-party electoral system, the Left was represented by the Social Democratic Party (SPD) and the Center/Right by the Christian Democratic Union (CDU), buttressed by the more right-wing Christian Social Union (CSU).

The figure who oversaw this first phase of normalization was the Christian Democratic leader Konrad Adenauer. The mayor of Cologne until he was forced out of office by the Nazis in 1933, Adenauer had stepped back from active politics for the duration of the Third Reich and reemerged in 1945 to play the role of "honest broker" for a new deal for

a country bent on restoring its economic self-sufficiency, while being equally determined to evade becoming the battleground in a Cold War turned hot. With the Soviet blockade of Berlin in 1948–49, and the construction of the Berlin Wall in 1961 by the communist German Democratic Republic, the prospect of a land war breaking out on German territory seemed at times all too probable. The "economic miracle" that made West Germany an industrial and financial power by the early 1960s was the product of Adenauer's single-minded policy of combining national recovery with political restructuring.

At the same time, ambivalence about the country's pivotal position in the worsening confrontation between the NATO nations and those of the Warsaw Pact prompted the SPD to adopt a friendly but arm's-length stance toward the United States and to cautiously oppose expansion of foreign, in particular American, military presence, especially the stationing of nuclear missiles. Under Adenauer, the Christian Democrats pursued economic independence through accelerated growth—high employment, high productivity, and high consumption. At the same time the Social Democrats pushed for greater geopolitical sovereignty under Kurt Schumacher (head of the party from 1945 to 1953), and, later, under its most popular leader Willy Brandt, who, having gone into exile in Sweden during the war, was also uncompromised by the Nazi era. By 1966, the two primary parties plus the smaller CSU formed a Grand Coalition with Kurt Kiesinger, representing the CDU/CSU as chancellor, and the dynamic and gregarious Brandt as his deputy and foreign minister. This coming together of the traditional Left and Right was the political predicate for the rise of a new radical opposition.

National rehabilitation was a conservative process in every sense of the word, based on shunning political extremes, reestablishing prewar hierarchies (albeit in a modern guise), and, when necessary, deferring to the authority of the great powers, principally the United States, which, particularly under president Dwight D. Eisenhower, was going through its own phase of conservative social consolidation and economic, political, and military expansion. The result was a Germany in many respects rigidly stratified, rule-bound, and aggressively materialist. A dozen or so years after the extreme deprivations of the postwar years, the country was well on its way to becoming a fully developed consumer society on the American model, to which Germans had been exposed by an influx of films, goods, and tourists as well as by the presence of occupation troops. In Gudrun Ensslin's scornful phrase, it had become "the raspberry Reich."[2]

Voluntary collective amnesia was at the heart of that process. Although Roberto Rossellini had titled his searing documentary drama of Berlin in 1945, *Germany Year Zero*, resetting the clock in this manner was a half-truth. Germans were not starting from scratch, and they were certainly not beginning again with a clean slate. Nevertheless, citizens were encouraged to place heavy emphasis on taking positive steps away from the desperate situation of 1945, with the bare minimum being said along the way about what had brought disaster down upon them. Historians and journalists showed scant enthusiasm for revisiting the Nazi years, much less investigating their connection to the present; school curricula minimized the period, and people generally held their tongues, except in the company of those who had shared their experiences and outlook, and even then little was said. Until Israel tried Adolf Eichmann for war crimes in 1961, and Germany followed suit by bringing a group of Auschwitz guards before the courts in 1963, public acknowledgment of the Holocaust was fitful at best, and individual admissions of complicity, much less atonement, were all but unimaginable. The proverbial question children asked their parents, "What did you do in the war?" was for the most part met with evasion or silence. Returning to

Germany, her homeland, in 1950, the Jewish philosopher Hannah Arendt, who later covered the Eichmann trial, and explained the massive slaughter supervised by that self-effacing "little man," as paradigmatic of "the banality of evil," wrote, "Everywhere one notices that there is no reaction to what has happened, but it is hard to say whether that is due to an intentional refusal to mourn or whether it is an expression of a genuine emotional incapacity."[3]

For many years the voices raised against this silent majority were few and far between, while active opposition to national consensus politics was marginal. The Cold War had much to do with this. Although some Germans—including important cultural figures like playwright Bertolt Brecht—cast their lot with East Germany, the Communist Party in the West was isolated and then outlawed in 1956, while the increasingly centrist SPD gradually retreated from its traditional socialist agenda. Except for scattered remnants of the old-school Marxist tendencies, university-based entities such as the Socialist German Students' Association (SDS) (originally a branch of the SPD), and the anti-atomic weapons movement that had flourished in the 1950s with its roots in Protestant and Catholic churches, resistance to the course Germany was taking lacked an organized center of gravity.

In addition to widespread resistance to reexamining National Socialism, there was a quiet reassertion of power by former members of its elite. In order to staff the renovated system, Adenauer turned a blind eye to the war records of many of those on whom he relied for their technical skills, administrative abilities, and wealth. It was not just a matter of demobilized soldiers or lower-echelon servants of Hitler's regime being called back to rebuild their country but, rather, of the return to prominence of many who had been intimately involved in the Nazi project, if not deeply committed to Nazi ideals. Thus, key posts in the diplomatic corps, courts, medical profession, educational system, business world, and many other strata of society, reaching even into the chancellor's office itself, were re-entrusted to men loyal to the old ways as well as to the old guard, and more or less overtly unsympathetic to the democratic principles of the new Germany.[4]

For example, Hanns-Martin Schleyer, taken hostage in 1977 by members of the RAF in the hope of gaining the release of Baader, Meinhof, Raspe, Ensslin, and the others held in Stammheim prison was, among several high posts, on the board of trustees of the Daimler-Benz Company, and president of the Federal Association of German Employers at the time of his kidnapping. What was not generally known at the time he was seized, but quickly became so, was that Schleyer had joined the Nazi party at sixteen, had been head of the Nazi student movement in Innsbruck, Austria, was the senior SS officer in Prague responsible for subordinating Czechoslovakian industry to the German war effort, and may have commanded an SS unit in the massacre of forty-one Czech men, women, and children in the final days of the conflict.

To mention Schleyer's murky and, insofar as they can be verified, unforgivable activities of the 1930s and 1940s is in no way intended to justify his execution by the RAF but, rather, to make specific the degree to which the "hiddenness" of the past was, in reality, an open secret and a crucial factor in the political choices made by the children whose parents cheered, or at least tolerated, Hitler. At the funeral, attended by leaders of government and commerce, including not only the SPD chancellor Helmut Schmidt but anonymous men of military bearing with dueling scars on their faces, many who mourned Schleyer's death might well have been those whom Arendt had earlier described as demonstrating an "intentional refusal to mourn" the catastrophe of National Socialism or "a genuine emotional incapacity to do so."

ROBERT STORR

Although the principals of the Baader-Meinhof group had no direct role in the decision to take Schleyer hostage and later to kill him, there is a striking contrast between their backgrounds and his. Both of those who gave their names to the group, Andreas Baader and Ulrike Meinhof, as well as Gudrun Ensslin, the driving force in the group's radicalization, came from families that had repudiated Hitler. And all three came of age aware of that dissidence and convinced that even greater defiance was necessary.

Ulrike Meinhof, the oldest of the three, was born in eastern Germany in 1934. Her father, Dr. Werner Meinhof, was the curator of the Jena Municipal Museum, a position he held from 1936 until his death in 1940. Coming from a long line of Protestant theologians, Dr. Meinhof belonged to a religious community that had objected to state control of church affairs since the time of Bismarck, and at considerable risk, continued to do so under Hitler. After his death, his widow, Ingeborg Meinhof, studied to be an art historian and—to supplement a meager stipend from the city for which her husband had worked—took in a lodger, a dynamic and independent-minded young historian named Renate Riemeck. Ingeborg Meinhof and Riemeck had similar anti-Nazi sentiments, pursued their academic ambitions in tandem, and together moved, with Meinhof's two children, from East Germany to the West, shortly after the war ended. Both joined the SPD as soon as political freedom was restored. When Ingeborg Meinhof died in 1949 of complications from cancer, Riemeck became a foster mother to Ulrike and her elder sister, Wienke, and in her unconventional manner, passion for ideas, and increasingly outspoken socialist views she became Ulrike's primary role model.

Gudrun Ensslin, the fourth of seven children, was born in 1940, and also came from a principled, staunchly Protestant family. Her father was a minister and her mother "a strong character inclined to mysticism."[5] Having tended his parish in a predominantly Catholic town from 1937 through 1948, Pastor Ensslin was calmly but stubbornly nonconformist. A subscriber to left-wing religious journals that argued for a reconciliation between East and West and for a ban on rearmament, he took heart in his daughter Gudrun's leadership in bible-study classes and youth groups. He encouraged her to go to the United States in 1958, where, at age eighteen, she spent a year with a Methodist community in Pennsylvania. She was dismayed at the lack of political sophistication and engagement of her hosts, which was typical of a particularly staid and self-involved moment in American social and cultural life. It also indicated something of her own internationalist orientation and intense activism, albeit then still church-bound.

Andreas Baader, the youngest of the three radicals, was born in 1943. His father, Dr. Berndt Phillip Baader, entered military service soon after his son's birth, was taken prisoner by the Russians in 1945, and disappeared. An historian and archivist who had opposed Hitler and spoken of joining the resistance, he was reportedly dissuaded from doing so by his wife, Anneliese, who was said to have feared the consequences for the family. However, after her son's death she told a reporter that Dr. Baader's failure to live up to his convictions was his own. In a strange display of matrimonial contempt and maternal pride, she said: "He was afraid. That was the difference between them. Andreas was never afraid. He went through with everything, right to the end."[6]

From these somewhat congruent beginnings to their encounter on the fringes of the new Left of the 1960s, the paths followed by Baader, Ensslin, and Meinhof differed significantly, but the fact that all of them came from families in which a heritage of dissent was a matter of pride, in a period and situation dominated by political self-effacement and subservience, cannot be stressed enough.

Also significant is the fact that all three leading members of the Baader-Meinhof group were solidly middle-class, as were the majority of those who gravitated to the armed political underground in general, and to the RAF in particular. Some, like Baader, had come from the lower economic strata, and at adolescence had slipped into the free-floating population of urban squatters and counterculture scene-makers. Others, like Susanne Albrecht, who at the height of the RAF's efforts to gain the release from prison of the original Baader-Meinhof group played a pivotal role in the botched 1977 kidnapping and murder of the head of Dresdner Bank, Jürgen Ponto, belonged to the upper middle class. The daughter of a Hamburg lawyer with close family ties to Ponto, Albrecht was admitted into the security-conscious banker's house in the company of two accomplices when she asked to speak to "Uncle Jürgen." This prompted Dr. Horst Herold, chief commissioner of the Federal Criminal Investigations Office (BKA) charged with coordinating the government's counteroffensive against terrorism, to remark: "There is no capitalist who does not have a terrorist in his own intimate circle of friends or relations. I mean that. There are no circles, however high, in our society—and this is the really alarming thing—which do not have people like Susanne Albrecht somewhere in their immediate or more distant vicinity."[7] Herold left unasked, as did so many who witnessed the spectacle of domestic political insurgency from the questionable safety of circumscribed lives, why this should have been so, and why so many, who in theory benefited most from the postwar "German miracle," spurned its comforts and ardently disputed the social contract that had made it possible.

General complacency and an initial failure of the middle class to take the deep disaffection of members of their own milieu seriously greatly exacerbated the frustration of those who moved to the Left in the 1960s (especially the young), reinforcing their sense that only categorical distinctions and sharply divisive acts could clarify their positions. The shock to the system resulting from the discovery of just how far such privileged but alienated intimates had in fact moved, while seeming to live parallel lives with their mainstream peers, was all that much more disorienting, and triggered a latent fear not of a foreign enemy, but of neighbors. This paranoid spasm and the exceptional legal measures instituted because of it did much to confirm the Manichean views of idealistic rebels, and, for a while, hardened their conviction that fundamental change was a now-or-never, all-or-nothing proposition. Thus, contrary to standard historical scenarios in which revolutionary momentum builds in response to the grinding oppression of the disadvantaged, this time matters came quickly to a head among men and women who had had some or all of the advantages, and who, as political novices, transposed their expectations of immediate gratification onto a reality that was fundamentally unripe for anything approaching a popular uprising.

It is correspondingly noteworthy that truly working-class youth generally kept its distance from the orthodox Left. Educationally ill-equipped for, or simply mistrustful of, doctrinal debate but strongly attracted to the new-found freedoms and the sex-drugs-and-rock-and-roll hedonism that neo-Marxists like Meinhof disdained—"We never played the Internationale but always Jimi Hendrix," the construction apprentice turned bomb-thrower Michael "Bommi" Baumann tartly recalled[8]—the relatively small proletarian contingent of the underground was every bit as eager for radical upheaval as its bourgeois contemporaries, and much better prepared for physical confrontation. However, previous experience had made them less inclined to romanticize violence and far more realistic about the power of the state. Indeed, Baumann and his equally hard-up and outspoken cohort Hans-Joachim Klein, were among the first members of the armed underground to renounce ter-

ROBERT STORR

rorism in the mid-1970s, and among the most frank and eloquent of those who criticized its use from the perspective of an unflagging refusal to submit to the status quo.[9]

Although students and other radicals were numerous and active throughout the Federal Republic from the mid-1950s through the 1980s, especially in Munich, Hamburg, and Frankfurt, Berlin was the hotbed of postwar German radicalism. The former imperial capital, hub of the Third Reich, and focus of East-West tensions during the Cold War. The city, with the construction of the Wall, became a political island tenuously connected to the rest of West Germany by air, rail, and highway corridors. Its exceptional concentration of young people was owed in varying degrees to its academic institutions, the fact that draft-age men living in this volatile zone were exempt from military service, the availability of cheap housing, and thriving bohemian communities. These circumstances, symbolic as well as material and social, made Berlin the flash point for student protest, and the crucible for countercultural experimentation.

Andreas Baader arrived in Berlin in 1963, quickly developing a reputation as a troublemaker and a charmer who lived at the center of an artistic ménage-à-trois, fathered a child by the woman, teased and rebuffed homosexual men, and engaged in the sport of petty theft. Although he was effectively apolitical, his swagger made him a minor local celebrity on the Kurfürstendamm, West Berlin's main drag. Meanwhile, Gudrun Ensslin had trained as a teacher, married Bernard Vesper (the maverick son of a well-known literary critic and poet sympathetic to the Nazis), had a child, and, with Vesper, founded a small press that published new literature and essays against the nuclear arms race. In 1965, she moved to Berlin to attend the Free University and participate in an SPD-oriented writer's workshop in preparation for the elections of 1965. Disillusioned by conventional parliamentary politics and dissatisfied by her vocation, she eventually separated from her husband and hovered on the Left without a clear purpose.

The catalytic events that embroiled them both in overt political conflict—with Baader at first caught up along the fringes, and Ensslin almost immediately at the heart—were the June 2, 1967, demonstrations mounted against the Shah of Iran during his visit to Berlin. Protests in Berlin against the American bombing in Vietnam in 1965 (during which the U.S. Embassy was attacked by an angry splinter group) and in 1967 against vice president Hubert H. Humphrey—during which Humphrey was hit by a custard pie hurled by representatives of Kommune 1 (K 1), a flamboyant Berlin collective—caused government embarrassment and alarm but were, given the times, comparatively peaceful. Overall, however, there had been a steady change in the tenor of dissent. In 1958, when 5,000 students—the twenty-four-year-old Meinhof among them—demonstrated against the bomb, they wore skirts and ties; nine years later, this disciplined show of discontent spun into absurdity by K 1's slapstick assault on an American dignitary. Even so, June 2, 1967, marked an abrupt and irrevocable escalation of street violence. Under the eyes of the Berlin police, the Shah's own security guards attacked the protesters with sticks, and turned the march into a melee, at the end of which, Benno Ohnesorg, a pacifist student who had never before taken part in a demonstration, was shot dead by a careless, or simply trigger-happy, police detective. The naked display of vigilantism by the Shah's men and the acquiescence by German authorities to the "accidental" killing of Ohnesorg both chilled and inflamed the protestors, who saw in the conduct of officials the specter of state terror. Ensslin was especially quick to make the connection. Speaking at a rally shortly after the news of Ohnesorg's death had broken, she voiced sentiments widely shared by her comrades, although acted upon by only a small number of them. "This fascist state means to kill

Benno Ohnesorg in the arms of passerby Friederike Hausmann after being shot and killed by police, West Berlin, June 2, 1967

us all. We must organize resistance. Violence is the only way to answer violence. This is the Auschwitz generation, and there's no arguing with them!"[10]

Shortly after making this speech, Ensslin met Baader, and her righteous passion matched with his delinquent impetuosity set the tone of their disastrous joint foray into revolutionary politics. Their first venture together was inspired by another K 1 prank. Following a catastrophic fire in a Brussels department store on May 22, 1967, in which about three hundred people perished, K 1 published a broadside that linked the fiery deaths of the shoppers to the ongoing bombing of North Vietnam by American planes, and the stationing of American troops in Germany. "When will the department stores of Berlin burn?" the text read. "The Yanks have been dying for Vietnam in Berlin. We were sorry to see the poor souls obliged to shed their Coca-Cola blood in the Vietnamese jungle. So we started by marching, and throwing the occasional egg at the America House and we would have liked to finish seeing HHH [Hubert H. Humphrey] die smothered in custard. Now our Belgian friends have at last found the knack of really involving the whole population in all the fun of Vietnam. Brussels has given us the only answer: BURN DEPARTMENT STORE, BURN."[11] The gruesome humor of this Swiftian proposal makes no sense unless one takes into account the horrifying reports issuing daily from Southeast Asia, and the strenuous efforts made by hawkish spin doctors to keep the war at a distance while emphasizing the concurrent "guns and butter" prosperity of the Western democracies.

Baader's and Ensslin's decision to literally carry out K 1's mock call to action is a measure of how easily satirical exaggeration can become an imperative to fervent but otherwise directionless individuals. Thus on April 2, 1968, a year after the Brussels calamity, and less than a year after the Berlin riots, Baader, Ensslin, and two friends, Thorwald Proll and Horst Söhnlein, planted firebombs set to explode after business hours in two Frankfurt department stores, causing considerable damage but, because of the bombs' predetermined timing, no injuries. Although approved by K 1, whose leaders (no doubt surprised that someone had actually taken them up on the idea) were then charged with incitement, the action was strongly condemned by the SDS, opening a split between the organized Left and its impatient veterans and fevered new recruits, which gradually undermined the authority and effectiveness of more programmatic radicalism for a decade and more.

Almost immediately apprehended, the foursome was charged with arson, and their case became a cause célèbre, attracting the talents of politically committed lawyers Horst Mahler and Otto Schily. The divergent trajectories subsequently taken by these defenders throw into stark relief the choices that sympathizers then confronted. Mahler, eager to put an end to his complicity in a legal system he contested, quickly succumbed to the heat of

ROBERT STORR

the moment and became a front line ally of his clients. Before the case was settled, the formerly buttoned-down attorney was arrested for rioting and soon thereafter fled to Italy, where he unsuccessfully competed with Baader for leadership of the fledgling RAF. Following an excursion to the Middle East to make contacts with revolutionaries, and a series of mishaps on his return to Germany, Mahler was captured, tried for a variety of crimes, and sentenced to a prison term of twelve years. (Among the sourest ironies of this period is the fact that since his release, Mahler has moved from the far Left to the hard Right, and become a featured speaker at meetings of the neo-fascist Nazionalsozialistische Partei Deutschland, claiming that this is consistent with his original beliefs.) Schily, who remained the Baader-Meinhof group's counsel throughout most of their long legal battles, is currently Minister of the Interior in a government composed of former student protestor and SPD Chancellor, Gerhard Schroeder, whose Foreign Minister, Joschka Fischer, an even more prominent figure in radical politics, had once tried to divert the trend toward armed struggle with the unsuccessful plea, "Comrades, lay down your guns and pick up paving stones."[12] One is reminded by such details that the differences in personal experience and ideological perspectives separating extremists from reformers in the 1960s and 1970s were sometimes comparatively small. The fact that the harsh choices made and the pain suffered in those difficult days have not faded from memory is not surprising, and neither is the fact that the political conclusions people on all sides of the issues rushed to at the time remain in question. We are dealing with living history. Openly or under cover, those touched by these events bear the scars, and many must still harbor doubts.

The sense of urgency that prompted public support for Baader, Ensslin, Proll, and Söhnlein in many quarters was heightened by the April 11, 1968, attempt on the life of Rudi Dutschke, a leader of SDS, and the most charismatic of the young radicals in the burgeoning APO. When he was arrested, his would-be assassin, a twenty-four-year-old housepainter named Josef Bachmann, was carrying clippings about Dutschke from the sensationalist, Springer-owned *Bild-Zeitung*. Also in his pocket was an article from the far right-wing *Deutsche Nationalzeitung* that read "Stop Dutschke Now! Otherwise there will be civil war. The order is to stop the radical left revolution now! If we don't, Germany will become a place of pilgrimage for malcontents from all over the world."[13] Superficially, there might seem to be parallels between K 1's provocation and that of the neo-Nazi writer who penned the article that appeared to have given Bachmann his marching orders, but K 1's idea was, by design, far-fetched, and the two members of the commune brought to trial for inciting the arson were acquitted of any responsibility. In the context of Germany's past, the bloody repression of the Revolution of 1918–19 by the proto-Nazi Freikorps, the gang-land style "anti-Bolshevism" of Hitler's Brown Shirts, and so much else, the hysterical xenophobic command to "Stop Dutschke Now!" was almost bound to produce the result that it did. Although Dutschke survived the attack, the lasting neurological damage he suffered contributed to his death eleven years later. Moreover, the reverberations of Bachmann's act included setting the stage for the RAF's terror campaign, while driving moderates more fearful of neo-Nazi violence than of anarchist attacks on property into their camp. The immediate response to the shooting were riots in Berlin at the site of Springer's corporate offices. For the first time, Molotov cocktails were used by the radicals—Mahler was among those who threw them—but unknown to the rioters and to the public at large, these had been supplied by a police agent who would later offer Baader and his comrades access to guns. Whether it was in an effort to polarize public opinion or to entrap hard-core protestors, someone in a position of authority was tempting fate.

Ulrike Meinhof was present at the Springer-building battle, which she wrote up for *Konkret*, the widely circulated left-wing journal of which she had been editor since 1960. After attending university in Münster, where she assumed a high-profile role in the anti-nuclear-weapons movement and SDS, Meinhof, still in her twenties, became a nationally known political speaker and columnist, and by her early thirties was appearing regularly on television as a resolute intellectual and moral voice of the new Left. In the meantime, she had married Klaus Rainer Röhl, a *Konkret* founder. Together they settled into a comfortable house in Hamburg with their two children, and were much in demand in liberal as well as radical social circles. Then things came unstuck. Like her foster mother Renate Riemeck, Meinhof had been sharply disappointed by the SPD's conciliatory swing toward the center in the mid-1950s, leading to the party's demand that SDS sever its affiliation with *Konkret* because of its Marxist leanings and continued contacts with the communists in the East. This led to a final break between the SPD and the still-dynamic SDS in 1959.[14] At each turning point, Meinhof took the more radical path. In keeping with that tendency, her editorial on the shooting of Dutschke, "From Protest to Resistance," announced a new militancy on her part, echoing Ensslin's declaration after the killing of Ohnesorg, but advancing the argument and ratcheting up the stakes several notches by exhorting her readers to emulate nationalist movements such as those of the Vietcong and the Palestine Liberation Organization, and urban guerillas such as the Uruguayan Tupamaros—primary role models for German urban guerrillas after 1967—and the American Black Panthers.[15]

Shortly afterwards, Meinhof interviewed Ensslin in jail, and was greatly impressed by her explicitly revolutionary aims; for that very reason, her potentially self-incriminating text was never published. Ensslin's fervor galvanized Meinhof, and their encounter effectively punctuated her own incremental ideological conversion to violence. A year after that first meeting and the Springer riots, Meinhof divorced Röhl, quit *Konkret*, and made her way to Berlin with her two daughters, where, among other projects, she worked on a television drama about reform-school girls called *Bambule*, a slang word meaning "riot" or "resistance."[16] In the meantime, Baader, Ensslin, and Proll had been sentenced to three years in prison and released under a special amnesty for political prisoners. During their five months of freedom, they worked in a program for teenage runaways from state-supervised homes. It was called the Frankfurt Apprentices Collective, and once more put them in touch with Meinhof; in that context, Baader's knack for enlisting the energies of young renegades came out, encouraging him in the belief that they might soon be marshaled into some kind of irregular revolutionary army. When, in November 1969, Ensslin, Baader, and Proll were ordered back to jail, they decided to go underground. Their first stop was Paris, where they stayed at the apartment of the French writer and activist Regis Debray, then serving a thirty-year term in Bolivia, where he had accompanied the late Cuban firebrand Che Guevara into the jungle.[17] For a group of freelance insurgents on the run, the legitimizing symbolism of this association was potent. After several months abroad, however, they decided to go back to Germany and plan further actions. Not long after returning, Baader was stopped for driving without a license, identified, and re-imprisoned. While serving his time in Berlin's Tegel jail, he managed to obtain permission to work with Meinhof in the library of the Institute for Social Studies, ostensibly on a project growing out of their involvement with troubled youth. But on May 14, 1970, Baader used this setup to make a daylight escape, assisted by Ensslin, Meinhof, and several other comrades, during which an elderly guard was shot, but not killed.[18]

The jailbreak sealed the bond between Baader and Meinhof, and its much-publicized

audacity fused their names in the popular imagination, though Ensslin was, in this instance, the driving force behind the deed. Seeking refuge from police pursuit and instruction in the techniques of armed struggle, Baader, Ensslin, and Meinhof made their way to East Germany, and from there traveled to Jordan, where for a month they trained at a PLO camp. Baader's arrogance, the group's lack of discipline, and the men's and women's displays of sexual liberation in an Islamic enclave, earned them an earlier-than-planned departure, and only the most skeptical support from their Third World role models, who had come to regard them as revolutionary tourists, and later took to thinking of them as counters in the larger game of postcolonial power politics.[19] Back in Germany, however, the Baader-Meinhof group promptly applied the lessons they had learned, securing apartments as safe houses under false or borrowed names, renting get-away cars and changing the license plates, and in September of 1970, pulling off three almost simultaneous bank robberies in West Berlin, the proceeds of which were intended to finance future operations.

The two years between Baader's flight in May 1970 and his capture after a shoot-out in a Frankfurt garage in June 1972 (along with two RAF comrades, Jan-Carl Raspe, and Holger Meins) followed an almost Bonnie-and-Clyde-like progression from bravado to desperation—relatively benign acts of lawlessness to increasing destructiveness and confusion of motives. It is unnecessary, here, to narrate the Baader-Meinhof group's many movements, narrow escapes, aborted schemes, thefts, and bombings, in the same detail that the process of their banding together has thus far been described. As in many stories that end badly, the seeds of destruction are sown in the earliest chapters, and the outlines of the denouement are readily foreseeable from the outset. In such situations, accidental encounters acquire the aspect of inevitability, while common misunderstanding or weaknesses of character assume specific tragic dimensions. Recognizing the importance of what happened to Baader, Ensslin, Meins, Meinhof, Raspe, and the other members of the RAF, and rendering a balanced account of what they did and why, hinge in large measure on the realization that these things could have happened to, or been done or thought by, any number of their contemporaries under comparable circumstances, though, as has been mentioned before, each of the actual participants was predisposed to dissent by particulars of personal or family history. The exemplary quality of the Baader-Meinhof group explains the attraction they held for so many disenchanted, but otherwise nonviolent, people. Meinhof's stern analytic conviction, Ensslin's fierce outrage, Baader's angry bravado, Meins's utter devotion to the cause, and Raspe's hapless earnestness, were the faces that German youth, pushed to its limits, showed to elders determined to contain substantive change, and intent on deflecting attention from their own past failures and excesses. At the crux, this was not just an ordinary clash of generations, but the collision of contrary and, as far as actual power at their disposal was concerned, grossly unequal manifestations of ideological rigidity and self-deception.

If, until now, there has been no discussion of the subtleties of the RAF's political rationale, that is for good reason. There weren't many. Of all its members, only Meinhof had a developed grasp of practical or theoretical politics, and after allying herself with Baader and Ensslin, she tended to doubt herself and to yield to their more reductive zealotry.[20] Roughly speaking, the coordinates of the RAF's fundamentalist worldview were American hegemony and German authoritarianism, exemplified by American bases and the bastions of the Auschwitz generation's renewed strength. Within this negative matrix, the RAF's points of positive alignment included, to a greater or lesser extent, virtually anyone who shared their anticapitalist and anti-imperialist rhetoric—from the rough-and-ready "Bommi"

Baumann or members of the Socialist Patients' Collective (SPK) (an erratic psychiatry-based political tendency), to shadowy representatives of Al Fatah, the Japanese Red Army, and the East German regime and its secret service, the Stasi. Notably lacking was sustained dialogue with other sectors of the APO—much less with the labor movement or other grass-roots organizations—though, for awhile, some in the above-ground Left secretly aided them. Frequently on the move, and usually cut off from all but essential local contacts, the Baader-Meinhof group was soon operating in a near-vacuum. As the crisis they had triggered worsened, it tended to occlude any social reality beyond the internal dynamics of their secret clusters, and inhibited the articulation of any vision of what their "revolution" would accomplish, beyond the rescuing of captured comrades and the disruption of the smooth-running machinery of the modern state.[21] Their fatal gamble—based on the widely read manifesto of the Brazilian insurrectionist Carlos Marighella, and on the Maoist notion that the triumph of the revolutionary Third World over the reactionary First World depended on bringing the battle from the margins to the center of empire—was that by relentlessly exposing the vulnerabilities of the establishment while goading them into overreaction, radical saboteurs could gradually expose the true, uncompromising nature of institutional power, and draw others into the fight with them as that power expressed itself in ever more punitive and provocative ways. Or, as Hans-Joachim Klein characterized their strategy in the 1970s: "From the beginning the RAF has always said: the important thing is to exacerbate contradictions in such a way that the situation becomes more and more openly fascist. The important thing is to make the latent fascism that's predominant in West Germany clearly visible. After that the masses will rally round. And also the Left, including those who are opposed to them today."[22]

The consequences of this adventurist doctrine was an increasingly heavy-handed response from the police, the courts, and lawmakers. However, the RAF's apocalyptic obsession, compounded by their isolation, was such that they could not see that instead of hastening the downfall of all that they held repressive or corrupt, they had cast themselves and their supporters into a whirlpool that would shatter the Left's fragile cohesion, and pulverize its hopes. Once the RAF moved from isolated gestures of defiance to a systematic campaign of violence, the maelstrom's pull was inexorable. And so what may at the outset have seemed quixotic and innocent to some rapidly revealed itself to be a death-dealing naiveté. Or, as another RAF member, Klaus Junschke, recalled: "It was like going down hill out of control, if you jump out you're done for, if you carry on you're done for just the same."[23]

Less than a week after Baader, Meins, and Raspe were captured in Frankfurt, Ensslin was arrested when a saleswoman in Hamburg spotted a gun in her purse and tipped off the police. A week later, Meinhof was seized in Langenhagen, near Hannover, when a teacher belonging to the RAF's network of protectors had second thoughts about hiding her, and turned informant. Sympathizers, frightened by the rising dangers of associating with outlaws whose faces appeared on wanted posters throughout the country were deserting them, along with dedicated leftists put off by the RAF's often imperious demands for shelter, as well as by their increasingly incoherent politics. Although Meinhof, like Ensslin, surrendered without incident, she was beaten in a struggle that took place afterward, and a photograph of her badly bruised face was widely published. As of mid-June 1972, all the principal figures of the Baader-Meinhof group and their closest collaborators were in custody. The crimes for which Baader, Ensslin, Meins, Meinhof, and Raspe were charged included seven counts of murder and twenty-seven counts of attempted murder in connection with bomb-

ings, as well as additional counts of murder, or attempted murder, for separate individuals. The indictment also cited a bank robbery, involvement in the raid that resulted in Baader's escape, forming a criminal organization with Horst Mahler, and other related offenses.

The most intense period of bombing was from early to mid-1972. On May 19, 1972, explosives were set off at Springer headquarters in Hamburg, at German police stations in Augsburg and Munich, at American military sites in Heidelberg and Frankfurt (timed to the escalation of American air raids over North and South Vietnam), and in various other locales, such as Karlsruhe. Although the exact identity of the perpetrators of these attacks remains in many cases unknown, several of them were claimed by Commandos bearing the names of radicals killed in the increasingly frequent and lethal shoot-outs with authorities. In addition to the RAF, terrorist cells associated with the June 2nd Movement (commemorating the date of Benno Ohnesorg's death), the Revolutionary Cells (RZ), and the SPK were pursuing the same tactics, and while casualties mounted among the RAF and affiliated organizations, the toll of policemen, U.S. soldiers, and those unlucky enough to be in the wrong place when bombs went off, also soared.[24] Although only a tiny percentage of the population had raised its hand in violence, it was in a very real sense a civil war. Lamenting the futility of the Baader-Meinhof group's crusade, the novelist Heinrich Böll called it, the war of "six against sixty million."

The most wrenching phase of that war began with the detention of those who had triggered its outbreak. By that time, Germany was a country under siege—and counter-siege. Presided over by Dr. Herold, the BKA effectively became a national police and surveillance unit on the order of the American FBI. For the first time since World War II, Germany collected massive quantities of information on its citizens—by 1979, the BKA's computer center in Wiesbaden had files on 3,100 organizations and 4,700,000 individuals, along with 2,100,000 sets of prints, 6,000 writing samples and 1,900,000 photographs. In the meantime, police searches became routine, and highways were periodically cordoned off all across the Federal Republic. At one roadblock in July 1972, Petra Schelm, an RAF member, was killed when she drew a gun and tried to flee. She was the first person to die in the expanding crisis. In March of the following year, however, a seventeen-year-old who attempted to run a barricade simply because he was driving without a license, was also shot dead, and incidents such as this one, plus a growing unease about pervasive police presence, turned many people against the government, even though the police suffered its own fatalities at the hands of gun-wielding radicals.[25]

The conditions in which the RAF prisoners were held and under which they were tried were similarly extreme and politically double-edged. For the first year of her confinement, Meinhof was kept in almost total physical and acoustic isolation in the so-called "Dead Section" of a Cologne jail. After more than a decade of activism, and two years as a fugitive (which had worn down her health and nerves), Meinhof suddenly found herself quite literally boxed in. She described the experience as "the feeling that your head is exploding . . . the feeling of your spinal column being pressed into your brain . . . furious aggression for which there is no outlet. That's the worst thing. A clear awareness that your chance of survival is nil."[26] The others were held in less draconian circumstances, but they, too, were cut off from the world and from each other for long intervals, and more importantly, they were periodically cut off from their lawyers, some of whom were summarily dismissed from the case on the grounds that they were in league with their clients. After a long build-up to the trial, involving the construction of a special high-security courthouse on the grounds of Stammheim prison, the majority of the RAF prisoners were eventually gathered in a block

Press conference at Stammheim prison, December 4, 1974: left to right, Klaus Croissant, lawyer for Gudrun Ensslin; Jean-Paul Sartre, existentialist philosopher and writer; and Daniel Cohn-Bendit, radical politician

of cells separate from the rest of the prison population, further restrictions were put on their attorneys, and surreptitious measures were taken to eavesdrop on discussions among them, and between them and their legal representatives. When the case finally came before the judge, his consistent rejection of motions made by the defense—in particular, motions seeking relaxation of the harsh regimen under which the prisoners lived—made it clear that whatever the courtroom provocations of the accused—and they were many—fair and open proceedings were impossible. Revelation late in the trial that listening devices had been placed in the defendants' cells and the rooms where they met with their lawyers came as no surprise, and neither did the discovery that the judge had been leaking information to a conservative newspaper, *Die Welt*, so as to counter stories in the more liberal news magazine *Der Spiegel*, for which, finally, he was obliged to step down.

The judge's actions alone, however, do not account for all the trial's flaws and inequities. Frustrated by Baader's, Ensslin's, and Meinhof's frequent outbursts in court, and especially by their request that daily sessions be limited to three hours due to their poor physical and mental stamina after years of incarceration, prosecutors asked for, and in late 1974 the Bundestag enacted, special laws, which in addition to imposing broad limits on the writing, publication, and dissemination of politically controversial materials, and laying down narrow guidelines for who could represent the accused on political cases (one lawyer was dismissed merely for calling himself a socialist), gave judges the right to carry on with a trial in the absence of those being tried. Thus, on the grounds that a state of national emergency existed, Germany overtly and covertly curtailed its civil liberties, summoning the ghosts of law-and-order past.[27]

The grim backdrop against which these maneuvers played themselves out was marked by death on all sides. Inside the prison, members of the RAF mounted a series of hunger strikes to protest their treatment. Torturous force-feeding of the strikers was the prison warden's response. The effects of these debilitating battles over the control of their own bodies further sapped the strength and attention of the defendants in court, and made a martyr of Holger Meins, who died in the Wittlich jail on the fifty-third day of the third strike, after proper medical attention was withheld. His last recorded words mix political slogans with genuine stoicism: "Either pig or man, either survival at any price or fight to the death, either problem or solution. There's nothing in between. Of course, I don't know what it's like when you die or when they kill you. Ah well, so that was it. I was on the right side anyway—everybody has to die anyway. Only one question is how one lived, and that's clear enough: fighting pigs as a man for the liberation of mankind: a revolutionary battle with all one's love for life, despising death."[28]

ROBERT STORR

Widespread rioting followed Meins's death, and a post-autopsy photograph of his horribly emaciated corpse became an icon of radicalism. Klein said: "I have kept this picture in my wallet to keep my hatred sharp."[29] Much of the general public was also shocked by the sight of this image, and by the cruel reality to which it testified. In the battle of symbols, the RAF had gained a heightened moral credibility even as direct support for its actions continued to wither. The keenness of public ambivalence was made manifest by the call paid on Baader by the existentialist philosopher Jean-Paul Sartre, whom Baader, like much of his generation, had read in the early stages of radicalization. A former fellow traveler of the conservative Soviet-controlled French Communist Party turned ally of the upstart, go-for-broke Maoist factions that played a crucial role in the general upheaval that shook France in May 1968 and its aftermath, Sartre was persuaded to visit Stammheim out of concern for the well-being of the prisoners, but not at all out of solidarity with their political stance. This brief cross-generational summit, which garnered much publicity, was a blunt non-meeting of minds. "This group is a danger to the Left. It does the Left no good. One must distinguish between the Left and the RAF," Sartre declared after it was over.[30] Of Sartre, Baader said: "As for him, what I got was the impression of *age*."[31] The fact remained, however, that much of the old Left which had remained militant was deeply distressed by the perilous detour taken by frenzied elements of the new Left. (This included Meinhof's foster mother Renate Riemeck who had done much to inspire her radicalism, but who, during the manhunt for the Baader-Meinhof group in 1971, had published a letter in *Konkret* headlined, "Give Up, Ulrike," arguing that terrorism would be blamed on the Left as a whole and used as a propaganda weapon to block progress of their common social aims.)

By December 4, 1974, when Sartre went to Stammheim, forces were in motion that resulted in actions and reactions far outstripping his or Riemeck's worst fears. After Meins's death, the second generation of terrorists went into high gear, immediately demonstrating an unpredictability and a willingness to spill blood that exceeded anything for which the original Baader-Meinhof group could be held responsible. Their first action, made by the June 2nd Movement, was the killing of a judge (during an attempted kidnapping) who was unconnected with any of the pending cases against the RAF. The second, also by the same group, was to kidnap the Christian Democratic politician and candidate for mayor of Berlin, Peter Lorenz, and demand a cease-fire with the police and the release of all radical prisoners not charged with murder. It is some indication, perhaps, of the divisions and mistrust within the movement that Mahler, one of those named by the hostage-takers, refused to accept the invitation. In any event, after tense negotiations, other prisoners were flown to exile in Aden, and Lorenz was let go unharmed. The next incident did not end peacefully. A month after the Lorenz case, six heavily armed terrorists invaded the German embassy in Stockholm, demanding freedom for twenty-six prisoners, including those in Stammheim. When the governments of the Socialist prime minister of Sweden, Olaf Palme, and the German socialist chancellor Helmut Schmidt refused to negotiate, the invaders shot two diplomats in full view of the surrounding police, and then, mishandling the bombs they had brought in to mine the building, set off a huge explosion that gutted the premises, killing one guerilla and one hostage, and wounding several others. The siege, engineered by the SPK, ended in chaos.

Similar incidents arising out of the Middle East stand-off between Israel and the Palestinians had occurred earlier, and had provided the background for the Lorenz kidnapping and the attack in Stockholm. In September 1972, Arab commandos seized members of the

Israeli Olympic team in Munich, and by the end of the confrontation, all eleven of the Israeli hostages, as well as five terrorists and one policeman, were dead. (Germany's decision not to arm police guarding the Olympic Village in order to avoid projecting a militaristic image, and its fatal bungling of the final showdown with the hostage-takers, added to political pressures to strengthen its security forces overall.) The brutal slaying of Jews on German soil raised the specter of anti-Semitism in ways few imagined possible. For example, by openly siding with the perpetrators of the attack on the grounds that they were Third World revolutionaries, Meinhof and some, but by no means all, of her anti-imperialist colleagues tacitly aligned themselves with Judaism's perennial enemies, in a context in which the assertion that their anti-Zionism was purely political rather than ethnically based, simply ceased to be a meaningful distinction. The December 1975 raid on the Vienna meetings of eleven OPEC ministers in which Hans-Joachim Klein participated was the next episode binding together the offensives of Arab and German terrorists. Although three people were killed and Klein was gravely wounded at the beginning of the siege, there were no further deaths after the ministers were ransomed by their governments, and Algeria agreed to be a refuge for the commandos who had been led by the cold-blooded sociopath, Ilyich Ramirez Sanchez, popularly known as Carlos the Jackal. Six months later, on June 27, 1976, an Air France plane flying from Tel Aviv to Paris was hijacked in Athens by a group that included members of the Revolutionary Cells (RZ). The standoff at Uganda's Entebbe airport came to an abrupt conclusion when German and Israeli special forces stormed the airport's control tower and the former terminal where the passengers were being held. Seven terrorists were killed and all the hostages were rescued, except for three who died in the fire-fight, and one other, an elderly woman named Dora Bloch, who died of suffocation after having been forcibly removed from a Kampala hospital by security guards of the Ugandan dictator Idi Amin, whose protection Bloch had been guaranteed.

The convergence of once disparate terrorist groups inside Germany and out, the entanglement of their still differing motives and aims, and the increasing savagery of their strikes, created the national and international setting for the last act of the Baader-Meinhof story. The isolation of Baader, Ensslin, Meinhof, Raspe, and the rest of the RAF prisoners from the world beyond their walls, their intensifying pessimism, and the gradual disintegration of relations among them, complete the demoralizing picture.

Gathered in adjacent cells on the seventh floor of Stammheim jail, the prisoners lived in what amounted to a bizarre collective, watched over by a squad of guards. For long periods, the special Baader-Meinhof laws enacted in 1974 effectively denied them contact with anyone except their lawyers, and even that was limited. Contact with each other was in principle allowed during certain hours and in certain common areas, but it was frequently interrupted; otherwise, they communicated by semi-coded messages sent back and forth through their attorneys or, near the end, with the aid of a walkie-talkie system improvised out of old transistor radios. Permitted record players and books—Baader, for example, had a library of some 974 volumes, most of it revolutionary literature, while Ensslin's collection also included *Measure for Measure* and *Moby Dick*, both of which she interpreted as revolutionary allegories—they passed their time listening to music, reading, writing, and arguing. At night, courtesy of their warders, several of them were routinely given strong sleeping drugs.

From the time of her year-long solitary confinement in Cologne, Meinhof experienced a gradual nervous breakdown. Political as well as personal tensions between her and Ensslin were at the core. Particular sore spots included Ensslin's criticisms of Meinhof's support

ROBERT STORR

for Black September, and their disagreements over whether or not the hunger strike should be maintained after Meins's death; Meinhof wanted to stop it, but Ensslin insisted that it go on, until finally it was called off after 146 grueling days. Self-criticism sessions conducted by letter or face-to-face dredged up Meinhof's abiding self-doubt and turned it into self-loathing. However, her slide into melancholy merely made Ensslin suspicious that she was trying to crack up so as to shirk responsibility. Meinhof's previously rebuffed attempts at composing manifestos acceptable to the others, and the never-completed history of the RAF she embarked on late in the trial, were further demonstrations of her need to make sense of their mission, and her inability to do so. By late 1975, Meinhof began withdrawing from her comrades into a numbing depression—she had long since severed ties with Riemeck and then, in late 1973, stopped writing to her daughters—a depression relieved, if that is the word, only by periodic eruptions in court, in which her old vehemence was momentarily restored. In the end, she became a victim of her own totalizing beliefs; revolution had consumed the whole of Meinhof's identity, but, ultimately, there seemed to be no place in the revolution for her.

On May 4, 1976, Meinhof briefly appeared for the last time at her own trial, and left before hearing her lawyer call Willy Brandt, Richard Nixon, and Helmut Schmidt as witnesses, the kind of political gesture she ordinarily would have savored. On May 9, she was discovered hanging by a strip of towel in her cell. While doubts were raised about the circumstances of her death—including the accusation that she had been raped before being murdered by a person or persons unknown—no substantial evidence was found to support these suspicions—though many believed it may have been destroyed—and the case was ruled a suicide. As was true after Meins's death by starvation, demonstrations occurred throughout West Germany, and a week after she died, thousands attended her funeral, at which twenty-six people were arrested.

Although Ensslin seems never to have lost her ardor, and Baader seems never to have lost his combativeness, desperation stalked them even as efforts to spring them from jail reached a climax. The final bid for their freedom started September 4, 1977, with the kidnapping of Hanns-Martin Schleyer in an ambush during which his chauffeur and three of his bodyguards were machine-gunned down. Release of the RAF prisoners in Stammheim, was the kidnappers' main demand. As soon as the news broke, Baader, Ensslin, Raspe, and the others, were placed in total quarantine, with all contact among themselves or with anyone on the outside—including their lawyers—banned. They were only allowed to speak to prison or government officials, and clergy members. Within the pressure-cooker atmosphere of their cellblock, tensions with guards, which had already led to brawls, reached fever pitch.

The German government's policy, as it had been in Stockholm, was to resist acceding to terrorist threats. Seeking to secure a clear mandate for that policy, Chancellor Schmidt called a special meeting of senior political figures and opposition leaders, including Helmut Kohl of the CDU, and Franz-Josef Strauss of the CSU, in which all parties agreed to a strategy of public negotiations and secret intransigence while police hunted for Schleyer and his captors. [32] The ins-and-outs of those pro-forma negotiations are too complicated to summarize, except to say that they involved bad faith toward Schleyer's family as well as toward the neutral human-rights activist who served as intermediary, and all the others with a vital stake in the outcome. After a delay of a month and a half, the ante was raised with the October 13 hijacking of a Lufthansa jetliner by a combined team of RAF gunmen and Palestinian guerillas, who, after several interim landings, brought the plane down on an airstrip in Mogadishu, Somalia.

Although Baader, Ensslin, and Raspe may intermittently have hoped that their self-appointed saviors would be successful, instinctive certainty that they would not, plus a widening gap between their sense of the politically appropriate tactics and those of their more fanatical allies, appear to have convinced them that the whole effort was one of remorseless futility. Throughout the weeks leading up to their mysterious deaths following the liberation of the captives on the Lufthansa plane by an elite unit of the German army, Baader, Ensslin, and Raspe sent mixed messages. On the one hand, the prisoners laid full responsibility for their fate at the feet of the officials; on the other, they intimated that one way out was to do away with themselves.[33] Thus Baader warned the prison doctor, Dr. Henck, of incipient attacks by guards: "A few more days and there'll be people dead. There's sadism bursting out everywhere now," he said.[34] "Putting together all the measures adopted over the last six weeks, one can conclude that the administration is hoping to incite one or more of us to commit suicide, or at least make suicide look plausible. I state here that none of us intend to kill ourselves. Supposing, again, in a prison officer's words, we should be 'found dead' then we will have been killed in the fine tradition of all the judicial and political measures taken during these proceedings."[35] Yet, in another recorded comment, Baader threatened that the prisoners might take the matter out of the negotiator's hands by coming to "an irreversible decision" on their own.[36] Moreover, it appears that Raspe had reached the point of despair, and Ensslin one of resignation, prompting her to summon a Catholic priest, as well as a Protestant minister to whom she entrusted the care of certain papers still in her cell, papers that vanished after her death and before the pastor could recover them, and have never since been located.

Meanwhile, as he watched events spin out of control, Baader offered a revisionist, partly exculpatory, but still pointed critique of the mercilessness of the second-generation terrorists and errors of the authorities facing them: "There are two lines to take in the fight against the state, and through its attitude, the federal government has helped the extreme form to break through. . . . International terrorism isn't the RAF scene. . . . I can see two possible ways ahead. One's further brutalization; the other's regulated struggle as opposed to total war. . . . Terrorism is not the policy of the RAF."[37] And, in a last-minute conversation with a high-ranking aide to the Federal State Secretary, Baader affirmed that the prisoners had had no direct or indirect part in masterminding the Schleyer kidnapping or the Lufthansa hijacking, and no leverage over those ostensibly acting on their behalf. Furthermore, Baader claimed, the original RAF would never have engaged in an operation that deliberately endangered innocent civilians, and, he promised, if they were sent into exile, they would never come back to renew their fight in Germany, given the new situation. In conclusion, Baader reasserted that the RAF's response to the Vietnam War had been necessary and just and the origin of all that ensued, but he admitted having made mistakes, and stated that whatever the outcome of the immediate crisis, he and the other prisoners would not survive.

The next morning, Baader, Ensslin, and Raspe were dead. Guards making their usual rounds at 7:40 a.m. found Baader on the floor of his cell clutching a pistol. A bullet had entered the back of his head. In her cell, Ensslin was hanging by an electric cord that had been attached to a metal grate. She too was dead. In his cell, Raspe, shot in the temple, was dying. A fourth prisoner, Irmgard Möller, had been stabbed four times in the chest, but was not mortally wounded.

The party or parties responsible for this carnage remains a matter of bitter speculation. Möller claimed that on the night of October 17, 1977, she had read until 4:00 a.m.—

roughly two and a half hours after Raspe was thought to have heard over the radio that the hijacking of the Lufthansa plane had ended in the total defeat of the hijackers, and reported the news to Baader and Ensslin—and that when she turned off her light, she had called out to Raspe in his adjacent room as was her custom, and that he had responded in the usual way. Sometime around 5:00 a.m., she was briefly awoken by thudding and squealing sounds through the walls and floor. The next thing she remembered was waking up covered in blood on a stretcher. Although Möller insisted that there was no suicide pact in place, it does appear that guns had been smuggled into Stammheim by lawyers involved in the case, and hidden in the molding of Raspe's cell, and the record player in Baader's, and their comrades had intimated that decisive action of some kind was in the offing. Whether or not Baader and Raspe fired the shots, Ensslin tied the noose, or Möller wielded the knife, can neither be proven nor disproven, nor do the incomplete facts in the case (mislaid evidence, important lapses in the investigation, and anomalies in the official explanation that raise numerous unanswered questions about official involvement or cover-up) provide sufficient grounds for calling their deaths murder. And if it was murder, there is no way of ascertaining if prison guards, some secret police or military unit, or others higher up in the governmental chain of command, were to blame. Chancellor Schmidt, for one, professed shock when he heard what had happened at Stammheim. He could not have wanted his clear victory in Mogadishu tainted in such a manner, though by the very same token, Baader, Ensslin, and Raspe surely understood that their untimely and inexplicable deaths would constitute a last weapon against the success of Schmidt's policy. A day after they occurred, a message was sent to the French daily, *Libération*, announcing the execution of Hanns-Martin Schleyer and the location of his body. The communiqué ended with the words: "The fight has only just begun. Freedom through armed anti-imperialist struggle."[38] Such freedom was a phantom, and more than a decade of skirmishes lay ahead.[39]

The funeral of Baader, Ensslin, and Raspe was the coda to their drama. Attended by thousands of mourners, most young, some bearing placards pointing the finger at the government and promising to avenge the martyrs, and many wearing Bedouin head-cloths as an expression of revolutionary solidarity and to conceal their faces from prying cameras, the common burial was also watched over by a thousand heavily armed police officers prepared for trouble, who busied themselves gathering intelligence. When it became public that out of respect for the dead prisoners' wishes, their families had made arrangements to inter them together in a cemetery on the outskirts of Stuttgart, conservatives seeking to obstruct the plans and have their common grave relocated, protested that the site would become a shrine. In one of the few genuinely noble moments of this otherwise dismal saga, the mayor of Stuttgart ruled against the ban. It is more than poetic irony that the city's mayor was Manfred Rommel, son of the German war hero General Erwin Rommel, who in order to save his family, had, in the manner of a Roman soldier, been forced to commit suicide by the Gestapo after being implicated in the plot to assassinate Hitler. Mayor Rommel's reasons were simple and dignified: "I will not accept that there should be first class and second class cemeteries. All enmity should cease after death."[40] One would like to be able to say that he had the last word, but the unrelenting recriminations and debates that continue to revolve around the Baader-Meinhof group suggest that no last word will ever be spoken.

II: THIRTY YEARS AGO TODAY

In 1968 a generation erupted. Before that there had been restlessness and angry optimism. Afterward there was retrenchment and stifled rage. It is nearly impossible to convey such a generation-defining experience to those who were not there or to others who may be indifferent to, or scornful of, the things in which so many of their contemporaries believed, or to evoke the expectancy that hung over everyone present and engaged. Likewise, it is hard to describe the letdown that followed when stagnation set in and idealism soured. The whole truth cannot be reconstructed from documents or statements made at the time. Indeed, words uttered in the flush of improvised history may sound absurd when lifted out of their once-urgent context. An essential element of this larger truth is preserved only in the consciousness of participants and witnesses—and occasionally in art. It is almost a sensory memory of ambient excitations, confusions, fear, anguish, and decisiveness, of compound reasons and liberating illogic, of unparalleled alertness and pent-up energy, and, finally, of an always lingering sense of imminence.

One did not have to be at the center of the power struggle to feel its spasms. Nor, wherever one happened to be, was it necessary to occupy a frontline position in an actual confrontation to be caught up in the exhilaration of the possibility that from one moment to the next the calcified old way might give way to the imagined new one. However, many who arrived late on the scene or stood on the sidelines assumed a premature cynicism, having been robbed of hope before it could take root. Those who endured the greatest disillusionment and later on sometimes caused the most suffering during the drawn-out aftermath of the crisis of 1968 were the young who instinctively sensed their defeat as they first entered the fray, and, staring down the odds against them, lashed out. The Baader-Meinhof group epitomizes that response, and though for a while it may have appeared to sympathizers that they had rekindled the passions of their generation, in fact, their actions were like a flame exploding with a last combustible infusion before it went out.

The example is not unique in history. In 1848 revolutionary pressures came to a head in Austria, France, Germany, and Italy, and their repercussions were felt throughout the rest of continental Europe as well as in Scandinavia, the British Isles, and across the Atlantic in the Americas. And so too, depending on the country, was the partial or full-fledged counterrevolution that came after. The spread of socialism and the birth of communism issue from that incomplete process of fundamental social transformation, as does the rise of anarchism. From 1848 on, through the end of the nineteenth century and into the first third of the twentieth, anarchism evolved—under the influence and stresses of industrial expansion, the disfranchisement of the peasantry, sectarian infighting, and police persecution—from a pamphleteer's doctrine to episodic outbreaks of terror, from Pierre-Joseph Proudhon's and Prince Peter Alexeivich Kropotkin's theories of unalienated association to Mikhail Bakunin's defense of the Russian fanatic Sergei Nachaev and the Italian anarchist Errico Malatesta's reliance upon "the propaganda of the deed." Bakunin's apology, like Malatesta's practice, was premised on the idea that exemplary acts of violence could revive the fervor of the masses in retreat. The appeal of this solution to the veterans of the revolutions of 1848, of 1871 in France, and of 1905 in Russia, as well as of numerous other inter-

ROBERT STORR

ludes of liberal reform and periodic success at radical grass-roots organizing in various countries, was that all it required was a handful of men and women with an agreed-upon aim and absolute resolve. Thus Bakunin and Nachaev wrote: "The revolutionary despises and hates present-day social morality in all its forms . . . he regards everything as moral which helps the triumph of revolution. . . . All soft and enervating feelings of friendship, relationship, love, gratitude, even honor, must be stifled in him by a cold passion for the revolutionary cause. . . . Day and night he must have one thought, one aim, merciless destruction."[1]

Terrorism of this kind differs from traditional forms of political violence such as regicide or tyrannicide in that it envisages not just the removal of a hated figurehead but the undoing of an entire system. If it picks its targets from among the elite the point is not so much to settle accounts with an individual as to disrupt the machinery of power of which that individual is a component so that a tiny minority can impress upon the majority that those who rule over them are not, after all, omnipotent.[2] Terrorist incidents inspired by this conviction are hardly exceptional in modern history. The indignation and fury they provoke is owing not only to the terrible losses they may inflict but to the way in which they destabilize ordinary life for ordinary citizens. The willingness to believe that terrorism is a total aberration is a mixture of voluntary forgetfulness in the hope of restoring a sense of security and of a simple ignorance of history. In the last century and a half terrorism has in fact been frequent and nearly universal.

Thus, for example, France was torn by bombs during the 1890s at the height of La Belle Epoque—it has been argued that the art critic Félix Fénéon was the author of one of the most infamous of these outrages—and again during the Algerian war (1954–62) when right-wing French officers of the Secret Army Organization (OAS) and members of the Algerian National Liberation Front (FLN) engaged in a clandestine war in Paris and Algiers. One of the most moving and chilling descriptions of the daily lives of a band of terrorists and their adversaries is to be found in the 1966 film *Battle of Algiers*. Anticolonial or irredentist causes have often compensated for their underdog status by terrorist tactics. The Irish uprising of the 1910s and 1920s, and its seemingly endless reprise since the 1970s, is another example, as is the struggle for Israel's independence from Great Britain in which the Stern gang and the Irgun—to which future Israeli prime minister Menachem Begin belonged—resorted to a strategy of surprise attacks that claimed the lives of numerous civilians and non-combatants as well as enemy soldiers.

Despite their common techniques, nation-building terrorists are of a different breed from system-destroying ones. The former sometimes opt for parliamentary government once the fight is over, the latter seldom do, in part because they are rarely victorious, but also because it is the basic forms of conventional politics against which they are pitted. In this regard, terrorism has never been an exclusive prerogative of the Left. Though it promises ideologically different remedies, the far Right has often chosen the same objectives and methods. Historically, terrorism has, thus, been pursued by the full spectrum of insurrectional movements from anarchism to fascism, from the unknown Chicago Haymarket bombers of 1886 to the 1995 Oklahoma federal building bomber Timothy McVeigh, from Malatesta to the anonymous right-wing terrorists who, in 1980, set off an explosion in the railroad station in Bologna, causing eighty-five deaths. If, as Karl von Clausewitz maintained, war is nothing but the continuation of politics by other means, then terror is the pursuit of revolutionary war by still other, unpredictable means—by any means necessary.

The purpose of these examples is not to relativize, and thereby dissolve, the crucial

political distinctions that engender terrorism under different circumstances, but simply to underscore terrorism's prevalence and its ineradicable roots in the utopian or dystopian eschatologies of convulsive and definitive social transformation. Revolutionary communists and neofascists do not share the same goals, but they are prepared to do, and have done, the same things to achieve their opposing purposes. To the extent that terror is a constant of developed as well as underdeveloped societies, it is not primarily because there is such a thing as a born terrorist—an inscrutable "lone assassin" often blamed for the deaths of statesmen—but because there are so many conditions in which terrorists are made, almost all of which arise out of, or are worsened by, reigning authority's refusal to countenance reasonable reform.

Encompassing "national liberation struggles" in the Austro-Hungarian Empire and national consolidation in Germany as well as democratic reforms coupled with demands for social and economic leveling, the turmoil of 1848 seeded Europe and the Americas with revolutionaries. The crises leading up to 1968 did the same. Two conservative forces were at risk: Soviet communism and Western-style capitalism. In Poland and Czechoslovakia, 1968 marked the beginning of the end of the former, though in both places the uprisings of that year were crushed by the Communist Party and Warsaw Pact apparatus, as the Hungarian revolt had been in 1956. In the West—which by ideological extension included Mexico and Japan—the rebellion challenged both the powers-in-place and the old Left opposition to them, especially in Italy and France, where established communist parties that had made accommodations with both the ruling elites of their own countries and with Russia—which feared a dramatic shift in Europe's Cold War equilibrium—tried to put the breaks on emerging radicalism. In France, the autocratic government of president Charles de Gaulle came within a hair's-breadth of being toppled when students, workers, cultural figures, and a significant proportion of the middle class took to the streets in May and June, bringing the country to a halt. In the end, though, the exhaustion of the strikers, the reluctance of the communists to join with socialists in forming a provisional government, adroit maneuvering by de Gaulle, and the threat of French tanks rolling into Paris from NATO bases in Germany saved the Fifth Republic.

Italy's always precarious, but somehow always flexible, parliamentary system absorbed the initial shock of mass demonstrations and riots much more readily than the rigid French system, but the split between the new Italian Left and the old deepened, and several new factions came into existence whose above-ground polemics posed a growing challenge to old-line communists and socialists, and whose underground activities would lead in the 1970s and 1980s to a sustained campaign of knee-cappings, bombings, hostage-takings, and murders that culminated in the 1978 kidnapping of Christian Democratic prime minister Aldo Moro by members of the Red Brigade, the RAF's Italian counterparts. Suspicions that the far Right, the Mafia, and members of Moro's own party—who wished to prevent his planned and unprecedented coalition with the communists—were involved rendered the already confusing situation even murkier. After protracted negotiations for his release similar to the talks that decided the fate of Hanns-Martin Schleyer in 1977, Moro was found dead in the trunk of a car in central Rome. What students had failed to do in 1968—overthrow an administration in power—terrorists almost accomplished ten years later, but the Moro case was the last major event in the profoundly destabilizing conflicts that dominated Italian public life during the intervening decade.[3]

In 1968 Japan was shaken by demonstrations at American bases and civilian airports used by American planes in transit to the war in Vietnam, as well as by protests against

Japanese institutions, and in 1969 Tokyo University was occupied by protestors, who were driven out by riot police backed up by water cannons. Out of these confrontations—in which students often marched in paramilitary formations—Japan too saw the birth of a terrorist network, the Japanese Red Army, which collaborated with some European terrorists, though not directly with the Baader-Meinhof group, and participated in jointly executed raids with Palestinian terrorists that were some of the bloodiest incidents of the 1970s.

And all this happened in the United States, too. 1968 was the fourth year since the Gulf of Tonkin Resolution gave president Lyndon B. Johnson the power to take "all necessary steps" to "prevent further aggression" by the North Vietnamese as well as the year that Johnson, sensing there was no way out of the fight and no way to win the upcoming election as long as the war continued, turned down the Democratic nomination for a second term. Meanwhile, the over 525,000 American troops in South Vietnam were caught off guard by the Viet Cong's offensive during the lunar New Year Tet, as some tens of thousands young men burned their drafts cards, and people of all ages flocked to antiwar rallies.

1968. This was the year the black-white coalition that had made the Civil Rights Movement possible fell to pieces, and attempts to repair it by liberal Democrats and others foundered as racial violence—particularly clashes between the police spoiling for a fight and militant black groups such as the Black Panthers—blazed out of control. Then, dooming future black-white/liberal-leftist alliances of any substantial political coherence or power, there were the assassinations of Robert F. Kennedy and Martin Luther King, Jr., whose deaths ignited fires in ghettos across the nation, which in turn brought down the heavy hand of the police and the national guard.

All the tensions of 1968 reached a climax at the Democratic National Convention in Chicago, when an army of law-enforcement officers staged a "police riot" against thousands of antiwar demonstrators who had converged on the city so that their voices would be heard by politicians inside the hotels and meeting halls. The morning after the Democratic Party regulars and the demonstrators left town, posters with the smiling face of the soon-to-be-victorious Republican candidate Richard M. Nixon appeared on the unbroken windows of downtown Chicago businesses.

Then, in 1969, after months of internal dissension, Students for a Democratic Society (SDS), the big tent under which moderates and radicals active in the Civil Rights movement and opposed to the Vietnam War had gathered, was torn apart by bitter fights between old-line organizers hopeful of expanding the SDS base into the working class by traditional means, neo-Marxists of various types anxious to align the group with differing interpretations of revolutionary dogma, and the so-called "action faction" that coalesced around a group that gave itself the name The Weathermen, and later, The Weather Underground. Among its first acts were blowing up the statue commemorating the Haymarket bombing in Chicago, and the October Days of Rage, when militants went on a rampage through Chicago's streets looking for—and finding—a showdown with police. The Weather Underground's aim was to repay the cops for the beatings protesters had endured the year before at the Democratic convention and to show them that henceforth radicals were ready to fight back.[4]

The constitution of The Weather Underground (overwhelmingly middle and upper middle class), its reductive program ("Bring the War Home"), its romantic idea of revolution and general lack of practical or theoretical political experience, its unquestioning commitment, and its calamity-begging impatience have everything in common with the RAF, and for a period its story closely paralleled theirs. The years 1969–70 saw the massacre of

innocent Vietnamese men, women, and children by American troops at My Lai; the deaths (at the hands of Chicago policemen who shot them in their beds) of Black Panthers Mark Clark and Fred Hampton, who had criticized The Weather Underground for its adventurism; the gunning down of four students by national guardsmen at Kent State University in Ohio; and the killing of two students by police at Jackson State University in Mississippi. Following the United States decision to invade Cambodia, The Weather Underground stepped up its campaign against the military's presence on college campuses, and against the judiciary responsible for cases involving radicals. This escalation of the conflict was further indicated by bombings in Long Island, New York; Madison, Wisconsin; Marin County, California; Chicago, New York City, San Francisco, Seattle, and Washington, D.C. The most dramatic explosion, however, was the one that gutted a townhouse in Manhattan, killing three "Weather people" who had been making bombs there and sending two survivors into the street. One, Katharine Boudin, was the daughter of a famous liberal lawyer; the other Cathy Wilkerson, had been raised a Quaker—that is to say a pacifist—and as a young woman had taken part in a sit-in at a segregated lunch counter in Cambridge, Maryland, at a time when nonviolent actions of that type took real courage. Like the RAF, the dominant personalities in The Weather Underground were educated, intensely committed women like Boudin, Wilkerson, and the group's Meinhof, Bernadine Dohrn.

Armed confrontations between the American government and left-wing groups—The Weather Underground, Black Panthers, American Indian Movement, Puerto Rican Liberation Front, and strangest of all, the Symbionese Liberation Army (with its hostage-turned-urban-guerilla Patty Hearst)—did not last as long as their European equivalents. But while they lasted they were intense and the cost in lives, political freedoms, and broken spirits was as high as it was on the Continent. Moreover, as in Germany, armed civil strife provoked lawmakers and law enforcers to bend, conveniently amend, or evade their own laws and step up legal and illegal surveillance of citizens.[5] By 1977, the mid-point in the RAF's history, The Weather Underground had begun to split up but the symbolic havoc they created and the conservative backlash they hastened were similar to the RAF's legacy.

The purpose of recapping and comparing the American situation to that of Germany, and the 1968 generation everywhere, is to underscore a basic fact: what the Baader-Meinhof group did and what they represented was not unique to Germany—far from it. Similarly motivated and similarly constituted clusters of young radicals emerged internationally out of the shaky, heterodox amalgam of the student Left of the 1960s, guided by the notion that the prologue of peaceful protest necessarily led to the main event of actual violent revolution. Time after time and place after place, that hypnotic, desperately simple assumption compelled dedicated and often outstandingly decent people to commit acts they previously could not have imagined for the sake of ideals they could not possibly achieve, and too often could scarcely articulate.

In recent years there has been much debate about whether or not Germany's history is in some basic way exceptional in modern times or whether equivalents exist. Insofar as this controversy has focused on the Nazi period and the Holocaust, it seems indisputable that regardless of the absolute numbers killed by Stalin as opposed to Hitler, or any other averaging comparisons that might be made between communist atrocities and fascist ones, Hitler's version of totalitarianism and his execution of the "final solution" are unique.[6] And, to the extent that they are, that heritage necessarily and significantly qualifies anything that one might say about the similarities between what the children of "the Auschwitz generation" did and what their contemporaries in other countries may have done. But the

ROBERT STORR

curse of the parents is not automatically passed along to their progeny, as some commentators on the Baader-Meinhof group would have it, nor do such cultural and historical specifics overshadow the larger correspondences where they exist.[7] After all, Vietnam, which mobilized German youth, was the nightmare and shame of Americans, as was the entrenched racism that also polarized radicals, liberals, and conservatives in the United States and tarnished the nation's image abroad.

The revolt in the 1960s of the postwar generations was a worldwide phenomenon, and its paradoxes reached into every society touched by it. This was the generation that was supposed to be content with its lot and to quietly ignore the falsehood, injustice, and contradictions of the system that produced material wealth for so many in its upper and middle levels. This was the generation that grew up after the struggle between the left-wing and right-wing revolutionary movements of the 1910s, 1920s, and 1930s had burned themselves out in war, or had supposedly lost their appeal in comparison to Western-style pragmatism and democracy—the generation, so the American sociologist Daniel Bell claimed, "after ideology." But no matter how privileged they were, no matter how cut off from the historical passions and mistakes of their elders, the men and women who came of age in the late 1950s through the late 1970s were not ready to accept what was offered on the condition of thankful obedience and silence; they could not shut out the glaring truth that poverty, prejudice, war, social conformity, and intellectual taboos were integrally connected to their presumed well-being. The more authority denied these discrepancies and insisted upon the "reasonableness" of their version of reality, the more resistant young people became, and the more critically "unreasonable." Furthermore, in the face of the official pretense that the modern democratic state has no ideology but only humanist principles and practical means and solutions, ideological tendencies resurged with a vengeance. Challenging the enforced "common sense" of business-as-usual governance and the ostensible objectivity of the social sciences, while reaffirming ideology's potential for explaining the deeper complexities of economics, politics, and human consciousness, these discourses also demonstrated their capacity for distracting undisciplined minds, perverting argument, and providing true believers and demagogues with rhetorical ammunition. The cultural and historical factors influencing how this process occurred, how discontent spread, how it devolved into violence and sometimes into terror, and how order was reimposed by the superior strength of a hard new conservatism vary from country to country, but the essential dynamic was the same in Germany as it was in France, Great Britain, Italy, Japan, Latin America, Mexico, the United States, and elsewhere.

Just as revolutionary terrorism has its history and etiology, so too it has its cultural myths. The most common expressions are stereotypes created by the media and codified in popular entertainment: the snarling sadists of the sort played by Alan Rickman in *Die Hard* and the shadowy ciphers like those in John Le Carré's thriller *The Little Drummer Girl*. *Die Hard* is reactionary pulp in the end-of-the-world mode, with its update of the nineteenth-century melodramatic villain, the black-clad dynamiter. *The Little Drummer Girl*, a morally ambiguous chase story partially based on the situation in Germany in the 1970s, takes off from the conventions established by Joseph Conrad's *The Secret Agent* and *Under Western Eyes*. Yet, whereas the Polish-born Conrad emphasized the incomprehensible foreignness of the revolutionaries he scrutinized with the attitudes of his adoptive England, Le Carré renders the Palestinian mastermind at the center of his tale with some appreciation of his motives and predicament. For both writers, however, exoticism, intrigue, and the final "poetic justice" of defeat are the essential tropes.

Conspiracy also defines the ambiance of Dostoyevsky's polemical classic *The Possessed*, in which a group of Russian terrorists—the most evil of whom is a dead ringer for Nachaev—are portrayed as corrupt, cowardly, deluded, or half-mad. All are demonic or enthralled by demons. Since the mid-nineteenth century the number of novels and stories in which bomb-throwers or assassins have appeared is vast—Henry James's *The Princess Casamassima* and Andrei Bely's *Petersburg* are two others. Other than the Le Carré, contemporary examples in English include Doris Lessing's *The Good Terrorist*, in which political extremism is reduced to the conflict between mother and daughter; Andre Brink's *An Act of Terror*, an examination of the backgrounds, motives, and evolution of multiracial activists who launch attacks on Apartheid; and Marge Piercy's *Vida*, an earnest but believable attempt at describing the life of a woman in The Weather Underground as her world shrinks and times change. Heinrich Böll's *The Lost Honor of Katharina Blum* chronicles the case of an innocent apolitical woman who, after a one-night stand with a political fugitive she meets at a party, is mercilessly harassed by the police and the press and finally murders one of her tormentors. A parable of Germany under "emergency laws" and during the tabloid frenzy that accompanied the pursuit of the RAF, Böll's novel is less about the ideological conversion to violence than the way in which ordinary people may be goaded into it by the abuse of power. But whether evil incarnate from central casting, or a carefully rendered invention by a serious writer, by and large the fictional terrorist is an aberration, the extreme political "other" made so by psychological predilection rather than an imaginable version of anyone we might know, anyone who by incremental steps or genuine trauma evolved into the mortal enemy of the things we may take for granted, much less anyone who, despite his or her actions or obsessions, retains a basic humanity.[8]

Experimental or independent film and video have responded more subtly to political realities than fiction. There is neither time nor space to review the recent history of even the major contributions in these media, but it is important to note that a growing number of works have been devoted to the Baader-Meinhof group, some while events were still unfolding, some long after them. Of the latter, two by Americans stand out, Dara Birnbaum's video installation *Hostage* (1994), in which six monitors—separated by six firing-range targets of a head and torso and connected by a red laser targetting light that traverses them—show a montage of images of Schleyer's kidnapping, police training exercises, TV news footage of the RAF, and coverage of the Stammheim prisoners. The other, *Outtake* (1998) by Dennis Adams, is the slow-motion recreation of a scene from Meinhof's film *Bambule*, in which a young woman flees the nuns who persecute her in a home for wayward girls, but after a series of twists and turns is trapped in a cul-de-sac. Adams rephotographed this helpless bid for freedom as a suite of individual frames from the film that he blew up into palm-sized prints and doled out to passersby on the streets of Berlin as if he were distributing leaflets. Each of these prints passes before his video camera lens in an agonizingly protracted replay of the scene before being handed over to a recipient who, by accepting it, is unsuspectingly drawn into the piecemeal reenactment of the drama and into the historical problematics of the Baader-Meinhof story.

Besides television reportage and docudramas like *Das Todesspiel (Death Play)* (1997), several German filmmakers have also tackled the subject of the RAF in a serious fashion. Margarethe von Trotta's *Marianne & Juliane* (1981) tells the story of two sisters, one a leftist journalist, the other a revolutionary who dies mysteriously in prison, and of the surviving sister's struggle to come to terms with the latter's death and to reach out to her nephew for whom she cares and who has been traumatized by his mother's choices and her

ROBERT STORR

fate. Like the movie version of Böll's *The Lost Honor of Katharina Blum* (1975), which von Trotta also wrote and directed (the former in collaboration with Volker Schlöndorff), *Marianne & Juliane*, which fuses the characters of Meinhof and Ensslin in the part played by the activist sister, is a reserved naturalistic treatment of the subject, which poses the unanswered question of how the rebellious children of the children of the "Auschwitz generation" will be able to make sense of their past. Rainer Werner Fassbinder—who belonged to the same milieu from which the RAF arose and who knew Baader as a figure on the Berlin scene of the late 1960s—dealt with the RAF twice, first in his segment of *Germany in Autumn* (1977–78), a collaborative project also involving Böll, Alexander Kluge, Edgard Reitz, and Volker Schlöndorff, among others, and second, in *The Third Generation* (1979). Fassbinder spares no one in either film: not the "third generation" of terrorists, by which he means the RAF members and others who came after Baader and Meinhof, and who, he felt, lacking even their confused political motives, had transformed the urban guerilla ethos into an excuse for thrill crime; not his mother, who in *Germany in Autumn*, portrays a woman who, having lived through National Socialism, counsels her son to accept the benign dictatorship of the state rather than side with those who make war on it; and not himself playing the son, argues for liberty yet bullies his male working-class lover. Even more so than the moving but prosaic films of von Trotta, the richness of Fassbinder's ironies brings home the private dilemmas and self-betrayals Germans faced in the midst of this very public crisis.

The most intellectually and psychologically complex film to center on the Baader-Meinhof group, Yvonne Rainer's *Journeys from Berlin/1971* (1980) also concentrates on the interpenetration of private and public realities. Mixing elliptical dialogues and monologues that speak of nostalgia for a pre-1933 Berlin that has disappeared forever, of suicidal depression, and of the misuses of psychiatry to deflect social criticism, the script, also punctuated by news bulletins detailing the RAF's actions and the government's reactions, is a meditation on terrorism as a quest for individual self-determination. Studded with excerpts from the memoirs of early twentieth-century anarchists Vera Zasulich, Angela Balabanoff, and Alexander Berkman, the would-be assassin of robber baron Henry Clay Frick, as well as statements by and about Meinhof, Rainer's scenario draws the connection between these two historical moments, and focuses on the promise of existential freedom held out by the categorical rejection of all external authority. Weaving strands that subtly bind elusive personal motivations to irrevocable political choices, Rainer's film is among the only works we have that renders palpable the moral and emotional pain out of which terrorism is born.

As with film and video, it is impossible to summarize all the visual art—painting, sculpture, drawing, photography, photomontage, prints, and multimedium works—made in response to the events of the 1960s and 1970s, but it is worthwhile making certain observations.[9] The first concerns the fact that for many if not most of the leading American painters of the 1960s and 1970s, political concerns were largely incidental to their principal aesthetic interests. This, of course is not true of Leon Golub, Philip Guston, Nancy Spero, and a number of others, but it is generally true of the major Pop artists, Minimalists, Process artists, and even most of the Conceptualists who made "things." James Rosenquist's *F-111* (1965) is undeniably a Cold War picture, but unrest in America was rarely the theme of "mainstream" art during the country's moments of greatest dissension in the 1960s and 1970s. Exceptions are the agitprop posters conceived by the Art Workers' Coalition, whose members included the painters Irving Petlin and Rudolf Baranik along with Conceptualists Mel Bochner and Carl Andre; posters made by Jasper Johns and Frank Stella

Gerhard Richter. **Mao.** 1968. Collotype, printed in gray, 33 × 23⅜"
(83.9 × 59.4 cm). The Museum of Modern Art, New York. Jeanne C.
Thayer Fund

for the anti-Vietnam War mobilization; and one-off protest works such as Barnett Newman's *Lace Curtain for Mayor Daley,* named for the Chicago machine boss who oversaw the mayhem at the 1968 Democratic convention.

Besides Rosenquist's magnum opus and the fragmentary social content of his other paintings and graphics, partial exceptions also include Robert Rauschenberg's references to the war and domestic turmoil, especially in prints and drawings based on direct newsprint transfers, for example the phalanx of riot police in *Canto XXI: Circle Eight, Bolgia 5, The Grafters: Illustration for Dante's Inferno* (1959–60). Indeed, just as in Rosenquist's work, political symbols and subjects are scattered throughout Rauschenberg's—symbols like the Bald Eagle, portraits of Eisenhower and Kennedy, military vehicles, Huey-helicopters, GIs, and so on—but it is this scattering that counts as much or more than the particular images. With a Cageian randomness, each of them is experienced on roughly equal terms with its incommensurable neighbors, a postcard landscape, printed text, or the hazy reproduction of an old master painting. The suave contrast and elision of shapes, textures, and colors, and the dizzying glide through shifting mental gears, is greater than any clash of social realities.

Using similar silkscreen and transfer techniques, Andy Warhol also incorporated news photography into his art but to jarring as well as distancing effect. In all of their permutations Warhol's Race Riot paintings and prints freeze the violence in a form that highlights the naked hostilities behind it. These are not paintings about the morality of hatred or remedies for it; they are paintings about the fact of it, but a fact seen at one remove as if one were watching a disaster happen from inside a bubble, now rose-colored, now jaundiced yellow. In that respect, they are akin to Warhol's other disaster paintings which say no more or less than that disasters *do* happen and death invariably eclipses life, just as the kodalithed darks eclipse the glaring lights that composed Warhol's wafer-thin shapes. Meanwhile, if death is the great leveler, striking electric-chair-bound thugs, joy-riding teenagers, unhappy debutantes, unlucky housewives, and all the anonymous people that haunt his

ROBERT STORR

pictures, death also burnishes the glamour of the famous: Marilyn, of course, and Jackie too. Their emblematic faces created the template for others whose status varies from the notorious but long forgotten to the notable and unforgettable. Thus Warhol enshrined The Thirteen Most Wanted Men on the exterior of a pavilion at the 1964 World's Fair, and, at the other extreme, he turned China's Chairman Mao into a Pop icon.[10]

Warhol's direct appropriations from the police blotter and media sources set in train paradigm shifts in aesthetic discourse and studio practice of which Richter's October cycle is, unmistakably, an extension. But there are differences to be taken into consideration that pertain not only to painterly process and intent, but to con-

Andy Warhol. **Mao.** 1972. Serigraph, printed in color, comp.: $35^{15}/_{16} \times 35^{15}/_{16}$" (91.4 × 91.4 cm). The Museum of Modern Art, New York. Gift of Peter M. Brant

text as well. When Warhol first made Mao a superstar in 1973, following Nixon's decision to play the "China card" and smiled on America's bogeyman, the Cultural Revolution that had created Mao's cult of personality was over. The mania for Mao's little red book that swept China between 1966 and 1968, and touched down in Europe on its way around the world, passed lightly over America, making only a superficial impression in the political and cultural domains.[11] In France, however, the Cultural Revolution left a definite mark in both arenas— the role of Maoist "groupuscules" and Sartre's support of the banned Maoist paper *La Cause du peuple* represent the first; Jean-Luc Godard's ambivalent film *La Chinoise*, in which apartment-bound Parisians dream of peasant revolution and shoot a member of the bourgeoisie whom they mistake for a Soviet diplomat, after which they assassinate the originally targeted representative of "revisionist" Russian communism, represents the second.

In Germany Maoism also had an impact on both the political and artistic avant-gardes that reached into the 1970s. Thus Eugen Schönebeck, who had begun painting in an expressionist style influenced by the Northern Renaissance masters and Francis Bacon that was close in form and feel to the contemporaneous allegorical work of Georg Baselitz, ended up painting the likenesses of paragons of Marxist virtue—from the Russian poet Vladimir Mayakovsky and the Mexican muralist David Alfaro Siqueiros to Lenin and Mao—before giving up painting altogether in 1966 at the onset of the troubles in Germany.[12] Jörg Immendorff, once the impish protégé of his Düsseldorf Art Academy professor Joseph Beuys, responded to the abrupt politicization of art in the late 1960s by joining a Marxist collective in the early 1970s (to which he tried to subordinate his art), and painting his own placardlike images of workers, students, the pantheon of Communist leaders, Marx, Engels, Lenin, Stalin, Mao, and a rainbow coalition of cartoony Mao-inspired babies. In short, there were accomplished artists for whom the prospect of adopting a hero-worshipping or party-line aesthetic was not a laughing matter.

Of the artists who raised the red banner in their work, Immendorff was not only the liveliest painter but the most critical, and his later 1985 canvas, *Worshipping Content*, of

Sigmar Polke. **Mao.** 1972. Synthetic polymer paint on cloth on cotton fabric, suspended from wood pole, 12' 3¹⁄₁₆" × 10' 3⅜" (373.5 × 314 cm). The Museum of Modern Art, New York. Kay Sage Tanguy Fund

a middle-aged artist on his knees in front of his portrait of the ever-radiant Mao, is retrospectively skeptical and self-mocking. Sigmar Polke's Mao (1972) is also satirical, but the joke is closer to Warhol's whimsical but acidic burlesque than to Immendorff's broad but still politically focused caricature. Significantly, Polke, like Richter, had left communist East Germany for the West not long before the Wall went up, and neither was tempted by new Left versions of the old Left tenets of faith, whereas Immendorff, who came from the West, tried, like Dada artists George Grosz and John Heartfield before him, to adapt his anarchic sensibility to the strictures of social realism as the necessary next step in his avant-garde rejection of bourgeois art-for-art's-sake. Nevertheless, Polke's rendition of Mao, like Richter's, arose from a context where Mao's myth held genuine sway. Richter's out-of-focus print of Mao occupies a special place at arm's length both from the paintings of his German counterparts and from Warhol. Conceived as a large unsigned edition, the slightly off-key gray 1968 lithograph has a ghostly quality to it, as if the Great Helmsman were watching from the shadows or behind a screen, or hovering over all like an intangible but threatening nimbus. Having grown up under two dictatorships, Richter had no illusions about what it takes to be a maximum leader, and this picture correspondingly assumes that Mao is more than a figure of fun, but instead is what Mao saw himself to be, the incarnation of a revolutionary idea.

Numerous other German artists have touched on the political crisis of the late 1960s in their work. In addition to making multimedium tableaus with apocalyptic overtones, Wolf Vostell dedicated one work each to Benno Ohnesorg and Rudi Dutschke; the Conceptual artist and publisher Klaus Staeck created a series of text- and photo-based posters and postcards that recall the agitprop montages of Heartfield. Of those who preceded Richter in addressing the Baader-Meinhof group, two in particular stand out. Beuys, the German vanguard's man-for-all-seasons was the first. During the course of his one hundred days of dialogue for "direct democracy" at Documenta 5 in 1972, Beuys announced to his principal interlocutor Thomas Peiter—who rechristened himself Albrecht Dürer for the occasion—"Dürer, I will guide Baader and Meinhof through Documenta 5, and thus they will be resocialized." Peiter/Dürer then lettered the statement—minus its didactic second half—onto two pieces of poster board with Beuys's signature, and Beuys later planted them in two felt slippers filled with fat and rose stems, thus transforming the signs into totems.

The felt, fat, and rose stems were Beuys's talisman of healing and spiritual flowering, and the whole gesture was in keeping with his efforts to symbolically repair a damaged postwar German society. At the time the peace statement was made, Baader and Meinhof were both still at large, and Beuys's invitation, in addition to calling for them to come back in from the cold, was an appeal to their followers and supporters to return to the fold rather than pur-

ROBERT STORR

sue revolution outside of the broad counterculture front in which Beuys saw himself as one of the father figures. It was thus not out of sympathy with the RAF that Beuys issued his plea, but, rather, out of a desire to recuperate the most alienated elements of the Left and redirect their energies toward his vision of a new society dedicated to the imagination and miraculously poised between communism and capitalism. Improbably, Beuys hoped to dissolve the antagonisms of Cold War era Germany and the violent tendencies they had nurtured in the amniotic fluid of his own poetic and philosophical transcendentalism, offering an ideology of unfettered creativity as the alternative to the ideology of destruction.

Jörg Immendorff. **Worshipping Content [Anbetung des Inhalts].** 1985. Oil on canvas, 9' 4³⁄₁₆" × 10' 9¹⁵⁄₁₆" (285 × 330 cm). Collection John and Mary Pappajohn, Des Moines, Iowa

Polke, Richter's comrade in the creation of the short-lived German Pop art movement, Capitalist Realism, was the second of the two artists to address the theme; his painting, made in 1978, a year after the Stammheim deaths, featured the cartoon image of a desk-jockey shooting himself in the head with a slingshot under the wanted-poster portraits of Baader and Raspe. The subtitle of the picture and presumably the name of the bureaucrat is "Dr. Bonn," after the capital of the Federal Republic. Characteristically irreverent, Polke's painting ridicules the faceless policy-makers who "managed" the Baader-Meinhof affair, suggesting that whatever may have happened to the Stammheim prisoners, it was the government that committed suicide in the crisis.

Richter was to wait another decade before approaching the subject himself. When he finally did, its immediate topicality had already begun to fade; there was no longer hope of saving the extreme Left from itself and its implacable adversaries, as Beuys had proposed by his gesture, nor was there any further point in attacking the authorities, as Polke had done so effectively. Radicalism had run its course, and the conservatism of Helmut Kohl, Ronald Reagan, and Margaret Thatcher was still ascendant. Lost or won, the battles of the 1960s and 1970s were over. The world had changed; and a different understanding was now needed.

III: THE PAINTINGS

Gerhard Richter embarked on the paintings that would eventually constitute the series *October 18, 1977* in March 1988, and completed work on them in November of the same year. Looking back on his nine-month labor in notes for a press conference at Haus Esters where the series was to be shown, Richter took stock: "December 7, 1988. What have I painted? Three times Baader shot. Three times Ensslin hanged. Three times the head of the dead Meinhof after they cut her down. Once the dead Meins. Three times Ensslin, neutral (almost like pop stars). Then a big, unspecific burial—a cell dominated by a bookcase—a silent, gray record player—a youthful portrait of Meinhof, sentimental in a bourgeois way—twice the arrest of Meins, forced to surrender to the clenched power of the State. All the pictures are dull, gray, mostly very blurred, diffuse. Their presence is the horror of the hard-to-bear refusal to answer, to explain, to give an opinion. I am not so sure whether the pictures ask anything: they provoke contradictions through their hopelessness and desolation; their lack of partisanship. Ever since I have been able to think, I have known that every rule and opinion—insofar as either is ideologically motivated—is false, a hindrance, a menace, or a crime."[2]

Richter's comments are revealing on several counts. Most obvious is the mention of canvases that were not included in the cycle when it was exhibited. Of the three versions of Baader shot, only two remained in the final grouping; of the three versions of Ensslin hanged, only one was used. The painting of the starved Meins on his deathbed was left out altogether, and eventually overpainted, as were at least one and probably both of the excluded paintings of the dead Ensslin.[3] One of the two Ensslin paintings can be partially seen in a photograph of the artist's studio; the composition of the Meins painting can be deduced from a photograph in the album of images the artist kept for reference, and bits of the composition can be glimpsed in the margins of the gestural painting that replaced it. Thus, beneath the surface of three abstractions lie layers that are not "underpainting" in the traditional sense but the intact archaeological sediment of deliberately obscured pictures. Their cancellation is a part of the meaning of the finished abstract work insofar as finding new ways to make images visible—or invisible—is at the heart of Richter's enterprise. In that respect these painterly outtakes constitute an appendix to *October 18,1977*, in a way similar to the frames of a movie that fall to the floor of a film editor's cutting room, frames that may in themselves be of great interest or beauty but that detract rather than add to the integrity of the realized whole.

Also revealing are Richter's descriptions of key paintings in the final selection. The three canvases of Ensslin that it seems had yet to be titled *Confrontation 1, Confrontation 2,* and *Confrontation 3* strike him as "neutral (almost like pop stars)," as if, cleansed by the camera's detachment and the painter's apparent dispassion, almost nothing of the tension that must have filled the air clung to the unguarded, then smiling face of Ensslin as she looked into the flashbulbs that made her famous. Richter emphasizes this neutrality else-

where by speaking of the pictures as "dull, gray, mostly blurred, diffuse" and underscores "their hopelessness and desolation; their lack of partisanship." Two remarks break this muted tone. First is his characterization of Meins being "forced to surrender to the clenched power of the state." Second is his concluding paragraph condemning "every rule and opinion" that is "ideologically motivated" as "false, a hindrance, a menace, or a crime." Embedded in the paintings' "refusal to answer, to explain, to give an opinion," and underlying the despair that seems evenly spread across them, there is anger.

What prompted Richter to paint this particular subject at this particular time? Preparing for his press conference the artist left that question aside, and it is one he has never fully answered when it has been posed to him. But what do we know? Published journals tell us that in the years leading up to the creation of *October 18, 1977*, Richter was wracked by aesthetic and moral doubts exacerbated by his mounting distaste for the hyped-up art world of the 1980s. A January 13, 1988, diary entry written on the eve of Richter's beginning the cycle voices his bitter discontent: "Art is wretched, cynical, stupid, helpless, confusing—a mirror-image of our own spiritual impoverishment, our state of forsakenness and loss. We have lost the great ideas, the Utopias, we have lost all faith, everything that creates meaning. Incapable of faith, hopeless to the utmost degree, we roam across a toxic waste dump in extreme peril: every one of those incomprehensible shards, these odds and ends of junk and detritus, menaces us, constantly hurts and maims us and sooner or later, inevitably kills us. Worse than insanity."[4]

Sitting alone at the center of an art world sharply divided between neo-Expressionist painting and neo-Conceptualist work in various mediums, and impatient with art of both varieties that exploited cleverness, stylistic novelty, or provocative subject matter for easy effect, Richter replayed the classic arguments of the relation between form and content in his head. On March 18, 1986, he had addressed the deficiencies of pure formalism, but affirmed that form could engender meaning rather than merely being instrumental in the presentation of preconceived ideas: "Formalism stands for something negative: contrived stuff, games played with color, form, empty aesthetics. When I say that I take form as my starting point, and that I would like content to arise out of form (and not the reverse, whereby a form is found to fit a literary idea), then this reflects my conviction that form, the cohesion of formal elements . . . generates a content—and that I can manipulate the outward appearances as it comes, in such a way as to yield this or that content. . . . The issue of content is thus nonsense: i.e., there is nothing *but* form."[5]

On October 12, 1986, Richter seemed to reverse his position in favor of the primacy of subject matter, but then took a half-turn back in disparaging journeymen painters who rely on signature "concerns" to validate their work: "What shall I paint? How shall I paint? 'What' is the hardest thing because it is the essence. 'How' is easy by comparison. To start off with the 'how' is frivolous, but legitimate. . . . The intention: to invent nothing—no idea, no composition, no object, no form—and to receive everything: composition, object, form, idea, picture. . . . Even in my youth, when I somewhat naively had 'themes' (landscapes, self-portraits), I very soon became aware of this problem of having no subject. . . . The question 'What shall I paint?' showed me my own helplessness, and I envied (still do envy) the most mediocre painters those 'concerns' of theirs, which they so tenaciously and mediocrely depict (I fundamentally despise them for it.)."[6]

The ambivalence of these remarks recalls the fact that as a young man Richter had studied at the Dresden Art Academy in East Germany, where officially sanctioned content overruled formal invention, and, while there had executed two public commissions with

Gerhard Richter. **Blanket [Decke].** 1988. Oil on canvas, 6'6¾" × 55" (200 × 140 cm). GR 680-3. Private collection, Berlin

allegorical programs in a modified but still conventionally heroic Socialist Realist style.[7] One is also reminded that as a relatively recent arrival in West Germany, Richter, who had previously worked for awhile as a photographer's assistant, chose "found" photography as a source for images because it allowed him to downplay modernist formal innovation while exploring many different subjects with an apparently Dada arbitrariness consonant with the avant-garde spirit of Düsseldorf and Cologne, the new centers of his artistic life. Remembering this later he said: "Do you know what was great? Finding out that a stupid ridiculous thing like copying a postcard could lead to a picture. And then the freedom to paint whatever you felt like. Stags, aircraft, kings, secretaries. Not having to invent anything any more, forgetting everything you meant by painting—color, composition, space—all the things you previously knew and thought. Suddenly none of this was a prior necessity for art."[8]

However, Richter was not a neo-Dada artist. As far back as 1964 he was clear in his mind that "for me there really exists a hierarchy of pictorial themes. A *mangel-wurzel* and a Madonna are not of equal value, even as art objects."[9] Explicitly contradicting a basic tenet of post-Duchampian art for which an at least polemical equivalency exists between ironing boards and Mona Lisas—turnips and Madonnas—Richter was already staking out a conservative territory within the aesthetically radical community of the Rhineland. This leads us to the third dialectical term in his debates with himself prior to painting *October 18, 1977*: ideology.

Richter's hostility toward ideology is the leitmotif of his interviews, statements, and studio jottings, particularly in the mid to late 1980s, just as it is the coda of his press-conference notes of 1988. Some of his vehemence derives from his experience of National Socialism and Soviet-style communism, and some is a reaction to varieties of extremism he encountered in the West. There are, of course, those who, never having subscribed to any consistent religious, philosophical, or political system of beliefs, uncomprehendingly look askance at anyone who does or has done so. And there are others who having once willingly submitted to orthodoxy and then lost faith, dedicate themselves to renouncing "the God that failed," thereby extending their dependence on their former beliefs.[10] Richter fits neither category. Thirteen years of living under Nazi rule and sixteen years living under Communist Party discipline had inoculated him against totalizing ideology. But, having been exposed to the virus, he was intimately familiar with its sometimes all-but-irresistible contagion. It is not, therefore, that Richter deems ideological commitment unimaginable, but rather that he judges it unacceptable precisely because it is, in its overcompensation

ROBERT STORR

for uncertainty, all too human. For Richter, absolute conviction precedes irrevocable error and, perhaps, moral or physical violence.

In the 1970s and 1980s, the rhetoric of artistic and political avant-gardes frequently overlapped, and so did the circles in which advocates of both moved, especially in the student milieu surrounding the Düsseldorf Art Academy, where Richter began teaching in 1971. Inevitably, Richter came in contact with people who were more or less actively engaged in promoting social revolution and the revolutionary transformation of art. While he was sometimes deeply impressed by their seriousness, he remained unsympathetic to their reasoning, and insofar as their arguments recapitulated the utopian dogma he had fled or dogma that called into question the legitimacy of art, he recognized the threat they represented to him and, to a degree, he internalized it.[11] Squeezed between the ideology-saturated art world of the 1970s and the market-driven art world of the 1980s, Richter confronted a dilemma: how to imbue painting with meaning whose complexity could resist co-option by a sensation-hungry public while at the same time fend off the pressures to reduce painting to one or another of its dialectical components—form or content. On the one hand, having felt the hot breath of political extremism with its call to action and, on the other, the chilling effects of aesthetic radicalism with its long list of prohibitions—including a prohibition against or at least theoretical objection to painting—Richter was confronted on all sides by unhappy choices. Notes dated February 1986, a month before he began *October 18, 1977*, show the separate strands of his thoughts—idea, theme, ideology, action, reflection—tied into a knot: "The idea as a point of departure for the picture: that's illustration. Conversely, acting and reacting in the absence of an idea leads to forms that can be named and explained, and thus generates the idea. ('In the beginning was the deed.') To put it another way, Marx 's teachings didn't cause historical change: new facts gave rise to interpretations, and thus to ideology. Action in pursuit of ideology creates lifeless stuff, at best, and can easily become criminal."[12]

A knot that can't be untied must be cut. The first step toward doing that is recognizing the knot for what it is. That recognition came with the realization that the Baader-Meinhof group was not only a subject matter of profound historical import and moral resonance in its own right but that the contradictions enmeshing it—in particular those issuing from the RAF's apocalyptic absolutism—were a metaphor for those that ensnared him as an artist.

Well before his thinking zeroed in on the events leading up to the deaths at Stammheim, Richter had been reading about and collecting documentary images of the Baader-Meinhof group. Pictures of the RAF were ubiquitous in Germany throughout the 1970s and 1980s, on posters, in magazines, and on television. By various means, Richter managed to amass a large trove of pictures—some of them taken by the police, some by the media, and some by members of the underground, such as Astrid Proll—which he filed in an album kept in his studio. The indexing of photographs had been fundamental to Richter's practice since 1962 when he started to compile *Atlas*, a still-evolving compendium of thousands of found, reproduced, and original photo-materials chronicling his career and containing most of the sources he has drawn upon for his paintings, and many he has passed over. Sharing space on the early pages of *Atlas* with publicity stills, advertising spreads, pornography, and family snapshots, are newspaper clippings of crime victims (a murdered prostitute, Helga Matura, the eight student nurses killed by Richard Speck), of perpetrators (Lee Harvey Oswald) as well as a memento of Richter's Uncle Rudi in a Nazi uniform, and photographs of concentration-camp victims presumably taken by their persecutors. Some have ended

Gerhard Richter. **Atlas: Panel 470.** 1989. Eight black-and-white photographs, 20⅜ × 26¼" (51.7 × 66.7 cm). Städtische Galerie im Lenbachhaus, Munich

up on canvas—Helga Matura, the nurses, Oswald, Uncle Rudi—and some did not. The concentration-camp photographs are among the latter. These Richter has termed "unpaintable," and having decided this was so, he pasted them together with the pornography pictures as if one obscenity deserved another, except that the two groupings of images remain wholly incommensurable. Richter thus shockingly juxtaposed romping nudes and corpses—a juxtaposition he himself called "weird and seemingly cynical"—in a manner so disorienting that the viewer is forced to look at the "familiar" atrocities of the Holocaust with fresh eyes.[13]

All of this raises the question of why other atrocities, almost as horrific, were "paintable." When asked about this with regard to the Baader-Meinhof photos, Richter claimed, with a glancing blow at intellectually overdetermined art, that the decision resulted from "more or less an unconscious process. That sounds terribly old-fashioned. These days, pictures are not painted but thought out."[14] Pressed by the interviewer Jan Thorn-Prikker as to whether he had been sure from the start that the subject of terrorism could be dealt with, Richter replied that "the wish was there that it might be—had to be—paintable."[15] In short, Richter felt compelled to tackle the theme of the RAF, but the process of deciding which images to paint, and, later, which paintings to keep was initially an intuitive and then an empirical one. The product of trial, error, and elimination, *October 18, 1977* is, by this measure, the very opposite of programmatic political art.

Atlas contains a hundred photographs pertaining to the Baader-Meinhof group that have been reprocessed and rendered more than usually fuzzy; they are works of art in their own right, or parts of a larger archival work of art rather than the artist's working models.[16] Richter's studio album contains 102 photographs of varying quality; not all of them are the same as those in *Atlas*, and none of them is significantly out of focus. At the outset, Richter had intended to paint a large selection of these pictures, covering the whole RAF story, which he had recently read about in the exhaustively detailed account published by Stefan Aust in 1985. In the end, he drastically narrowed his choices by excluding everything documenting the actions, life on the run, or trial of the RAF, and, with the exception of *Funeral*, set aside pictures in which the RAF members appeared together or with others. What remained, in addition to one image of Baader's empty cell and one of his record player, were pictures in which each of them—even Meins facing a mini-tank—appears in

ROBERT STORR

Gudrun Ensslin, 1972. Photographic models for *Confrontation 1*, *Confrontation 2*, and *Confrontation 3*, with hand notations by Richter, from the artist's notebook

isolation, such that the viewer faces them as they confronted their fate. Playing on the question already raised by Thorn-Prikker, Richter explained the paradoxes of his winnowing down the images in this way: "The ones that weren't paintable were the ones I did paint. The dead. To start with, I wanted more to paint the whole business, the world as it then was, the living reality—I was thinking in terms of something big and comprehensive. But then it all evolved quite differently, in the direction of death. And that's really not all that unpaintable. Far from it, in fact. Death and suffering always have been an artistic theme. Basically it is *the* theme. We've eventually managed to wean ourselves away from it, with our nice, tidy, lifestyle."[17]

Death is the *eidos*—the essential form—of photography, the French critic Roland Barthes has written.[18] What we witness in a picture taken of a particular person or thing at a precise instant is what Barthes calls "the that-has-been," the unrepeatable moment that in reproduction can be infinitely multiplied. While a painting may seem lifelike, a photograph never does and never can. Unlike painting, which is a synthetic fiction even when it is based on observation, the fact of the photograph's static quality is always at odds with the fact—actual or potential—of movement. Indeed, the more vitality recorded in a photograph, the more uncanny such signs of life appear. Dramatic action in a painting is action at or approaching its climax; gesture or motion in a photograph is action interrupted and forever suspended. And inaction? A figure standing stock-still for a photo-portrait is a figure waiting to ease the set of the body and face, a figure waiting to breathe. And if the person is dead? But for decay that will in reality waste the body, the picture before us is what that person will look like henceforth: this is their final aspect. And yet the expectation we have of such a picture is the same we have of pictures of the living. We anticipate a shiver, twitch, or abrupt realignment while we ourselves inhale and exhale. Suddenly the duration of our gaze is thrown out of sync with the permanent "momentariness" of the image. We cannot match it up again by thinking that in the next photographically unrecorded instant he will turn away, she will turn toward us. Time has stopped twice, in the click of the shutter and in the extinction of a life. Camera-time equals an increment of unchanging eternity. More than the thought of this is unbearable. Our body rebels, our eyes cannot stay fixed on this already redoubled inertia. Physically restless as much as troubled by

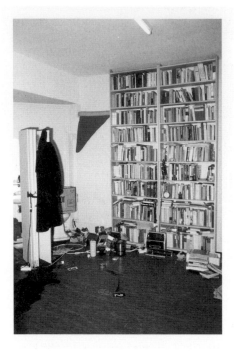

Andreas Baader's Stammheim cell, October 18–19, 1977. Photographic model for *Cell*, from the artist's notebook

the confrontation with mortality we move on. In photographs we can see death with a nakedness no other medium affords. But photography does not allow us to contemplate death. In order to do that, duration must reenter the equation, for without a measure of time's passage the depiction of time arrested becomes tautological, senseless.

Painting, which takes time to make—time indelibly marked in its skin—restores duration to images of death. *October 18, 1977* introduces an existential contradiction between painting's slowness and photography's speed, between the viewer's condition, which allows one to spend time, and that of the subject for whom time has ceased to exist. Because of this, one might say, *painting* chose the images of the dead over those of the living when Richter went to work on the Baader-Meinhof cycle because painting could open up the experiential space that photography reduces to zero, a space defined not by our identification with the dead subject but by our differences and distance from him or her, differences and distances which we can ponder but never diminish or obliterate. Like all that preceded their deaths, this, the paintings of the dead RAF members insist, happened to them alone. Death claims us all, but it is an individual not universal phenomenon, and though it operates as a leveler it does not bind us to each other but instead separates us categorically and definitively. Based on the evidence provided, we can reflect on what Baader, Ensslin, and Meinhof did and speculate on what was done to them, but we cannot imagine them in their final hour or even in the death-haunted hours and years that led up to it, and we cannot bridge the divide that the camera points to and that painting widens.

"Death and suffering always have been an artistic theme. Basically it is *the* theme. We've eventually managed to wean ourselves away from it, with our nice, tidy, lifestyle," wrote Richter. Well-ensconced in armchairs, we may look at magazines and watch television programs in which images of death abound but they do not intrude very far on "our nice, tidy, lifestyle." On the contrary, they generally reassure us that we are among the lucky. Or, they may give us a vicarious thrill. Richter has said, "people can't wait to see corpses. They crave sensations."[19] However, encountering such images in public—even in the safe precincts of a museum—lowers our defenses. The history of art (and, for that matter, the history of film) prepares the way for this. The presence of paintings and sculpture (or the expanse of the big screen) makes the specter of death stronger than on the tube or glossy page, and the proximity of strangers leaves our suppressed discomfort and fear more exposed to scrutiny than they would be in the company of familiars whom we can count on to excuse our nervous responses. Multiplying this effect fifteen times, *October 18, 1977* bombards us with death from every side. Altogether the series is a relentless assault on

ROBERT STORR

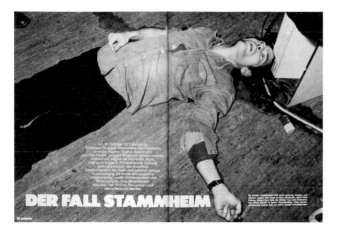

Andreas Baader, dead, October 18, 1977, as published in *Stern*, October 30, 1980

denial and decorum and the false security they foster. In harrowing contrast to their well-appointed environs, the paintings are suffused with the air of annihilation. No crucifixion or deposition was ever more morbid, or more enhanced in that quality by the grandeur or solidity of its church or gallery setting. In these paintings, however, there is no hope, no resurrection, only numbing finality.

Of course, some of the canvases give us glimpses of Ensslin, Meins, and Meinhof alive, but all of the paintings tend toward oblivion. The manner in which they do, the particular images selected, and the types of photography used as sources phrase the series as a whole. The primary images from which Richter worked are of several distinct kinds. The *Youth Portrait* of Meinhof, which begins the cycle, is based on a picture posed in a movie-star manner and derived from old-master painting, a manner that is "sentimental in a bourgeois way," as Richter was quick to point out. The two *Arrest* paintings were based on magazine photographs of Meins being taken prisoner at gunpoint by police in an armored car; these had first been taken from television coverage of the event. As mentioned, the three *Confrontation* paintings were based on pictures taken in June or July of 1972 by a photographer present when Ensslin was being escorted to a police lineup. Except for *Funeral*, which is also a news shot, all the rest—*Man Shot Down 1* and *Man Shot Down 2*; *Dead 1*, *Dead 2*, and *Dead 3*; *Hanged*; *Cell*; and *Record Player*—are, as is plain from their routine framing, harsh exposures that concentrate on gruesome or evidentiary detail, photographs made by the prison authorities or police after the discovery of the bodies.[20] The ordering and repetition of some images in the cycle evoke cinematic techniques as well; action or stop-action sequences in *Arrest 1* and *Arrest 2*, and *Confrontation 1*, *Confrontation 2*, and *Confrontation 3*, the close-up and fade-out in *Man Shot Down 1* and *Man Shot Down 2*, and three versions of *Dead*. Overtly dramatized narrative is thus introduced or implied by reference to film effects to which the viewer will almost involuntarily respond. We have left the realm of "straight" photography, and even within the range of pictures that might lend themselves to such a reading Richter subtly insists on telltale differences in genres—studio portrait, photo-journalism, forensic shots—that belie such homogenizing assumptions. Meanwhile, for those familiar with Richter's source-images from their heavy as well as heavy-handed use in news coverage of the time—or familiar with the way comparable images have been packaged when other such stories have been fed through the machinery of attention-grabbing journalism—the artist's subtle manipulations downplay all the sensational qualities the mass media exploited, effectively short-circuiting the viewer's reflex

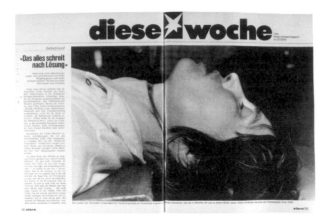

Ulrike Meinhof, dead, May 9, 1976, as published in *Stern*, June 16, 1976

reaction to seeing them again.[21] In sum, we are not dealing with documentary photography and we are not dealing with documentary painting either. Instead, we are confronted with a continuum of representations stretched taut between the abstract concepts of photography and painting, each of which by asserting its own conventional reality implicitly questions the conventions and the truth of the other.

Richter's other interventions are both more and less obvious. As it turns out, the photograph that is the model for *Youth Portrait* (page 188) was probably taken in 1970 for publicity purposes around the time Meinhof's film *Bambule* was to have been released and shortly before she participated in Baader's escape from jail.[22] Comparison with the painting shows that Richter has considerably softened not only the look of the photograph itself, but the severe unflinching look Meinhof directs at the lens. The woman in the photograph has been an activist and writer for over a decade, has married and divorced, has given birth to twin daughters, has undergone a life-threatening operation, and is on the verge of breaking with everything such a "bourgeois" likeness represents. The woman in the painting, which resembles a high-school yearbook picture, is on the eve of maturity. As the German critic Kai-Uwe Hemken has pointed out, she is the only RAF member whom Richter has given a past, but in altering that past and making her younger, Richter has not idealized her in any hagiographic sense; the sentimentality he has injected into the picture is an antidote-in-kind to the true poison of tabloid kitsch, and he has created a hypothetical innocent against which to gauge the ravages of three versions of *Dead* (pages 194–195).[23]

Richter's treatment of Ensslin in *Confrontation 1*, *Confrontation 2*, and *Confrontation 3* is similar (page 190). In this case, the original photographs are denuded of atmosphere. Dressed in a rough shirt, skirt, sandals, and high socks, with bare knees and straggly hair, Ensslin is seen standing full-length against a barren institutional context. She smiles at the photographer as if enjoying the attention; only a fourth image, which Richter rejected, betrays any wariness. In the paintings, though, Richter crops out all but Ensslin's upper torso and head, eliminating her body's awkwardness, and places her in front of a uniform gray backdrop, narrows the tonal span, and diminishes the contrast of lights and darks—making the confrontation oddly less confrontational—smoothes out the angularities of her face, removing the strain from her expression (along with some of the sparkle in her eyes), and in the end presents a disconcertingly intimate three-stage encounter during which Ensslin catches our eye out of the side of hers, turns to us, lips parted, brightening face open and expectant, and then turns away, drops her head, squares her jaw and the line

ROBERT STORR

of her mouth, and seemingly steps toward the outer edge of the frame as if she were about to disappear behind a door. Initially, the three canvases suggest a first meeting with someone we have heard about but never seen close up before, but what Richter has really staged is her parting.

In *Arrest 1* and *Arrest 2* (page 188) Richter transforms two sharply focused images of Meins's capture to a hazy smear in which Meins is reduced to a faint shadow and all one can see of "the clenched power of the state" is the amorphous mass of the armored car. *Cell* and the smaller *Record Player*—in effect a detail of the larger picture though the source image was a separate photograph—are "portraits" of Baader's prison reality. The turntable that sits silently and does not turn is a memento mori, analogous to the skulls Richter painted in 1983, but without their explicit art-historical associations. *Record Player* (page 193) is a vanitas for our time. One must conjure up the real mechanical, noise-making thing to appreciate the painting's leaden objectivity, and in so doing consider not only the suicide gun which was said to have been hidden there but also the resonance of music in a locked room cut off from the world.[24] The black coat hanging off the screen to the left in the photograph, which Richter used as his point of departure for *Cell* (page 193), becomes in the painting the husk of the man whose intellectual universe is contained on the book-lined shelves to the right.[25] However, as the floor drops out it is the vertiginous mass of those books that dominates the canvas, which represents a cul-de-sac of the revolutionary mind, and a queasy, claustrophobic icon of ideology.

Man Shot Down 1 and *Man Shot Down 2* complete the Baader paintings (page 192). The first painting most nearly approximates the photograph—Richter chose not to use a closeup of Baader's head but instead opted for the three-quarter-length image, with its almost Pieta-like disposition of arms and body—but the painter has obscured Baader's dead stare and the pool of blood under his head, and lent his torso a brittle, insubstantial aspect accentuated in the second painting in which everything floats in a ghostly void. The progression from muted realism to the near-total dematerialization of the images in the three versions of *Dead*, follows the same pattern. In the first canvas, Richter surrounds Meinhof's head in rich blacks, adding space not found in the photograph to the top and bottom edge of the horizontal canvas, but otherwise faithfully rendering Meinhof's features. In the second painting, Richter deepens the blacks, squares off his format, gives her a less-distinct, more-somnolent expression, and then cocks Meinhof's chin backwards, straightens her neck and darkens the ligature around it, thus emphasizing the horrible manner of her death in contrast to the peace that has settled on her face. In the third version, Richter shrinks the size of the canvas, slightly elongating it again, and lets the image dissolve into the engulfing but no longer quite so deep gray-black background. With each iteration Meinhof withdraws from us.

More disturbing even than the paintings of Baader and Meinhof is that of Ensslin. The source photograph, in which a slender woman, head tucked, legs dangling, is suspended from a grate in her cell window, is ghastly. Once again Richter's handling of a cut-and-dried documentary image softens the forms but intensifies the effect. In *Hanged* (page 191), the curtain to the left of the figure and the floor beneath fuse to create a framing device that focuses attention on Ensslin's body, whose torso is the same black as the curtain and floor, but Richter has tilted her shoulder, arms, and torso away from the vertical window, making her swing against gravity as her legs fade into the pale gray below, and the floor falls away. Read one way these almost unnoticeable adjustments make it seem as if Ensslin had been dropped from a gallows; read another way she seems almost to be levitating above the abyss at her feet.

Funeral (pages 196–197), the largest and last painting in the cycle, centers on the three coffins of Baader, Ensslin, and Raspe as they were escorted through the cemetery by a crowd of mourners and journalists. In the daylight-filled photograph these attendants—many wearing the period dress of the Left—can be clearly made out. In the penumbral painting they are homogenized into a somber, virtually undifferentiated mass that optically pushes and shifts around the barely distinguishable rolling carts bearing the three RAF members to their graves. Lowering the horizon, much as he flattens the background in other paintings in the series to close out the space beyond the primary image, Richter gives the trees in the distance only the vaguest definition, which is why one tree in particular—a simple vertical with lateral branches—draws attention to itself. Nothing exactly like it appears in the original photograph, though such an addition could easily be extrapolated from trees that do appear. Perhaps, however, it is not a tree after all, but a cross positioned at the top and near the middle of the composition. A dozen years ago this suggestion would have seemed implausible and it might still strike secularists of the Left as a kind of blasphemy. However, Richter has since made a sculptural multiple of a similarly proportioned cross and he has painted his wife Sabina with their son as a kind of Madonna and child. In light of this, it is hard not to acknowledge the deliberateness of what Richter has done and recognize his addition to *Funeral* as a discrete benediction at the end of a modern-day passion play which, in his scrupulous and agonizing rendition, offers no other consolation. [26]

Richter is vague about the specifics of how such differences between the photographic and the painted image come about, just as he is about why certain images were chosen over others. The techniques employed to achieve these nuances and to give the paintings their muffled feel—feathering the edges of the shapes, dragging brushes or squeegees across the still-wet surface of the canvas—are a kind of erasure or, as some critics have called it, a *de*painting or *un*painting. There is, of course, a long history of aesthetic substraction reaching down in the modern era to Alberto Giacometti's tonal paintings and Willem de Kooning's mottled ones, but Richter's removal of information, which varies in quality from a *sfumato* pall hovering over the canvas to the rich disorienting impastos that slide vertically in *Cell* and sweep horizontally in *Funeral*, is at odds with Photorealism generally, where a premium is usually placed on hyper-verisimilitude. It is also different in character from the photomechanical depletions of Warhol's silkscreen pictures, just as Richter's solemn meditation on death is different from the macabre voyeurism of Warhol's Disasters paintings. In *October 18, 1977* we are not looking at average, redundant death but an exemplary suffering. Responding to a question about voyeurism with Warhol perhaps in the back of his mind, Richter said of his paintings: "I hope it's not the same as seeing an accident on the motorway and driving slowly simply because one is fascinated by it. I hope that there's a difference and that people get a sense that there is a purpose in looking at those deaths, because there is something about them that should be understood." [27]

But what Richter wants us to understand is directly connected to the difficulties of visual access he puts in our way. The contradictory impression resulting from Richter's unpainting is to push the physical reality of the painting forward while pushing the image back, so that it seems to retreat as the viewer advances to have a better view of the painterly manipulations that body it forth. To paint an artificially crisp version of a photograph can call into question the artifice of the source, but to blur a photograph as Richter does accomplishes the same thing but adds this: whereas the super-real picture allows us to distill a more "natural" image of the surfeit of visual data, the blurred picture prevents us from doing the reverse—we cannot supply the missing details or correct the incomplete resolution of part-to-part relations.

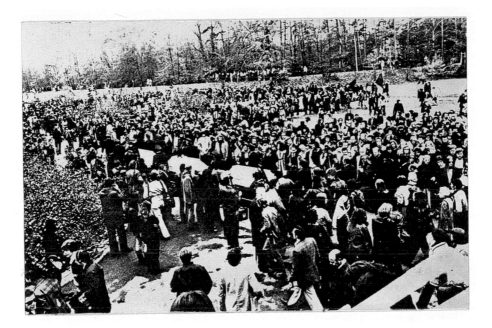

Funeral of Andreas Baader, Gudrun Ensslin, and Jan-Carl Raspe, Stuttgart, October 27, 1977. Photographic model for *Funeral*, from the artist's notebook

Richter's use of gray is of a piece with these obfuscations, all of which open gaps among the painter, the viewer, and the subject. In part, his motives were contextual. "When students at the academy heard I was doing these works," Richter recalled, "most of them said I wasn't allowed to paint this, that I was too bourgeois, too much a part of the establishment. This seemed very stupid to me. But many young artists are going to say this is bullshit, polit-kitsch, and maybe it is possible to see the works this way."[28] In qualified recognition of the contention that he was not capable of rendering the situation with the urgency and immediacy of those close to it, he added, "It is impossible to paint the misery of life, except maybe in gray, to cover it."[29] Gray was also a way of showing that he was painting the past, and a signal that he had opted for a style belonging to *his* past. Other than the two versions of *Tourist (with a Lion)* of 1975, Richter had not painted purely tonal realist pictures since completing *48 Portraits* in 1971–72. "I never really make contemporary works," he told a London critic. "When it's painted gray like this it's partly a way of establishing distance. I knew it was an anachronism to return to my old technique, but I couldn't really do anything else."[30] In the earlier paintings Richter had used gray as a buffer or demurrer: "Gray. It makes no statement whatever; it evokes neither feelings nor associations: it is really neither visible nor invisible. Its inconspicuousness gives it the capacity to mediate, to make visible, in a positively illusionistic way, like a photograph. It has the capacity that no other color has, to make 'nothing' visible. To me, gray is the welcome and only possible equivalent for indifference, non-commitment, absence of opinion, absence of shape."[31]

Richter's recourse to gray, in a series of works that were bound to be lightening rods for repressed anxieties and animosities, carried with it an element of resistance and of discipline. After years in which he painted color-saturated abstractions, his decision constitutes a refusal to be carried away by painterly pyrotechnics, even as the work itself threw conceptual and emotional sparks by pitting aesthetic non-commitment against political

commitment, the artist's apparent indifference against his inner need to finally come to grips with what had impressed him about the Stammheim prisoners despite their false ideology and destructive acts, namely "their energy" and their "absolute bravery."[32]

At one level, then, gray is a symbolic middle term in a context where many are prone to seeing things black and white. The keynote of an anti-rhetorical style, moreover, it not only distinguishes his work from the neo-Expressionist painting prevalent at that time, it fundamentally alters our appreciation of the tradition of chiaroscuro painting, which *October 18, 1977* updates in unanticipated ways. Whereas chiaroscuro painters have usually employed extremes of light and dark to give forms muscular volume and to highlight significant details, Richter has lopped off the top of his gray scale and sometimes the bottom as well, leaving himself a *grisaille* range of ashen, slate, or anthracite tones that in their variously warm shades, cool bluish tints, and occasionally white-streaked accents deflate rounded shapes, slow the darting eyes on the lookout for surprises, and dampen the pictorial ambiance like a low, hushed cello drone. Above all, Richter does the opposite of what we expect from chiaroscuro painting; rather than reveal the essence of the image, his dour palette further conceals it. Playing against our desire to trust our own eyes, he has given us reason to mistrust them.

Combined with various *un*painting procedures, gray thus operates as the agency and emblem of doubt, in a situation where doubt is intolerable to many if not most of those with the deepest involvement. The conventional wisdom is that radical doubt defines the postmodern condition in a world in which traditional notions of cause and effect, and the assumed connection between representation and the thing represented, have lost their authority. Nothing in contemporary reality, it is said, retains a "necessary" meaning or remains subject to the reliable methods of verification. Consequently, we have been cast adrift in the flotsam and jetsam of disconnected signs whose plural use-value overshadows the importance of whatever they originally signified.

With roots in linguistic theory, the collapse of old political and social antinomies, and the vogue for the "end of history," this relativizing postmodernist tendency of thought has its stylish apogee in the work of the French gadfly Jean Baudrillard. In an influential essay, Baudrillard has written that the semiotic breakdown of links between the image and what has been pictured leaves the viewer with four possibilities: the image can be the reflection of a basic reality; the image may mask and pervert a basic reality; it may mask the absence of a reality; or it may bear no relation to any reality.[33] Increasingly, he argues, we are at a loss as to which of these cases applies to what we see, and this uncertainty produces a phantasmagoria of possibilities that annul objective truth.

Baudrillard's examples include one that is particularly apropos of the Baader-Meinhof episode and Richter's *October 18, 1977*. He asks: "Is any given bombing in Italy the work of leftist extremists, or of extreme right-wing provocation, or staged by centrists to bring every terrorist extreme into disrepute . . . or again is it a police-inspired scenario in order to appeal to public security. All this is equally true, and the search for proof, indeed the objectivity of the fact does not check this vertigo of interpretation."[34]

The contingencies Baudrillard cites are hardly frivolous. One has only to think back to the police agent provocateur who supplied Horst Mahler with Molotov cocktails and promised Baader guns in order to establish an exact parallel with this kaleidoscopic scenario. The various conspiracy theories that lay the blame for the deaths of the Stammheim prisoners at their own doors or at the feet of the police, prison officials, or some secret government agency fall into the same multiple-choice miasma.

What is lacking in Baudrillard's elegant intellectual gambit is the abiding compulsion to understand the terrible things that happen, the imperative to investigate and judge incomplete and inconclusive evidence, and above all an appreciation of the price of never knowing and the emotional and spiritual weight of ineradicable doubt. It is not enough to shrug and say that history is inscrutable or fictional or that only the victors write it. Not all interpretations are equally plausible or equally flawed. But all interpretations *do* have consequences for the present and the future. Richter's reticence and the ambiguity of his work are not evasive in this fashionably postmodern sense. They are, instead, the probity of his art. He does not answer the question "How and why Baader, Ensslin, Meinhof, and Raspe died," but he has asked it publicly at a time when others have made up their minds once and for all or have fallen silent. More importantly, Richter has suggested—and his paintings confirm—that the lasting significance of their lives and deaths rests on the contradictions within society and within the individuals their ideas and actions so violently exposed. Those unresolved contradictions are RAF's unwelcome but unavoidable bequest and the crux of *October 18, 1977*.

IV: PAINTING HISTORY—PAINTING TRAGEDY

"**S**how your wounds," Joseph Beuys scrawled on two blackboards in 1980. The blackboards were the centerpiece of Beuys's densely symbolic work on the theme of death, which brought together many of his signature materials and emblems. The brown cross is the most conspicuous example of these older devices, but some new ones had been added as well, notably a copy of the newspaper *La lotta continua (The Struggle Continues)*, the public voice of the Italian revolutionary Left, clandestine elements of which had kidnapped and killed Aldo Moro two years before, provoking a crisis similar to that which was triggered by the RAF's seizure of Hanns- Martin Schleyer. Beuys's invitation/command was in keeping with his overall program for curing Germany's—and Europe's—social, political, and spiritual ills, a process beginning, in this instance, with the call for a ritual display of stigmata. Respectful but always skeptical of Beuys's proselytizing, a respect and skepticism that runs parallel to his feeling toward true believers of the strictly political variety, Richter has been neither a joiner nor a mystic. If Beuys was the Christological shaman of Germany's trauma, Richter is its Doubting Thomas. Beuys pantomimed his culture's wounds; Richter stuck his finger into them.

Prior to *October 18, 1977*, the number of works in Richter's oeuvre that explicitly referred to German history was relatively small, and most were painted in the early to mid-1960s. In addition to *48 Portraits* of 1971–72 (pages 70–73)—an omnibus conceptual work composed of separate paintings of internationally prominent writers, composers, scientists, and thinkers executed with a touch that mimics the soft photogravure-like quality of old encyclopedia illustrations—these include a 1962 head of Hitler haranguing an unseen crowd, *Mr. Heyde* of 1965 (page 59); a picture of the surrender of an infamous SS doctor who had lived quietly in Germany until he was exposed in 1959; eight canvases and several prints completed in 1963–64 depicting military aircraft in action or on the ground (not all were World War II planes nor were all German, but all were painted in a period when Allied bombing of Germany, NATO bases in Germany, and German rearmament were hotly contested issues); and *Uncle Rudi* of 1965 (page 20), the smiling portrait of the average Wehrmacht "soldier in the family." Whereas *Uncle Rudi* is a deliberately modest and richly ambiguous reminder of a past that people might prefer to forget, the Hitler painting is an anomalous attempt to represent demagogic tyranny. While *Mr. Heyde* quotes newspaper sources that refer to the Nazi "murderers among us," the warplanes are, in conjunction with his contemporaneous paintings on the theme of death—*Coffin Bearers* (1962), *Dead* (1963), and even *Helga Matura* (1966) and *Eight Student Nurses* (1966)—more metaphoric than documentary (pages 19, 28–29). Together they foreshadow at an early stage Richter's later conviction that: "Reality may be regarded as wholly unacceptable. (At present, and as far back as we can see into the past, it takes the form of an unbroken string of cruelties. It pains, maltreats, and kills us. It is unjust, pitiless, pointless, and hopeless. We are at its mercy, and we are it.)"[1] Part of the explanation for his fascination with the Baader-Meinhof group's doomed but unshakable fixity of purpose, this profoundly pessimistic remark led Richter to a heavily qualified endorsement of the positive virtues of hope and faith: "The experience and knowledge of horror generate the will to change, enabling us

to create altered conceptions of a better reality, and to work for their realization. Our capacity to know—that is to conceive—is also, simultaneously, our capacity to believe. Faith itself is primarily knowing and conceiving, but it simultaneously becomes the polar opposite of knowing (in that it mentally transforms the known into something different) and thus becomes the means of surviving the knowledge of horror; this strategy we call Hope; Faith is consequently the extension and intensification of the instinct to life, to be alive. Looked at cynically, the capacity for faith is only the capacity to generate befuddlement, dreams, self-deceptions, as a way of partly forgetting reality; it's a pep-pill to get work started on realizing the conception. Looked at cynically, everything is pointless."[2]

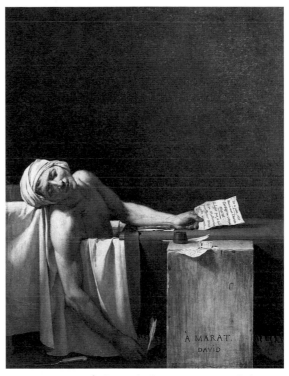

Jacques-Louis David. **The Death of Marat (Marat assassiné).** 1793. Oil on canvas, 64¹⁵⁄₁₆ × 50⅜" (165 × 128 cm). Musées Royaux des Beaux-Arts de Belgique, Brussels

Richter has repeatedly stated that his aim in commemorating the Stammheim prisoners was not political and not topical but a response to their misguided idealism. The fact remains, however, that for the first time in his career he chose subject matter that was unmistakably political and topical, and he devoted to it not a single work or a handful of works, but one of the few extended series of pictures he has undertaken and—compared to *48 Portraits* and others—by far the most complex.

So doing, Richter has also recuperated a genre—history painting—that has been for the most part consigned to art history's dustbin. In the eighteenth and nineteenth centuries, history painting had been the pinnacle of academic art, ranking ahead of but encompassing all the other categories— figure painting, portraiture, still life, and landscape. Originally the historical component of history painting was broadly defined, often mythic, and generally exclusive of current or even recent events. Instead, painters concerned themselves with noble principles and noble action in magnificent decors often borrowed from antiquity. And when they later turned their attentions to the present or near present it was usually for the glorification of the state and its illustrious men and women. History was the affair of heroes, and so was its artistic re-creation.

Bridging the two centuries, Jacques-Louis David was the quintessential history painter. Celebrating patriotic virtues in a Roman setting, *The Oath of the Horatii* (1784) epitomizes the first type of history painting. David's *Le Sacre* (1805), in which the Emperor Napoleon I crowns his consort, represents the later type. Between them lies the French Revolution and David's portrait of Marat, a friend and radical Jacobin assassinated in his tub by Charlotte Corday. This is perhaps the first history painting devoted

to the martyrdom of a radical opponent of the old order. With a simplicity that is more classical in its austerity and formal perfection than any of David's costume dramas, *The Death of Marat* (1793) is an essential precedent for Richter's *Man Shot Down 1* and *Man Shot Down 2*, including its allusion to Michelangelo's *Pietà*. For the record, David was an atheist and his formal reference to the sculpture in St. Peter's is no more proof of a hidden religious program in his work than are the redoubled references in Richter's two paintings of Baader. Moreover, the similarities between *Marat* and the Baader paintings are indirect rather than strictly genealogical. Asked if David had been an influence, Richter said, "One has half of art history in one's head, and of course that sort of thing does find its way in involuntarily—but as to taking something out of a given picture, that doesn't happen."[3]

As the power of the ancien régime declined in France after 1789, the evolution of history painting traced the vicissitudes of Republicanism through several attempts at monarchist restoration and further revolutionary outbreaks. Most of the artists with the formal training and access to public commissions and exhibition venues that this very public form required were privileged noncombatants in the political arena. Thus, for example, Eugène Delacroix, a patrician epicure, painted *Liberty Leading the People* (1830), while Gustave Courbet, the most radical artist of his day and an active participant in the ill-fated Commune of 1870–71 never painted history paintings, though he did limn a portrait of the pioneering anarchist Pierre-Joseph Proudhon in the curiously domestic company of his pinafore-dressed daughters.

The two greatest French history painters of the period were Théodore Géricault and Édouard Manet, and their contributions to the genre upset most of the assumptions and most of the conventions that had previously caused it to flourish under official patronage. Géricault's *The Raft of the Medusa* (1818–19) depicts the moment when survivors of the shipwrecked vessel *Medusa* sighted their rescuers at sea. The picture caused a scandal for two reasons; the first was political. The *Medusa* had been captained by an incompetent aristocrat who, with his officers, had taken flight and abandoned the common passengers to their fate, which, among other horrors, involved cannibalism. With the Revolution fresh in memory and royalism reentrenching itself, the social subtext of the painting was obvious. The second reason for the painting's notoriety was aesthetic; despite the dramatic scale and the invention of the picture, which melded romanticism and classicism as well as elements from Michelangelo's *Last Judgment* with painterly Sturm und Drang, and the statuesque figure in the upper right of the canvas waving to a ship in the distance, the painting had no identifiable hero, no great man.

The three versions of *The Execution of Maximilian* that Manet labored over from 1867 to 1868 mark decisive steps away from the grand manner Géricault had renovated.[4] Like *The Raft of the Medusa*, Manet's paintings were implicit critiques of the powers-that-be. Eager to expand his influence into the Americas, Napoleon III, who rose from president to emperor after a coup d'état in 1851, dispatched Archduke Maximilian of Austria and a small expeditionary force to Mexico where the archduke was installed as emperor under French protection. That protection evaporated when revolutionary followers of the nationalist Benito Juarez stormed Mexico City and drove Maximilian out. Still refusing to abdicate, the emperor without an empire soon fell into the hands of Mexican forces who put him before a firing squad with two of his loyal generals. Together they died in vain but with valor. Pointing an accusing finger at Napoleon III by ennobling the man he had betrayed through inaction, Manet implicitly attacked the self-appointed personification of France, and because of this, none of the three paintings were shown in France during the artist's

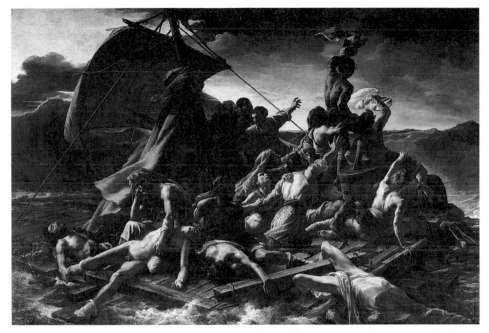

Théodore Géricault. **The Raft of the Medusa (Le Radeau de la Méduse).** 1818–19. Oil on canvas, 16' 1¼" × 23' 5⅞" (491 × 716 cm). Musée du Louvre, Paris

lifetime, and none found a permanent home there afterward.[5] All three of Manet's paintings record the instant of Maximilian's execution and memorialize the honorable deaths of the would-be emperor and his comrades, and all three would have fit neatly into the grand tradition of history painting but for the way in which this portrait of courage is constructed and presented.

Manet's tableaus were directly inspired by Francisco Goya's *The Executions of the Third of May* (1808). Perhaps the greatest of all nineteenth-century history paintings, it turns the slaughter of the common people of Madrid by Napoleonic troops—troops ostensibly bringing the French cause of Liberty, Equality, and Fraternity to benighted Spain—into a modern Golgotha. In his first rendition of Maximilian's last moments Manet exaggerated Goya's brushiness, and rearranged his composition, moving the massed executioners front and center while obscuring their victims in smoke. In the second version, Manet's brushwork tightened, the picture's focus sharpened, and the men facing death were pushed to the left-hand side of the canvas, counterbalanced on the right side by a distracted officer loading his rifle for the coup de grâce. Later the canvas was cut into irregular sections, four of which were reassembled and remounted. In the third and final version, Manet pulled back from the extreme close-up of the second version and reset his stage, adding landscape, a background wall, and a Goyaesque chorus of observers.

Manet is a painter the young Richter had hoped to emulate, and, along with David's *Marat*, his three Maximilian paintings belong to "the half of art history in one's head" that comes into focus when one looks at *October 18, 1977*. The aesthetic, as distinct from political, radicality of Manet's paintings rests on several factors that are most pronounced in the second version. First, the entire project was based on documentary evidence: not-always-reliable "eyewitness" reports in Paris newspapers, journalistic sketches made from those reports, and, most important, photographs of the execution site, the firing squad, the

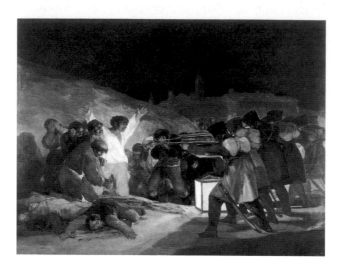

Francisco Goya. **The Executions of the Third of May (El 3 de Mayo de 1808 en Madrid: Los fusil-amientos en la montaña del Príncipe Pio).** 1808. Oil on canvas, 8' 9½" × 11' 4⅜" (268 × 347 cm). Museo Nacional del Prado, Madrid

dead emperor, and his relics. Second, Manet's naturalism marks his shift away from roman-tic dramatization in the first version to cool observation and a matter-of-fact mise-en-scène in the second, a tendency reversed in the third, which is the most conventionally finished and least successful of the paintings. It was that detachment—epitomized by the soldier looking down at his weapon and away from the fusillade—that characterized the paradigm-altering modernity of Manet's, in many other ways, traditional work. Together these pic-tures give the executioners greater prominence than the martyrs, and the lone officer greater individuality than Maximilian. With a discreetly democratic inversion of hierarchies, Manet accords the latter figure a dignity unexpected in the depiction of a man doing his cold-blooded duty. Finally, there is the matter of the fragmented second version and its curi-ously photographic cropping, a quality that Edgar Degas, who specialized in such effects, must have recognized when he acquired the separate pieces, and that one cannot help but think of in relation to the disposition, varying sizes, and recropping of photographic images in Richter's *October 18,1977*. Contrary to modernist teleologies that regard the traffic between photography and painting as all in photography's direction, painting has taught artists over the last century and a half to look at photographs differently and to treat them differently in light of the ways painting has changed in response to photography during that interval. As far as the reciprocity of influence between mediums goes, the line link-ing Manet to Richter by way of photography spirals, rather than runs straight.[6]

The formal, procedural, and psychological shifts in emphasis Manet pioneered had great consequences for painting in general, but until Richter came along, Manet's anti-rhetorical approach had few echoes in history painting, which languished with the demise of the Salon and in the absence of patrons sophisticated enough to choose superior artists for major com-missions. If Manet's experience was any indication, history painting was best done "on spec"—as if it were portraiture, still life, or landscape painting—and at that there were no guarantees that it would ever find its audience.[7] By the twentieth century, when art sought to trumpet great causes, celebrate great leaders, or record great events it tended either toward expressionism or academic revivalism. Mexican muralism in the 1920s through the 1940s split exactly along these lines, with José Clemente Orozco at one extreme and Diego Rivera at the other. *Guernica* is another modern painting in the heroic mode, but it is arguable

ROBERT STORR

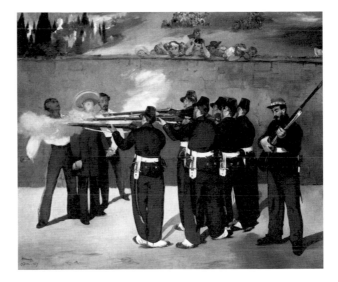

Édouard Manet. **The Execution
of Emperor Maximilian of
Mexico (L'Exécution de
Maximilien de Mexique).** 1867.
Oil on canvas, 8' 3³⁄₁₆" × 10' 1¹⁄₁₆"
(252 × 305 cm). Städtische
Kunsthalle, Mannheim.
Donated in memory of the
Kunsthalle's reopening on
December 5, 1909, by Louise
Lauer, Ms. Scipio, born Gerdan,
Kommerzienrat E. Mayer,
Kommerzienrat E. Reinhardt,
Geh. Kommerzienrat Dr. C.
Reiß, Major W. Seubert and
three anonymous donors

whether Picasso's masterpiece is history painting or an allegorical painting taking off from
an historical event. Regardless of the arguments for either interpretation, as a hybrid of
expressionism and Cubism, *Guernica* has nothing to do with Manet's innovations.

Frequently modern historically minded art hasn't been painting at all. In Germany
many of the most compelling works of this kind—principally works dealing with World War
I and the Revolution of 1919—were in graphic mediums: Max Beckmann's lithographs in
his *Hell* portfolio come immediately to mind as do Käthe Kollwitz's prints—for example,
her woodcut of the revolutionary Karl Liebknecht on his bier, *Commemorative Print for
Karl Liebknecht*—and George Grosz's drawings and cartoons. An especially pointed exam-
ple, a depiction of the murdered Liebknecht and his comrade Rosa Luxemburg in their
coffins, offers a telling contrast with Kollwitz's bereaved image. But these too are expres-
sionist or dramatically stylized works, and graphic art of roughly comparable sorts also
flourished in Latin America and elsewhere in the decades between the two world wars. Back
on the academic side, meanwhile, under Stalin's mandate, Socialist Realism produced ware-
houses full of history paintings, nearly all of which were stilted, overwrought, and fright-
eningly obedient to Communist Party dictation as well as grotesquely worshipful of the
Communist Pantheon.[8]

Recent examples of ambitious history painting are few and far between. A blatantly
reactionary one is *The Murder of Andreas Baader* (1977–78) by Odd Nerdrum, a former
student of Beuys, who "reenacted" the alleged assassination of Baader in a style that mixes
Caravaggio or Ribera-like compositional formats with B-movie costuming and props. Begun
the year of Baader's death, when the reality of the RAF's confrontation with the state was
still current, this absurdly anachronistic "J'accuse" sensationalizes its subject, reinforces
the misconception that history painting is inherently old-fashioned in style, and turns the
meaningful unknowns of Stammheim into a meaningless embroidery on the suspicion-
inducing facts.[9] A far more complex and provocative case of contemporary art addressing
a contemporary historical situation is Leon Golub's *Mercenaries IV* (1980), which brings
postcolonial war-by-proxy home in the shape of a band of irregulars engaging in horseplay
or on the verge of a face-off. A modern-dress frieze against a Pompeiian red ground, the
unstretched mural-sized canvas deploys the conventions of history painting to pose politically

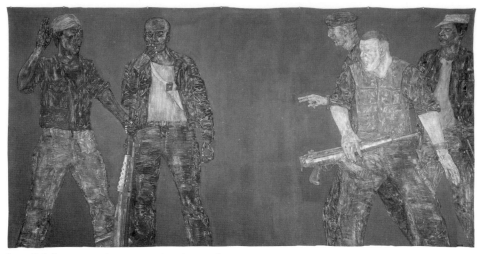

Leon Golub. **Mercenaries IV**. 1980. Synthetic polymer paint on canvas, 47¼" × 7' 6⁹⁄₁₆" (120 × 230 cm). Collection Ulrich and Harriet Meyer

loaded questions on a heroic scale, when plainly these men are no heroes. But what, then, are they up to, what have they done, for whom do they work? Nothing in the picture provides a satisfactory answer; nothing betrays the artist's position or simplifies ours. Therein lies the work's potency. It is as if Golub had taken Manet's second version of *The Execution of Maximilian* (c. 1867–68) and painted only the firing squad, and only after they had completed their lethal mission. Evolving out of panoramas protesting American involvement in Vietnam, Golub's Mercenary paintings moved attention from the unambiguous abuse of power to circumstances in which moral certainties teeter on the edge of pictorial uncertainties.

Richter's ambivalence also cuts in multiple directions. First comes his decision to make paintings on a well-known series of events while not wanting them to be read either as partisan works or traditional history painting. "These pictures," he wrote, "possibly give rise to questions of political content or historical truth. Neither interests me in this instance."[10] The artist's desire to deflect such readings does not, however, automatically exempt his work from those categories—it may simply, or not at all simply, alter them forever. Indeed, by virtue of its very lack of polemical intent, the Baader-Meinhof cycle *repoliticizes* the controversy surrounding the RAF, by redefining the parameters of a deadlocked debate and shifting it away from fixed polarities. Richter's is not an apolitical stance so much as one that cannot be aligned with existing political options. He pushes discussion past the reflex taking of sides, past self-protective neutrality, and past a "plague on both your houses" disengagement to a consideration of the internal flaws and inconsistencies of all available positions. Richter has not found a "third way"—Manichean ideology's phantom alternative—but by picturing doubt he has made the jagged cracks and spiderweb fissures in supposedly monolithic blocks of public opinion apparent along with those that cause private consciousness to ache.

Likewise, *October 18, 1977* and its relation to history painting is not, as critics such as Benjamin Buchloh and Stefan Germer have asserted, a demonstration that the genre can no longer be practiced but, as was true for Manet, only that it can no longer be practiced as it had been before. Or, as Richter said of Romantic landscape painting, another genre he has revived and transformed to the consternation of critics wedded to mid-twentieth-century modernist

ideas about what painting must do and what it should never do again: "A painting by Caspar David Friedrich is not a thing of the past. What is past is only the set of circumstances that allowed it to be painted. It is therefore quite possible to paint like Caspar David Friedrich today."[11] The Baader-Meinhof cycle is not painted like anything by anyone else, and it was not painted for reasons other than Richter's own, but the problems it poses arise out of a tradition, and they manifest that tradition's struggle to adapt to new circumstances.

Both Buchloh and Germer base their arguments on the death of painting as a representational or communicative medium. Hence Buchloh writes: "But the history of history painting is itself a history of the withdrawal of a subject from painting's ability to represent, a withdrawal that ultimately generated the modernist notion of aesthetic autonomy."[12] And yet in *October 18, 1977*, the optical withdrawal of the subject or subjects—the fading of Baader, Ensslin, and Meinhof into arid shadows—activates memory and the critical faculties that strain to bring them back, or partway back. Richter, in effect, summons the subject by depicting its imminent disappearance, aesthetically transferring responsibility for performing this task from the eyes to the intellect and the emotions. That this can never be fully achieved through representation or remembrance is essential to the work's pathos— and the point where inchoate feeling begins to take shape and to take over. Without this coordinated effort, forgetfulness would claim them sooner and beyond remedy. But, unmistakably, painting sets the process in motion, extending and guiding it in ways no photograph or text or alternative medium has done or could do. Is *October 18, 1977* the last gasp of history painting? No, it is its first deep breath in over half a century. And if the air is thin and harsh that is because the atmosphere around us is comparably diminished and polluted.

Richter has referred to the series as a leave-taking. "Factually," he said, "these specific persons are dead; as a general statement death is a leave-taking. And then ideologically, a leave-taking from a specific doctrine of salvation and beyond that from the illusion that unacceptable circumstances of life can be changed by this conventional expedient of violent struggle (this kind of revolutionary thought and action is futile and passé)."[13] One might add that the kind of doctrinaire criticism that grew out of late 1960s and early 1970s radicalism has also run its course, namely, criticism based on the prediction that a definitive and salutary rupture with the past was at hand, with the corresponding assumption that all traditional mediums and conventions were soon to be swept away, and that if they lingered it could only be as ghosts or vacant simulacra of their former selves. Undeniably the near-death of modernist painting in those years, and the gaudy rise of postmodern painting in the 1980s had a profound impact on Richter's thinking and has given his work much of its rigor and its poignancy. Unless he himself had felt that painting was endangered, he could not have overcome his self-mocking belief that the discipline he practiced daily was "total idiocy," nor could he have made the extraordinary effort to rescue that discipline from obsolescence and triviality, an effort that has culminated in *October 18, 1977*.[14] The one thing that the cycle is not, therefore, is a "leave-taking" from painting. On the contrary it is a startling reengagement with a much abused and much maligned art form. Ideologically inflexible criticism, which sidesteps this hard-won recommitment and refuses to grapple with the embattled but unapologetic sincerity of Richter's faith in painting's prospects and art's potentially redemptive function, is clinging to the received wisdom of a bygone period just as surely as any avowedly conservative school of thought. Such criticism builds a wall of dogma around an unadmitted nostalgia for a future that came and went and was never so glorious as it was supposed to be—or just never arrived at all. Richter has no more use for such nostalgia than he has for updated mirages of progress. Neither

an avant-garde ironist nor a cynic, he is, instead, a stoic who contemplates the probable futility of his endeavor with a Samuel Beckett-like wit and melancholy, and then, Beckett-like still, goes stubbornly back to work. It was Beuys's contention that the silence of Duchamp was overrated. To those who have routinely allied Dada strategy with sociopolitical theory, Richter has parried with the modest proposal that, perhaps, the irony of post-Duchampian aesthetics is overrated as well.

That Richter began to drop his guard after completing *October 18, 1977* is just one indication of the change in emphasis that the work itself has undergone. Lest frequent use of quotations here be seized upon as overeagerness to accept the artist's intentions as the sole criteria for judging his art, it should be noted that writers anxious to embrace Richter as a deconstructionist member of the avant-garde have been at least as quick to cite his words in support of their elaborately selective arguments. Deaf to the artist's tone and incurious about his creative survival tactics, they have done so at the expense of a deeper and more nuanced appreciation of his overriding aims. Speaking to an interviewer in 1990, Richter explained his earlier evasions and mixed messages this way: "My own statements about my lack of style and lack of opinion were largely polemical gestures against contemporary trends that I disliked—or else they were self-protective statements designed to create a climate in which I could paint what I wanted," later adding, "If I ever did admit to any irony, I did so for the sake of a quiet life."[15]

Likewise, those who take a less-than-full account of the human pain and sadness embedded in *October 18,1977* in haste to integrate them into narrowly defined social or formal discourses do the work a disservice. On this score, as well, Richter has been forthright. "It is impossible for me to interpret the pictures," he has said. "That is, in the first place they are too emotional: they are, if possible, an expression of a speechless emotion. They are the almost forlorn attempt to give shape to feelings of compassion, grief, and horror (as if the pictorial repetition of events were a way of understanding those events, being able to live with them)."[16] Elsewhere the artist has spoken of "dismay," and "pity." Taken together, these are not "aesthetic" sentiments, or matters of opinion, they are empathetic responses to suffering, and Richter's work is frankly intended to stimulate similar responses in the viewer. A lament, *October 18, 1977* is, at the same time, a wager on painting's expressive power over and above its impotence in the face of irremediable misunderstanding and misfortune.

For their part, some writers responding to the cycle in this spirit have gone on to speak of the work as a eulogy or requiem for its subjects.[17] This is true, but as nearly every commentator agrees, established forms of mourning and the artistic translation and relocation of those forms are inadequate to the task of purging the sorrow and anguish from which these images draw their force. As historical paintings they remain eloquently unresolved; as a contemporary requiem they stop short of transfiguration. Thus, from a postmodernist perspective, Germer writes with a keen sense of the work's capacity to frustrate the desire for unwarranted closure: "As in the case of Manet, in Richter's work history painting must be seen as monuments of mourning, as a lament for loss, which painting cannot alleviate or soothe, but must assert in its full brutality. . . . Richter's series stresses the moral necessity of painting at precisely the juncture where it becomes aware of its own limitations: this is the consequence of that medium's socially marginal position, and involves a concomitant loss of its transformative or consoling functions. . . . The fact that these paintings slip from our grasp, escape hasty categorization, and fail to overcome their subject matter, gives their content an uncanny character which is due to the fact that it has not been transformed, since the social process of mourning is still blocked by psychological repression."[18]

ROBERT STORR

In this latter regard, Richter's involvement perfectly matches that of his presumptive public. "The deaths of the terrorists, and the related events both before and after stand for a horror that distressed me and has haunted me as unfinished business ever since, despite all my efforts to suppress it," he wrote.[19] Rather than preaching to the converted of whatever persuasion, the paintings actively do the never-to-be-completed work of mourning on behalf of those who have postponed it and in the process deferred their personal reckoning between past convictions and present realities. For Richter the Baader-Meinhof group is the fulcrum of a long seesawing struggle with himself. Having left East Germany behind in the early 1960s, and with it any residual susceptibility to Marxism, Richter operated as a creative free agent in the improvisatory art world of West Germany until the late 1960s, when that scene began to fragment and the new Left asserted its claims and, in the process, reasserted those of Marxism. Although disinclined to revise his fundamental social and philosophical views, Richter acknowledged this resurgent radicalism as a serious challenge to the status quo both within his milieu and in the increasingly conservative society outside it. While there are no grounds for second-guessing Richter's declaration that politics or history per se are not his real concern, his moral and artistic consciousness was plainly thrown into turmoil by political and historical forces. It is one thing to live without orthodoxy, another to live without belief of any kind; one thing to live without optimism another to live without the least hope that something of value can be salvaged from the wreckage of history. Thus the debacle of the RAF paradoxically revived Richter's sense of the stakes for which he was playing.

Richter pulls no punches in his assessment of the RAF members. Baader elicits the least sympathy from him, Meinhof and Ensslin the most. It is they who embody the positive "will to change" he reluctantly admired. "I do think the women played the more important role in it," he said. "They impressed me much more than the men."[20] A painterly aside reinforced this impression in 1988 and anchored the artist's preoccupations in his immediate circumstances. Toward the end of the long gestation of the cycle Richter took time out to paint a single, full-color head-and-shoulders portrait of a girl or young woman seen from behind. Wearing a bright red-and-white patterned sweater, the sitter was his then teenaged daughter, Betty. The opaque background of the picture is one of the large gray monochromes Richter painted shortly before the photograph from which *Betty* was derived was taken, sometime in 1977. Juxtaposing that dark flat surface with her vital, fully dimensional form in a compressed pictorial space Richter staged a confrontation between two styles of painting and, implicitly, between the two realities in which he lived in the months leading up to the Stammheim crisis: the coming of age of a new generation over whose head hung the pall of the German Autumn of 1977, and his own attempts to break through the end-game logic of avant-garde art that preoccupied him. Rather than look ahead at the viewer or into the future, Betty casts a glance backward into a void that seems impenetrable at first, but then swells forward like a looming storm cloud. Thus, after months of painting death, Richter gave himself a respite and painted life, pairing in his own mind the image of Betty with a spectral likeness of the rejuvenated Meinhof. Almost hermetic in its iconography and retrospective on several levels, in its fashion *Betty*, too, is history painting (page 79).

If, in this deceptively simple image, Richter subtly links the youth of 1988 to that of twenty years earlier—as if Betty were staring into a mirror of the sort the painter began fabricating around that time—Richter resists identifying himself with the rebels. It is, after all, not the terrorists' ideas that he instinctively understood, but their desperation and their penchant for violence. At this level, destructive anger directed at authority psychologically

dovetails with vengeful hatred of the RAF. That is the trap the paintings set for viewers who seek to exempt themselves from the grim alternatives Richter puts before them: "If people wanted to see these people hanged as criminals, that's only part of it: there's something else that puts an additional fear into people, namely that they themselves are terrorists. And that *is* forbidden. So this terrorism is inside all of us, that's what generates the rage and fear, and that's what I don't want anymore than I want the policeman inside myself—there's never just one side to us. We're always both: the state *and* the terrorist."[21]

The split in Richter's own mind goes deeper still. In the same breath that he says "I was impressed by the terrorists' energy, their uncompromising determination and their absolute bravery," he adds, "but I could not find it in my heart to condemn the state for its harsh response. That is what states are like: and I have known other, more ruthless ones."[22] In short, both the terrorists and the state acted in accordance with their given roles and their own sense of necessity, and Richter, standing apart from the antagonists, sees the fatal logic of both positions and is torn between respect for the former and acceptance of the latter.[23] If, in light of these dynamics, the basic themes of *October 18, 1977* are the sources and inescapable consequences of rationalized faith, or ideology, and the link between ideological commitment and death—either death meted out in the name of a cause or death suffered for that same cause—then underlying its status as history painting reinvented, Richter's cycle is also predicated on the pictorial reinvention of tragedy.

These days the word tragedy is carelessly applied. Every airplane crash, every cataclysmic flood or fire is a tragedy in the headlines, prompting Warhol's voyeuristic but dry-eyed correctives to the oversold drama of tabloid death. True tragedy involves more than unforeseen or accidental calamity. The pathos of such banal misfortunes is basically unproblematic; however, tragedy is always and essentially problematic. Classically it results from defects in human character and the misapprehension of human situations that lead ineluctably to the undoing of those condemned to play out the parts they have chosen or accepted. Richter's statements about the respective conduct of terrorists and the state implicitly recast the story of the RAF in this mold.

He was not alone in drawing such a conclusion. A segment of the collaborative film *Germany in Autumn* (1977–78), scripted by Heinrich Böll, focuses on a group of filmmakers and television programmers who have gathered to discuss a new production of Sophocles' *Antigone.*[24] Intercutting scenes from the play and snatches of dialogue among the executives, the scenario draws explicit parallels between the case of the Baader-Meinhof group and the dire ramifications of Antigone's decision to enlist her sister Ismene in the effort to bury their brother Polynices, whom Creon, King of Thebes, has decreed shall rot unmourned outside the city's walls because he raised his hand against the state. Ismene initially resists Antigone's entreaties, but finally comes to her aid. When, as punishment for her defiance, Creon imprisons Antigone in an isolated cell rather than execute her, she hangs herself. Conversation around the television-station meeting table centers on what sort of disclaimer dissociating the producers from the violence of the play should be used to introduce the film, and the ensuing debate draws out the correspondences between the "terrorist women of the fifth century B.C." and those of the late twentieth. In the end, the programmers set the film aside for a future date when, in the words of one of them, the young would not be so likely to view it as an incitement to subversion.

Superficially this sequence is a bitter commentary on media cowardice—"the next thing you will say is 'censorship' and 'fascism,'" one executive shouts in a self-betraying retort to a colleague who defends the film—but the strength of the vignette lies less in this

satire than in the aptness of *Antigone* to the situation facing Germany at that time. Parts of the play not shown on screen deepen those connections. Creon is the incarnation of established order. The slain Polynices was his natural adversary but, assuming the prerogatives of men while refusing to heed even the restrictions imposed on them, Antigone and Ismene constitute a greater and more subtle threat to authority. The dilemma of Haimon, Creon's son and Antigone's betrothed, represents the plight of those caught between duty and passion, patriotism and personal loyalty. When Creon accuses him of standing up for anarchy by speaking on Antigone's behalf Haimon protests. When Creon refuses to hear that other notables in the city do not see her as a criminal and declares himself the sole voice for the collectivity, Haimon answers that if that is so, "the state is a desert." Yet Antigone's resistance to Creon is not rooted in the lust for power or a longing for chaos but rather in a sense of justice. Nor does she accept Creon's argument that by seeking to honor Polynices she insults the memory of her other brother Eteocles, who was killed defending Thebes alongside Creon. Instead, she asserts: "There is no guilt in reverence for the dead."[25] Nevertheless, Creon and Antigone are locked in a mortal combat of wills that he will not break and she, equally intransigent, cannot survive.

It is unnecessary to spell out the connections between *Antigone's* theme and the German crisis of 1977 in any greater detail. However, a crucial distinction between Richter's treatment of the Baader-Meinhof story and Sophocles' play remains. Aristotelian tragedy rests on the concept of catharsis. In the end, Creon's rigidity precipitates not only Antigone's death but Haimon's suicide as well, and with it the destruction of his father's world. The costly wisdom the king achieves and the moral and social lessons taught the public are the justification of the suffering he endures and they witness. Richter's paintings offer no such consolation. Instead, they reconfigure tragedy's structure along the lines sketched by Bertolt Brecht's evolving concept of epic theater. Rather than identification with the characters, Brechtian drama creates distance between them and the audience; rather than involving the public with the action, as was true in classical dramaturgy, it confronts the public with difficult choices; rather than smooth transitions from scene to scene it presents discontinuous self-contained episodes; rather than emotional release, it leaves the viewer with unsolved problems and persistent intellectual and spiritual discomfort. Richter's paintings do much the same.

Of course, no precise analogy can exist between modern painting and modern theater. Nor is Richter a student of Brechtian theory. But the terms classical tragedy proposed, and Brecht altered, offer us a better way to approach Richter's October cycle and his world view generally than those currently dominating art discourse. Suppose you are an artist beset by a sense of the cruelty of the world and the fallibility—or worse, criminality—of the ideological systems designed to make that world perfect. Suppose you are a witness to your times but see in the miseries and follies around you something more than particular historical causes and effects, something larger that refracts, as if through a cracked prism, or reflects, as if in a smudged mirror, the workings of a society at war with itself and men and women at war with their own contradictory selves. But suppose, also, that unlike the artists of the past who placed their trust in capricious Gods, in one inscrutable God, or in a fine-tuned philosophical construct, that faith in an overarching order or principle that might somehow make sense of these horrors and set right the discord that produced them, no longer held against the onslaught of violence and unreason and the mounting evidence that there is no end to it. To speak in this context of a work addressed to the human condition is not to affirm the existence of the singular, self-contained subject or any fixed and

therefore reactionary definition of human nature. Rather, it posits a continuum of restless identities within each individual and a correspondingly unstable continuum of attitudes and instincts within the society to which they belong, all of which ensure perpetual disquiet, force ceaseless self-examination, disallow any rigidly consistent set of standards of right and wrong, and in the final analysis promise no relief, only contingent insight and renewed uncertainty. It is a bleak vision, and a fully tragic one that points to the desire to master what we imperfectly comprehend as the origin of our error and exposes the temptation to master others with that flawed self-awareness as the harbinger of our downfall.

As in Brechtian tragedy, Richter creates a distance that accentuates tensions rather than lessening them, that heightens emotions rather than cools them, such that we are left puzzled and agitated, though unlike Brecht Richter stage-whispers no marching orders. But Richter has taken matters further. Traditional tragedy ends with the death of the hero, but *October 18, 1977* is devoid of heroes. Neither are there clear-cut antiheroes in the modernist tradition. Disconcerting partisans on every side, he has taken the radical step of subtracting heroism and villainy from the equation altogether. Moreover, the men and women he paints are not "characters" at all. Actual people filtered through compound layers of representation that simultaneously concentrate our attention and destroy the illusion of transparent reality, they are put before us with a reticence that transfers the burden of response and interpretation from the author of the pictures, and what he knows or thinks, to viewers and to what we, with ever increasing ambiguity, recall or surmise. Thus, what we see in these images of Baader, Ensslin, Meins, and Meinhof are figments of our unreliable grasp of history and our fluctuating response to its undecided questions. Beyond that, they are personifications of the collective passions and delusions of their time and ours and of the horrendous effects of that era's and this one's equally collective urge to smother dissent and banish discontent.

The deaths of the Stammheim prisoners did not end the tragedy in which they participated but merely punctuated the one in which we are still actors and from which, Richter's paintings make plain, we will not exit unsullied or unscathed. At the end of the twentieth century, which has seen so much tragedy but whose art has too often retreated from the difficulties of the tragic mode and sought safety in closed formal logic or moral and political didacticism, Richter has restored and fundamentally remade that enigmatic, unforgiving, and indispensable form.

Some may argue that the transformation of current, or near-current, historical events into tragedy removes them from the heat of political and cultural contention and aestheticizes them in a detrimental fashion. But the truth is that the *agon* that came to its conclusion on October 18, 1977, has already receded from us. Reportage and archival information can, within limits, reconstitute the context in which it occurred, but only simultaneously evocative and resistant aesthetic means will preserve its painful and confounding essence. Furthermore, much of the photographic documentation upon which Richter drew is now out of reach in government and news-magazine dossiers that are not readily available to scholars and the public. Consequently, not the least of the paradoxes of the present situation is that the only form in which some of these images can readily be seen is in Richter's rendition of them. Time, bureaucratic policy, and the material immediacy of painting have thus conspired to make *October 18, 1977* the most actual and accessible representation we have, even as the paintings underscore the unreliability of official versions (or any other version) of the record, while deepening the anguish and sorrow that suffuses the images in all their previous incarnations.

ROBERT STORR

Richter's achievement has been an almost solitary one, and there is no reason to suppose that he will find followers, and none at all to think that he would welcome them. Style can be imitated but the psychological and intellectual chemistry that produced *October 18, 1977* and that confirms the tragic dimension in his earlier work is unique to the painter, even though the work itself speaks to a large public in direct and disturbing ways. We should not be surprised, then, that Richter has so little artistic company, nor should the lack of it cause us to doubt that he is doing what our eyes and minds tell us he is doing or to prompt us to rearrange our impressions and understanding the better to fit him into a well-populated aesthetic category or camp. Instead, we must start from the realization that *October 18, 1977* is the exception to painting in this period, and not the rule. Nor does it codify new laws. Rather, it requires us to set aside the assumptions and unwrite the critical formulas that currently impede thought and inhibit feeling. The reward for this is an imaginative freedom Richter has fought hard to secure for himself, and it is a freedom he offers to anyone willing to invite the discomfort he has come to accept. It is a conditional offer, therefore, and in every respect an unusual and demanding one. But, after all, while at any given moment powerful and compelling art may be relatively plentiful, great art is always rare.

Asked if it was difficult to be surrounded for a long time by such lugubrious images, Richter answered laconically: "It was hard. But it was connected to work. I didn't have to look at the dead inactively, I could do something. As I paint the dead I am occupied like a gravedigger."[26] Although Meinhof lies buried in Berlin and Baader, Ensslin, and Raspe were interred together in a Stuttgart cemetery almost a quarter century ago, in another sense they and all that they represented have, like Polynices, been left out in the open and neglected. Richter has, in effect, lightly covered them with dust, but he has not presumed to remove from sight what it is not in his power to lay to rest. Quite the contrary: with his austere, perplexing, prodding, and relentless self-critical art, he has made them more visible.

NOTES

Introduction—Sudden Recall

1. Gregorio Magnani, "Gerhard Richter: For Me It Is Absolutely Necessary that the Baader-Meinhof Is a Subject For Art," *Flash Art*, international edition 146 (May/June 1989): 97.
2. Peter Ludwig, the prominent German collector, had approached Richter about acquiring the paintings, but the artist pointedly refused the offer.
3. Ingeborg Braunert, in *Die Tageszeitung* (March 18, 1989): 20.
4. Benjamin H. D. Buchloh, "A Note on Gerhard Richter's *October 18, 1977*," *October* 48 (spring 1989): 93. Buchloh's link between Richter's October cycle and Mies van der Rohe's 1926 Liebknecht-Luxemburg monument in Berlin is double-edged insofar as Mies van der Rohe's essentially apolitical dedication to modernist architecture led him to look for accommodation with National Socialist cultural policy after Hitler came to power in 1933; with roughly the same professionalism he accepted the Communist's commission for the 1926 project. The aesthetic and moral distance that Richter takes from partisan politics is of another order altogether. It is inconceivable that he would accept commissions from or work around the ideological strictures of any party, Left or Right. Unlike Mies van der Rohe's project, Richter's *October 18,1977* paintings were made without a patron, in response to the artist's own need to make them. For a detailed discussion of Mies van der Rohe's political views, see Richard Pommer, "Mies van der Rohe and the Political Ideology of the Modern Movement in Architecture," in Franz Schulze, ed., *Mies van der Rohe: Critical Essays* (New York: The Museum of Modern Art, 1989): 96–145; and Elaine S. Hochman, *Architects of Fortune: Mies van der Rohe and the Third Reich* (New York: Weidenfeld and Nicholson, 1989).
5. Sophie Schwarz, "Gerhard Richter: Galerie Haus Esters, Krefeld," *Contemporanea* 3 (May 1989): 99.
6. Hansgünther Heyme, "Trauerarbeit der Kunst muss sich klarer geben," *Art: Das Kunstmagazin* 4 (April 1989): 15.
7. Buchloh, "A Note on Gerhard Richter's *October 18,1977*": 105. In a footnote to this article Buchloh names Anselm Kiefer as one of the most prominent exponents of a group of artists he accuses of making "polit-kitsch." In the body of the text he cites Richter's paintings as an implied criticism of "the irresponsible dabbling in the history of German fascism with the meager means of generally incompetent painting." Jean-Christophe Ammann, however, argues that Richter and Kiefer are, to the contrary, *de facto* collaborators in the project of reinterpreting the past. Of the October cycle he writes: "This painting is intimately linked to World War II and the history after World War II. . . . Thus it is a work about Germany itself. . . . There are three oeuvres in German art that I see in this way: the oeuvres of Beuys, Kiefer, and Richter." See Ammann, "Das Werk als Menetekel," *ZYMA* 5 (November/ December 1989).
8. Ibid.
9. Stefan Germer, "Unbidden Memories," in *18. Oktober 1977* (London: Institute of Contemporary Arts and Anthony d'Offay Gallery, 1989): 7.
10. Ibid.: 8
11. In June 1995 The Museum of Modern Art announced the acquisition of *October 18, 1977* for an unspecified price, rumored in the press to have been three million dollars. Earlier, in the spring of that year, the author had made inquiries about the status of the works through Richter's New York dealer Marian Goodman, who came back with the surprising news that Richter had not as yet promised them to any institution and would indeed be interested in discussing their possible acquisition by MoMA. One of the first questions asked by the author during those conversations, which took place in the artist's studio in Cologne, was whether Richter had any lingering doubts about the paintings leaving Germany, since the author and the Museum, which he represented, had no desire to take the works to the United States if there was any question of that altering or clouding their meaning. Richter insisted that it would not and that in many ways their presence at The Museum of Modern Art might clarify their content. The artist did, however, ask that MoMA respect the ten-year commitment he

had made to the Museum für Moderne Kunst in Frankfurt, and that was agreed to without hesitation.

12. Magnani, "Gerhard Richter,": 97.
13. The Diözesanmuseum in Cologne had approached Richter with a serious offer, but the artist had declined it. See Stefan Koldehoff, "Stammheim in New York," *Die Tageszeitung* (Berlin) (October 28/29, 1995): 15.
14. Ibid.
15. Hilton Kramer, "MoMA Helps Martyrdom of German Terrorists," *The New York Observer* (July 3–10, 1996): 23.
16. David Gordon, "Art Imitates Terrorism," *Newsweek*, Atlantic edition (London) (August 14, 1995).
17. Hubertus Butin, in *Neue Zürcher Zeitung,* International edition (October 23, 1995): 25.
18. Michael Brenson, "A Concern with Painting the Unpaintable," *The New York Times* (March 25, 1990): 35, 39.
19. Peter Schjeldahl, "Death and the Painter," *Art in America* 4 (April 1990): 252, 256.
20. Michael Kimmelman, "At the Met and the Modern with Richard Serra: One Provocateur Inspired by Another," *The New York Times* (August 11, 1995): C26.
21. Koldehoff, "Stammheim in New York."
22. Butin, in *Neue Zürcher Zeitung.*
23. Ibid.
24. Stefan Koldehoff, "Stammheim in New York," *Die Tageszeitung* (October 28/29, 1995): 15. Lisa Lyons, who organized the Lannan Foundation presentation of *October 18, 1977*, had a notably different take on the audience reactions to the paintings and the supplementary materials. "I've noticed that there is a lot of chatter in the galleries where the photographs and documentation of the gang are displayed, but when people see the paintings there is total silence. These paintings are just overwhelming." Suzanne Muchnic, "A Showcase for Controversial Art in Marina del Rey," *Los Angeles Times* (July 10, 1990): F1.

I: What Happened

The narrative of this chapter has been based on facts gleaned from several sources, but one in particular deserves to be acknowledged, Stefan Aust's *The Baader-Meinhof Group: The Inside Story of a Phenomenon*, trans. Anthea Bell (London: The Bodley Head, 1985), which is as close to being a definitive journalistic account of the Baader-Meinhof group's origins and activities as we can expect to have. A friend of many of the principals, and a protagonist in part of the story, he was instrumental in preventing Meinhof's daughters from being spirited away to a PLO camp in Jordan, where they would most likely have been killed in the war between the PLO and King Hussein that broke out there in September 1971. Aust is a convincing participant-observer and a scrupulous researcher. I have relied heavily on the facts he provides, and trust his judgments regarding matters of speculation. Aust's book is also significant in that Gerhard Richter was in part spurred on to paint *October 18, 1977* after reading it.

The insights provided by Michael "Bommi" Baumann and Hans-Joachim Klein in their books—*Wie Alles Anfing/How It all Began*, with statements by Heinrich Böll and Daniel Cohn-Bendit, trans. Helene Ellenbogen and Wayne Parker (Vancouver, Canada: Pulp Press, 1977), and Jean-Michel Bougereau's "Interview with Hans-Joachim Klein" in *The German Guerilla: Terror, Reaction and Resistance* (Sandey, Orkney: Cienfuegos Press; Minneapolis: Soil of Liberty, 1981)—were also indispensable. Tom Vague's *Televisionaries: The Red Army Faction Story 1963–1993* (Edinburgh and San Francisco: AK Press, 1994) provided a running chronology and additional information of great value. Last, there is Jillian Becker's *Hitler's Children: The Story of the Baader-Meinhof Terrorist Gang* (Philadelphia and New York: J. P. Lippincott, 1977). A sloppy and blatantly biased version of the story, published in haste after the Stammheim deaths, Becker's book hinges on the crude analogy suggested by the title that the Baader-Meinhof group was made up of direct descendants of the Nazis rather than young adults belonging to a generation struggling to overcome Hitler's legacy. Its biases and analytic faults aside, the book does contain some facts and sources that I have used.

In addition to these sources, and others cited directly below, I have reviewed newspaper coverage of the Baader-Meinhof group in the English and German press, read various other journalistic accounts of the situation, as well as consulting general histories, such as J. A. S. Grenville's *A History of the World in the Twentieth Century* (Cambridge, Mass.: Harvard University Press, 1980), and specialized studies such as Sabine von Dirke's *"All Power to the Imagination!": The West German Counterculture from the Student Movement to the Greens* (University of Nebraska Press, 1997).

1. *Wie Alles Anfing:* 119.

2. Aust, *Baader-Meinhof:* 58.

3. Anton Kaes, *From Hitler to Heimat: The Return of History as Film* (Cambridge, Mass.: Harvard University Press, 1989): 83.

4. In 1960 Adolf Eichmann was kidnapped by Israeli agents and brought to Jerusalem to stand trial. Eichmann's case spurred a series of arrests of his accomplices still living in Germany as well as renewed inquiries into the war records of judges and other civil servants, some of whom were forced to resign when the full truth of their past was acknowledged. One of them was among Adenauer's closest advisers, Dr. Hans Globke, who, it was revealed, had helped draft the notorious anti-Semitic Nuremberg laws promulgated by the Nazis in 1935, as well as other racist commentaries. Much press coverage accompanied these events: it was the first time since the war that the exposure and trial of war criminals made regular headlines. See Hannah Arendt's *Eichmann in Jerusalem: A Report on the Banality of Evil* (New York: Viking Press, 1963).

5. Aust, *Baader-Meinhof:* 25.

6. Ibid.: 10.

7. Ibid.: 418.

8. Baumann, *Wie Alles Anfing:* 66.

9. Published in 1975, banned in 1976, and then republished in 1977, Michael "Bommi" Baumann's account of his progression from "a perfectly normal person, a competent, well-adjusted apprentice" to a bomb-throwing agitator—hence his nickname—who claimed that "violence in the political realm has never been a problem for me," is the testament of a candid, subtle man, and one of the key documents of the period. Hans-Joachim Klein was another influential working-class radical. A victim of regular beatings at home, whose Jewish mother had died at Ravensbrück concentration camp, he was drawn into dissident circles after witnessing women protesters being cudgeled by the police during a demonstration. After being wounded in the 1975 attack on the OPEC ministers' Vienna Summit—an action, he says, in which he was coerced into taking part—Klein backed away from his former colleagues, and in May 1977 wrote a public letter to the liberal German news magazine *Der Spiegel*, dissociating himself from the militant Left. The letter was followed by a 1978 interview published in the Parisian daily *Libération*, in which he detailed his harrowing experiences and the reasons for his having bolted the terrorist movement. Like Baumann's memoir, Klein's insider's analysis of the inherent contradictions of urban-guerrilla strategy in the 1960s and 1970s was often denounced, but also much debated, in the radical community. It too is an essential text for understanding the pull of fanaticism, and the motives and doubts of the perfectly ordinary people who succumbed to its logic. See Bougereau, "Interview with Hans-Joachim Klein": 7–61.

10. Aust, *Baader-Meinhof:* 44. Röhl also emphasizes the shock of Ohnesorg's death, and, like Hans-Joachim Klein, sees the attempted assassination of Rudi Dutschke as the turning point for the Left. "Whatever one may say about the later escalation of violence . . . however one may condemn the regression into a wild west epoch as senseless . . . no one who seriously aims at understanding this time and the people of this time, such as Ulrike Meinhof, can ignore that the majority of this 'robber' gang, which declared a war against the entire society, still acted out of the feeling that developed at that time [when Ohnesorg was killed] and which became more pronounced after the attack on Rudi Dutschke: the feeling one had to shoot back." Klaus Rainer Röhl, *Fünf Finger sind keine Faust: Eine Abrechnung* (Munich: Universitas Verlag, 1998): 203–204.

11. Vague, *Televisionaries:* 8-9. A quite different version of this text appears in *Hitler's Children,* and the variants in translation—for example, "marched" in *Televisionaries* is rendered as "shambled" *in Hitler's Children*—is indicative of the slant of the latter book.

12. Klein, *Interview:* 45. Klein went on to say that the urban guerillas to whom Fischer appealed "killed themselves laughing. They don't pay any attention to what the left is doing."

13. Aust, *Baader-Meinhof:* 52–53.

14. According to Klaus Rainer Röhl, who helped found the student journal in 1957, *Konkret* was subsidized by the East German government and the Communist Party, despite the critical articles it sometimes published attacking the communists' reactionary cultural positions and other policies. Income from newsstand sales was enhanced when the journal began to include increasing doses of erotica, but Röhl credits Meinhof in her capacity as editor-in-chief with turning *Konkret* into a serious journal, in part by securing the participation of writers like Hans-Magnus Enzensberger. See Röhl, *Fünf Finger sind keine Faust:* 119–120.

15. It is worth noting that numerous former radicals, including those who took up arms, have become integral parts of government in sev-

eral countries thirty years after the crises of the 1960s. This includes not only Otto Schily and Joschka Fischer in Germany, but also Daniel Cohn-Bendit, "Danny the Red," who was one of the leaders of the national student strikes in France in 1968, and who has since distinguished himself as the representative of the Greens in the European Parliament. It also includes anti-war organizer and Chicago 7 defendant Tom Hayden, and former Black Panther Bobby Seale in the United States, and recently members of the Tupamaros, who were among the first urban guerilla groups to emerge in the 1960s. They entered the Uruguayan government in the spring of 2000. It is also important to point out that the past involvements of some of these figures have been used against them; also, in the spring of 2000, a call was made to remove parliamentary immunity from Daniel Cohn-Bendit for having allegedly concealed the whereabouts of Hans-Joachim Klein while he lived incognito in France, after breaking with the terrorist underground. The 1960s and 1970s are still very much with us.

16. Gritty and compelling cinéma verité, *Bambule* was completed before Meinhof went underground, but its planned broadcast was set aside after her part in the escape of Baader was made public.

17. Guevara was killed by Bolivian troops in 1967.

18. Although she was a member of the RAF underground for only nine months in 1970–71, Astrid Proll is an important eyewitness to the origins and internal dynamics of the Baader-Meinhof group. Like that of Michael "Bommi" Baumann and Hans-Joachim Klein, her testimony captures both the initial idealism and eventual disenchantment of an insider. "Our group was formed from a network of friendships and love relationships: everything was based on trust," she wrote. But she was also critical of the consequences of this bonding: "After Baader was arrested while trying to procure arms, I had no doubts whatsoever that I would be part of the action to free him. This action, on May 14, 1970, was the birth of the RAF. It is strange that, as in the autumn of 1977 with the abduction of Hanns-Martin Schleyer, which was intended to obtain his release, Andreas was always the center of attraction. From that point of view the RAF was the RBF, a Free Baader Faction." Although the RAF attacked many military and civilian targets, from the outset their focus tended to be on trying to rescue each other as much or

more than to pursue other political objectives. Astrid Proll, ed., *Baader-Meinhof/Pictures on the Run 67–77* (Zurich, Berlin, New York: Scalo, 1998): 9–10.

19. In Aust's account, the response to the nude sunbathing of women members of the RAF drew the comment from the military commander of the camp where they trained: "This is not the tourists' beach in Beirut." Further details about tensions between the RAF and their Palestinian hosts can be found in Aust, *Baader-Meinhof*: 92–99.

20. In assessing the personal and political dynamics among Baader, Ensslin, and Meinhof, I have relied primarily on the documentation in Aust's account, but Klein also provides some insider's insight into the tensions between Ensslin and Meinhof, and the latter's demoralization prior to her death. See Klein, *Interview*: 52–53.

21. Both Baumann and Klein speak about the intellectually stultifying and emotionally draining effects of living clandestinely, as well as the political consequences of such isolation. See Baumann, *Wie Alles Anfing*: 105–106, 108–110, and Klein, *Interview*: 47, 50.

22. Klein, *Interview*: 49.

23. Vague, *Televisionaries*: 47.

24. The number of deaths and injuries suffered by all parties involved in the civil conflict in Germany in the 1960s through the late 1980s, is truly appalling. As noted, in July 1971, Petra Schelm was the first RAF member to die at the hands of police. In October 1972, Norbert Schmid was the first law officer killed by the RAF; although a security guard, Georg Linke, was badly wounded by a gunshot during Baader's escape in 1970. In February of 1972, a sixty-six-year-old boat builder was killed when a bomb planted by "Bommi" Baumann (then a leader of the June 2nd Movement) went off at the British Yacht Club in West Berlin, on February 2, 1972. The death of this innocent bystander led to Baumann's decision to cease his terrorist activities, but other actions by the J2M, and the RAF quickly added to the body count; in May of 1972, bombs killed an American Army colonel, and maimed thirteen others in Frankfurt. The attack was claimed as an act of retribution by the Petra Schelm Commando. Days later, bombs in various locations crippled the wife of a German judge, wounded fifteen workers at a Springer publishing plant, and killed three more GIs and injured five others. RAF bombings and shootings crescendoed through the late 1970s, and continued sporadically through 1989. Meanwhile, the toll of

terrorists killed or wounded in shoot-outs mounted apace, the most recent having occurred in September of 1999. The overall number of casualties cannot easily be calculated, but Hans-Peter Feldmann's book *Die Toten (The Dead) 1967–1993* contains portraits and short biographies of eighty-nine people, although some, such as the Italian publisher and terrorist Giangiacomo Feltrinelli, did not die as a direct result of events in Germany.

25. During the mid-1970s political instability in Germany grew after the resignation in 1974 of Chancellor Willy Brandt, whose close aide Gunther Guillaume had been exposed as an East German spy. SPD leader Helmut Schmidt, an able but less charismatic figure within the SPD, became chancellor upon Brandt's departure. In the meantime, economic instability increased with the onset of a deep recession bringing with it serious labor unrest, and making many people feel that the virtually uninterrupted prosperity of the postwar "economic miracle" had come to an end. The middle and latter phases of the Baader-Meinhof drama played themselves out against this doubly unsettling background.

26. Aust, *Baader-Meinhof:* 232.

27. The "Baader-Meinhof" laws passed in 1974 were only a part of the larger umbrella of anti-terrorist legislation enacted by the government that compromised previously exercised liberties. Another such law was the Professional Ban that made it a crime for government employees to advocate antigovernment activity. Insofar as broad latitude for interpreting this law's application rested with the courts, and most teachers and professors were paid by the state, the law amounted to a loyalty oath inhibiting free speech. Under auspices of the Professional Ban, some 1,300,000 security checks were made between 1973 and 1975. Open-ended restriction on the press, a law permitting the use of German Army troops on German soil, and many police search-and-surveillance practices instituted during the 1970s created a new climate in Germany. Most of these laws and practices remain on the books or in use, despite calls for their repeal and court challenges as to their abuse.

28. Aust, *Baader-Meinhof:* 262–263.

29. Klein, *Interview,* title page.

30. Aust, *Baader-Meinhof:* 278.

31. Ibid.

32. Aust, *Baader-Meinhof:* 489; Vague, *Televisionaries:* 78.

33. One indication of the lynching mentality that spread in official circles as well as in some parts of the population during the Schleyer crisis was the suggestion made by the CSU leader Franz Josef Strauss that a special court-martial should be created, and that for every hostage killed by terrorists, one of the RAF prisoners would be shot in retaliation.

34. For documentation of conflicting statements regarding suicide made by the Stammheim prisoners during the Schleyer crisis, see Aust, *Baader-Meinhof:* 489–495, passim, and with regard to Ensslin's earlier suggestion of a suicide pact, see ibid.: 277.

35. Ibid.: 489.

36. Ibid.: 491.

37. Ibid.: 525–526.

38. Ibid.: 541.

39. The story of the RAF and allied underground groups did not come to an end with the deaths in Stammheim prison. Less than a month after the events of October 18, 1977, Ingrid Schubert, an RAF prisoner whose release had also been demanded by the Mogadishu hijackers was found hanged in her cell in Munich. Meanwhile Birgitte Mohnhaupt, an RAF prisoner set free in February 1977, assumed leadership of the organization, and for the next decade a string of arrests, jail-breaks, shoot-outs with police, robberies, bombings, kidnapping, assassinations, and attempted assassinations made news in Germany and kept the nation in a state of tension. Occasionally, former RAF members would be discovered living quietly in hiding. Thus, Astrid Proll took refuge in England after having dropped out of the group in 1971, only to be captured and extradited back to Germany in 1978. She was released from prison in 1988 after having served her term. In 1989 the Berlin Wall came down and the East German government collapsed, whereupon it was revealed that a number of RAF members were holed up in the GDR as guests of the Stasi. Several of them were arrested and brought back to West Germany for trial. In 1991, during the Gulf War, surviving members of the RAF shot up the United States Embassy in Bonn and killed a West German government official in charge of overseeing economic privatization in East Germany. It was the RAF's last major action. In April of the following year a letter arrived at the Bonn office of a French news agency announcing that the RAF was prepared to renounce violence in exchange for the release of seriously ill and long-term prisoners, and explained that with the fall of communism their raison d'être had ceased to exist. Even so, armed RAF members remained under-

ground, and as late as September 1999, the fugitive Horst-Ludwig Meier was shot dead when he was stopped by the Vienna police.

40. Aust, *Baader-Meinhof*: 542.

II: Thirty Years Ago Today

1. Quoted in James Joll, *The Anarchists* (London: Eyre & Spottiswoode, 1964): 95.

2. The 1966 assassination of Dr. Hendrik Voerster, the prime minister of South Africa and one of the principal architects of Apartheid, by Demetrios Tsafendas, a man of mixed racial heritage who stabbed Voerster to death on the floor of the Parliament, is one of the surprisingly rare examples of modern tyrannicide.

3. The activities of the Italian Red Brigades had many parallels and some overlaps with those of the Red Army Faction in Germany, but the reactions of the Italian and German governments were quite different, in particular, as regards the trials, which in the case of those charged with the kidnapping and murder in Italy lasted even longer than that of the Baader-Meinhof group. But this did not involve extreme prison conditions, emergency abridgement of the rights of lawyers or defendants, or the widespread suspension of civil liberties. Furthermore, in keeping with Italian legal traditions, defendants who "repented" of their actions or otherwise testified in ways that helped the courts solve the crime were shown considerable leniency, and even those who adamantly refused to concede the charges or recant their political beliefs were treated with a measure of respect. The result was that while the Italian Red Brigades came far closer to overthrowing the government in Rome than the RAF came to destabilizing the one in Bonn, those directly involved with or generally sympathetic with the Red Brigades have been in many instances reintegrated into the fabric of Italian political life to a much greater degree than have the survivors of the RAF and their sympathizers. This said, the Italian system of justice was in a number of respects prejudiced against defendants when insufficient evidence of their guilt was presented. For a detailed account of the principal trials of the Red Brigades, see Richard Drake, *The Aldo Moro Murder Case* (Cambridge, Mass.: Harvard University Press, 1995). A view similar to the author's is taken by Arnulf Baring, a German historian quoted in Benjamin H. D. Buchloh, "A Note on Gerhard Richter's *October 18,*

1977," *October* 48 (spring 1989): 105. See also Carlo Ginzburg, *The Judge and the Historian: Marginal Notes on a Late Twentieth Century Miscarriage of Justice* (New York: Verso, 1999): 192.

4. For detailed discussions of the formation and activities of The Weather Underground, see Kirkpatrick Sale, *SDS* (New York: Vintage Books, 1974); Todd Gitlin, *The Sixties: Years of Hope, Days of Rage* (New York: Bantam Books, 1987); and *The Way the Wind Blew: A History of the Weather Underground* (London and New York: Verso, 1997).

5. In the United States, infringement of the constitutional rights of dissenters in regional courts, unlawful police searches and surveillance by police "Red Squads," as well as the use of agent provocateurs were not at all uncommon during the 1960s and 1970s, but for much of that period such abuses were the work of local or state authorities. At the Federal level the FBI campaign against "subversives" was of long-standing, but in 1968 the institution of the Nixon administration's COINTELPRO (Counter Intelligence Program), under the auspices of the FBI with linkages to the CIA and other intelligence services, carried government surveillance of and secret interference with dissenters to a new level and was the rough equivalent of the sort of tactics employed in Germany at the same point in time.

6. At the center of the recent debates over the uniqueness of the Nazi period, or over its similarity to other totalitarian episodes in history, have stood two scholars: the historian Ernst Nolte, who has taken the view that fascism has multiple faces and fascist terror many essentially comparable perpetrators; and the philosopher Jürgen Habermas, who has rejected this revisionist thesis as a form of politically motivated exculpation by specious analogy.

7. Jillian Becker, *Hitler's Children: The Story of the Baader-Meinhof Terrorist Gang* (New York: Lippincott, 1977) is the most egregious example of this simplistic correlation of the Nazi past and present.

8. In addition to these fictional works, a raft of books on terrorism appeared from the mid-1970s onward, and their tone and frequency map the political mood in the countries where they were published like a fever chart. Some, such as Benjamin Netanyahu, ed., *Terrorism: How the West Can Win* (New York: Farrar/Straus/ Giroux, 1986), review policy choices from a fixed political perspective rather than question those political

assumptions in the light of terrorism, while others, like Claire Sterling, *The Terrorist Network: The Secret War of International Terrorism* (New York: Holt Reinhart & Winston, 1981), are blatantly sensationalist and factually unreliable. Both are documents of the Cold War in that they take every opportunity to emphasize the involvement of Soviet and Eastern European communists—which was real enough in some situations but virtually irrelevant in others—at the expense of inquiring into local or regional factors that were far more important, as do many of the academic works published in the United States during the period.

9. Over the years the Baader-Meinhof group has gradually entered into the popular culture. A recently published compendium of interviews from the trend-setting British magazine *Dazed and Confused* not only featured an interview with Astrid Proll about her involvement but a photo spread juxtaposing an image of Meinhof under arrest and the filmmaker Harmony Korine. See Mark Sanders and Jefferson Hack, *Star Cultures* (London: Phaidon Press, 2000): 232–233, 283–287. Already in 1979 the singer and ex-addict Marianne Faithful had written a song, "Broken English," with Ulrike Meinhof in mind. "I indentified with [Meinhof]. The same blocked emotions that turn people into junkies turn other people into terrorists. It's the same rage." (Marianne Faithful with David Dalton, *Faithful: An Autobiography*, New York: Cooper Square Press, 1994: 234). For discussion of "Broken English" see Greil Marcus, *Double Trouble* (New York: Henry Holt and Co., 2000): 87–90.

10. Jim Dine and Roy Lichtenstein also made Pop versions of Mao—both in print mediums—but Mao was never the icon for them that he was for Warhol.

11. In the United States there were several groups with strong Maoist leanings, most notably the Progressive Labor Party, a faction of SDS which played an instrumental role in the splits within that organization that in 1969 produced The Weather Underground. But outside of the organized student Left these groups had no impact, nor did they benefit from or create anything like the vogue for Maoist slogans and Red Army style and mystique that was prevalent in Europe outside the committed left.

12. Like Richter, Schönebeck came from Dresden and his turn to a Pop-influenced Socialist Realism is interesting precisely because it would seem to have been motivated by a desire to resuscitate the themes and formats of conservative East German painting within a more sophisticated painterly manner; however, the artist has kept silent about his intentions as well as about his reasons for abandoning his art after 1966. In the same context, it is also noteworthy that A. R. Penck (born Ralf Winkler) returned to East Germany from the West after the Wall went up, convinced, it appears, that his future and the future of socialism to which he was committed lay there. Although his artistic ambitions and accomplishments were largely ignored by the East German cultural establishment, it was nineteen years before he crossed back over to the West.

III: The Paintings

1. "Interview with Rolf Schön, 1972" in Hans-Ulrich Obrist, ed., *Gerhard Richter: The Daily Practice of Painting. Writings and Interviews, 1962–1993* (London: Thames & Hudson and Anthony d'Offay Gallery, 1995): 73.

2. "Notes for a Press Conference, November–December 1989," in Richter, *Daily Practice:* 175.

3. The corner of the window frame and dark shadow on the left hand side of the image of Ensslin hanging are readily discernible around the margins of a 1988 painting, *Blanket,* that was shown in the 1989 exhibition *Richter 1988/1989* at the Museum Boijmans Van Beuningen in Rotterdam, which also included *October 18, 1977.* The title plainly suggests that the veil of white pigment the artist has dragged over the image is equivalent to covering a corpse with a sheet or blanket. A similar reading of the white painting spread over the small painting of the dead Meins, *Abstract Painting* (1988) is also reasonable. There is no painting of the same dimensions in the works from this year, which leads one to believe that the third version of *Hanged* Richter painted was destroyed and not painted over, but two vertical canvases measuring 140 x 100 cm are of the same size as *Man Shot Down 1* and *Man Shot Down 2,* and it is possible that under one of these the third version of this subject Richter cited in his notes can be found. If that is the case, it is perhaps significant that unlike *Blanket,* these two paintings have agitated surfaces and harsh colors—charred blacks and fiery reds, yellows and oranges—that are singularly violent.

4. Richter, *Daily Practice:* 171.

ROBERT STORR

5. Ibid.: 127.

6. Ibid.: 129.

7. See Peter Guth, *Wände der Verheissung: Zur Geschichte der architekturbezogenen Kunst in der DDR* (Leipzig: Thom Verlag, 1995).

8. "Notes, 1964-65," in Richter, *Daily Practice:* 33–34.

9. "Notes, 1964," in ibid.: 23.

10. The phrase comes from the title of a famous collection of anticommunist essays written by former communists and fellow-travelers, such as Richard Wright, Stephen Spender, and Ignazio Silone that was published in 1950 at the height of the Cold War.

11. Two personal factors may also help explain why Richter felt compelled to paint incidents out of the recent history of the German Left, a Left with which he had no direct involvement and scant sympathy. The first, suggested by the German writer Ulf Erdmann Ziegler, was Richter's marriage to the sculptor Isa Genzken, who, according to a 1972 article published in *Der Spiegel*, was reported to have traveled in circles close to the RAF. Ulf Erdmann Ziegler, "How the Soul Leaves the Body: Gerhard Richter's Cycle *October 18, 1977*, The Last Chapter in West German Postwar Painting," in Eckhart Gillen, ed., *German Art from Beckmann to Richter: Images of a Divided Country* (Cologne: DuMont Buchverlag; Berlin: Berliner Festspiele GmbH, 1997): 374–380. Furthermore, Richter explained that he first met Genzken around 1972 but did not get to know her until she was introduced to him again by the Marxist-oriented critic Benjamin H. D. Buchloh, who had recommended that she study with the painter. Richter recalled that the first real conversation they had together was about the recent killing of Hanns-Martin Schleyer, which, contrary to some opinion on the left at that time, Richter thought was a bad end to a bad affair. (Conversation with the author.) The second personal factor was Richter's ongoing dialogue with Buchloh, whose interview with the painter in the catalogue of his 1988 North American retrospective, organized by Roald Nasgaard (see Benjamin H. D. Buchloh, "Interview with Gerhard Richter," in Roald Nasgaard, *Gerhard Richter: Paintings* (London: Thames & Hudson, 1988)—conducted while Richter was at work on the Baader-Meinhof pictures—shows the two friends taking diametrically opposite positions not only on fundamental questions regarding Richter's work and motivation but on the nature and role of art itself. At almost every turn, the painter rejects the critic's sweeping generalization about the obsolescence of painting as a medium, the impossibility of conveying true emotion in works of art and other postmodernist assumptions arising out of the then current mix of Duchampian or Warholian tropes and ideas transposed from the writings of Walter Benjamin and the Frankfurt School. It is a testament to Buchloh's respect for Richter that he permitted such a thoroughgoing rebuttal of his interpretations to be published, and, reciprocally, it is an indication of Richter's regard for Buchloh that he responded forthrightly to the critic's challenges and incredulity when affirming his faith in ideas that Buchloh treats as anathema. In his private writings, Richter argued with himself; in public he argued with Buchloh, who represented political and aesthetic ideas antithetical to his own with a seriousness Richter could honor. Ideology had, in effect, become Richter's antimuse. Meinhof and Ensslin were its fullest embodiments, Buchloh its spokesman in the present.

12. "Notes, 1986," in Richter, *Daily Practice:* 125.

13. "Conversation with Jan Thorn-Prikker Concerning the Cycle *October 18 1977*, 1989," in ibid.: 185.

14. Ibid.: 183.

15. Ibid.

16. More so even than the cancelled paintings of Meins and Ensslin, the photographs in *Atlas* are an appendix to *October 18, 1977*, as is the cycle of twenty-three pages of a book by Pieter H. Bakker Schut on the Stammheim trial, which Richter painted on and the Anthony d'Offay Gallery published in facsimile in 1995 as *Stammheim*. When asked in 1995 by a reporter for the left-wing newspaper *Die Tageszeitung* how this work came about, Richter answered, "I do not know. The book [by Bakker Schut] was lying around, the situation similar to the one before [Aust's book]. I did not know what to do with the book. Then I began to paint the pages, the way I sometimes paint photographs. Maybe I wanted to finish the topic for myself entirely. One, two years later I showed the painted pages to a friend who thought they were very good and advised me to keep these pages as one piece." In 1991 Richter made a series of performance-based photographs titled *Six Photos 2.5.89–7.5.89* in which one sees the artist—usually in shadowy gray, at times a nearly phantasmagorical double-exposure—moving uneasily around a dark, otherwise vacant room. Akin in certain respects to some

of Bruce Nauman's early black-and-white videos, these images also suggest solitary confinement and in that way seem to refer back to Richter's preoccupations in *October 18, 1977*, painted three years earlier.

17. In another statement, Richter even more emphatically says of the Baader Meinhof cycle that: "It was meant to be far more comprehensive, far more concerned with the subjects' lives. But then I ended up with a tiny selection: nine motifs and a strong concentration on death—almost in spite of my intentions." "Interview with Sabine Schütz, 1990," in Richter, *Daily Practice:*. 209.

18. Roland Barthes, *Camera Lucida: Reflections on Photography* (New York: Hill and Wang, 1981): 15.

19. "Conversation with Jan Thorn Prikker," in Richter, *Daily Practice:* 185.

20. In "Notes on Gerhard Richter's *October 18, 1977,* Buchloh speaks of Richter's refusal to accept the socially prejudicial instrumentalization of the photographic gaze, particularly with regard to the police photographs used by Richter insofar as they seemed to Buchloh to be designed to "ritualistically" assure "the final liquidation of the enemies of the state." There is some truth to Buchloh's argument. Certainly the Bolivian government's "trophy" picture of the dead Che Guevara fits this description, but when asked by Jan Thorn-Prikker whether he intended his paintings as a criticism of the "cruel gaze" of the police photographs, as Buchloh had asserted, Richter demurred: "No that's not what I meant at all. Perhaps I can describe the difference [between the photograph and the painting] like this: in this particular case, I'd say the photograph provokes horror, and the painting—with the same motif—something more like grief." "Conversation with Jan Thorn-Prikker," in Richter, *Daily Practice:* 189.

21. This implicit "critique" of the media's treatment of the Baader-Meinhof story is central to the interpretation of many German writers, including Kai-Uwe Hemken who deals with the subject in detail in his book *Gerhard Richter: 18 Oktober 1977* (Frankfurt and Leipzig: Insel Verlag, 1998). It is also worth pointing out that among Michael "Bommi" Baumann's criticisms of the underground was its preoccupation with the media. This he felt both distracted radicals from attention to their own base of support but also caused them to play into the hands of powers they could not control, creating a vicious circle in which the underground's own hunger for media attention made it prey for media con-

sumption: "There was a great interest in the press. We figured out particularly how the press in Berlin would react to an action, how they would interpret the thing, and our strategy was planned with that in mind. There's a mistake in that, because the position of the bourgeoisie toward revolutionary action is clear in the final analysis: one should not measure one's actions against it. There is far too much attention paid to the media, which lies in capitalist hands. There was a great tendency to overestimate the media, which later had unexpected effects." Of the Baader-Meinhof group in particular, Baumann observed: "RAF said the revolution wouldn't be built through political work, but through headlines, through appearances in the press, over and over again, reporting: "Here are guerrillas fighting in Germany." This overestimation of the press, that's where it completely falls apart. Not only do they have to imitate the machine completely, and fall into the trap of only getting into it politically with the police, but their whole justification comes through the media. They establish themselves only by these means. Things only float at this point, they aren't rooted anymore in anything." Michael "Bommi" Baumann, *Wie Alles Anfing/How It All Began,* with statements by Heinrich Böll and Daniel Cohn-Bendit, trans. Helene Ellenbogen and Wayne Parker (Van-couver, Canada: Pulp Press, 1977): 28, 110.

22. In a letter to the author, Klaus Rainer Röhl, Meinhof's former husband, has suggested that the photograph was taken in May 1970.

23. Kai-Uwe Hemken, "Suffering from Germany—Gerhard Richter's Elegy of Modernism: Philosophy of History in the Cycle *October 18, 1977,*" in Gillen, ed., *German Art from Beckmann to Richter:* 384.

24. Just as this book was going to press, we received from the archives of the public prosecutor's office in Stuttgart a folder containing original prints of two images that appear in *October 18, 1977,* for which we were informed, the negatives have been lost. The images, taken days after Baader's body was discovered, are of his cell and record player. The information contained in these photographs is remarkable in several aspects. First, they are in color—as was, incidentally, the original videotape from which the magazine images of *Arrest 1* and *Arrest 2* were taken, though all the versions Richter had in his scrapbook were black and white. Although the prints are in a small format, the color and the relative clarity of focus permits one to make

ROBERT STORR

out certain details lost in the black-and-white magazine reproduction, and further obscured in Richter's painting, such as the red triangle in the upper-right-hand corner of the picture—apparently a rolled red pennant or banner lying on a ledge, titles of several books on Baader's shelves (for example one titled *All Lenin's Children* and another on Goya), bloodstains and a chalk silhouette on the floor, two packages of cigarette tobacco next to the record player and other objects, which no matter how incidental, taken together make the scene overwhelmingly macabre, claustrophobic, and forlorn. The most unexpected and disturbing fact that emerges from close inspection of the photographs—an inspection involving careful scrutiny with a high-powered microscope as well as computer-enhanced re-imaging—was that the record on the turntable in Baader's cell the night of his death was Eric Clapton's 1974 release, *There's One in Every Crowd*, a melancholy mix of gospel, blues, and reggae. Given what occurred during the night or early morning of *October 18, 1977*, the lyrics of several of these songs—"We've Been Told (Jesus Coming Soon)," "Swing Low Sweet Chariot," "The Sky Is Crying," "Better Make It Through Today"—are, to say the least, eerie and depressing. However, none of the cuts is more so than the last song on side two of the album, the side facing up on the record player. Titled "Opposites," its single, hauntingly repeated verse goes: "Night after day, day after night,/White after black, black after white./Fight after peace, peace after fight./Life after death, death after life."

25. Although a high-school dropout, Baader was credited by at least one of his teachers as being highly intelligent, and he was also remembered for writing exceptionally good essays. The extensive library he amassed during his incarceration suggests that he worked hard to make up for his lack of a university education and, so far as can be judged from the photographic evidence, to deepen his understanding of German history and politics.

26. Anyone who, as a matter of ideological rigor, bridles at the possibility that Richter has inserted a cross on the horizon-line of *Funeral* might also recall that Ensslin, as a pastor's daughter, had been a devoutly religious person in her youth and, in the days just before her death, summoned both Protestant and Catholic clergy to her cell. It is of further note that much of the dissident Left in Germany, as elsewhere, found its voice through involvement with churches and church organizations that opposed nuclear buildup, conventional rearmament, and the Vietnam War. The secular Left has no monopoly on the proper interpretation of the Baader-Meinhof story.

27. Gregorio Magnani, "Gerhard Richter: For Me It Is Absolutely Necessary that the Baader-Meinhof is a Subject for Art," *Flash Art*, international edition (May–June 1989): 69.

28. Ibid.

29. Ibid.

30. James Hall, "Oktober Revelation," *The Guardian* (London) (August 30, 1989): 37.

31. "From a letter to Edy de Wilde, 23 February 1975," in Richter, *Daily Practice*: 82–83.

32. "Notes for a Press Conference, November–December, 1989," in ibid.: 173.

33. Jean Baudrillard, "Precession of the Simulacra," in *Simulations* (Paris: Semiotexte, 1983): 11.

34. Ibid.: 31.

IV: Painting History—Painting Tragedy

1. "Notes for a Press Conference, November–December 1989," in Hans Ulrich Obrist, ed., *Gerhard Richter, The Daily Practice of Painting. Writings and Interviews, 1962–1993* (London: Thames & Hudson and Anthony d'Offay Gallery, 1995): 174. A so-called rubble film like Rossellini's *Germany Year Zero* contributed a phrase to the language and was a rare example of a German movie of the immediate postwar years dealing with the theme of the war criminal next door.

2. Ibid.: 175.

3. "Conversation with Jan Thorn-Prikker Concerning the Cycle 18 October 1977, 1989," in ibid.: 199.

4. In addition to the three versions of the *Execution of Maximilian*, Manet painted three other pictures on historical themes, two of the escape from a prison island of the exiled communard Henri Rochefort; and one of a naval engagement from the American Civil War, *The Battle of the Kersage and the Alabama* (1864). Manet also made two lithographs of images from the last bloody days of the Paris Commune of 1871, *The Barricade* (1871), in which Republican troops execute rebels; and *Civil War* (1871–73), showing a dead communard in a pose similar to Manet's *The Dead Toreador* (1864–65), which has been spoken of as a precedent for Richter's *Man Shot Down 1* and *Man Shot Down 2*; the connection is tenuous at best.

5. The first version, Manet's *Execution of the*

Emperor Maximilian, is in the Museum of Fine Arts, Boston; the second, partially destroyed, version, which once belonged to Edgar Degas now hangs in the National Gallery in London; and the third is in the Städtische Kunsthalle, Mannheim.

6. It is interesting to note that in 1999–2000, Jasper Johns made a painting and at least one drawing based on the London version of Manet's *The Execution of Maximilian* in which he obliterated the images, working only with the contours of the rectangular fragments, and interwove Manet's name with those of Degas and himself.

7. Like traditional history painting, *October 18, 1977* includes all these genres, but rather than synthesize them into a single unified image, presents them sequentially: *Youth Portrait* (portrait); *Confrontation 1, Confrontation 2, Confrontation 3* (figure study); *Record Player* (still life); and *Funeral* (landscape).

8. A rare exception is Isaak Brodsky's *Lenin in Smolny* (1930). To be sure, this image of an ascetic Lenin is propaganda, but its aesthetic reserve partially redeems its formal conservativism. Brodsky's picture is a reminder that within countries where Socialist Realism held total sway not all the permissible models were equally bombastic or clichéd. This was true of East Germany when Richter attended the Dresden Academy, though his preferences in the 1950s were Picasso and Renato Gutusso, whose differing brands of modified modernism—think of *Massacre in Korea* (1951), Picasso's grotesque and cartoonish reprise of Goya's *The Executions of the Third of May* (1808)—were excused by Stalinist cultural bureaucrats because of the artists' allegiance to the Communist Party.

9. It was Nerdrum's painting Richter was no doubt referring to when, asked whether photography now sets an aesthetic norm that prevents an artist from painting such a theme out of his head, he answered, "I do know one such picture, by a Norwegian painter, rather old-masterish, as phoney as [the East German painter] Werner Tübke. Now photography is so unsurpassed by definition, it's changed everything so greatly, there's just nothing to be said." "Conversation with Jan Thorn-Prikker," in Richter, *Daily Practice*: 187.

10. "Notes for a Press Conference, November–December, 1989," in ibid.: 174.

11. "To Jean-Christophe Ammann, February 1973," in ibid.: 81.

12. Benjamin H. D. Buchloh, "A Note on Gerhard Richter's *October 18, 1977*," *October* 48

(spring 1989): 93.

13. "Notes, 1989, " in Richter, *Daily Practice*: 178.

14. "Notes, 1973," in ibid.: 78.

15. "Interview with Sabine Schütz, 1990," in ibid.: 211. Richter's distrust of theory comes out repeatedly in recent years and never more clearly than in this interview, which makes it abundantly clear how perverse it is for those who maintain that everything is "text" to have chosen as their star witness someone so positive about art's ability to bring other nontextual resources and constructs to bear on experience. "Intellectuals are far more endangered than ordinary people or artists. They're intelligent, very good with handling words and therefore brilliant at constructing theories, and they share in the overwhelming power of words. Almost everything is prompted, forbidden, or authorized by words; explained, transfigured, or falsified by words. So we ought to be skeptical, and not forget that there's another, highly important kind of experience. Whatever we experience nonverbally—by sight, touch, hearing or whatever—gives us a certainty or a knowledge that can lead to better actions and decisions than any theory. . . . The problem is, however, that a theory can be so logical in its own terms, so complicated, so intricate—almost as complex as life—that you're compelled to go along with it because it is so convincing or so beautiful." Ibid.: 213.

16. "Notes for a Press Conference, November–December 1989," in ibid.: 174.

17. Ibid.: 178, and Hannes Böhringer, quoted in Jean-Christophe Ammann, *Gerhard Richter: 18. Oktober, 1977* (Frankfurt am Main: Museum für Moderne Kunst, 1991): 2.

18. Stefan Germer, "Ungebetene Erinnerung," in *Gerhard Richter: 18. Oktober, 1977* (Frankfurt: Portikus; Cologne: Buchhandlung Walther König, 1989): 53.

19. "Notes for a Press Conference, November–December 1989," in Richter, *Daily Practice*: 173–174.

20. "Conversation with Jan Thorn-Prikker," in ibid.: 190.

21. Ibid.: 186.

22. "Notes for a Press Conference, November–December, 1989," in ibid.: 173.

23. Whether Baader, Ensslin, Meinhof, and Raspe committed suicide or were murdered is less of an issue for the artist than the inevitability of their dying as a result of their confrontation with authority. When asked what prompted his compassion for the RAF, Richter answered: "The death that the terrorists had to suffer. They probably did kill themselves

ROBERT STORR

which for me makes it all the more terrible. Compassion also for the failure; the fact that an illusion of being able to change the world has failed." "Interview with Jan Thorn-Prikker," in ibid.: 203–204.

24. The directors of *Germany in Autumn* are Rainer Werner Fassbinder, Alexander Kluge, Volker Schlöndorff, Bernhard Sinkel, Alf Brustellin, Edgar Reitz, Katja Rupé, Hans Peter Cloos, Beate Mainka-Jellinghaus, Maximiliane Mainka, and Peter Schupert.

25. Sophocles, *Antigone: The Oedipus Cycle,* trans. Dudley Fitts and Robert Fitzgerald (New York: Harcourt Brace & Company, 1949): 210.

26. Stefan Weirich, "RAF in Wort und Bild. Aus dem Leben: Eine schwierige Geschichte: Gerhard Richter und der Deutsche Herbst," *Die Tageszeitung* (December 28, 1993): 12.

PHOTOGRAPH CREDITS

Photographs of the works of art reproduced in this volume have in most cases been provided by their owners or custodians, as identified in the captions. Individual works of art appearing herein may be protected by copyright in the United States of America or elsewhere, and may not be reproduced in any form without the permission of the copyright owners. The following credits appear at the request of the artist or the artist's representatives and/or the owners of individual works. For certain documentary photographs reproduced in this volume, we may have been unable to trace the copyright holders, and would appreciate notification of such information for acknowledgment in future editions.

Michael Agee, Yale University Art Gallery, New Haven: 60
David Allison: 21 top, 69, 232, 241 left, center, and right (copy prints)
Jorg P. Anders, Staatliche Museen zu Berlin, Preussischer Kulturbesitz, Nationalgalerie: 67 top
© ARD-aktuell (MoMA copy print): 247
© 2002 by Artists Rights Society (ARS), New York: 52, 88, 140
Ben Blackwell, San Franciscco Museum of Modern Art: 18 top, 125
Jose Luis Braga, Filipe Braga, Serralves Foundation, Porto: 64
Courtesy Isabel and David Breskin: 128 bottom
Courtesy Frieder Burda: 45, 52
© Burghard Huedig/Der Spiegel/XXP: 180
Carlos Catenazzi, Art Gallery of Ontario: 107 bottom
The Czech Museum of Fine Arts, Prague: 20 bottom
Daros Collection, Switzerland: 29 bottom
Peter Dibke: 101
Courtesy Anthony d'Offay Gallery, London: 23 bottom, 126 bottom,129 top, 141, 144
Thomas R. Du Brock, Museum of Fine Arts, Houston: 130–131
Joachim Fliegner: 66 top, 238
Courtesy Marian Goodman, New York: 68 bottom
Tom Griesel, The Museum of Modern Art, New York: 144, 145
Mark Gulezian: 20 top
Reni Hansen, Kunstmuseum, Bonn: 25 top, 31 top
Courtesy Helga Photo Studios: 30 bottom
Jürgen Henschel/Ullstein: 208

ID.art: 66 bottom
© by Jorg Immendorff: 235
Jung Collection: 67 bottom
Paige Knight, The Museum of Modern Art, New York: 76 top, 132 bottom
Kasper König: 52
Horst Kolberg, museum kunst palast, Düsseldorf: 28 bottom
Jean-Pierre Kuhn, Zurich, Kunstmuseum Winterthur: 22 top
© 2002 by the Roy Lichtenstein Foundation: 60
Salvatore Licitra, Milan, courtesy Massimo Martino: 23 top right, 31 bottom, 76 bottom, 77 top
Courtesy Luhring Augustine Gallery, New York: cover, 19 top
Courtesy Joshua Mack and Ron Warren: 23 top left
Courtesy Barbara Mathes Gallery, New York: 75 top
George Meister: 48
Modern Art Museum of Fort Worth: 24 top
Martin Müller: frontispiece
© by Museum Associates/LACMA: 88
Rudolf Nagel, Museum für Moderne Kunst, Frankfurt: 55
© by The National Gallery of Art, Washington, D.C.: 140
Jens Nober, Museum Folkwang, Essen: 68 top
Courtesy Pace Gallery, New York: 107
Courtesy Park Hyatt, Chicago: 30 top
Fritz Pitz: 22 top
© by Sigmar Polke: 234
© Museo Nacional del Prado, Madrid: 254
Tim Rautert, Essen: 199
Ian Reeves: 64–65
© Réunion des Musées Nationaux, Paris: 253
David Reynolds: 256
Rheinisches Bildarchiv, Cologne: 27
© by Gerhard Richter: 144, 240
Courtesy Gerhard Richter: frontispiece, 10, 35, 38, 42, 59, 65, 70–73, 74 bottom, 87, 101, 122, 124 bottom, 126 bottom, 127, 129 bottom, 141, 158, 232
Friedrich Rosenstiel, Cologne: 25 bottom, 126 top, 132 top, 133, 135
Stefan Rötheli, Zurich, Kunstmuseum Winterthur: 28–29
© Musée Royaux des Beaux-Arts de Belgique, Brussels: 251
Johnsen Røyneland, Oslo: 128 top
The Saint Louis Art Museum: 80, 81 top and bottom

San Francisco Museum of Modern Art: 134

Alex Schneider: 19 bottom

Uwe H. Seyl: 21 bottom

SMK Foto, Statens Museum for Kunst,
 Copenhagen: 123

Courtesy Sperone Westwater, New York: 51, 124
 top

© Staatsammaltschaft Stuttgart (MoMA copy
 print): 242

Lee Stalsworth, Hirshhorn Museum and Sculpture
 Garden: 74 top

Städtische Galerie im Lenbachhaus, Munich: 44,
 240

© Städtische Kunsthalle, Mannheim: 255

© Stern: 243, 244

Michael Tropea: 77 bottom

Ferdinand Ulrich, Kunsthalle, Recklinghausen: 22
 bottom

Elke Walford, Hamburger Kunsthalle: 106

© by Andy Warhol Foundation for the Visual
 Arts/Artists Rights Society (ARS), New York:
 55, 233

Courtesy Michael Werner Gallery, Cologne and
 New York: 47, 235

Greg Williams, © by The Art Institute of Chicago:
 26

John Wronn, The Museum of Modern Art, New
 York: 100, 105, 188, 189 top and bottom, 190
 top, center, and bottom, 191, 192 top and bottom,
 193 top and bottom, 194, 195 top and bottom,
 196–197, 234

Zindeman/Fremont: 78 top, 98

INDEX OF ILLUSTRATIONS